Who Owns the Past?

CULTURAL POLICY,
CULTURAL PROPERTY,
AND THE LAW

**Rutgers Series on the
Public Life of the Arts**

A series edited by

RUTH ANN STEWART
MARGARET JANE WYSZOMIRSKI
JONI MAYA CHERBO

Who Owns the Past?

CULTURAL POLICY,
CULTURAL PROPERTY,
AND THE LAW

KATE FITZ GIBBON, EDITOR

RUTGERS UNIVERSITY PRESS
NEW BRUNSWICK, NEW JERSEY, AND LONDON
in association with
AMERICAN COUNCIL FOR CULTURAL POLICY

On the very day this book went to press, we received news that journalist and fellow author Steven Vincent had been kidnapped and killed in Basra, Iraq. We are shocked and saddened by his death. His incisive and thoughtful contribution to the dialogue on the arts has been cut short, and his loss will be deeply felt by friends and colleagues.

Library of Congress Cataloging-in-Publication Data
Who owns the past? : cultural policy, cultural property, and the law / Kate Fitz Gibbon, editor.
 p. cm. – (Rutgers series on the public life of the arts)
 Includes bibliographical references and index.
 ISBN-13: 978-0-8135-3687-3 (alk. paper)
 1. Collectors and collecting–History.
2. Cultural property–Protection–International cooperation. 3. Intellectual property. 4. Material culture. 5. Museums–Acquisitions. 6. Antiquities–Collection and preservation. 7. Art and state. 8. Culture and law. 9. Cultural policy. I. Fitz Gibbon, Kate. II. American Council for Cultural Policy. III. Series.
AM221.W48 2005
344.73'097–dc22 2005002950

A British Cataloging-in-Publication record for this book is available from the British Library.

We gratefully acknowledge the following for permission to print articles previously published:

Margaret Ellen Mayo, *Collecting Ancient Art: A Historical Perspective,* © 1983 The Kimbell Art Museum
Clemency Coggins, "Archaeology and the Art Market," *Science Magazine,* January 21, 1972, Volume 175, pp. 263-66, © 1972 American Association for the Advancement of Science
Clemency Coggins, "Observations of a Combatant," *International Journal of Cultural Property* 8, No. 1, 1998
John Henry Merryman, "A Licit International Trade in Cultural Objects," *Art Market Matters,* The European Fine Art Foundation (TEFAF), Helvoirt, Netherlands, 2004

Page ii: Mound 7, Trench I, from the east, Harappa, Indus Valley, South Asia; photo 1927-28, courtesy Anahita Gallery, Inc. All rights reserved.

General editor: Kate Fitz Gibbon
Editor: John Stevenson
Copyeditor: Sherri Schultz
Legal proofreader: Patricia Halsell
Indexer: Candace Hyatt
Design: Susan E. Kelly and John Hubbard
Color separations: iocolor, Seattle
Produced by Marquand Books, Inc., Seattle
 www.marquand.com
Printed and bound by Thomson-Shore, Inc., Dexter, Michigan

Contents

II. COLLECTING AND THE TRADE

III. ART IN PERIL

IV. THE UNIVERSAL MUSEUM

V. APPENDICES AND LINKS

Statue of the Lingapura hunchback, 9th–13th c., in situ, Lingapura, Southeast Asia (after Parmentier 1939, pl. XVIIIB). Photo courtesy Emma C. Bunker and Douglas Latchford.

THE LAST TWENTY YEARS have seen an increasingly strident debate over what constitutes a legal and ethical market for art and antiquities. Throughout the art world, the focus has been on moral considerations, and challenges to long-held beliefs and practices have become ever more frequent. At the same time, the legal framework pertaining to the collection and exhibition of works of art has grown increasingly complex. Museums, private collectors, and dealers now function under a continually evolving network of civil and criminal laws, customs policies, and international treaties. Acquisition, exhibition, and ownership of art are fraught with risk and uncertainty for the most careful curator or collector.

Interested parties in the worlds of art, law, education, and government need assistance to understand these rapidly changing and often conflicting cultural policies. Existing museum and academic organizations have their own pressing agendas and little time to focus on issues of collecting. There is urgent need for forums to encourage active participation from within the art world—as well as without—to develop new policies for the future.

The American Council for Cultural Policy was founded in 2002 as a not-for-profit organization dedicated to informing the public on arts issues. Our membership includes scholars, museum professionals, art collectors, and those who advise them. Our Web site, www.culturalpolicy council.org, contains background readings and resources for arts professionals, educators, and students.

The ACCP's first major project was to commission and publish a sourcebook of writings to clarify the legal, moral, and practical issues raised by collecting and exhibiting works of art. Museum professionals, collectors, scholars, and legal experts were encouraged to express views that have not been widely disseminated or discussed. In the course of conversations with our distinguished contributors, we realized that there are questions subsumed in the debate that go directly to the fundamental values of Western culture and our democratic political process.

The challenges of developing workable cultural policies for the future are tremendous, as are the stakes. For more than a century, works of art from many cultures have been displayed in America's public institutions, conserved and studied for the benefit of all. Truly, these works of art are America's patrimony as well, mirroring the rich blend of nationalities on which American culture is founded, providing roots for many and inspiration to all. It is imperative that we work together to preserve cultural resources for our citizens while respecting international concerns over loss of heritage. Our success will be measured by our recognition of common goals in safeguarding cultural heritage, not by striving to place one interest above another. We hope that by presenting a variety of viewpoints on issues of cultural policy, we can help to transform what has been at times an acrimonious debate into an informed and rewarding conversation between all of us whose lives are enriched by art.

ASHTON HAWKINS, PRESIDENT
AMERICAN COUNCIL FOR CULTURAL POLICY

ON BEHALF of the American Council for Cultural Policy, I am most grateful to all of the authors who contributed such eloquent, informative, and authoritative essays to *Who Owns the Past?: Cultural Policy, Cultural Property, and the Law.* This book represents a remarkable collaborative exercise between many of the nation's finest attorneys specializing in art law, legal academicians, distinguished anthropologists, archaeologists, museum professionals, art dealers, and collectors, each of whom has made extraordinary donations of time and effort. With their help, what was first conceived as a simple handbook on art law evolved into a much broader exploration of the legal and ethical issues facing the art world today.

Warm thanks are also due to all the supporters of the American Council for Cultural Policy over the last two years, whose generosity helped bring this book to fruition. Noteworthy among these are the Art Dealers Association Foundation, the Robert and Renée Belfer Family Fund, the Madeline and Kevin Brine Charitable Trust, the Eli and Edythe L. Broad Foundation, the Lewis B. and Dorothy Cullman Foundation, the Fernwood Art Foundation, James Ferrell, Dr. Guido Goldman, the J. M. Kaplan Fund, the Kislak Family Fund, the Jerome Levy Foundation, the Hazen Polsky Foundation, the Thomas and Margot Pritzker Foundation, Jonathan Rosen, the Rosenkranz Foundation, the Randall and Barbara Smith Foundation, Dr. Howard Solomon, the Gerald G. Stiebel and Penelope Hunter-Stiebel Fund, the Judy and Michael Steinhardt Foundation, the Eugene V. and Clare E. Thaw Charitable Trust, and Shelby White.

I want to also thank our indefatigable editor, Kate Fitz Gibbon, who wrote several chapters, organized and edited the book, and shepherded our numerous authors through the publishing process. Judith Church and William Pearlstein have contributed substantially to the crafting of the book as a whole, providing creative direction as well as editorial and legal expertise as members of the ACCP Editorial Board. Thanks are due to John Henry Merryman for the constant inspiration his work has provided

and his gentle critical assessments throughout. Peter Tompa brought many important issues and valuable sources to our attention; without his thoughtful contributions, the book would not be what it is. Shira Hecht gave enormously of her time, reviewing and improving many chapters. The Kimbell Museum, the European Fine Arts Foundation and the *International Journal of Cultural Property* generously granted permission for republication of articles.

Ed Marquand of Marquand Books served as mentor and guide through the publishing process, and managing editor Marie Weiler and designers Susan E. Kelly and John Hubbard brought grace and humor to the task of organizing the book. Editor John Stevenson did more than correct our texts: the book benefited from his expertise in cultural heritage issues and thoughtful suggestions. Sherri Schultz also brought her considerable expertise to copyediting the manuscript and Patricia Halsell brought clarity to the legal notations. We are delighted that Rutgers University Press selected *Who Owns the Past?: Cultural Policy, Cultural Property, and the Law* for publication in their Series on the Public Life of the Arts, and wish to thank director Marlie Wasserman for her guidance in bringing the book to final publication.

ASHTON HAWKINS

WHAT WOULD AMERICA BE LIKE without its public and private collections
of art, antiquities, ethnological materials, or natural history? What if the
only art trade was in contemporary American art? Would we be richer or
poorer as a nation? Would US citizens have greater or even less under-
standing of the world outside our borders?

This book takes a comprehensive look at the development of US and
foreign cultural property law, as well as recent US case law that affects
the ability of both private collectors and US museums to own artworks
from other countries and other times. Its purpose is to explain the ethi-
cal, legal, and practical arguments on which current US cultural policy is
based, and to make the cultural property debate comprehensible to all.

Most US laws affecting cultural policy regulate the international and
intercultural transfer of art. They focus on antiquities and ethnological
materials from both dead and living cultures, on the spoils of war and
civil and religious strife. These are hot-button issues. They are also issues
over which thoughtful and well-intentioned people can disagree.

There is a widely accepted view—voiced often by archaeological
interests, and reverberating through the echo chamber of the press—
that issues of cultural heritage are simple moral arguments between
opposing scientific and commercial interests. Archaeological organiza-
tions have urged changes to US law that would significantly reduce the
trade in art, and make it more difficult for museums to preserve access
to materials from the world's diverse cultures.

In reality, the debate over cultural heritage is not between two inter-
nally consistent, highly polarized positions. Archaeologists, anthropolo-
gists, art historians, museum directors, curators, collectors, dealers, and
auction houses all have legitimate, often overlapping interests in this
discussion. Over all stands the premise contained in the preamble to
the 1970 UNESCO convention, that "the interchange of cultural property
among nations for scientific, cultural and educational purposes increases
the knowledge of the civilization of Man, enriches the cultural life of all

peoples and inspires mutual respect and appreciation among nations."
When that sentiment is truly shared, our differences become small.

The goal of this book is to encourage and broaden the discussion by
providing new information, by giving weight to legal, practical, and fac-
tual arguments that have been overlooked or discounted, and by criti-
cally examining the emotional issues that have clouded the debate. The
timing is crucial. There is a broad consensus among all parties that the
legal mechanisms currently in place to protect cultural heritage are not
working well, and there is increasing political and social will on all sides
to press for change.

New laws and new policies are being propounded in Congress and
through the courts. Precipitate or ill-considered actions are likely to dam-
age America's existing cultural resources and prospects for their future
growth while failing to provide effective solutions to the continued loss
of the world's cultural heritage.

The debate is over not only who *owns* the past, but in whose hands
the stewardship of cultural heritage should lie. The recent focus on an
archaeological perspective raises important questions. Do archaeologists
have the most compelling claim on public policies and public resources?
Do museums? Where do the goals of stewardship meet the public inter-
est? The policies that emerge from this discussion will determine the
future of America's cultural institutions and what subsequent genera-
tions will find when they enter their doors.

The first section of this book is intended to provide an overview of the
historical development of US cultural-property law. The section begins
with a brief "Chronology of Cultural Property Legislation," which de-
scribes the evolution of US and multinational laws recognizing that art
should receive special protection, even in times of war.

International agreements and US laws affecting cultural policy
are layered and interconnected in ways that are not always apparent
to the nonlegal observer. Simply signing on to an international agree-
ment does not create a legal structure within the signatory country for
enacting its provisions. In the United States, the primary law regulat-
ing cultural property issues is the 1983 Convention on Cultural Prop-
erty Implementation Act. This law was created by the US Congress to

implement the 1970 UNESCO Convention on the Means of Prohibiting and Preventing the Illicit Import, Export and Transfer of Ownership of Cultural Property. In the Implementation Act, Congress attempted to balance the need of source-country governments to retain important national patrimony with the interests of US museums, collectors, and dealers in promoting a legitimate trade in antiquities and ethnological materials.

In the first and lengthiest legal essay, "Cultural Policy, Congress, the Courts, and Customs," **William Pearlstein** argues that US courts have given unprecedented recognition to blanket-ownership claims under foreign laws. The result of the recent US Court of Appeals case of *US v. Schultz* is to place all objects removed from source countries subsequent to the enactment of foreign-ownership laws into a legal limbo. Private owners and institutions that have owned, exhibited, and published objects for decades cannot know whether they would be considered "stolen" under the National Stolen Property Act unless a court case determines the applicability of the source-nation ownership laws.

Steven Vincent's essay, "Indian Givers," deals with the current ramifications of the Native American Graves Protection and Repatriation Act (NAGPRA). For many, NAGPRA is a long-overdue measure that protects Indian burial remains and sacred objects and helps to redress the wrongs suffered by Native Americans since the arrival of Europeans on the continent. Others, including many archaeologists and scientists, are concerned by the law's increasingly stringent implementation and rapidly expanding mandate for the transfer of artifacts from museums into tribal hands.

Other authors describe aspects of US laws that determine how US courts evaluate competing claims. **Rebecca Noonan**'s "Immunity from Seizure" covers the 1965 Immunity from Seizure Act, a federal law enacted in response to Soviet concerns that art loaned for public exhibition might be subject to claims by descendants of pre-Revolutionary owners from whom it was confiscated. The federal law grants broad immunity to foreign governments for cultural objects and works of art imported for temporary exhibition in United States.

In "A Tale of Two Innocents," **Ashton Hawkins** and **Judith Church** look at the different approaches taken by US courts regarding the respective obligations of a good-faith purchaser and a person whose art has been stolen in determining when, if ever, the statute of limitations on

claims for the return of the stolen property begins to run. The authors argue that the traditional secrecy regarding art theft is counterproductive, and that museums and collectors should act swiftly and publicly to make thefts known. A legislative solution in which owners of stolen art were granted a generous time period in which to record the theft of artworks in a government-operated registry could reduce the punitive effects on innocent purchasers and help to stem the illicit art trade.

Several authors describe their experience with litigating recent cases involving artworks and antiquities. In a highly publicized case involving paintings by Egon Schiele, the Museum of Modern Art in New York relied on the 1968 Arts and Cultural Affairs Law, state legislation similar to the federal Immunity from Seizure Act discussed earlier. **Stephen W. Clark** discusses in "The Schiele Matter" the series of court cases resulting from claims by heirs of the original owners that the paintings had been improperly taken from them during the Holocaust. As a result, the paintings have been crated and unavailable to the public for the last six years. Mr. Clark questions the propriety of subjecting a US museum that is merely a participant in a loan agreement to a criminal charge involving foreign claims to artwork.

The authors of "The Sevso Treasure," **Harvey Kurzweil**, **Leo Gagion**, and **Ludovic de Walden**, were directly involved in the litigation surrounding a valuable hoard of late Roman silver. The case is a dramatic example of the complexities of art litigation in the United States, involving claims to the treasure by three different countries, falsification of records by national governments, and purported murder and suicide.

Competing claims to cultural property arise outside the United States as well. In the United Kingdom, the debate has been vigorously pursued in the legislature, the courts, and the press. The Dealing in Cultural Objects (Offences) Act, discussed in "The Art Market in the United Kingdom and Recent Developments in British Cultural Policy," makes it illegal to trade in or acquire "tainted" art objects. The law allows continued trade in art objects already in circulation, but makes it a crime to deal in objects that are known to have been illicitly excavated or exported after December 30, 2003. Similar legislation has been suggested for the United States as an alternative to the broad application of the National Stolen Property Act to cases in which source countries claim ownership of all "national patrimony." Authors **Anthony Browne** and **Pierre Valentin** describe the active involvement of the British Art Market Federation in

the crafting of the law, its potential impact on trade in Britain, and the need to establish an international art registry to ensure compliance with these new laws.

An essay by **Kate Fitz Gibbon** summarizes the current international debate over the appropriate home and legal status of the marbles removed from the Parthenon. In "The Elgin Marbles," she describes the conflicting positions of international legal scholars David Rudenstine and John Merryman, the ethical arguments for retention by the British Museum, and claims for restitution by the government of Greece.

A commentary by **Jeremy G. Epstein**, "The Hazards of Common Law Adjudication," precisely outlines the challenges of litigation under the laws discussed in the preceding articles, and the likely patterns that future cases will follow.

The second section of the book looks at private and public art collecting and its importance to the continued growth of US cultural institutions. The articles explore how collecting activities are encouraged or constrained by US laws and by the ethical guidelines established by museum organizations.

Margaret Ellen Mayo's essay, "Collecting Ancient Art: A Historical Perspective," discusses the changing social and moral justifications for collecting antiquities. Dr. Mayo also describes the role of individual collectors in establishing the US public institutions that are the foundation of today's museum network.

James Cuno's essay, "Museums, Antiquities, Cultural Property, and the US Legal Framework for Making Acquisitions," discusses the central role of the museum in the stewardship and preservation of cultural heritage and the necessity of establishing cultural policies which further that ideal. Dr. Cuno elucidates the ethical principles on which museum policies are founded, noting that any policy which inhibits the collection and preservation of antique works of art and cultural objects challenges the entire premise for the existence of museums.

In "The Expert and the Object," **Ronald D. Spencer** examines practical and philosophical issues of authentication in art and antiquities and the broad range of scholarly interests to be considered in laws regulating the ownership and transfer of art.

Private and corporate philanthropy provides substantial financial support to our largely independent US museums. In "Building American Museums: The Role of the Private Collector," **Shelby White** discusses

the role of the collector in the founding and expansion of two US museums.

How does the market actually work? An accurate assessment of the economic impact of the trade and the role of dealers in providing specialized knowledge and expertise is essential to the crafting of future laws and cultural policies. Police agencies and the press have often described the value of the trade in smuggled art as in the billion-dollar range and as a close runner-up to the trade in arms and illegal drugs. In "The Antiquities Market: When, What, Where, Who, Why . . . and How Much?," **Arielle Kozloff** takes a serious look at these inflated numbers.

"Dealers Speak," a series of short interviews with some of the most important antiquities dealers in the United States by **Peter Marks**, provides insight into the actual workings of the highly personal art business.

In "ATADA: Building Ethical Consensus through Trade Organization," **Ramona Morris** describes the formation of the Antique Tribal Art Dealers Association and their efforts to build culturally sensitive, harmonious relationships with native communities in the United States and Canada and to work cooperatively with museum and other cultural institutions.

Ancient coins are the most widely collected and popular item within the antiquities trade. Millions of ancient coins remain extant. Coins have formed a special, exempted category within past antiquities laws, in part because they were widely circulated in antiquity, and it is therefore nearly impossible to identify the country of origin. In "A Modern Challenge to an Age-Old Pursuit," **Peter Tompa** and **Ann Brose** discuss the historical cooperation between numismatists and scholars, recent US legislation that threatens the trade in ancient coins, and the effectiveness of the British Treasure Act as a model for source-country legislation.

The next group of articles considers specific instances of site spoliation and loss of cultural heritage though mischance and deliberate destruction. A number of constituencies within the cultural-property debate believe that abolishing the trade in all forms of illicitly excavated cultural patrimony is an essential first step in preserving archaeological sites intact. "Archaeology and the Art Market" by archaeologist **Clemency Chase Coggins** is a 1972 article that galvanized the archaeological world and had tremendous impact in formulating the ethical basis for an anti-trade stance among archaeologists. Dr. Coggins was the first

to suggest that academics were legitimating collecting activities by advising on and publishing looted objects. In this seminal article, she describes the destructive consequences to archaeological context in South and Central America, calling for a halt to the trade and an end to both private collecting and the accession of unprovenanced objects into museums, sentiments that continue to resound throughout the cultural-property debate. In "Observations of a Combatant," Dr. Coggins reviews the tangible results of the implementation of these policies, and gives her perspective on the current relationship between art historians, archaeologists, and the museum and collecting communities.

xix

Other factors apart from the trade in art and antiquities have contributed significantly to the destruction of the archaeological record. Industrial and infrastructure development, armed conflict, religious and ethnic prejudice, and indifference on the part of source-country governments account for far greater destruction than illicit looting for profit. **Andrew Solomon** writes about the losses to humanity through the destruction of pre-Islamic art in Afghanistan in "Art in Jeopardy." In "Improving the Odds: Preservation through Distribution," **André Emmerich** writes about the effects of natural disasters, construction, and infrastructure development on site destruction, and points to "the grave danger of having too large a part of a culture's heritage gathered in a single place on earth."

David Matsuda's anthropological research among subsistence farmers of Central America has contributed significantly to understanding the causes of illicit digging in this region, and the integration of both seasonal digging and organized looting into the ordinary economy. In "Subsistence Diggers," Dr. Matsuda gives a dramatic personal account of traveling with a looting consortium. His article questions the current top-down legislative approach to the pervasive site destruction in Central America, and demonstrates the necessity for alternative programs to restore economic stability to the peasant farmers of the region.

In the final section, several authors discuss the reasons why current legal and philosophical approaches have failed to abate the continuing loss of cultural heritage, and propose innovative, alternative strategies for remedy and regulation.

In "A Licit International Trade in Cultural Objects," **John Henry Merryman** reviews the intellectual and political grounding for the

anti-trade bias within UNESCO and the antipathy toward collecting expressed by some in the archaeological community. Professor Merryman also notes the apparent conflicts between excessive source-country retention of artworks and the civil rights provisions contained within international instruments and European Union law, arguing for policies that recognize a legitimate international interest in a licit market.

In "Alternatives to Embargo," **Kate Fitz Gibbon** points to the effectiveness of export control systems in the developed world that retain the most valuable and historically important art objects while permitting the export of duplicative materials. Her article describes model programs utilizing Internet-compatible museum management databases that could provide source countries with security in tracking permitted objects and facilitate a rapid response in cases of art theft.

Two articles offer examples of innovative approaches to repatriation and to beneficial reciprocal relationships between dealers, collectors, and cultural institutions. "The Kathmandu Valley Preservation Trust" by **Erich Theophile** and **Cynthia Rosenfeld** and "The Acquisition and Ownership of Antiquities in Today's Age of Transition" by art historian **Emma C. Bunker** describe successful preservation and restitution efforts undertaken by US and European museums and organizations in concert with source-nation cultural institutions. While government-sponsored restitution efforts can also be effective, these scholars have found workable solutions by building bridges between collectors, arts institutions, and communities in source countries.

A final commentary by the editorial board of the ACCP, "Museums at the Center of Public Policy," outlines new cultural policy directions that could be implemented through legislation to resolve current conflicts in the law. The authors regard the US museum system as a successful model for cultural education and outreach, and suggest an expanded role for US institutions in preserving cultural heritage worldwide. Beyond the establishment of more equitable and practical legal structures regulating the transfer of art, US policy should focus on the development of cultural institutions within the Third World; provide financial support for failing and endangered local museums, archaeological tourism, site excavation, and conservation assistance; and encourage—in every way possible—a meaningful cultural internationalism.

KATE FITZ GIBBON

PART I **THE LAWS**

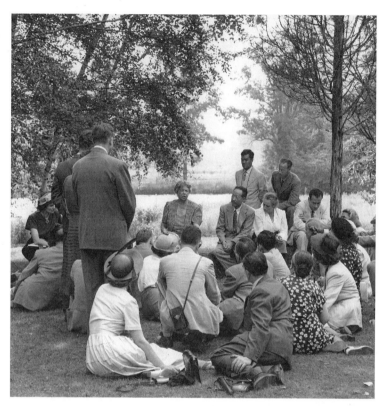

Members of the United Nations Educational, Scientific, and Cultural Organization (UNESCO) meet with Eleanor Roosevelt, July 1948. Franklin D. Roosevelt Museum and Library Collection.

CHRONOLOGY OF CULTURAL PROPERTY LEGISLATION

KATE FITZ GIBBON

THE RIGHTS OF CONQUEST are woven deeply into the history of human-kind. Ideas regarding the protection of cultural monuments found expression even in the ancient world but, in general, victors in battle helped themselves to whatever they wanted, and art treasures were considered not only legitimate but preeminent spoils of war. Cultural property in various forms—monuments, archives, and works of art—was damaged, destroyed, and plundered. It was also sold, given as dowry, and passed from one country to another through inheritance.

The Roman tradition of bringing back works of art from conquered regions to ornament the victors' capital was revived during the Renaissance, and reached its fullest expression in modern times in France during the Napoleonic Wars. The earliest holdings of the Louvre consisted of art confiscated from clerical and aristocratic collections. Under Napoleon's personal direction these collections were enriched with art from the Low Countries, from Italy and the Papal States, from Austria and from Egypt. Some Frenchmen voiced criticism of these massive appropriations, but others strongly supported them. In a petition sent to the Directory in 1876, leading French artists asserted, "The French Republic, by its strength and superiority of its enlightenment and its artists, is the only country in the world which can give a safe home to these masterpieces. All other nations must come to borrow our art, as they once imitated our frivolity."[1] In their view, France was the most enlightened and civilized nation, so far in advance of others that only she could appreciate great art, and therefore deserved to own it. Although some artworks were eventually returned to their original sources, there was no recognition by treaty or international compact to do so.

In the second half of the nineteenth century there began to be widespread acceptance of ethical principles regarding the protection of noncombatants and nonmilitary targets in war. The Lieber Code, promulgated by Abraham Lincoln in 1863 at the height of the American Civil War, was founded on the notion that it is wrong to impose unnecessary suffering on the losers in a conflict. The Lieber Code stated, "Classical

3

works of art, libraries, scientific collections, or precious instruments, such as astronomical telescopes, as well as hospitals, must be secured against all avoidable injury, even when they are contained in fortified places whilst besieged or bombarded." However, the code also explicitly recognized that conquering nations had the right to remove works of art, libraries, and scientific collections belonging to the hostile nation and that ultimate ownership would be settled by a treaty of peace.[2]

The promulgation of the Lieber Code excited much interest in Europe, and a series of declarations and treaties followed that attempted to prevent and limit war and control the actions of the belligerents. The Declaration of Brussels of 1874 extended the protections offered to the arts and sciences: "institutions dedicated to religion, charity and education, the arts and sciences even when State property, shall be treated as private property. All seizure or destruction of, or willful damage to, institutions of this character, historic monuments, works of art and science should be made the subject of legal proceedings by the competent authorities."[3] The influential manual of Oxford's Institute of International Law issued in 1880, *The Laws of War on Land,* offered governments a text "suitable as the basis for national legislation in each State . . . stating clearly and codifying the accepted ideas of our age."[4]

These important documents laid the groundwork for the 1907 Hague Convention Respecting the Laws and Customs of War on Land (Hague IV), to which the United States is a signatory, which sets rules for the treatment of noncombatants and forbids damage to "institutions dedicated to religion, charity and education, the arts and sciences . . . historic monuments, [and] works of art." In 1933 the International Museums Office of the League of Nations met in Washington to recommend what is known as the Roerich Pact, the Treaty on the Protection of Artistic and Scientific Institutions and Historic Monuments, which established the neutrality of monuments, museums, scientific, artistic, educational, and cultural institutions, and designated a flag by which they could be identified, just as hospitals and medical personnel were by the Red Cross. The Roerich Pact was signed by eighteen nations at Montevideo, Uruguay, in 1935.[5]

The establishment of rules of warfare did little to mitigate the damage inflicted by World War II. Although Allied commanders and officers on the ground tried to avoid destruction of monuments except in cases of "military necessity," the punitive destruction of cultural property by

Germany was unprecedented. The Germans destroyed 427 museums, confiscated tens of thousands of art objects and antiques from private owners and institutions, and embarked on a campaign to expunge "degenerate art." At the same time that the US Army was engaged in the immediate postwar effort to return art to its rightful owners, the Soviet army seized cultural property from Germany as war reparations.

In 1945, the United Nations Educational, Scientific, and Cultural Organization (UNESCO) was first convened. Nine years later, UNESCO efforts produced the Hague Convention for the Protection of Cultural Property in the Event of Armed Conflict. (The United States signed but never ratified the convention.) The preamble to the 1954 convention gave strong expression to the interests of all peoples in a common heritage. "Damage to cultural property belonging to any people whatsoever means damage to the cultural heritage of all mankind, since each people makes its contribution to the culture of the world." Today there is nothing unusual about this statement, but at the time its recognition of *all* world art as constituting an important part of human heritage was an extraordinary leap from the prejudices of the past.

In 1970, UNESCO crafted the Convention on the Means of Prohibiting and Preventing the Illicit Import, Export and Transfer of Ownership of Cultural Property, and in 1972 the Convention Concerning the Protection of the World Cultural and Natural Heritage. With one hundred signatory nations, the 1970 UNESCO convention is still the most important international instrument dealing with cultural property.

While the 1970 UNESCO convention regulates the international movement of art, it was strongly directed toward national property interest rather than the risk to art from war or civil conflict. The tenor of the convention was very much opposed to the illicit export of cultural property; signatories undertook to oppose such practices, but the convention did not provide for the return of objects simply on the basis of national ownership claims. The convention provided that state parties (signatories to the convention) would prohibit the import of property stolen from a museum or a religious or secular monument, and take steps to recover the property if requested by another state party. Moreover, it required that the state making the request pay just compensation to an innocent purchaser.

Although the United States participated in the crafting of the 1970 UNESCO convention, it signed the convention only in 1972, and did so

with reservations that are reflected in the 1983 US implementing legislation. The Convention on Cultural Property Implementation Act, which took eight years to reach final form in the US Congress, gives the president authority to negotiate bilateral agreements for the restriction of trade in cultural property with source nations, and powers to impose unilateral import restrictions in emergency situations. The Cultural Property Advisory Committee is an appointed body that makes recommendations to the president in response to applications from source countries for relief.

The 1995 Convention on Stolen or Illegally Exported Cultural Objects was drawn up by the International Institute for the Unification of Private Law (UNIDROIT) in response to dissatisfaction with the failure of the 1970 UNESCO convention to halt the trade in illicitly exported art.[6] UNIDROIT called for the restitution of stolen or illegally exported objects and allowed claims for their return to be brought before the courts of the signatory states. The much more stringent requirements for action may have left many nations unwilling to sign UNIDROIT; of the twenty-two nations that have signed the convention, eleven have ratified it, and twelve other nations have acceded to it.[7] As of early 2005, the United States has not signed UNIDROIT.

US legislation independent of international conventions began with the 1971 US-Mexico Treaty of Cooperation, which provided for the return of stolen items of outstanding importance to the national patrimony, and the 1972 Regulation of Importation of Pre-Columbian Monumental or Architectural Sculpture or Murals, which prohibited the import of architectural monuments and sculpture into the United States.

The 1990 Native American Graves Protection and Repatriation Act (NAGPRA) requires federal agencies, as well as museums or institutions that receive federal money, to inventory the remains of Native Americans, Hawaiian peoples, and native Alaskans, and important cultural objects they have in their collections. They must return those items, on request, to "culturally affiliated" tribes or descendants. In addition, the statute restricts commercial trade in these objects. NAGPRA does not apply to items amassed in private collections before 1990 or discovered on private land. NAGPRA stands in stark contrast to foreign cultural property legislation that places the rights of states over those of their indigenous peoples. Materials held by the Smithsonian Institution are subject to a separate statute, the 1989 National Museum of the American Indian Act.

Because works of art are sometimes treated differently from other forms of property under the law, there are difficulties in creating a consistent legal framework to deal with cultural property issues. For example, it has been an accepted principle of law in legal relations between states that a foreign court is not bound by a source nation's characterization of the removal of an object as "theft." In private international law concerned with foreign transactions between individuals or corporations, it is up to the court where the case is being considered to accept the source nation's characterization or to make its own.

Recent US court decisions based on the *McClain* decision of 1979 have recognized blanket national patrimony laws as giving foreign states an ownership interest in cultural property enforceable in American courts. An object "found in the ground" may be considered state property, and the illicit export of an object claimed by a state, even if the state has never had possession of it, or even knew of its existence, can make that object "stolen" under US law.

Since World War II, international and European human rights conventions have expressly addressed the right of all people to travel freely. Some scholars have suggested that people may not actually be free to travel under the terms of the European Convention on Human Rights if they do not have the right to take along their goods—including art.[8] People cannot be deprived of their property as a condition of freedom. These rights are consistent with rights of property, yet there is potential for conflict with laws vesting in a state ownership of antiquities, paintings, sculpture, and other works deemed "national patrimony."

This is the background against which current laws and international conventions must be viewed. International instruments are created with certain goals in mind, but they may or may not be fully implemented or reach a level of international acceptance that makes them effective. US laws tend to be very fully enforced, and have been aggressively applied in circumstances that may never have been envisioned by their creators.

It will not be possible to resolve every disagreement over rights of property, rights of freedom, and legitimate scholarly or national interests. There will always be some tension between the varied goals of national and international law, between the rights of individuals, of nations, and of all humankind. Compromise can be achieved only through a constructive dialogue between all the parties concerned.

NOTES

8

1. Dorothy Mackay Quynn, "Art Confiscation of the Napoleonic Wars," *The American Historical Review,* April 1945, 437-460, cited in John Henry Merryman and Albert E. Elsen, *Law, Ethics, and the Visual Arts,* 4th ed. (The Hague and New York: Kluwer Law International, 2002), 4-8.

2. Articles 34-36, General Orders No. 100, Instructions for the Government of Armies of the United States in the Field (Lieber Code), Correspondence, Orders, Reports, and Returns of the Union Authorities from January 1 to December 31, 1863, 7, O.R., Series III, Vol. III [S 124].

3. Article 8, Project of an International Declaration Concerning the Laws and Customs of War. Brussels, August 27, 1874.

4. Preamble, *The Laws of War on Land,* Oxford Institute of International Law, September 9, 1880.

5. Treaty on the Protection of Artistic and Scientific Institutions and Historic Monuments, April 15, 1935, art. I, Seventh International Conference of American States, Montevideo, Uruguay.

6. Adopted at the Diplomatic Conference for the Adoption of the Draft UNIDROIT Convention on the International Return of Stolen or Illegally Exported Cultural Objects, Rome, June 7-24, 1995.

7. The convention enters into force for Cyprus on September 1, 2004, and for Slovenia in October 2004.

8. See John Henry Merryman, "A Licit International Trade in Cultural Objects," in this volume, citing Erik Jayme, *Nationales Kunstwerk und Internationales Privatrecht* (Gesammelte Schriften Heidelberg, Germany: C. F. Muller, 1999), 201.

CULTURAL PROPERTY, CONGRESS, THE COURTS, AND CUSTOMS
The Decline and Fall of the Antiquities Market?

WILLIAM G. PEARLSTEIN

Introduction

At the time of this writing, a generation has passed since the formative congressional debates in the 1970s and 1980s about whether to regulate the international antiquities trade or criminalize it. Until the late 1990s, the sense of the few legal specialists who monitor cultural-property issues was that the application of US stolen-property laws was and should be limited to objects that had been clearly stolen from a foreign museum, individual, or archaeological site. In other words, it should not be a crime under US law to acquire an object knowing that it might have been exported at some time from a country claiming to own all its national antiquities without also knowing that it had been freshly looted from an archaeological site or cultural monument.

This view was thought to be consistent with the legal framework created when Congress passed the Convention on Cultural Property Implementation Act (the *Implementation Act*) in 1983. The Implementation Act was passed in order to allow foreign nations to request US import restrictions on important categories of unprovenanced cultural objects while preserving the ability of the United States to limit those categories of restricted objects. The grant of US restrictions was conditioned on similar actions by other importing nations and the adoption of meaningful self-help remedies and sensible internal policies regarding site preservation, conservation, and policing by the requesting nation.

Those who thought the Implementation Act reflected an appropriate balance of interests optimistically hoped that the carrot of US import restrictions would be used as a stick to negotiate agreements for *partage,* museum loans, excavation permits for US archaeologists, cooperation and exchange among curators and art historians, and even export permits for redundant, noncritical objects. This kind of proactive cultural diplomacy would promote a range of cultural and academic activity and satisfy the Implementation Act's requirement that US import restrictions be consistent with the promotion of the international exchange of cultural property.

9

Left unresolved by the passage of the Implementation Act was the critical question of whether and how the importation of cultural property into the United States would continue to be subject to the National Stolen Property Act (the *Stolen Property Act*), a general-purpose criminal law enacted in the 1940s to deter, among other things, interstate car theft. Under the rule of *US v. McClain*,[1] a controversial 1979 criminal case, US courts have held that the knowing importation of cultural property subject to a clear declaration of ownership by a foreign nation is grounds for the criminal prosecution of the importer by the United States under the Stolen Property Act.

The Implementation Act and the *McClain* doctrine under the Stolen Property Act represent incompatible, irreconcilable approaches to the difficult issues raised by foreign patrimony claims. The Implementation Act reflects an elaborate compromise designed to balance the competing interests of US museums, the art market, the US public, archaeologists, and source nations. It was designed to promote the international exchange of cultural property for the benefit of the US public while allowing for the creation of import barriers only when necessary to protect important archaeological sites and significant objects that merit retention and return. It embodies a definitive, thoroughly considered rejection of arguments for the unconditional retention of cultural property made by many foreign nations and archaeologists.

The *McClain* doctrine, on the other hand, is a crude, judicially crafted approach to a complex problem that was neither designed to address such matters nor intended to survive passage of the Implementation Act. Most importantly, *McClain* conflicts with or negates every operative feature of the Implementation Act. Under *McClain,* a foreign nation can, by relying on the US Justice Department and Customs Service, obtain the extraterritorial enforcement of sweeping national-patrimony laws against US citizens without regard for the checks and balances built into the Implementation Act or for the US interest in promoting the international exchange of cultural property.

The open question concerning the relationship between the Implementation Act and the *McClain* doctrine was resolved on June 25, 2003, when the US Court of Appeals for the Second Circuit affirmed the conviction of Frederick Schultz for conspiring to deal in smuggled Egyptian antiquities under the rule of *McClain.* Schultz was thus convicted not for

dealing in objects stolen from known archaeological sites or museum inventory but for conspiring to deal in objects to which Egypt claimed non-possessory title under its 1983 patrimony law.

Schultz has deeply troubling implications for legitimate owners and importers of antiquities and other cultural objects, and places the *McClain* doctrine under which Schultz was convicted squarely at odds with congressional policy regulating the importation of cultural property. It must also be seen as an unqualified victory for those opposed in principle to the private ownership of cultural objects.

Schultz converts the Implementation Act from the centerpiece of US cultural policy into a sideshow. It is a classic example of judicial nullification of congressional intent. The question remaining after the decision is whether any organized constituency will mount a successful congressional challenge to it.

The Constituencies

Today, the ethical consensus inherent in the Implementation Act has eroded into an attack by source nations, archaeologists, and US government enforcement agencies against an increasingly defensive grouping of dealers and concerned individuals, many of whom have museum or art historical backgrounds, and who continue to insist that a regulated antiquities trade operating under clear guidelines should serve as a medium of cultural exchange that enriches American cultural life.

The national debate about the competing values embodied by the Implementation Act and the *McClain* doctrine was largely informed by the scholarship of Professor Paul Bator, who was part of the American delegation to the 1970 UNESCO convention and thereafter took a leading role in shaping the Implementation Act, the US response to the UNESCO convention. Professor Bator observed that nations rich in archaeological sites and cultural objects, such as Italy, Turkey, and Egypt, have enacted patrimony laws that claim state ownership of all cultural objects within the nation's borders, whether in or out of the ground, or privately held, from the most common pot shard to the rarest, most aesthetically refined masterpiece. In his important "Essay on the International Trade in Art," Professor Bator persuasively criticized patrimony laws as being overbroad, ineffective, difficult to enforce, and counterproductive, and for

institutionalizing the black market in cultural property.[2] Bator's essay served as a critical point of departure and informed Congress's passage of the Implementation Act.

Professor John Merryman thereafter sharpened the analysis by characterizing the debate as one between "retentive cultural nationalists" and "cultural internationalists." He observed that market-nation enforcement of source-nation patrimony laws is not merited in cases of covetous neglect, which occurs where a source nation allows its inventory of cultural property or archaeological sites to deteriorate or be destroyed by public infrastructure projects and tolerates a domestic antiquities market while insisting on the broad international enforcement of its patrimony laws.[3] The idea that the international legal framework should foster "cultural internationalism" continues to resonate, particularly as influential museum directors such as Philippe de Montebello, James Cuno, and Neil MacGregor continue to emphasize the internationalist role of major museums.

The cultural internationalist viewpoint is firmly rejected by many archaeologists, who believe first and foremost in the need to preserve and protect virgin stratigraphic context pending professional excavation. To paraphrase the archaeological view, the depredations of local looters are driven by the demands of unscrupulous dealers and collectors, who aid and abet site looting by purchasing unprovenanced objects. These archaeologists, led by the Archaeological Institute of America, insist that the US vigorously enforce foreign patrimony laws, the violation of which should be a serious crime under US law.

The archaeological perspective often ignores the fact that patrimony laws are not intended to preserve virgin stratigraphic context pending permitted excavation but simply to retain objects out of context within national borders. It seems unwilling to criticize the wholesale destruction of archaeological sites in such countries as Turkey and China, where records of certain cultures have been obliterated by, for example, massive hydroelectric projects, or Italy, which licenses the destruction of its past by selling dispensations to real-estate developers.

US enforcement agencies, including the Department of Justice, the Customs Service, and the Department of State, have no interest in balancing the interests of competing schools of thought, and are powerfully motivated to placate their foreign counterparts. They have no incentive to tolerate, much less promote, the importation of cultural property if

the result would be to antagonize foreign governments that might, in consequence, withhold cooperation on matters of greater concern to the US government (such as terrorism, drug smuggling, illegal immigration, money laundering, military bases, trade preferences, and so on). US government agencies have thrown their weight in favor of the source nations against participants in the art market while trumpeting each new seizure as the recovery of an irreplaceable cultural treasure.

No group or lobby exists to promote the reasoned middle ground represented (in theory, if not in practice) by the Implementation Act. The act was effectively orphaned in Congress by the passing of Professor Paul Bator and Senator Daniel Patrick Moynihan, its prime proponents. Only a handful of US museums actively collect antiquities—among them the Metropolitan Museum of Art, the J. Paul Getty Museum, the Cleveland Museum of Art, and the Museum of Fine Arts, Boston—although many US museums continue to benefit by donations of ancient materials from private donors. The Association of Art Museum Directors and the American Association of Museums, the two main US museum umbrella groups, are, if anything, more constrained than individual collecting museums. Dealers, dealer associations, and the auction houses are perceived by the other constituencies as tainted by commercial interest, even though many dealers and auction house specialists have academic backgrounds and a devotion to their subject matter equal to those of any museum curator or archaeologist. Private collectors either lack a voice or are reluctant to speak. The prospect of any sort of pro-trade legislative reform amounts to little more than a good issue in search of a constituency.

Initial Executive Action and *McClain*

Prior to *Schultz,* US law and policy had historically favored the free trade of cultural property.[4] This policy began to be modified only in the 1970s, when public attention focused on the widespread looting of fresh archaeological sites in Mexico and Central America. In response to this looting, the United States entered into a treaty with Mexico, created executive agreements with Peru, Ecuador, and Guatemala, and passed the Regulation of Importation of Pre-Columbian Monumental or Architectural Sculpture or Murals, which prohibits the importation of fragments of looted Mayan stelae into the United States.[5]

The *McClain* cases were decided against this background in 1979, prior to passage of the Implementation Act. *McClain* involved the forfeiture of freshly excavated pre-Columbian artifacts and the prosecution of several individuals engaged in a scheme to plunder the objects and smuggle them into the United States for resale. The first Court of Appeals decision in *McClain* held, in effect, that the knowing importation of cultural property subject to a clear declaration of national ownership by a source nation was sufficient basis for a criminal prosecution of the importer by the United States under the Stolen Property Act.[6] In doing so, however, *McClain* emphasized the need for a strict showing of *scienter* (deliberately or knowingly violating the law) and the high burden of proof this imposed on the prosecution.[7]

McClain was opposed at the time by dealer groups and a number of US cultural institutions, which argued that the decision represented a radical departure from US common law and accepted interpretations of international law. *McClain* was thereafter widely criticized.[8] According to one leading commentator:

> The cases leave no room for debate within the United States on whether certain classes of art should be banned from this country. Rather, the opinions delegate that decision to foreign governments.... The truth is that in the *McClain* cases the Court of Appeals ... handed art-exporting nations something of a "blank check" to create crimes in the United States.[9]

McClain was not used again as the basis for a criminal prosecution by the United States for the forfeiture of cultural property under the Stolen Property Act for more than twenty years, until the indictment of Fred Schultz in 2001.

The Implementation Act

While *McClain* was being decided, Congress was considering the US response to the 1970 UNESCO convention,[10] a multinational attempt to respond to the problem of archaeological looting by regulating the international antiquities market. The UNESCO convention would have required any signatory state party to return cultural property claimed by another state party on the basis of a national-ownership law. The United States was, however, unwilling to return cultural property imported into the

14

United States on the basis of a mere legislative declaration of ownership. The Implementation Act was thus passed in 1983 only after a lengthy debate about the reservations under which the United States would ratify the 1970 UNESCO convention.

The Implementation Act limits the scope of relief available to a foreign nation through the circumstances under which the United States may impose bilateral or multilateral import restrictions, or unilateral "emergency" restrictions, and in the provisions relating to "stolen" cultural property.

The limitations were intended "to ensure that the United States will reach an independent judgment regarding the need and scope of import controls. That is, US actions need not be coextensive with the broadest declarations of ownership and historical or scientific value made by other nations. US actions in these complex matters should not be bound by the characterization of other countries. . . ."[11] "In general, [the other determinations under Section 303] are intended to ensure that the requesting nation is engaged in self-help measures and that US cooperation, in the context of a concerted international effort, will significantly enhance the chances of their success in preventing the pillage."[12]

Although Section 302(6) defines the term "cultural property" to be coextensive with the broad definition used in the UNESCO convention, under Sections 303 and 304 the US may impose import restrictions only with regard to "significant" archaeological or "important" ethnological materials.[13]

The terms of the Implementation Act, its legislative history, and statements by the principal US drafters all support the conclusion that the Implementation Act was intended to afford relief to source nations only in certain narrowly defined circumstances, and to facilitate the broadest possible international exchange of cultural property consistent with the protection of important archaeological sites and the retention of significant or important materials, the pillage of which would jeopardize the applicant's "cultural patrimony."

A critical difference between the Implementation Act and the National Stolen Property Act is their respective treatment of "stolen" property. Under the Implementation Act, an object is considered to be stolen only if it is documented as having been "stolen from the inventory" of a museum, archaeological site, or other cultural institution. Objects that meet this test are subject to forfeiture and return. By contrast,

although the Stolen Property Act does not define the term "stolen" under *McClain,* cultural property is deemed stolen if it is subject to a national declaration of ownership regardless of whether the plaintiff can document that any owner actually lost possession. *McClain* thus provides a conceptual artifice that allows a foreign nation to claim that objects of undocumented provenance are "stolen," thereby avoiding the more difficult process under the Implementation Act of applying for import restrictions on the category of materials to which the unprovenanced objects belong.

The evaluation of requests by foreign nations for import restrictions lies at the heart of the Implementation Act. The act allows the United States to impose import restrictions on specified categories of "archaeological or ethnological materials" after the president (or his delegee) makes the required determinations. In short, these determinations state "that the cultural patrimony of the State Party is in jeopardy from the pillage of archaeological or ethnological materials of the State Party; that the State Party has taken measures consistent with the convention to protect its cultural patrimony; that the application of the import restrictions . . . if applied in concert with similar restrictions implemented . . . by those nations (whether or not State Parties) individually having a significant import trade in such material, would be of substantial benefit in deterring a serious situation of pillage, and remedies less drastic than the application of the restrictions set forth in such section are not available; and that the application of the import restrictions . . . in the particular circumstances is consistent with the general interest of the international community in the interchange of cultural property among nations for scientific, cultural, and educational purposes. . . ."

An eleven-member Cultural Property Advisory Committee reviews the state party's application and concludes that the grant of import restrictions would be consistent with such determinations. The Advisory Committee is required to have a balanced composition of three archaeologists; three experts in international sales of archaeological and ethnological materials; three representatives of the public interest; and two representatives of the museum community. The United States has, to date, granted bilateral or emergency import restrictions to eleven nations. Restrictions on Canadian objects were allowed to expire after the Advisory Committee determined that Canada could no longer satisfy the statutory criteria for relief.

The Implementation Act creates a "safe harbor" from seizure for any cultural property that has been imported by a US museum or other cultural institution unless the property was imported in violation of the Implementation Act and if the object was published, catalogued, or exhibited for specified periods. The safe harbor is subject to only two limited exceptions. It does not extend to objects acquired by the institution with knowledge that the object had either been "documented as stolen from inventory" or belonged to a class of "Designated Materials" subject to US import restrictions at the time of import and had been imported in violation of the safe harbor for Designated Materials. Although these provisions of the act were clearly intended to shield US institutions from liability for stale ownership claims based solely on a national vesting statute, *Schultz* casts doubt on their continued reliability. Museum curators may be dismayed to learn that although careful compliance with these provisions may insulate them from civil seizure under the Implementation Act, they remain exposed to *McClain*-based criminal claims, including claims against any prior owner, however remote. What, they may ask, was the point of complying with the safe harbor?

"Designated Materials" that are subject to import restrictions must be "specifically and precisely" described in order to give fair notice of the restrictions to importers and others through publication in the Federal Register. Section 307 of the act essentially provides that, after publication, Designated Materials may not be lawfully imported into the United States unless the importer is able to present either an export permit from the applicable state party within ninety days (which for practical purposes is never granted) or "satisfactory evidence" that the material was exported from the state party either not less than ten years before the date of such entry *or* on or before the date on which such material was designated through publication in the Federal Register. Without an export permit or such "satisfactory evidence" of prior export, the material is subject to seizure and forfeiture by Customs.[14] Section 307 provides an important window for Americans who import cultural property, and reflects the determination that it would not be fair to impose liability on importers of Designated Materials without giving notice of the applicable import restrictions.

Import restrictions went into effect on January 23, 2001, with respect to Designated Materials subject to the Memorandum of Understanding between the United States and the Republic of Italy dated January 19,

2001 (the Italian MOU). Under Section 307, such Designated Materials may be lawfully imported on the basis of "satisfactory evidence" that they were exported from Italy prior to January 23, 2001. Under *McClain* (and *Steinhardt,* discussed below), however, the importer of the same Designated Materials would be subject to criminal liability and/or *in rem* forfeiture if the importer knew that the materials left Italy after 1939, the date of the latest of Italy's patrimony statutes (or 1909, the date of Italy's earliest patrimony law, which Italian officials insist may also apply). Thus, in the case of Italy, there is a gap of sixty-two years between the legality of importing the same materials under the Implementation Act and under *McClain.*

It is reasonable to assume that every country that is granted import restrictions under the Implementation Act has enacted or will enact a national ownership law. The same gap in time will exist with respect to every one of them. The effect of *Schultz* with respect to a country that has previously been granted import restrictions under the Implementation Act is to create two target dates for importers of objects from that country. These are the safe harbor date under Section 307 and the date of the earlier patrimony law, leaving the importer exposed to criminal liability even after complying with the safe harbor. Again, what is the point of negotiating selective import restrictions under the Implementation Act with a nation that has an earlier, all-inclusive patrimony law?

The disconnect between the two statutes is nowhere more apparent than on this practical, mechanical level. *McClain* throws into confusion the validity of the import certification process established under the Implementation Act, a feature that is critical to the integrity of that act. An importer of Designated Materials who takes the trouble to comply with the "satisfactory evidence" safe harbor under Section 307 should be dismayed to learn that *McClain* makes such compliance irrelevant. Members of the Advisory Committee should be equally surprised to learn that their painstaking efforts to parse through the request of a state party applying for import restrictions and cull out qualifying "Designated Materials" are rendered irrelevant by *McClain* with regard to the same Designated Materials.

Even if one assumes that US enforcement agencies would not presume to apply *McClain* against Designated Materials imported in

compliance with Section 307, it is clear that *McClain* continues to apply to non-Designated Materials from the same state party. For example, although ancient coins are not Designated Materials under the Italian MOU, they remain subject to *McClain*. This leads to the absurd result that the criminal penalties for importing non-Designated Materials (which might not have been included in Italy's original application) are worse than the civil penalties to which Designated Materials are subject. Again, such a result vitiates the rationale for having the Advisory Committee evaluate Italy's request in the first place.

The members of the Advisory Committee would be even more surprised to learn that, as a result of *Schultz,* the Advisory Committee itself may be out of the business of considering fresh requests for import restrictions. Why would any foreign nation go to the time, effort, and expense of applying for import restrictions under the Implementation Act, which by definition must always be narrower than the scope of the applicant's patrimony law and subject to the satisfaction of strict statutory determinations, when it can simply cultivate good working relations with customs agents and the Justice Department and obtain the protection of US criminal laws and customs policies at the expense of US taxpayers? After *Schultz,* Egypt, for example, has no incentive to apply for restrictions under the Implementation Act, which, in theory at least, can never be coextensive with Egypt's 1983 patrimony law. It is conceivable that the Advisory Committee may be reduced to considering applications for the renewal of existing restrictions or conversion of emergency restrictions into broader bilateral agreements. This is hardly the role Congress envisaged for the Advisory Committee in 1983, yet it may be the consequence of allowing individual federal prosecutors and customs agents to operate what is, in effect, an independent foreign policy on an ad hoc, discretionary basis.

Senate Bills S. 2963 and S. 605

McClain survived passage of the Implementation Act in 1983 by accident. In 1985, both Professor Bator, the prime academic proponent of the Implementation Act, and Senator Moynihan, its prime architect, testified before the Senate Judiciary Committee in favor of S. 605, a companion bill and necessary complement to the Implementation Act that would

have amended the Stolen Property Act to delete *McClain* as a cause of action.[15] Passage of S. 605 would have established a US legal framework under which the Stolen Property Act would have continued to apply to objects stolen from the possession of private citizens, museums, monuments, and archaeological sites in a particular nation, while the legality of importing categories of culturally significant objects from that nation that could not be identified with a particular owner or site would have been governed by the Implementation Act.

Senator Moynihan testified that passage of S. 605 was part of the understanding in 1983, among all concerned parties, including the Departments of State and Justice, to speed passage of the Implementation Act.[16] However, the Senate Finance Committee, to which the Implementation Act was reported, lacked jurisdiction to consider an amendment to a criminal statute. Thus, shortly after passage of the Implementation Act, Senator Moynihan, one of its sponsors, introduced S. 605.

After S. 605 was referred to the Senate Judiciary Committee, the State and Justice Departments reneged on what Senator Moynihan believed were their earlier assurances and opposed the bill because they wanted to retain the ability to bring *McClain*-based prosecutions on an ad hoc basis in a limited number of "egregious" cases. They testified that the strict *scienter* showing imposed by *McClain* itself imposed a high burden of proof that would prevent them from abusing their discretion and destroying the regulatory structure created by the Implementation Act.[17] S. 605 was never passed.

Both the District Court and the Court of Appeals in *Schultz* relied on language in the Senate Report stating that the Implementation Act does not preempt any rights or remedies under federal or state law otherwise available to a state party, or affect the rights and remedies of a private claimant who would not have standing to raise a claim under the Implementation Act. Taken out of historical context, this "no-preemption" language can be read to imply that Congress intended *McClain* to survive passage of the Implementation Act. The more plausible interpretation, given Senator Moynihan's expectation in 1983 that the Stolen Property Act would subsequently be amended, is simply that the "no-preemption" language meant that, after the passage of S. 605, the Stolen Property Act would continue to apply to claims by state parties and non-state parties for the return of cultural property stolen from their possession.[18]

Senator Moynihan's statements introducing S. 605 remain as true today as they were in 1985.[19] The failure of S. 605 and the continued survival of *McClain* should not be inferred to represent a definitive statement of congressional intent. Instead they can simply be attributed to the accident that the Senate Finance Committee lacked jurisdiction to amend the Stolen Property Act when the Implementation Act was passed in 1983.

Passage of S. 605 would have been desirable to avoid the confusion and disruption in the antiquities markets caused by continued reliance on *McClain* by federal prosecutors and the Customs Service. But even without passage of S. 605, the *Schultz* courts could have concluded that the Stolen Property Act was never intended to apply to cultural objects that are not stolen from the possession of a foreign claimant, or that, as a matter of statutory construction, *McClain* could not be extended to govern the importation of such objects without gutting the Implementation Act.

US v. Schultz

On July 16, 2001, Frederick Schultz was indicted for conspiring to deal in antiquities smuggled from Egypt. In January 2002, the District Court denied Schultz's motion to dismiss the indictment, holding in part that the Implementation Act does not preempt the Stolen Property Act.[20] Schultz was subsequently convicted under the Stolen Property Act on a single count of conspiring to deal in stolen property. The District Court charged the jury, among other things, that they could find that Schultz had violated the Stolen Property Act if he "was at least aware that under Egyptian law the Egyptian government owned all recently discovered antiquities or that a given object embraced by the conspiracy had actually been acquired from the possession of the Egyptian police."[21] The jury were further charged that they could infer Schultz's knowledge if they found that he had "consciously avoided" learning the requirements of Egyptian law.[22]

The District Court conceded that "[the Implementation Act] takes a more nuanced and complicated approach to when and under what circumstances such property can be imported into the United States; but this is because the act is chiefly concerned with balancing foreign and domestic import and export laws and policies, not with deterring

theft."[23] The District Court thus concluded that there is "[no] inconsistency between the application of the . . . Implementation Act and application of [the Stolen Property Act] to the 'cultural property' involved in this case."[24]

The Court of Appeals also noted the "overlap" between the two approaches, but it failed to address, much less resolve, the tension between them. "The [Implementation Act] is an import law, not a criminal law. . . . It may be true that there are cases in which a person will be violating both the [Implementation Act] and the [Stolen Property Act] when he imports an object into the United States. But it is not inappropriate for the same conduct to result in a person being subject to both civil penalties and criminal prosecution and the potential overlap between the [Implementation Act] and the [Stolen Property Act] is no reason to limit the reach of the [Implementation Act]."[25] By declining to pursue the analysis after observing that the "potential overlap" between the two acts might create liability under both for the same actions, the Court of Appeals missed the essential point that *McClain* criminalizes activity that Congress expressly decided to permit—after weighing the merits of the issues for more than ten years.

The Court of Appeals' statement that it saw "no reason that property stolen from a foreign sovereign should be treated any differently from property stolen from a foreign museum or private home"[26] is a clear rejection of the congressional determination to treat import restrictions on unprovenanced objects differently from thefts of cultural property stolen from inventory. The Court of Appeals' conclusion "that the [Stolen Property Act] applies to property that is stolen from a foreign government, where that government asserts actual ownership of the property pursuant to a valid patrimony law"[27] flatly contradicts the determination in the Senate Report that "US actions in these complex matters should not be bound by the characterization of other countries."

Both the District Court and the Court of Appeals erred fundamentally in concluding that these two antithetical approaches can concurrently govern the importation of unprovenanced objects. By affirming *McClain,* the *Schultz* courts cast a cloud over title to every cultural object otherwise lawfully imported into the United States, including objects imported and subsequently exhibited in compliance with the Implementation Act.

Conscious Avoidance and the Dilution of the
Scienter Requirement

Schultz effectively conditions the lawful importation of cultural property on the importer's familiarity with and accurate interpretation of the laws of any of the various foreign nations that may claim against an object. This imposes a difficult burden on the importer that increases the risk of acquiring or dealing even in an object that survives the strictest due-diligence investigation by the best-informed expert.[28] The fact that provenance is unknown, and perhaps unknowable, prior to purchase, does not mean that the importer's investigation will be found to survive retrospective scrutiny under the "conscious avoidance" test.

Foreign patrimony laws can be difficult or impossible to obtain in their native language, let alone in English translation. Once the law is obtained, it may be difficult to obtain reliable legal advice as to their meaning and construction. They vary widely in substance. Some laws provide for the vesting of all cultural property in the state (e.g., Mexico, Egypt), some for vesting of unauthorized export (e.g., New Zealand), and some for hybrid treatment, such as vesting of all antiquities discovered prior to a certain date but registration and a right of first refusal with respect to other cultural property (e.g., Italy), or a preemptive right of purchase (e.g., England). The construction of ambiguous foreign patrimony laws has been a central issue in at least five reported decisions.[29] The federal courts have succeeded in creating a judicially crafted import regime under which the rights and remedies of the source nation and the liability of importers and remote owners may not be clarified until after a lengthy trial, thereby creating a state of uncertainty and anxiety that fails to protect anyone.

The District Court's charge that Schultz's knowledge could be inferred by his "conscious avoidance" of learning the requirements of Egyptian law further erodes the importer's margin of error. The effect of the conscious avoidance standard is to reduce the otherwise difficult showing of actual knowledge to a potentially minimal showing that a defendant was simply aware that a foreign nation might have had some law of unknown scope and substance relating to its cultural property. A jury may be inclined to find, with the benefit of hindsight and the help of testimony by the prosecution's foreign law experts, that a defendant

indicted for allegedly shady dealings would, could, and should have been able to learn the requirements of foreign law, or should have abandoned the transaction in light of any uncertainty. That is a far cry from the strict *scienter* requirement of *McClain* itself and contrary to the testimony of the Department of Justice at the hearings on S. 605.

Steinhardt, the Customs Directive, and the Elimination of *Scienter*

If the "conscious avoidance" standard dilutes the *scienter* requirement, the use of *McClain* in the context of a civil forfeiture proceeding eliminates it altogether.

Customs Directive No. 5230-15, dated April 19, 1991, titled "Detention and Seizure of Cultural Property," summarizes the Customs Service's policies and procedures regarding the importation of cultural property. Among other things, the Customs Directive advises agents that they have the power to detain and seize cultural property under both the Implementation Act and the Stolen Property Act (by virtue of *McClain*). That was the basis for the Court of Appeals' holding in *Steinhardt*[30] that the misstatement on the "country of origin box" on a form filed with Customs when the objects were imported was material to the integrity of the customs process.

The Customs Directive correctly observes (on page 1) that "it is important to note that merely because an exportation of an artifact is illegal within a particular country does not necessarily mean that the subsequent importation into the United States is illegal." If there is doubt as to whether a foreign nation might claim an interest in a particular object or the nature of a foreign nation's claim, agents are directed to contact the appropriate foreign embassy or detain the object pending resolution of competing claims.

Steinhardt involved the appeal by Michael Steinhardt of the District Court's order of the forfeiture of a Phiale, a purportedly antique gold platter.[31] The District Court held that false statements on the customs entry forms regarding the value of the Phiale ($250,000 instead of Steinhardt's $1 million–plus purchase price) and its country of origin (Switzerland instead of Italy), and the Phiale's status as stolen property under Italian law (and thus under the Stolen Property Act by virtue of *McClain*), rendered its importation illegal.[32] Steinhardt contended, among other

things, that the false statements on the customs forms were not material under the applicable customs statute and that stolen property under the Stolen Property Act does not encompass property presumed to belong to the state under Italian patrimony laws. The Court of Appeals held that the false statements on the customs forms were material.

The Court of Appeals did not address the District Court's Stolen Property Act holding. But its holding on the materiality of the importer's misstatements on the customs forms implicates *McClain* in a way that may have lasting adverse consequences for the legitimate market for cultural property.

The Court of Appeals stated that the Customs Directive undermined Steinhardt's argument that listing Switzerland as the country of origin was irrelevant to the importation. Instead, the court noted that since the Customs Directive advises customs officials to determine whether property is subject to a claim of foreign ownership and to seize that property, an item's country of origin is relevant to that inquiry. Seizure of the Phiale would be authorized under *McClain*.[33]

The implication of the court's discussion of the Customs Directive is that the directive confers license on customs agents to seize any cultural property imported without an export permit from any source nation with a patrimony law, *even if* the country of origin is correctly stated on the customs form, because the country of origin will *always* have *at least a colorable claim* to the property under *McClain*.[34] Broadly construed, *Steinhardt* may effectively give Customs the "blank check" to enforce foreign patrimony laws that was denied to source nations by the Implementation Act. *Steinhardt* may thus have the effect of chilling the importation of cultural property into the United States *regardless* of the circumstances of acquisition.

Leading US museum associations filed an *amicus* brief opposing the *McClain*-based Stolen Property Act claim made in *Steinhardt*. This critical constituency argued that *McClain* is contrary to US common law and to public policy as reflected in the Implementation Act, emphasized the long-standing public interest the United States has in promoting the international exchange of cultural property, and decried the harm resulting to the public from the chilling effect of *McClain* on the legitimate market. The museum *amici* also objected to *Steinhardt*'s application of a civil forfeiture law in tandem with the Stolen Property Act as a dangerous relaxation of the demanding burdens of proof required by *McClain*. That

unprecedented procedure permitted the US government—acting as a surrogate for the Italian government—to use its extraordinary forfeiture powers to circumvent the demanding burden of proof, both as to legal and factual issues, that it would have faced in a National Stolen Property Act prosecution, or that Italy would have faced in a civil replevin case to recover the Phiale in its own right.[35]

The museum *amici* decried the administrative license apparently conferred on Customs to conduct an independent foreign policy:

> Yet another disturbing consequence of the decision in [*Steinhardt*] is that Customs officials now appear to believe that, although Congress has steadfastly refused to bar the importation of objects by virtue of foreign patrimony laws, they have a roving commission to do so and then to use US forfeiture powers to enable foreign governments to appropriate objects without compensation and without proof. The decision below will permit and, indeed, encourage Customs officers to exercise their own predilections as to which foreign laws to enforce and which objects to seize at the behest of foreign governments, without regard to US law and policy.[36]

Steinhardt poses a frightening scenario for those who collect and exhibit antiquities. It is *McClain* with a vengeance, stripped of any *scienter* requirement and, depending on the whim of individual customs agents, creating a potentially impassible barrier at each port of entry against the importation of cultural property that would otherwise be lawful under the Implementation Act. This is a far cry from the carefully conditioned, limited import restrictions sanctioned by the Implementation Act.

In a further twist, the absence of a *scienter* requirement was compounded by the apparent absence of knowing wrongdoing in the act on which the seizure was based. The dealer who located the Phiale for Steinhardt has written that the customs broker's computer was programmed by default to name the country of export in the country of origin box.[37] *Steinhardt* has thus had the extraordinary effect of converting a possibly inadvertent technical error into a judicially sanctioned customs policy that threatens to obliterate the statutory framework envisaged by Congress.

In the hands of Customs, *McClain* has been reduced to mere punctuation for the proposition that any property imported from a country with a patrimony law may be seized at the port of entry or at any time

and place thereafter from the hands of any holder in the chain of posses-
sion.[38] Customs' current policy and practice is to aggressively prosecute
forfeiture claims on this basis against US citizens on behalf of foreign
governments claiming an interest in cultural property imported into the
United States, and Schultz's conviction appears to have coincided with a
fresh wave of seizures of Greek and Roman objects.

Conclusion

The arguments for reforming US criminal law to trigger liability by
archaeological looting but not by mere breach of a foreign-ownership
law are more persuasive than ever before. Passage would restore the
effectiveness of key features of the Implementation Act, including the
"museum" safe harbor and the "satisfactory evidence" safe harbor, and
restore the role of the Advisory Committee to its intended primacy in
evaluating fresh requests for import restrictions. Effective civil and
criminal deterrents and remedies would remain to foreign claimants
and US enforcement agencies with respect to stolen objects under the
Implementation Act (seizure and forfeiture), state law (replevin and con-
version), and the Stolen Property Act. What would change is that foreign
nations would have to justify the scope and effect of their domestic pat-
rimony laws and policies to the Advisory Committee before a violation
thereof became actionable under US law, instead of simply relying on
federal prosecutors and the Customs Service to police their borders.
Unless and until Congress reforms US criminal laws to base liability on
archaeological looting and not the mere breach of a foreign-ownership
law, the potential for a proactive US cultural diplomacy will be forgone in
favor of the reflexive enforcement of foreign patrimony laws. US cultural
life will be diminished, and this important area of US cultural policy will
be regulated by the courts instead of by Congress.

NOTES

1. *US v. McClain,* 545 F.2d 988 (5th Cir. 1977), 593 F.2d 658 (5th Cir. 1979).

2. See Paul M. Bator, "An Essay on the International Trade in Art," *Stanford Law Review* 34 (1982): 317–18.

3. John Henry Merryman, "Two Ways of Thinking About Cultural Property," *American Journal of International Law* 80 (1986): 845–52.

4. James R. McAlee, "From the Boston Raphael to Peruvian Pots: Limitations on the Importation of Art into the United States," *Dickinson Law Review* 85 (1981): 566.

5. See "Treaty of Cooperation for the Recovery and Return of Stolen Archaeological, Historical, and Cultural Property," July 17, 1970, United States–Mexico, 22 *United States Treaties and Other International Agreements* 494, *Treaties and Other International Acts Series* 7088 (ratified in 1971). Notably, the parties agreed "to permit legitimate international commerce in art objects." Art. II(1)(d). *Importation of Pre-Columbian Regulation of Monumental or Architectural Sculpture or Murals,* 19 USC § 209195 (1972).

6. A "declaration of national ownership is necessary before illegal exportation of an article can be considered theft, and the exported article considered 'stolen,' within the meaning of the National Stolen Property Act." *McClain,* 545 F.2d at 1000–1001. At the same time, the court reversed the Stolen Property Act convictions, finding that the government had failed to demonstrate that Mexico's patrimony laws clearly vested ownership in the government, and thus failed to demonstrate that the objects were "stolen." In a second ruling (after retrial), the Fifth Circuit again reversed the Stolen Property Act convictions for the same reason, and upheld only a conspiracy conviction based on a scheme that arose after the effective date of one Mexican law, which the court concluded did pass muster as an ownership law. In doing so, the court held that although Mexico may "ha[ve] considered itself the owner" of undiscovered cultural objects under various other patrimony laws, "it has not expressed that view with sufficient clarity to survive translation into terms understandable by and binding upon American citizens."

Brief of Amici Curiae American Association of Museums et al., in Support of the Appeal of Claimant Michael H. Steinhardt (hereinafter "Steinhardt Museum Brief"), *US v. Antique Platter of Gold,* 991 F. Supp. 222 (S.D.N.Y.1997); *aff'd,* 184 F.3d 131 (2d Cir. 1999). The museum *amici* included the American Association of Museums, the Association of Art Museum Directors, the Association of Science Museum Directors, and the American Association for State and Local History.

7. *McClain,* 545 F.2d at 1001, n. 30.

8. "[T]he case erodes the distinction [between 'stolen' and 'illegally exported' antiquities] . . . in a way that is disturbing. A blanket legislative declaration of state ownership of all antiquities, discovered and undiscovered . . . is an

abstraction.... Yet *McClain* gives this abstraction dramatic weight: Illegal export, after the adoption of the declaration, suddenly becomes 'theft.' The exporting country, without effecting any real changes at home, can thus invoke the criminal legislation of the United States to help enforce its export rules by simply waving a magic wand and promulgating this metaphysical declaration of ownership." Bator, "International Trade," 350-51.

9. McAlee, "Limitations," 565-66.

10. "UNESCO Convention on the Means of Prohibiting and Preventing the Illicit Import, Export and Transfer of Ownership of Cultural Property," November 4, 1970, art. I, 823 U.N.T.S. 231, 10 I.L.M. 289 (1971).

11. S. Rep. No. 97-564 at 27 (1982).

12. *US v. Schultz,* 333 F.3d 393, 409 (2003).

13. Section 302(2) Clause (i) defines the term "objects of archaeological interest" to include objects that are of "cultural significance, at least 250 years old and normally discovered as a result of excavation, digging or exploration." Clause (ii) defines the term "objects of ethnological interest" to include objects that are "the product of a tribal or nonindustrial society and important to the cultural heritage of a people because of its distinctive characteristics, comparative rarity, or its contribution to the knowledge of the origins, development or history of that people." The Senate Report states that archaeological materials include only "culturally significant objects" of "significantly rare archaeological stature," and that ethnological materials include only "objects of comparative rarity" that "possess characteristics which distinguish them from other objects in the same category" and are not "common or repetitive or essentially alike ... with other objects of the same type." *Schultz,* 333 F.3d at 408.

In interpreting these definitions, it is helpful to bear in mind that perhaps no more than a dozen objects can fairly be said to rise to a level of historical, spiritual, or emotional significance with regard to any source nation that merits an object's retention or return. John Henry Merryman, "The UNIDROIT Convention: Three Significant Departures from the Urtext," *International Journal of Cultural Property* 5 (1996): 16.

14. Section 307(c) essentially provides that "satisfactory evidence" must consist of a declaration under oath by the importer, stating that, to the best of his knowledge, the material was exported prior to the applicable date, and a statement by the consignor or seller of the material stating the date on which the material was exported from the state party, or if not known, the importer's belief that the material was timely exported and the reasons on which that statement is based.

15. S. 2963, the earliest version of that companion bill, was introduced in 1982.

16. "[A]s part of the compromise that led to passage of the [Implementation

Act], the concerned parties agreed to support separate legislation to overturn the *McClain* decision's interpretation of the [Stolen Property Act]. I considered that agreement an essential element of the understanding that led to uncontested passage of the [Implementation Act]." Testimony of Senator Moynihan, Hearing on S.B. 605 Before the Senate Committee on the Judiciary, 4–5 (1985).

17. Hearings on S. 605, Testimony of James Knapp, Hearing on S.B. 605 Before the Senate Committee on the Judiciary, 29; U.S. Dept. of Justice Memorandum, 34.

18. "It is ... apparent that the remarks concerning preemption in the Senate Report did not mean that Customs officials or courts were free to disregard either the provisions of the [Implementation Act] or the important US policy judgments it reflects. Congress obviously did not spend more than a decade deliberating over and legislating US policy regarding foreign patrimony laws (including defining the duties of Customs), only to leave it to Customs officers or courts to reach totally different policy judgments as to these same issues and thereby countermand the legislation. Stated more simply, Congress did not pass the [Implementation Act] with one hand, and invite Customs officers and courts (by virtue of two sentences in a Senate report) to abrogate or undercut it with the other. Thus, whether the [Implementation Act] is preemptive in this sense or not, the incontrovertible point—clear from both the terms of the statute itself and the legislative history—is that the [Implementation Act] reflects a critically important statement of US policy and law regarding the enforcement of foreign patrimony laws that must weigh heavily in any determination

regarding these matters." Steinhardt Museum Brief, *US v. Antique Platter of Gold,* 991 F. Supp. 222 (S.D.N.Y.1997); *aff'd,* 184 F.3d 131 (2d Cir. 1999).

19. "S. 605 would reverse the interpretation of the [Stolen Property Act] set forth in the *McClain* decision. There are three reasons why it would be proper to do so:

"First, it would make the [Stolen Property Act] consistent with the comprehensive national policy regarding the importation of cultural property explicitly set forth in the [Implementation Act].

"Second, it would require the Executive Branch to adhere to the principles and procedures set forth in the [Implementation Act] regarding the US response to legitimate problems of pillage of archaeological or ethnological materials abroad. The Customs Service and the State Department have ignored the [Implementation Act] and taken actions that have resulted in a unilateral embargo on the importation of all pre-Columbian objects—relying on the *McClain* decision for doing so.

"Third, it would assure that American citizens are not subject to criminal prosecution on the basis of foreign declarations of law, without regard to whether the property was 'stolen' in the common law sense of taking it from someone with a real possessory interest in the property." Hearings on S. 605, 13-14.

20. *US v. Schultz,* 178 F. Supp.2d 445 (2002).

21. *US v. Schultz,* 178 F. Supp.2d 445 (2002) trial Vol. 11, February 12, 2002.

22. *Schultz,* 333 F.3d. 393 (2003).

23. *Schultz,* 178 F. Supp.2d at 449.

24. Schultz, 178 F. Supp.2d at 449.

25. *Schultz,* 333 F.3d. 393 (2003).

26. *Schultz,* 333 F.3d. 393 (2003).

27. *Schultz,* 333 F.3d. 393 (2003).

28. McAlee, "Limitations," 591.

29. *McClain* (Mexican law); *Schultz* (Egyptian law); *Jeanerret v. Vichey,* 541 F. Supp. 80 (S.D.N.Y.1982), *rev'd,* 693 F.2d 259 (2d Cir. 1982) (Italian law); *Attorney General of New Zealand v. Ortiz and Others,* 1 Lloyd's Rep 173 (QB 1982); 2 W.L.R. 10, 3 All ER 432; 3 W.L.R. 570 (Eng.C.A.1982), *aff'd,* 2 W.L.R. 809 (Eng.H.L.1983) (New Zealand law); *Peru v. Johnson,* 720 F. Supp. 810 (C.D.Cal. 1989), *aff'd sub nom. Peru v. Wendt,* 933 F.2d 1013 (9th Cir. 1991) (Peruvian law).

30. *US v. An Antique Platter of Gold,* 991 F. Supp. 222 (S.D.N.Y. 1997); *aff'd* 184 F.3d. 131 (2d Cir. 1999).

31. The *International Herald Tribune* reported that three defendants in Italian criminal proceedings subsequently testified in affidavits that the Phiale is a modern forgery. The suspicion of forgery was reflected in the low asking price for the Phiale in Italy and Switzerland prior to its purchase by Steinhardt, and is the likely reason why local museum officials in Sicily first declined an offer to purchase the Phiale from one of the defendants, at the low price, prior to its export, and then failed to "notify" the Phiale so as to formally subject it to Italy's cultural-property laws. Italian cultural authorities were thus indifferent to the Phiale while it was in Italy, and remained so until the national police were shown photographs of the Phiale in Steinhardt's New York apartment and learned of the relatively high price he paid. Only at this point was the Phiale transformed in Italy's view from a worthless fake into a priceless national treasure. After the US Attorney received letters rogatory from the Republic of Italy for the return of the Phiale, US prosecutors never thought to question whether it was appropriate to expend US taxpayer dollars and departmental resources on the recovery of an object whose attribution was in question before it left Italy. There is also a sense in the trade that if the Phiale is authentic, its true "country of origin" (which Customs regulations define as the country of manufacture, not the country of export) was Turkey, not Italy.

32. The District Court summarily explained its Stolen Property Act holding as follows: "Under [the Stolen Property Act], an object may be considered 'stolen' if a foreign nation has assumed ownership of the object through its artistic and cultural patrimony laws." *Antique Platter of Gold,* 991 F. Supp. at 231.

33. *Antique Platter of Gold,* 991 F. Supp. at 231.

34. "[Steinhardt's] argument . . . misperceives the test of materiality. Regardless of whether *McClain*'s reasoning is ultimately followed as a proper interpretation of the [Stolen Property Act], a reasonable customs official would certainly consider the fact that *McClain* supports a *colorable claim* [emphasis added] to seize the Phiale as having possibly been exported in violation of Italian patrimony laws." Steinhardt Museum Brief, *US v. Antique Platter of Gold,* 991 F. Supp. 222 (S.D.N.Y.1997); *aff'd,* 184 F.3d 131 (2d Cir. 1999).

35. Steinhardt Museum Brief, at 5, *US v. Antique Platter of Gold,* 991 F. Supp. 222 (S.D.N.Y.1997); *aff'd,* 184 F.3d 131 (2d Cir. 1999).

36. Steinhardt Museum Brief at 49, at 5, *US v. Antique Platter of Gold,* 991 F. Supp. 222 (S.D.N.Y.1997); *aff'd,* 184 F.3d 131 (2d Cir. 1999).

37. "The Steinhardt Phiale, A Trading History," *Art Newspaper,* Issue 93, January 6, 1999.

38. McAlee, "Limitations," 587-94.

Charles H. Carpenter, *Portrait of a Hopi*, 1900-1902.

INDIAN GIVERS

STEVEN VINCENT

There has been much debate with regard to the definitions con-
tained in the [Native American Graves Protection] Act. Members
of the scientific community express concern that if Native Ameri-
cans are allowed to define terms such as "sacred object," the defi-
nition may be so broad as to arguably include any Native American
object.... Many tribes have advanced the position that only those
who practice a religion or whose tradition it is to engage in a reli-
gious practice can define what is sacred to that religion or religious
practice. Some have observed that any definition of a sacred object
necessarily lacks the precision that might otherwise characterize
legislative definitions ... pointing to the difficulty that would arise
if one were charged with defining objects that are central to the
practice of certain religions, such as defining the Bible or the Koran.

—SENATOR DANIEL K. INOUYE[1]

For persons in a cultural context where "the past" is not viewed as
property, perhaps not even as "past" (e.g., some Native American
cultures), or where talk of property ownership, utility and right do
not capture important conceptions of the past (e.g., communal kin-
ship with the "living past") ... parties to the debate must take enor-
mous care not to see as inferior, irrelevant or of less significance
the sorts of concerns that indigenous peoples raise.

—KAREN J. WARREN[2]

IMAGINE AN AMERICA where the federal government takes an active role
in promoting the spiritual values of a certain cultural group. This group
differs in its means of worship, rarely documents its religious practices,
and in fact considers many rituals too secret for public knowledge. Yet
should outsiders violate this group's beliefs, the government swoops
down, threatening malefactors with lawsuits, fines, or prison sentences.
Impossible, you say, given our constitutional safeguards? Many people
believe this scenario is occurring right now, particularly in the south-
western United States, where the Native American Graves Protection

and Repatriation Act (NAGPRA) has created a legal and cultural imbroglio that has many scientists frustrated, art dealers scared, and the general public confused. "What we're seeing here is the triumph of political correctness over logic and reason," says Arizona State University archaeology professor Geoffrey A. Clark.

Native American groups and their supporters don't see it that way. To them, NAGPRA and similar laws are long-overdue measures that protect Indian burial remains and sacred objects and help redress the wrongs suffered by Indians since the European invasion of 1492. According to Arizona State Judge Sherry Hutt, speaking before the US Senate in 1999, NAGPRA is "one of the most significant pieces of human rights legislation since the Bill of Rights." Says Kathleen Fine-Dare, a professor of anthropology and women's studies at Fort Lewis College in Durango, Colorado, and the author of *Grave Injustice: The American Indian Repatriation Movement and NAGPRA,* "This was more than a law, it was a change in the American consciousness." More specifically, Native Americans welcome the respect NAGPRA gives to the dead bodies of their ancestors. Remarks Cherokee tribe member Steve Russell, an associate professor of criminal justice at Indiana University, "This law has helped transform Indian bones from being archaeological specimens to the remains of human beings."

Critics argue that the issue isn't quite so simple. Citing well-publicized controversies like the case of Kennewick Man—in which Indian groups attempted to block scientific research on a nine-thousand-year-old skeleton discovered in Washington—as well as lesser-known cases such as the federal sting operation that snared a Santa Fe art dealer named Joshua Baer, they contend that NAGPRA is a statute with troubling ramifications. "This law presents a clear and present danger to our study of the past—the people in Congress who voted for this measure never thought it would go this far," says Alan L. Schneider, an attorney with the Oregon-based pro-archaeology group Friends of America's Past. "NAGPRA frightens everyone—dealers, collectors, everyone," complains one leading dealer of Indian artifacts who, like many people interviewed for this chapter, declined to give his name. "I don't want Big Brother snooping around my business."

How did a well-intentioned piece of legislation take on such Orwellian overtones? The answer is complicated, a result in part of the weighted history of Indian relations in this nation, a vaguely written federal law,

and zealous government agencies that seek to enforce it—as well as the confusing, subjective, and often contradictory nature of Native American culture itself. But, mostly, NAGPRA is an object lesson in what happens when the American political and legal establishments delve into race and race consciousness, blurring the line between myth and science, the sacred and the profane, while affirming values that are in many ways antithetical to the basis of Western culture.

But what is this law? Signed by President George H. W. Bush in 1990, NAGPRA requires federal agencies, as well as museums or institutions that receive federal money, to inventory the remains of Native Americans (as well as Hawaiian peoples and native Alaskans) and important associated cultural objects they have in their collections and to return those items, on request, to "culturally affiliated" tribes or descendants. In addition, the statute restricts commercial trade in these objects. Exempt from the law is material in the Smithsonian Institution (a separate statute, the 1989 National Museum of the American Indian Act, pertains to that institution) or objects found after 1990 on state-owned lands (most states have their own repatriation laws). NAGPRA also does not apply to items amassed in private collections before 1990 or discovered on private land. "Congress was seeking a balance between private rights and the rights of Indians," says Jack Trope, executive director of the not-for-profit Association on American Indian Affairs (AAIA), who served as an instrumental advisor to legislators during the creation of NAGPRA. "But at the same time, most people drafting this law felt that our legal system needed to do a better job of representing Native American culture."

In many ways, NAGPRA is the latest in a series of legal and social developments that reflect America's often faltering efforts to preserve Native American culture and grant Indian peoples equal protection under the law. Congress established the Antiquities Act of 1906 in part to prevent the looting of Native American sites. In 1978, legislators passed the American Indian Religious Freedom Act, under which the government recognized Indian religious values and rituals, and in 1988 they created the Archaeological Resources Protection Act, which mandated stiff penalties for removing Native American objects from public lands without a permit. The law, however, stipulated that recovered objects remained the property of the United States, to be "preserved by a suitable university, museum, or other scientific or educational institution," rather than repatriated to Indian tribes.

The sea-change in public attitudes toward Native American culture began in an unlikely place. In 1976, a Yankton-Sioux woman living in Iowa named Maria Pearson learned that a road crew had excavated a gravesite, unearthing twenty-six skeletons of Caucasians and one of an Indian woman. State officials reburied the white bones in a new cemetery, but shipped the Indian remains to Iowa City for further study. "That's discrimination," said Pearson, reliving the incident for an Iowa newspaper in 2002 (she died in May 2004). "What made those white people not worth studying? The Indian has got to remain buried just like everyone else." Arguing that the issue was a civil rights violation, Pearson went to Iowa's governor, but was rebuffed. Undeterred, she rallied a grassroots movement that led, in 1982, to the first state law requiring that public agencies return Native American remains to their affiliated tribes. Coupled with the rise in Indian-rights awareness witnessed nationwide at the time, Iowa's statute gave impetus to a legal groundswell that eventually led to the passage of NAGPRA.

Today, museums across the country are inventorying and repatriating thousands of bones and funeral objects held in their collections. For example, the Smithsonian's National Museum of Natural History is returning some of the 18,500 human remains and tens of thousands of artifacts it possesses from more than ninety Native American, Hawaiian, and Alaskan peoples. In the largest repatriation case to date, the Robert S. Peabody Museum at Phillips-Andover in 1999 returned the bones of two thousand Pecos Indians and more than five hundred funerary items to the pueblo of Jemez, New Mexico. And as recently as last October, Chicago's Field Museum returned the bones of one hundred and fifty people to the Haida tribe in British Columbia. "It's been good for everyone," says Fine-Dare, who applauds her own college's efforts to inform more than twenty-five Indian tribes about the school's holdings of Native American bones. "It helps show that historical wrongs can be corrected—and that museums don't have to be gutted in the process." Still, in part because of the huge number of bones possessed by American museums, "it seems right to say that only around 10 percent have found their way back to their tribes since NAGPRA's passage," estimates Karenne Wood, repatriation coordinator for the AAIA.

Few, if any, observers take issue with returning Indian bones to their descendants. It's the *abuse* of this process that angers many archaeologists and anthropologists. They argue that NAGPRA has given Native

Americans license to claim human remains whether or not there is a genealogical link—often at the expense of scientific knowledge. In 1988, for example, an eight-thousand-year-old skeleton was found in Hourglass Cave in the Colorado Rockies. The National Park Service repatriated the skeleton to the Ute Indians after inadequate study, claim many leading anthropologists. In 1989, an eleven-thousand-year-old skeleton was discovered in Idaho. State officials turned this over to the Shoshone-Bannock, permitting only one anthropologist to examine the bones, even though the tribe has dwelt in the region for only two thousand years. "NAGPRA and similar laws have created expectations among Native American activists and some government officials that they can use these statutes to impede scientific study," says Schneider.

Critics contend that the law encourages Indians to assert claims based on myths, rituals, oral traditions, and other tribal practices not normally recognized by the scientific community—or a secular society, for that matter. For example, some Indians now argue that information garnered from the study of their ancestors' bones is "proprietary" and thus the exclusive possession of the tribe. Others attempt to prevent the publication of photographs of sacred objects, or dictate the means in which institutions exhibit certain artifacts, based on a belief that the items are "alive," or otherwise possess a divine spirit. In many cases, Indians have persuaded state agencies to uphold tribal taboos such as preventing menstruating women from handling certain objects. "A lot of this nonsense comes from the politicization of NAGPRA," says one physical anthropologist who wishes to remain anonymous. "Many Indian tribes are just creating traditions as a way of pursuing social, legal, and cultural power."

This issue came to a head with the Kennewick Man. In this much-publicized case, the chance discovery of a skull along the Columbia River in Kennewick, Washington, led to the finding of a nine-thousand-year-old skeleton. Although scientists believed that the bones originated from a Caucasian man, a coalition of Indian groups claimed the remains, asserting that the skeleton lay in territory that has traditionally belonged to their people. Or, as one tribal leader stated, "From our oral histories, we know that our people have been part of this land since the dawn of time." The US Army Corps of Engineers—which has jurisdiction over the Columbia River—accepted this argument and announced that it would repatriate the skeleton. Members of the scientific community filed a lawsuit, which succeeded in blocking the repatriation; the government

and Native American tribes appealed. Meanwhile, archaeologists battled Indians and their government supporters for every scrap of information they could glean from the skeleton. "The government did a CAT scan of the bones and we asked for the results," comments Schneider, who served as a lawyer representing the scientists in the case. "Native Americans objected, and we had to file a motion to see the data." Or, as one physical anthropologist puts it, "It's clear to me that Native Americans are eager to block study of the skeleton; otherwise, it might prove they were not the first to inhabit this continent." Finally, in late 2004, the Ninth Circuit Court concluded that the skeletal remains were not "Native American" in the terms of the statute, and held that the plaintiff-scientists should be permitted to continue their study.

To NAGPRA's credit, the law has not accepted some of the more outrageous claims put forth by tribal groups. In 1993, for instance, archaeologists working on a ten-thousand-year-old archaeological site in Montana discovered ancient human hairs and announced their intention to study them. Although there was no evidence of burials at the site, two Native American tribes, the Confederated Salish and Kootenai and the Shoshone-Bannock, filed a NAGPRA suit, contending in part that such research was sacrilegious. The government rejected their argument— although the lengthy court battle prevented study of the hairs for years. Similarly unsuccessful were the Fallon Paiute-Shoshone, who in 1997 attempted to assert "cultural affinity" with the ninety-five-hundred-year-old remains found in Spirit Cave, Nevada, basing their claim in large part on tribal traditions that indicated that their ancestors had lived in the area since "time immemorial." In November 1999, the Confederate Tribes of Grand Ronde, Oregon, claimed the Willamette Meteorite on display in New York's American Museum of Natural History, declaring it to be a "holy object" that conveyed messages from the spirit world. The case was settled with an arrangement that allows the Indians access to the meteorite for cultural and religious purposes.

Perhaps the most bizarre NAGPRA case involves Honolulu's Bishop Museum. This institution had in its collection eighty-three artifacts and human remains taken in 1905 from the Kawaihae Cave complex on the island of Hawaii. In 2000, the Bishop gave the objects to an ethnic Hawaiian organization called the Hui Malama, which proceeded to rebury the objects somewhere in the complex. Several other native Hawaiian groups complained, arguing that the Bishop had not allowed

them time to assert *their* claims to the objects, as stipulated by NAGPRA. The issue was taken up by the NAGPRA Review Committee, which in May 2003 castigated the Bishop for giving the Hui Malama possession of the objects and ordered the group to return the objects *to the museum.* When the Hui Malama refused, the Bishop then requested the right to break into the complex and seize the objects back again. The Department of Hawaiian Homelands declined the request, and the matter is heading for the courts. In early August 2004, reports surfaced in the press that law enforcement officials had searched two Big Island addresses in a federal investigation into allegations that ancient Hawaiian burial artifacts had recently been put up for sale. According to a Bishop Museum official, the artifacts were believed to be among those that were thought returned by the Hui Malama to the burial cave.

It is the affirmation of group—or tribal—rights over the imperatives of science and the free transmission of knowledge that outrages so many critics of NAGPRA. "This is a question of who owns the past," maintains Clark. "I believe in an archaeology that is scientific and belongs to the national patrimony, not to any ideology or 'consciousness group.'" Others worry about the statute's effect on the law and rational thought in general. Argues Schneider, "A lot of people in government agencies have bought into the idea that they can do anything they want, to do right by Indians. Look at the state of Nebraska—it repatriated *all* skeletal remains to Indian tribes, even those which were Caucasian." Meanwhile, he continues, "you have agencies giving tribal oral traditions the same weight as written documentation—and people in the federal Justice Department contending that scientific study of Indian culture is a savaging of that culture." Add to these concerns the extraordinary sensitivity the government shows toward Native American religion, and you have what many perceive as an emotion-based attack on the heart of our society's mores. Or, as the late Clement Meighan, a UCLA archaeologist and fierce NAGPRA critic, wrote in the November 1994 issue of *Archaeology* magazine, "The New Age disposition to invoke or invent beliefs no one really holds, and to maintain they are of a value at least equal to, if not supremely greater than, those that account for the triumph of Western civilization, is given concrete expression in the repatriation movement."

At least no one is going to jail—not in the museum community, at least. The story is different in the commercial trade of Native American artifacts, where NAGPRA casts an even longer and darker shadow. Says

Jeff Myers, a New York dealer of Eskimo artifacts, "What started as a way to return Indian bones and protect Native American burial grounds from looting has turned into something far more complex and troubling."

The first case of a private individual convicted under NAGPRA occurred in 1994. FBI agents arrested an Arizona man, Richard Corrow, for attempting to sell sacred Native American artifacts he had purchased on tribal lands, in addition to possessing objects containing bald-eagle feathers in violation of the 1940 Eagle Protection Act and the 1918 Migratory Bird Treaty Act (MBTA). He received five years' probation. In 1997, a federal court in New Mexico sentenced Arizona dealer Rodney Tidwell to thirty-three months in prison for selling Acoma priest robes and Hopi ritual masks. Both Corrow and Tidwell appealed, arguing that NAGPRA is too vague regarding which Native American objects are sacred and which are not. Their appeals were unsuccessful, but the debate they started continues.

Critics maintain that the whole idea of "sacred objects" is often problematic and open to various interpretations and politicization. Many Indians converted to Christianity, they observe, and sold or gave away objects that they once considered holy. Now, encouraged in part by NAGPRA, Indians are rediscovering their ancestral beliefs and demanding the repatriation of these items. "A lot of Native Americans are born-again animists," Ramona Morris, president of the Antique Tribal Art Dealers Association, notes wryly. Others complain that, with more than two million Native Americans in over 769 federally recognized tribes, no one knows the full extent of Indian rituals and methods of worship, especially the many that Indians keep secret. Worse from the viewpoint of objectivity, the only experts are Indians themselves. As one dealer states, "The government will ask Indians, 'Is this important to your tribe?' and of course they'll say yes in order to get possession of the object. Next thing you know, *they're* putting it back on the market." By relying on the subjective judgment of tribal leaders, government agencies edge closer to a relationship with Native American spirituality that may violate the constitutional separation of church and state.

Tribal art dealers stay on the right side of the law by avoiding human remains as well as objects known to be deemed sacred—such as tribal masks—and anything containing feathers of eagles and other birds protected by law. ("Eagle feathers?" snorts one of the leading collectors of Native American artifacts in the country, who spoke on condition of

anonymity. "I have headdresses with 150-year-old eagle feathers. Why should I be prevented from selling the items—the birds are long dead!") At the same time, dealers handle only artifacts they know came from private collections, since NAGPRA's writ over Native American objects is limited to those that originate from federal or tribal lands. Some observers worry that even this affirmation of private ownership is eroding. "Although the law was originally intended just for museums," says Albuquerque's Robert Gallegos, one of the few Native American dealers unafraid to publicly criticize NAGPRA, "federal agencies are trying to make it apply in the private sector."

In the early 1990s, this fear was palpable among dealers in the Southwest. Stories circulated like the one involving agents from the Bureau of Land Management (BLM), who confiscated three perfectly legal pots from a Southwestern dealer, only to return the objects soon afterward. "We made a mistake," the agents told the dealer in effect, "but don't talk about it, or else we'll come back and make life miserable for you." Others spoke of raids by a joint task force including agents from the FBI, the BLM, the Bureau of Indian Affairs, and the National Park Service, among others. This task force would enter even the most respected Santa Fe businesses looking for nonexistent contraband goods "as if we were crack houses," as one dealer put it. The task force was disbanded in 1992, for reasons not entirely clear. In defending his agents' actions, a BLM spokesman at the time stated, "For years dealers have had a free hand in illegally trafficking Native American artifacts . . . so of course they're going to complain and spread accusations against us."

Nowadays, dealers say, officials' "cowboy mentality" in enforcing NAGPRA has eased a little. Unchanged, however, remain the government's dismissive attitudes toward their concerns. For example, when recently questioned about the trade's criticisms of NAGPRA, a spokesperson for the US Attorney for the State of New Mexico first claimed he didn't know of *any* negative comments. Then, after hearing a list of complaints about the law and its enforcement, he scoffed, "Somebody's fed you a lot of paranoia." That's the point, contends Gallegos. "The government *wants* dealers to get paranoid about the law. They want us to become so afraid of NAGPRA that we voluntarily stop trading in this field and don't challenge the law in court."

In the view of Gallegos and others, federal officials will often bundle a NAGPRA violation together with violations of such court-tested laws

as the MBTA. "But prosecutors will get the dealer to plead guilty to NAGPRA," Gallegos adds. "In this way, they build legal precedents to buttress NAGPRA, while spreading a climate of fear through the dealer community."

This is what many observers believe lay behind the government's sting operation against Joshua Baer, perhaps the most aggressive private-sector application of NAGPRA to date. The case began in August 1999, when the dealer was approached by an art dealer named Bob Clay. Clay told Baer he represented a wealthy Norwegian collector named Ivar Husby, who was interested in buying some first-rate Indian artifacts. In fact, Clay was undercover FBI agent Robert Whitman, and Husby was an agent of the Norwegian National Bureau of Investigation. Over the next sixteen months, Baer did some $40,000 worth of business with the two men. In September 1999, the agents expressed interest in purchasing items from the dealer's personal collection. Baer at first declined, noting that the objects contained eagle feathers, which the MBTA forbade him to sell. The agents persisted in their requests, with Husby threatening to terminate future business dealings. In need of cash, the dealer offered Husby more than a dozen Indian artifacts from October 1999 to January 2000. In January, federal agents raided Baer's gallery, confiscating artifacts and business records; in October 2001, he was indicted for violating NAGPRA and the MBTA.

"This was a classic abuse of the law, when cops enforce a vague statute and make criminals out of people," says Albuquerque lawyer Peter Schoenburg, who represented Baer in the case. "How do you define what's sacred to Indians? The traditions are secretive, sometimes contradictory, and tribes refuse to write them down. Take the Navajo bull roarers, for instance—Navajos will say some, none, or all the bull roarers are sacred. How is anyone to know?" Worse, Schoenburg notes, was the way in which the two agents manipulated Baer. Agent Whitman actually became a close friend of the Baer family, writing to the dealer soon after the raid on his gallery, "I've been doing this all over the world for a long time. This was the toughest case I ever had because I truly like you and your family." Schoenburg filed a motion arguing that the agents' behavior constituted entrapment, but the court dismissed it.

In September 2002, Baer pled guilty to six charges of violating the MBTA and three charges of violating NAGPRA, crimes that carried a maximum of ten years in prison. But Judge John Edwards Conway noted

at Baer's sentencing that many of the types of objects he had offered for sale had been sold by Native American tribes themselves. Conway refused to give Baer prison time. "This is not my favorite statute, so I'm not going to put him in jail," the judge remarked. He encouraged Baer to spread the word about NAGPRA to other dealers because "most people have no idea this law exists."

Native Americans and their advocates retort by saying that most people have no idea how important NAGPRA is in protecting Indian culture from looters who regularly pilfer objects. (*Archaeology* magazine once estimated that thieves have ransacked 90 percent of the known archaeological sites in the Southwest.) "Native Americans suffered from a kind of 'historical trauma,'" says Trope. "The repatriation of ancestral objects is a very emotional, healing experience for them." Moreover, they add, most of the horror stories about the statute are overblown, and tend to ignore how NAGPRA has actually *increased* scientific knowledge. "Through consultation with Indians, we've learned more about tribes than ever before," says Thierry Gentis, assistant curator and collections manager of the Haffenreffer Museum at Brown University.

This does little to mollify critics of the statute, who believe that the law threatens such core Western values as the scientific method, constitutional liberty, and the right to own private property. As one NAGPRA critic says, "No one in the government cares about archaeologists or tribal art dealers. They have a weak constituency compared to Indians." Others add that because of the headlines and gratification of doing good for Indians that NAGPRA cases generally bring, law-enforcement officials and prosecutors eagerly look for and pursue violations of the statutes. "In the end," says Clark, "it's all about identity, politics, and power." As a law that deals with some of the oldest objects found on the North American continent, NAGPRA is very much connected with the hot-button issues of our time.

NOTES

1. Testimony of Senator Daniel K. Inouye, S. Rep. 104-473 at 5–6, 101st Cong. (2d Sess.).

2. Karen J. Warren, Introduction, in Phyllis Mauch Messenger, ed., *The* *Ethics of Collecting Cultural Property. Whose Culture? Whose Property?* (Albuquerque: University of New Mexico Press, 1989), 11.

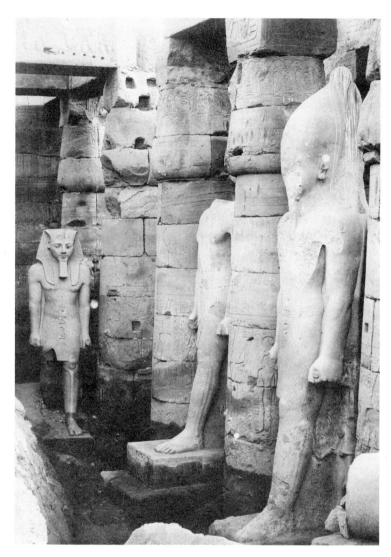

Zangaki Studio, *Le trois Ramses de Louqsor,* c. 1870-85.

IMMUNITY FROM SEIZURE

REBECCA NOONAN

THE 1965 IMMUNITY FROM SEIZURE ACT[1] was conceived as a means of promoting cultural exchange between the United States and foreign nations. Driven in part by Soviet concerns that art loaned for public exhibition might be subject to claims by descendants of pre-Revolutionary owners, Congress drafted protective legislation that would apply universally to any loan of art from any foreign lender.[2]

The act has turned out to be a powerful diplomatic and cultural tool, balancing the public's interest in seeing art from other countries with the need to be circumspect in allowing such loans to come to the United States. The act encourages foreign institutions to loan artworks to US museums, while the permitting process screens the work for potential claims. In this way, the act shields US cultural diplomacy from embarrassing legal entanglements that could damage international relations.

The act is a necessary component of US cultural policy. The security of knowing that an exhibition has been granted protection, and the forty-year track record behind this protection, permits foreign lenders to entrust their works to US museums and to display them publicly without exposing them to the risk of a claim. Since the act's inception, demand for the protection of the program has grown from 125 grants of immunity in the first fifteen years to sixty-nine grants in the last year alone.[3]

The federal statute is titled Immunity from Seizure under Judicial Process of Cultural Objects Imported for Temporary Exhibition or Display. The statute provides that if, prior to importation, notice is published in the Federal Register that the president has determined that an object is of cultural significance and its exhibition is in the national interest, no court in the United States may enforce any judicial process against the object or enter a judgment having the effect of depriving the borrower or a carrier of control of the object.

To be eligible for immunity from seizure, certain technical prerequisites must be met. The loan must come from abroad, and the lender (whether the owner or custodian) must be a foreigner; the borrower must be a US government entity or a cultural or educational

institution within the United States. The importation must be pursuant to an agreement between borrower and lender; the loaned material must be exhibited within the United States, and this exhibition must be temporary. Finally, the exhibition must be administered, operated, and sponsored without profit.

To secure immunity, application must be made to the Department of State.[4] Lawyers within the Office of Public Diplomacy and Public Affairs review the application, route portions of the application around the State Department to the staff making the required determinations, and, with the final approval of the Assistant Secretary of Educational and Cultural Affairs, send notice to the Federal Register. There are no formal guidelines for applications, but the Department of State provides a checklist for applicants, who must supply information about the nonprofit nature of the exhibition, furnish any sponsorship, merchandise, or catalogue agreements, describe the cultural significance of the loan objects, and provide a copy of the loan agreement.[5]

The apparently straightforward criteria for eligibility do not always match real-life loan and exhibition arrangements, and the State Department must often make a judgment based on specific circumstances. Would immunity extend to a loan held abroad by a foreign dealer, for objects owned by an American? Is a for-profit gallery eligible to apply as a cultural or educational institution? Loans from the Soviet Union exhibited at the Knoedler Gallery in 1973 and 1979 as part of exhibition tours including museum venues were granted immunity.[6] How long can a temporary loan term be? The Metropolitan Museum of Art has been able to secure immunity for a maximum term of three years.[7] At the time of the immunity application, typically three months prior to importation, formal agreements with lenders may not have been executed, raising a concern that the loans will not be imported pursuant to a formal agreement.

An aim of most exhibitions is to generate revenue, albeit usually for a nonprofit institution. The nonprofit status of most US applicant institutions appears to satisfy the State Department. Perhaps not unrealistically, the State Department presumes that exhibitions are money-losing ventures. Although significant loan fees are increasingly common in loan contracts, the statute does not appear to be construed by the State Department to apply to lender profit. For example, a traveling loan show, *The Quest for Immortality,* earned the Egyptian government $24 million, yet still qualified for immunity.[8]

The statute requires that two determinations be made by the State Department. The first is that the works of art are of cultural significance. Fine art and decorative objects generally meet such criteria, but the applicant may need to provide a persuasive argument for including more esoteric objects, such as modern clothing, archival materials, or ephemera within that classification. Neither the act nor related executive orders provide standards by which to make these determinations, nor has the State Department promulgated such standards.[9] Based on a 1978 Executive Order, the State Department may consult with the secretary of the Smithsonian Institution and the director of the National Gallery of Art, and with "other such officers and agencies of the Government as may be appropriate" in order to determine whether loan objects are culturally significant.[10]

The State Department makes the determination that the importation of loans would be in the national interest. The US national interest is served by increasing public access to works of art and fostering a positive attitude toward cultural exchange and friendly relations between the United States and other nations. A legal dispute over a loan exhibition could jeopardize these interests; therefore, the application for immunity status is designed to weed out exhibitions and objects that might trigger a legal imbroglio.

In 1999, in the wake of the *Schiele* case (see Stephen Clark, "The Schiele Matter," in this volume), the government added a new dimension to the determination of national interest. As the Manhattan District Attorney's office opined, "There shouldn't be an interest in the United States exhibiting stolen art work."[11] The United States Information Agency (USIA), then administrator of the immunity program, stated, "Before, we asked [museums] to let us know whether they were aware of a particular problem. Now . . . we have asked museums to actually look into the provenance of objects through whatever sources are available and to certify to us that they've done that, and if there are gaps then they let us know."[12]

Beginning in 1999, the State Department required every applicant to certify that

> it has undertaken professional inquiry, including independent,
> multi-source research, into the provenance of the objects proposed
> for determination of cultural significance and national interest.

The applicant certifies further that it does not know of or have reason to know of any circumstances with respect to any of the objects that would indicate the potential for competing claims of ownership.[13]

What constitutes "independent and multi-source research" is left to the discretion of the applicant. The lender is not "independent," but is often in the best position to inform the museum about the prior whereabouts and ownership of the work. Other sources include exhibition and auction catalogues, literature in the field, museum colleagues, and, when confronted with a suspicious gap in knowledge, the Art Loss Register. An application for an exhibition of Old Master paintings or one of archaeological materials will look quite different from an application for furniture or textiles, for which provenance records do not generally exist, or for prints and photographs, which may exist in multiples and be difficult to track.

A "competing claim of ownership" could stem from a dispute to title between the current and prior owner or his heirs; or from a creditor, where the lender is a debtor or, more commonly, a debtor government, and the artwork might be sought to settle the amount owed. For example, lawsuits by the victims of terrorism have been brought against Iran, for which judgments remain outstanding. At least partly for this reason, loans from the Iranian government have failed to qualify for immunity.[14] However, as the Shchukin claim against the Los Angeles County Museum of Art (below) reveals, a competing claim of ownership does not necessarily forestall a declaration that the exhibition is in the national interest. Finally, as a consequence of the *McClain* and *Schultz* cases (see William Pearlstein, "Cultural Property, Congress, the Courts, and Customs: The Decline and Fall of the Antiquities Market?," in this volume), a claim could potentially come from a foreign government that claims title to certain classes of cultural property on the basis of national ownership. To date, no such claim to an immunized work has been made public.

Applicants must become students of history to trace the legitimate or illegitimate ways in which property has changed hands: eighteenth- and nineteenth-century spoliation in war, the nationalization of church property in eastern Europe, the systematic campaign of the Nazis to seize artwork, and modern-day looting all form bases for consideration.

Applicants must consider whether lender nations are vulnerable to suit in the United States and bring all of these concerns to the attention of the State Department in order to assess the risk of the loan.

Other factors in the determination of national interest are internal State Department concerns. Country desks examine the list of loans originating from their respective countries for political implications. While there is no official record of denied applications, a reported rejection on the basis of national interest occurred when an exhibition of paintings from the Hermitage Museum was scheduled to appear at the National Gallery of Art in 1980. After the Soviet invasion of Afghanistan in December 1979 strained Soviet-US relations, the exhibition was determined not to be in the national interest.[15]

Once publication occurs, no court in the United States may enforce judicial process or issue a judgment depriving the borrower of the work. The act is no guarantee that a work will be imported or exported without legal entanglement. The statute is directed at courts, but prosecutors, federal investigative agents, and customs officials have all been known to seize artwork,[16] and civil litigants may still claim artwork.[17] Pursuant to the act, however, courts have no authority to enforce such claims.

Should there be a claim to an immunized work, the local US Attorney is authorized to intervene in the proceedings at the request of the institution facing the claim. In the event that the claim may adversely affect a governmental entity of the United States, the Attorney General may direct the US Attorney to act in the manner it deems most appropriate. Contrary to some public misconceptions,[18] the affected cultural institution has no right to insist upon the intervention of its local federal prosecutor. That said, in every case to date, a government representative at least made an appearance and, in two instances, intervened and filed supporting briefs.

For the act's first thirty-five years, according to reported cases, the act was almost never litigated. (Presumably, the immunity notice works such magic that legal skirmishes are confined to the filing of motions that never reach the level of fully reported decisions.) Recently, in the space of three years, there have been three suits seeking to encumber artwork loaned for exhibition in the United States: all were defeated by immunity.

In January 2000, *Nicholas and Alexandra: The Last Imperial Family of Tsarist Russia,* an exhibition that included the Golden Coronation

Carriage, the grand piano of the Empress Feodorova, and a miniature copy of imperial regalia by Fabergé, was on display in Mobile, Alabama.[19] The show had been licensed for a fee by the Russian government, and had traveled to other venues in the United States before reaching Mobile.

On January 26, four days before the works were to return to Russia, a petition was filed for a writ of execution in aid of a judgment entered in the Southern District of Texas and now registered in the Southern District of Alabama. In *Magness v. Russian Federation,* the heirs of Ivan Karlovich Shroder, a wealthy Russian businessman whose property was seized by the Bolsheviks at the time of the Revolution, had won a $234,792,000 judgment (the present-day value of what Shroder had lost) against the Russian Federation in federal court in Texas and had yet to collect. Shroder's property had included a piano factory, and the Texas trial court found that the works traveling in the *Nicholas and Alexandra* exhibition were "of like kind and character of those items expropriated."[20] Russia did not make an appearance in the Texas suit.

On January 27, the court gave the parties twenty-four hours to brief the Shroder heirs' petition. The next day, the US Attorney intervened in the case, filing an opposition to the petition. On that same day, the Shroder heirs asked for a temporary restraining order prohibiting removal of the exhibition from the United States.

The court issued its decision the following afternoon: the Shroder heirs' petition for a writ of execution failed because "seizure [is] not permitted . . . due to [a] law which specifically forbids the use of judicial process to seize another country's works of art or objects of cultural significance," i.e., the Immunity from Seizure Act.[21] The court refused to consider the exceptions to the Foreign Sovereign Immunities Act[22] that allow attachment of property owned by a foreign state when used for a commercial activity, accepting the USIA's determination that the exhibition was without profit. (The previous year, the Texas court had specifically found that the exhibit was "for profit.") The court declined to "put in jeopardy the Exhibition which was originally brought into this country in reliance on such a determination."[23] For *Nicholas and Alexandra,* deliberation was swift, deference to the executive agency was great, and the statute's protection was without exception.

Russian property was the target of a suit brought by André Marc Delocque-Fourcaud against the Los Angeles County Museum of Art (LACMA) in the summer of 2003.[24] Delocque-Fourcaud is a French

citizen and the grandson of Sergei Shchukin, a wealthy businessman whose collection was nationalized at the time of the Revolution; works from his art collection are now in the Pushkin Museum in Moscow.[25] Delocque-Fourcaud alleged that twenty-five works of art in the exhibition *Old Masters, Impressionists, and Moderns: French Masterpieces from the State Pushkin Museum, Moscow,* including works by Degas, Picasso, and van Gogh, were from his grandfather's collection, in which he possessed a fractional interest. At the time of the suit, the exhibition had been in the United States for at least seven months, and had been displayed at the Museum of Fine Arts, Houston, and the High Museum in Atlanta.

The suit was filed twelve days prior to the scheduled opening at LACMA. Delocque-Fourcaud sought an injunction to preclude exhibition and a declaration that the works were not immune from seizure. The complaint included a claim against LACMA for receiving stolen property, a claim for money damages, and a claim for all proceeds earned by the exhibition. The Pushkin Museum was not named as a defendant. Delocque-Fourcaud alleged that the State Department had improperly approved immunity because it was not aware of the Shchukin family's claim to the works in the Pushkin Museum. He was quoted in the press as saying that his lawsuit was "a symbolic act of harassment."[26] His lawyer explained that the suit was filed late in the tour "because California jurisdictions have been 'a little bit friendlier' to the plaintiffs regarding art-restitution matters."[27]

Despite the suit, the exhibition opened as scheduled, and in August 2003, LACMA filed a motion to dismiss as well as a motion for Rule 11 sanctions, under which a district court may sanction attorneys or parties who submit pleadings for an improper purpose or that contain frivolous arguments or arguments that have no evidentiary support. LACMA refuted Delocque-Fourcaud's improper-immunity claim by asserting that the State Department already had notice of such claims when it approved immunity: the "file describes the 1917 nationalization of the Pushkin paintings and the plaintiff's prior lawsuits" based on it.[28] The US Attorney for the Southern District of California also intervened on LACMA's behalf.

At the end of October, the parties entered into a settlement agreement whereby Delocque-Fourcaud agreed to file a stipulation to dismiss action with prejudice, each side agreed to bear its own attorney fees, and Delocque-Fourcaud agreed to release any claims against the United

States and its museums. LACMA explained in its press release, "Faced with a vigorous defense by the United States government in support of LACMA's factual and legal case, the plaintiff moved to withdraw the lawsuit."[29] Again, resolution of the claim was relatively swift. Here the shield of immunity was used offensively as a substantive basis for the threat of sanctions.

A final example of a case involving federal immunity began on the evening of January 20, 2004, when the Metropolitan Museum of Art learned from a reporter that a suit had been filed seeking to retain *Mount Sinai* by El Greco in the United States and compel its production for examination, testing, and appraisal. The painting had recently been displayed in the Metropolitan's El Greco exhibition; the museum was packing the show, and the painting in question was scheduled to travel to London, the exhibition's next venue, the following day.

The goal of the suit was not entirely clear. It had been filed by Joram Deutsch, a Swiss lawyer who was the son of a lawyer who represented Baron Ferenc Hatvany, a Hungarian. Hatvany had suffered immense losses during the German and Soviet occupations of Budapest and had once been the owner of *Mount Sinai*. In his complaint, Deutsch alleged that his father was the target of a "plot and conspiracy that was intended to frustrate, impede and/or interfere with restitution efforts . . . defraud his father of his rights and destroy his ability to represent Holocaust victims." He stated that "he must know the truth about what was done to my father and why and [*Mount Sinai*] holds the key to this." He did not claim an ownership interest in the work.

Without a copy of Deutsch's suit, lawyers for the Metropolitan appeared in New York State Supreme Court the following day to explain that *Mount Sinai* was scheduled to leave the country imminently and to argue that the work was immune from judicial seizure. An Assistant US Attorney also made an appearance but, with such short notice, declined to take a position on the case. Upon learning that the museum had secured federal immunity from seizure for the exhibition, the court denied Deutsch's application and dismissed the matter. The painting was returned to the Historical Museum of Crete the following day.

Subsequent to the lawsuit, the Metropolitan conducted intensive research into the provenance of the work, which did not substantiate Deutsch's claim. The Red Army had looted the painting in 1945 from a bank vault in Budapest, where it had been placed by Hatvany.[30] A

corrupt Soviet officer purportedly sold it back to Hatvany in 1947.[31] The Metropolitan had not been aware of the looting and return to Hatvany when it applied for immunity from seizure. Despite the fact that the State Department had not been notified of this provenance, immunity prevailed. Deference to the State Department's determinations was complete, and the decision was immediate.

Substantive changes have occurred in both museum organization and the legal environment since 1965, when the Immunity from Seizure Act was promulgated. Exhibitions have become more commercially oriented; German and eastern European archives that allow better research into transfers of art have been opened; claims based on foreign patrimony laws may now be brought in the United States.

Through informal changes by the State Department to the application process, the Immunity from Seizure program has adapted to these changes, and case law on the books demonstrates how well the system functions. The success of the Immunity from Seizure Act is perhaps best measured not by the few claims it forestalls, but by the comfort it provides to the hundreds of lenders to US exhibitions each year.

1. *Immunity from Seizure under Judicial Process of Cultural Objects Imported for Temporary Exhibition or Display,* 22 USC. § 2459 (1965), www.culturalpolicy council.org/laws_conventions.htm.

2. Senator Harry F. Byrd, Sr., of Virginia was a strong supporter of the bill due to a prospective loan from the USSR to the University of Richmond. See Rodney M. Zerbe, "Comment: Immunity from Seizure for Artworks on Loan to United States Museums," *Northwest Journal of International Law and Business* 6 (1984-85) 1121, n. 21. Enjoying broad support from the museum community in the mid-1960s, the act was sponsored by the Smithsonian Institution and the American Association of Museums, and had the backing of the Department of Justice and Department of State. H.R. Rep. No. 1070, 111 Cong. Rec. 3578 (1965).

3. See Zerbe, "Comment," n. 5, stating that from February 1970 through November 1985, there were 125 separate grants of immunity; Federal Register 2003.

4. See Delegation of Functions to the Assistant Secretary for Educational and Cultural Affairs, 64 Fed. Reg. 63, 840 (1999). From 1978 until 1999, when the bulk of the United States Information Agency was absorbed by the Department of State, USIA administered this program. See Exec. Order No. 12, 047, 43 Fed. Reg. 13, 359 (1978), amended by Exec. Order No. 12, 3888, 47 Fed. Reg. 46, 245 (1982) and Delegation Order No. 85-5, 50 Fed. Reg. 27, 393 (1985).

Prior to 1978, the State Department was the presidential designee.

5. See Check List for Applicants, *Statute Providing for Immunity from Judicial Seizure of Certain Cultural Objects* (22 U.S.C. § 2459). Full text available at www.culturalpolicycouncil.org/laws_conventions.htm.

6. 38 Fed. Reg. 4, 583; 7, 348; 13, 681 (1973) and 44 Fed. Reg. 25, 277 (1979). See Rodney M. Zerbe, "Comment," n. 136.

7. Public Notice 4045, 67 Fed. Reg. III, 39782-3 (2002).

8. See Immunity Notice for *The Quest for Immortality,* Public Notice 3944, 67 Fed. Reg. 50, 11543 (2002); compare with "The \$24 Million Blockbuster," *Art Newspaper,* January 7, 2002.

9. See Zerbe, "Comment," 1136.

10. Exec. Order No. 12, 047, 43 Fed. Reg. 13, 359 (1978), amended by Exec. Order No. 12, 38888, 47 Fed. Reg. 46, 245 (1982).

11. "USIA Stiffens Rules on Art," *Forward,* May 21, 1999, 4. See also *ARTnews,* May 1999.

12. Ibid.

13. See n. 5.

14. See Elaine Sciolino, "Imperial Eden Lies at the End of a Quest for Illuminated Paintings," *New York Times,* May 2, 2001, E1.

15. See *New York Times,* January 22, 1980, 8 col. 1. See also Zerbe, "Comment," 1129; Marie C. Malaro, *A Legal*

Primer on Managing Museum Collections (Washington, D.C.: Smithsonian Institution Press, 1998), 317, n. 8.

16. Brooks Barnes, "Heir of Russian Collector Sues Los Angeles Museum," *Wall Street Journal,* July 16, 2003, www.bslaw.net/news/030716.html.

17. LACMA's Notice of Motion and Motion for Rule 11 Sanctions; Mem. of P. & A. at 2, *Delocque-Fourcaud v. Los Angeles County Museum of Art,* No. CV03-5027R (CTx) (C.D. Cal. filed August 15, 2003).

18. See American Association of Museums, "Statement on Immunity from Seizure," August 2003.

19. *Magness v. Russian Federation,* 84 F. Supp. 1357 (S.D. Ala. 2000) (Magness II).

20. *Magness v. Russian Federation,* 54 F. Supp. 700 (S.D. Tx. 1999) (Magness I).

21. The application for the temporary restraining order failed, as there was no showing of irreparable injury: there was no suggestion in the papers that "the plaintiffs will be unable to recover on their judgment in some other fashion, rather than by seizing the exhibit." Magness II, 84 F. Supp. at 1359.

22. 28 U.S.C. § 1609.

23. Magness II, 84 F. Supp. at 1360.

24. *Delocque-Fourcaud,* No. CV03-5027R (CTx) (C.D. Cal. filed August 15, 2003).

25. In November 2004, Delocque-Forcaud announced the donation of six remaining paintings from the Shchukin collection to the Pushkin Museum, ending his family's fifty-year battle with the museum for recovery of some 250 paintings from the Shchukin estate. John Varoli, "Shchukin Family Makes Peace with Russia," *Art Newspaper,* Issue 153, November 2004.

26. David Holley, "She Works the System," *Los Angeles Times,* July 27, 2003, E35.

27. Barnes, "Heir of Russian Collector."

28. LACMA's Notice of Motion and Motion for Rule 11 Sanctions; Mem. of P. & A. at 2, *Delocque-Fourcaud* No. CV03-5027R (CTx) (C.D. Cal. filed August 15, 2003).

29. LACMA, "Plaintiff Withdraws Lawsuit Against LACMA over French Masterworks," press release, November 2003.

30. See László Mravik, "Hungary's Pillaged Art Heritage, Part Two: The Fate of the Hatvany Collection," *The Hungarian Quarterly,* Summer 1998; Hungarian National Archive, XIX-J-1-k-4/fh-1001/FO/1945 (box 38): "List of the Banks in Question and Catalogue of the Items Deposited at These Banks," Budapest, August 3, 1945.

31. See László Mravik, ed., *The 'Sacco di Budapest' and Depredation of Hungary, 1938-1949: A Preliminary and Provisional Catalogue* (Hungarian National Gallery, 1998), 233 n. 16830.

Johann Zoffany, *Charles Townley and His Friends,* 1781-83,
Towneley Hall Art Gallery and Museums, Burnley, England.
Photo copyright © The Bridgeman Art Library.

A TALE OF TWO INNOCENTS
The Rights of Former Owners and
Good-Faith Purchasers of Stolen Art

ASHTON HAWKINS, JUDITH CHURCH

Introduction

The destruction or loss of works of art during times of war or through
theft or neglect is a tragedy. Fortunately, art objects that are "lost" are
sometimes rediscovered, but this can create a difficult situation between
the previous owner of the artwork and the present owner. If the loss
resulted from theft, the Anglo-American legal tradition provides a ready
answer to the question "To whom does this art object belong?" Unless
a jurisdiction has modified the general rule in some way, under Anglo-
American law, neither a thief nor a good-faith purchaser from a thief, nor
even subsequent good-faith purchasers, can pass good title.

When a former owner finally locates the art in the possession of a
good-faith purchaser and commences an action against this innocent pur-
chaser for return of the art object, the courts are faced with the unpleas-
ant dilemma of allocating rights and burdens between two innocent
victims of the thief, who is typically either unknown or judgment-proof.

At the heart of the stolen-art problem—the deciding factor in many
cases—is the question of the appropriate statute of limitations, i.e., how
long after the theft can the former owner sue the current holder of the
art? The statute of limitations problem is heightened with respect to
valuable works of art because, unlike most forms of personal property,
art is frequently nonperishable (often lasting for centuries); easily trans-
portable (the art trade, legitimate and otherwise, is notable for its inter-
nationalism) and hence easily concealed; readily identified; generally
irreplaceable; and often of dramatically increasing value. Thus, it is not
uncommon for claims to recover stolen art to be made decades after the
theft, often against innocent purchasers.

Each of the existing legal rules has flaws that point to the need for
an alternative approach to judicial rule making. This article proposes
a legislative solution based on use of a comprehensive registry for lost
and stolen art.

The Demand and Refusal Rule

The judicially created demand and refusal rule was originally developed and applied by New York courts to protect good-faith purchasers from being hauled into court prior to engaging in a knowingly wrongful act: refusing a demand by the former owner for return of his property.

New York's Civil Practice Law and Rules section 206(a) provides that "where a demand is necessary to entitle a person to commence an action, the time within which the action must be commenced shall be computed from the time *when the right* to make the demand is complete,"[1] that is, when a good-faith purchaser exercises control over property in a manner inconsistent with the former owner's rights, even if the *ability* to make demand is prevented by lack of knowledge of the identity of the possessor.

In 1964, however, the Appellate Division in the case *Menzel v. List* turned the prior demand and refusal case law on its head, converting it from a shield for good-faith purchasers into a sword for former owners. The Menzels had fled Brussels in 1941, leaving behind a painting by Marc Chagall that was confiscated by the Nazis as "decadent Jewish art." The painting was later purchased by Albert List from the well-known Perls Galleries; both List and Perls were good-faith purchasers. In an extremely brief, substantively two-sentence opinion, the court in *Menzel* concluded that when demand is "an essential element of the cause of action," section 206(a) is inapplicable and the statute of limitations, therefore, does not begin to run until actual demand and refusal. *Menzel,* however, left open the critical question of the former owner's duty of diligence, that is, their duty to act with due care in their own interest.

In *DeWeerth v. Baldinger,*[2] the Second Circuit Court looked beyond *Menzel* for the first time and conducted a detailed analysis of the origins of the demand and refusal rule and its impact on the start of the limitations period.[3] *DeWeerth* involved a claim for a valuable work of art, a painting by Claude Monet that disappeared from Germany during World War II. The good-faith purchaser had held the painting for more than thirty years without facing a claim, although her identity was readily accessible through the Monet catalogue raisonné, available a few miles from the plaintiff's residence near Cologne, Germany.[4]

The court acknowledged that *Menzel* stated the law of New York, i.e., that demand and refusal was a substantive and not a procedural element

of a claim, and that the starting point for the statute of limitations did not begin until demand and refusal.[5] In *DeWeerth,* however, the court defined the issue to be whether the courts would impose a duty of reasonable diligence on an owner "prior to learning the identity of the current possessor," and predicted (incorrectly, as it turned out) that the New York courts would "impose a duty of reasonable diligence in attempting to locate stolen property. . . ."[6]

Guggenheim v. Lubell

In 1987 the Solomon R. Guggenheim Museum brought an action against Rachel Lubell seeking replevin, the recovery of the property, or alternately, a judgment of conversion, the wrongful exercise of ownership over the property of another, in the case of a Chagall gouache that had been stolen from the museum sometime after April 1965.[7] The painting had been purchased by Lubell and her since-deceased husband from the prestigious Robert Elkon Gallery in Manhattan for $17,000. The Lubells were treated as innocent, good-faith purchasers for value: they investigated the painting's provenance, paid fair market value, and publicly displayed the painting.[8]

The Guggenheim had taken no steps to publicize the theft, nor did it inform any other museums, galleries, or artistic organizations, or any law-enforcement agencies, of the painting's disappearance. Apparently, other than conducting an internal investigation, the Guggenheim did nothing to attempt to recover the painting.[9]

In August 1985, almost twenty years after its sale to the Lubells, the Guggenheim fortuitously learned of the painting's location. An art dealer had brought a transparency of the painting to Sotheby's for an auction estimate, and a former Guggenheim employee working at Sotheby's recognized the painting and notified the Guggenheim. In January 1986, the museum formally demanded that Lubell return the gouache. She refused, and the Guggenheim commenced suit in September 1987 in the Supreme Court, New York County, seeking return of the Chagall gouache or, in the alternative, its then fair market value of $200,000.

The trial court granted Lubell's motion for summary judgment based on a statute of limitations defense. The court, following *DeWeerth v. Baldinger,*[10] in which the Second Circuit interpreted New York law as imposing on art-theft victims a duty of reasonable diligence to attempt

to locate stolen property, held that the museum's failure to do anything for twenty years except search its own premises was unreasonable as a matter of law.

The Appellate Division reversed the lower court decision, finding that, under New York's demand and refusal rule, the trial court (and the Second Circuit) erred in imposing a duty of reasonable diligence on the theft victim in the context of a statute of limitations defense.[11] The court found it "plain that the relative possessory rights of the parties cannot depend upon the mere lapse of time, *no matter how long.*"[12] According to the Appellate Division, the three-year limitations period did not even *begin* to run until the missing property was located, demand for its return had been made by the museum, and its return had been refused by Lubell.

Instead, the court held that the issue of the museum's diligence should be considered only in the context of Lubell's equitable *laches* defense. (A *laches* defense is based essentially on issues of fairness: relief may be granted to one party when there has been negligence in performing a legal duty or in asserting a right on the part of another.) To prevail in such a defense, Lubell would have to show that she suffered a wrong or injury as a result of the museum's unreasonable delay.

The New York State Court of Appeals affirmed the decision of the Appellate Division and adopted its reasoning on the statute of limitations issue. The court then leapt to the conclusion that the limitations period cannot begin prior to refusal.[13] The court noted the incongruity between the demand and refusal rule and the rule that when the stolen property remains in the possession of the thief, the statute "runs from the time of the theft, even if the property owner was unaware of the theft at the time that it occurred." The court, however, otherwise failed to address or to justify this anomaly.

Although the court rejected Lubell's limitations defense, it agreed with the Appellate Division that the museum's lack of diligence could be considered "in the context of [Lubell's] *laches* defense. The conduct of *both* [parties] will be relevant . . . and . . . prejudice [injurious effect] will also need to be shown." Finally, the court agreed with the Appellate Division that the burden of proof for Lubell's affirmative defense that the painting was not stolen rested on Lubell, not the Guggenheim. The court then remanded the case to trial for consideration of, among other issues, Lubell's *laches* defense. The case ultimately settled on the eve of trial on December 28, 1993.

Since the Appellate Division's decision in *Guggenheim,* the Second Circuit and Southern District have followed the rule and reasoning applied in that case.

Alternative Approaches to *Guggenheim*

In choosing a rule that affords the greatest possible protection to former owners, the *Guggenheim* court ignored the effect and intent of *all* statutes of limitations—to extinguish otherwise valid rights by dint of the mere passage of time, regardless of the underlying merits of the claim. The fundamental purposes of statutes of limitations are to prevent stale claims, promote stability, and grant relief from the prospect of lawsuits in commercial and other relations. Unlike *laches,* statutes of limitations focus on the objective actions of the claimant, not on (often subjective) harm or prejudice to the defendant.

The *Guggenheim* court noted the existence of three alternative statute of limitations rules but rejected them for inconsistent reasons that have little to do with the appropriateness of New York's unique demand and refusal rule. These other approaches would have begun the three-year period in which the good-faith purchaser has no title to the object at three different times: (1) when the theft took place, as is the case when the action is brought against the thief; (2) when the good-faith purchaser took possession of the goods (the accrual rule); or (3) when the former owner discovered, or through *reasonable* diligence should have discovered, the location of the stolen art (the standard discovery rule), as the Second Circuit held in *DeWeerth.*

Historically, a legal action for conversion (wrongful appropriation of another's property) or replevin (recovery or replacement in market value) "ordinarily will run against the owner of lost or stolen property from the time of the wrongful taking."[14] In jurisdictions following this rule, the former owner must find the possession within a few years of the taking, or the action is barred after a specific period of time has elapsed.

This traditional rule has two important advantages: certainty as to when the limitations period commences and expires, at least for the good-faith purchaser, and simplicity of application in litigation. Unfortunately, the inequity of this rule to owners who are art-theft victims, particularly those who diligently seek to recover their property, outweighs these advantages.

The harshness of the traditional rule has also been mitigated by courts in several states through recent adoption of "discovery" rules for actions concerning recovery of stolen art.[15] The standard discovery rule contains both a subjective and an objective component: the statute of limitations begins to run when the former owner actually knew or reasonably should have known the whereabouts of the property. This rule requires former owners to exercise reasonable diligence in searching for their stolen property.

The discovery rule, while certainly more equitable to purchasers than *Guggenheim*'s demand and refusal rule, still suffers from two of the basic flaws of that rule, albeit to a lesser degree. First, under both rules, the purchaser never has true repose from a claim by a former owner, because there is no date-certain from which the limitations period begins to run. Moreover, the uncertainty and unpredictability inherent in the discovery rule is heightened because the innocent purchaser's right to retain the art may well turn on a sliding scale of diligence dependent on whether the former owner is unfamiliar with the art world or is a sophisticated collector or a museum.

Second, like the *laches* inquiry, "[d]etermination of due diligence is fact-sensitive and must be made on a case-by-case basis."[16] Thus, the issue of due diligence will generally not be amenable to resolution without extensive discovery and a trial. Nevertheless, the discovery rule does have the advantage of avoiding the fact-intensive scrutiny of the second prong of a *laches* defense—injury to the defendant attributable to unreasonable delay on the part of the former owner.

Proposed Legislative Solution

In its 1980 decision in *O'Keeffe v. Snyder,* the New Jersey Supreme Court lamented the absence of "a reasonably available method for an owner of art to record the ownership or theft of paintings."[17] The court recognized that an "efficient registry" of artworks might better serve the art community than arcane legal doctrines. Unable to "mandate the initiation of a registrant system," the court resorted to the discovery rule. While in fact at the time there was a registry maintained by the International Foundation for Art Research, Inc. (IFAR), begun in 1976, there is now a British not-for-profit corporation formed by IFAR, Sotheby's, Christie's, London-based insurance brokers, and other British and American companies

called the International Art & Antique Loss Register, Ltd. (ALR). This registry has emerged as the leading international clearinghouse for information on stolen art.[18] The existence of such a registry allows for an alternative approach to the dilemma of allocating rights and burdens between two innocents.

We would suggest a national legislative solution to the stolen art statute of limitations problem based on an international stolen art registry such as the ALR. Ideally, an ALR-type registry would be operated by an agency of the government—such as the FBI, the Library of Congress, or the Smithsonian Institution—or by a nonprofit entity (as it was initially). The ALR, however, is currently the only available registry of its scope and quality, and this legislative solution should not be deferred until a comparable government or nonprofit registry is created. As an interim measure, we propose that state legislatures, particularly in important art markets such as New York, adopt this proposal.

Under this legislative proposal, both owners and purchasers would be encouraged, but not required, to use one specified international art theft registry, which would maintain a confidential record of the contact with the registry. Owners and purchasers who used the registry would receive specified protections from the other party.

Former owners (or their insurers) who registered their stolen art soon after the theft with both law enforcement and the registry would receive protection under a statute of limitations defense from a subsequent purchaser. That subsequent purchaser either would consult the registry and ignore the information that the work was stolen, or would not consult the registry at all.[19] In either event, the purchaser would not be considered a good-faith purchaser under the terms of the statute, and the purchaser's right to protection from legal action would be subject to the discovery rule outlined above. The statute could treat the registration as per se due diligence (effectively eliminating a statute of limitations defense), or as creating a strong, but rebuttable, presumption of due diligence.[20]

If the prospective purchaser consults the registry and the work is not registered, the statute would consider him a good-faith purchaser. A confidential record would be kept of the inquirer's name and address and the location of the art. The statute of limitations would commence running in favor of this purchaser at the time of the inquiry. Subsequent good-faith purchasers—those who checked the registry and found the

work not registered—would be able to tack on the time period from the initial good-faith purchase.[21] Thus, three years after the initial good-faith purchase and inquiry, the limitations period would expire, and ownership would effectively vest in the current good-faith holder of the work, who could then transfer good title to subsequent purchasers.

This proposal also gives substantial protection to the former owner who does not report the theft to the registry until *after* the good-faith purchase. The proposal permits the former owner in excess of three years (i.e., from the time of the theft to the good-faith purchaser's inquiry, plus three years) to discover the theft, register the stolen art, and locate and bring suit against a prior good-faith purchaser. When an owner registers the stolen artwork after a purchaser's inquiry, the registry would provide the former owner with identifying information regarding the inquirer, the date of the inquiry, and the then-location of the art. At that point, the diligent owner—with the aid of law enforcement —should be able to locate the work relatively quickly. Active concealment by the person who originally queried the registry of the current location of the art would *toll* the limitations period: during the relevant period, the statute of limitations would cease to run.

Such an approach should also deter commerce in stolen art by encouraging purchasers and dealers to investigate provenance beyond inquiry with the registry. Because the registered good-faith purchaser is at risk of discovery by the former owner for three years after registration (since the purchaser's identity and the location of the art are available to the former owner), he has strong incentives to take steps beyond inquiring with the registry to determine provenance at the time of purchase.

Moreover, because the good-faith purchaser could take legal action against the seller, reputable professional dealers and auction houses would have a strong incentive to investigate the art's provenance prior to their own purchase or acceptance on consignment. This investigation would reduce the likelihood that the seller is dealing in stolen art and that the seller would be subject to a third-party suit within the next three years. This contrasts with the present situation, in which a dealer selling a work of questionable provenance to a good-faith purchaser may reasonably choose to take the risk that the former owner will not discover the location of the object, and that even if the owner does fortuitously discover the work in a decade or more, the dealer may be unavailable, out of business, or otherwise not liable.

To encourage use of the registry, it is crucial that the information provided be kept confidential, with the following exceptions: (1) the registry should notify the prospective purchaser that the work has been reported as stolen, but identifying information as to the former owner should be disclosed to the purchaser only at the owner's option; (2) the registry should report the prospective purchaser's inquiry with respect to a stolen work of art, including identifying information, to the owner or the owner's insurer, and appropriate law enforcement; and (3) the registry should provide the owner's report of stolen art to law enforcement authorities if the owner has not already done so.[22]

Owners may choose not to use the registry for a number of reasons —the object is not valuable enough, insurance proceeds have been recovered,[23] the former owner considers it unlikely the art will turn up in a jurisdiction in which registration is relevant, or he is simply negligent. As noted, if the purchaser *has* consulted the registry and the owner has not, for whatever reason, the former owner's ability to take legal action would expire three years after the purchase.

Purchasers may also choose not to consult the registry. They may realize the provenance of the art is questionable and not want to risk revealing their identities to the police or the owner, or they may simply be negligent.[24] In these cases, and when the former owner has previously reported the stolen art, the owner should be the beneficiary of the rules set forth above.

In cases in which neither party registers, the most appropriate rule would be a discovery rule. With a discovery rule, the non-registering owner must be diligent in other ways, while the non-registering purchaser runs the risk that the diligent owner could recover the property in ten, twenty, or thirty or more years after purchase. The uncertainties for both parties of a discovery rule create an added incentive to use the registry.

Retroactivity and Other Issues

There are three primary difficulties with the proposal: (1) what to do when one party registers and the other party is reasonably unaware of the registry; (2) whether to apply the proposed statute retroactively; and (3) how to handle the "gap" problem, in which the innocent purchaser consults the registry, but the former owner subsequently registers the art within the limitations period and claims the art.

The easiest way to deal with the first issue is not to create any special exemptions and to treat the non-registering owner or purchaser the same as any other non-registering party, as set forth above. There may be cases, however, in which it is truly unfair to expect the owner or purchaser, particularly individuals in developing countries, to be aware of the registry. The standard in such cases should be whether a reasonably diligent owner who seeks to recover his property, or a reasonably diligent purchaser investigating the provenance of the object, knew or reasonably should have known of the existence of the registry.[25] The burden of proof should be on the party asking for the exception, but when the exception does apply, the courts should use the discovery rule to measure the limitations period.

As to retroactivity, the easiest approach again would be to make the statute non-retroactive, except to the extent of overruling *Guggenheim* and retroactively applying a discovery rule. This would leave decades of stolen art (and tens of thousands of valuable objects) outside the scope of the registry system. This article, therefore, proposes that former owners (or their insurers) of art that was stolen prior to the statute's effective date be afforded the opportunity to register the object within a reasonable "window" (for example, two years after the effective date) to obtain the statute's benefits. This registration, however, would serve only as evidence of diligence,[26] because it is unreasonable to expect present possessors of art to check all their current possessions against the registry.

If a subsequent purchaser consults the registry and the object is not registered, the statute would run from that date.[27] The former owner's registration, however, should not revive any rights that the owner had lost under a discovery regime if he had been non-diligent during the years from the theft to the registration. In such events, the owner's registration would be a legal nullity. Otherwise, an anomalous situation would exist, in which the former owner could not recover against the original good-faith purchaser, yet the art would be unmarketable. In such situations, a present holder or subsequent purchaser could bring a claim to *quiet* title (a lawsuit to establish a party's title to real property, and thus "quiet" any challenges to the title), and prevail on a showing that, prior to the statute's enactment and subsequent registration, the former owner had been non-diligent and the limitations period had run.

The third problem—what might be termed the "gap" problem—involves the apparent unfairness to the purchaser who consults the registry, finds the art is not registered, pays fair market value, and then is forced to return the object when the former owner *subsequently* (but within three years of the registration) learns of its location. This result, however, is a function not of the proposed statute but of the Anglo-American rule that provides that the thief cannot pass good title to the good-faith purchaser and that the former owner's title remains superior to the purchaser's within the limitations period. This also increases incentives for the seller and the purchaser to investigate provenance beyond registration. Because this proposal shortens and defines the limitations period, it does potentially mitigate the unfairness to the purchaser in two ways. First, the purchaser's chances of recovering against a solvent seller are greatly enhanced because the purchaser's liability runs for only three years. Second, because title insurance would be needed for only three years, the likelihood that such insurance would be made more generally available and affordable should increase.

This legislative proposal cannot address every stolen-art permutation, nor can it eliminate all harm to an innocent party. However, through the use of widely available, relatively low-cost technology, this proposal allocates burdens, rights, and duties far more equitably and pragmatically than current limitations rules, while at the same time encouraging the recovery of stolen art and deterring the stolen-art trade.

The authors wish to acknowledge the contribution of David B. Goldstein and Richard A. Rothman, co-authors with Ashton Hawkins of "A Tale of Two Innocents: Creating an Equitable Balance Between the Rights of Former Owners and Good Faith Purchasers of Stolen Art," 50 Fordham Law Rev. 49 (1995), from which certain portions of this article are drawn.

1. N.Y. Civ. Prac. L. & R. § 206(a) (McKinney 1990) (emphasis added).

2. *DeWeerth v. Baldinger,* 836 F.2d 103 (2d Cir. 1987), *rev'd,* 658 F. Supp. 688 (S.D.N.Y. 1987), *cert. denied,* 486 US 1056 (1988).

3. *DeWeerth,* 836 F.2d. at 106–10.

4. *DeWeerth,* 836 F.2d. at 105.

5. *DeWeerth,* 836 F.2d. at 106–7 & n. 3.

6. The court did not certify the issue to the New York Court of Appeals, see N.Y. Compo Codes R. & Regs., tit. 22 500.17 (1986) because it did not believe (again, incorrectly) that the issue would recur with sufficient frequency. *DeWeerth,* 836 F.2d at 108 n. S.

7. *Solomon R. Guggenheim Foundation v. Lubell,* 77 N.Y.2d 311, 569 N.E.2d 426, 567 N.Y.S.2d 623 (1991).

8. *Guggenheim,* 569 N.E.2d at 428.

9. *Guggenheim,* 569 N.E.2d at 428.

10. *DeWeerth,* 836 F.2d 103 (2d Cir. 1987), *rev'd* 658 F. Supp. 688 (S.D.N.Y. 1987), *cert. denied,* 486 US 1056 (1988).

11. *Guggenheim,* 569 N.E.2d 426 (1991).

12. Emphasis added.

13. *Guggenheim,* 569 N.E.2d at 430 (stating that "the demand and refusal is a substantive and not a procedural element of the cause of action"); see *Solomon R. Guggenheim Foundation v. Lubell,* 550 N.Y.S.2d 618, 620 (App. Div. 1990), *aff'd,* 569.

14. *O'Keeffe v. Snyder,* 416 A.2d 862, 872 (N.J. 1980).

15. See, e.g., *Autocephalous Greek-Orthodox Church v. Goldberg & Feldman Fine Arts, Inc.,* 717 F. Supp. 1374, 1391 (S.D.Ind. 1989); *aff'd,* 917 F.2d 278 (7th Cir. 1990); *reh'g denied,* 502 U.S. 1050 (applying discovery rule to find that plaintiff's failure to locate stolen art was reasonable due to fear of "physical harm or destruction to human life or the art itself"); *O'Keeffe,* 416 A.2d at 869-70 (finding that discovery rule should be applied in replevin action for stolen paintings "[t]o avoid harsh results from the mechanical application of the statute [of limitations]").

16. Autocephalous, 717 F. Supp. at 1389.

17. *O'Keeffe,* 416 A.2d at 872.

18. At present the Art Loss Register has more than 100,000 records of items that were lost during World War II and the postwar years. All Holocaust claims are registered on the ALR database free of charge and are systematically checked against forthcoming auction house sales—over 300,000 lots per annum. Additionally, the ALR attends art trade fairs where dealers' stock is compared to the data-base in order to identify stolen and

looted art on behalf of theft victims. Claims are also compared to museum records, Nazi confiscation lists, catalogue raisonnés, exhibition catalogues, and other literature.

19. A third possibility exists—that no match is found because the items are described differently or the registry made an error. The parties should be required to provide sufficient detail to minimize these problems, and a purchaser should be required to carefully pursue evidence of a possible match. The registry would need to be protected from liability for such errors.

20. Making the presumption rebuttable has the advantage of creating incentives for the owner to take additional steps that will increase the likelihood that the art will be recovered, but also the disadvantages of the expensive and uncertain litigation that is associated with the discovery rule. The concern with making the registration the deciding factor is that an owner could then take no other steps for years, yet recover from a non-registering purchaser whose possession was so public that minimal efforts would have disclosed the object's location.

21. The requirement that subsequent purchasers also consult the registry is intended to avoid a situation in which the former owner registers the work after the initial good-faith purchase but within the limitations period, and the possessor then tries to sell the work to avoid recovery by the former owner. Regardless, registration by the former owner more than three years after the initial purchaser's inquiry would be ineffective against subsequent purchasers.

22. Alternatively, report of the theft to law-enforcement officials could be a precondition of registration, as the ALR currently requires.

23. Insurers presumably could then either register the object, pursuant to standard insurance provisions whereby the insurer takes title to the stolen object upon payment to the insured, or require the owner to register the stolen object.

24. In many transactions, the provenance of the art may be so certain or the market value of the art so minimal that the purchaser sees no reason to consult the registry.

25. The inquiry should not be whether the party understood the legal consequences of registering or not registering.

26. Claims against present possessors should be controlled by the discovery rule.

27. If the current possessor chose to consult the registry, then he should receive the same protections as any other registering purchaser.

Egon Schiele, *Portrait of Wally*, 1912. Photo courtesy
Museum of Modern Art, New York.

THE SCHIELE MATTER

ON NEW YEAR'S EVE 1997, the Museum of Modern Art (MOMA) received letters from representatives of two families in the New York metropolitan area, each family asserting rights in paintings on view at the museum as part of the exhibition *Egon Schiele: The Leopold Collection, Vienna.* All of the 150 or so works in the exhibition were on loan to the museum from the Austrian government–financed Leopold Museum in Vienna. The basis for both families' claims was that the works had been improperly taken from their relatives in Vienna after Nazi Germany annexed Austria.

Two sisters-in-law, one a former *New York Times* art writer, claimed that a small panel called *Dead City III,* 1911, had been misappropriated from their late husbands' father's cousin, Fritz Grunbaum, an anti-Nazi cabaret performer, in 1938. The other family wrote that a small oil on panel, *Portrait of Wally,* 1912, had been the subject of a coerced sale just before World War II by a now-deceased relative, Lea Bondi Jaray.

The letters demanded that the museum not return the paintings to the Leopold Museum when the exhibition ended in a few days. The museum wrote in response that it was "extremely sympathetic to the issues raised in [the letters], and supportive of efforts to recover misappropriated art," and would consider the matter and advise the families how it intended to proceed. Several days later, the museum wrote to the families to tell them that it was "under a contractual obligation to return the painting[s] to the lender," and added that the museum was "clearly not in a position to pass on the factual or legal foundation of [either families'] claim." Accordingly, MOMA advised the families that the paintings would be flown to Barcelona in six days, pursuant to the established shipping schedule, for the next venue in the Schiele exhibition tour.

Hours before they were to be sent to the airport in preparation for shipment, the New York County District Attorney issued a *subpoena duces tecum*[1] for the two paintings, compelling the museum to produce them before a grand jury for a criminal investigation. The target of a

criminal investigation in Manhattan was not clear: any crime that might have taken place involving these paintings would have been committed sixty years earlier, in Vienna. Further, the District Attorney announced that MOMA, the only entity subject to the jurisdiction of New York courts, was not being investigated.

What, then, was the purpose of the so-called investigation? Even as a theoretical matter, who could the District Attorney prosecute? In later papers submitted to the court, the District Attorney's Office explained that it wished to present evidence to a grand jury "investigating whether specific paintings were stolen by a Nazi agent or collaborator just before World War II, and if so whether the property was, very recently, possessed in New York County in violation of Article 165 of the [New York State] Penal Law."[2] It remains a mystery what the grand jury, or anyone else, would do even in the event that they reached the conclusion that such property had been in New York County.

After several discussions with the District Attorney in an effort to resolve the matter, the museum moved to quash the subpoena, arguing that the District Attorney lacked authority to issue the subpoena, and that as the cultural center of the United States, New York had a strong public policy interest in protecting works of art on loan for the benefit of the city's residents and visitors. MOMA based its motion on section 12.03 of the New York Arts and Cultural Affairs Law, which was enacted in 1968 to encourage art owners outside New York State to lend their art for public, not-for-profit exhibition in the state. Among other things, the law protects works of art on loan in New York State from "any kind of seizure . . . for any cause whatever."

The museum's position was that a *subpoena duces tecum* is a seizure within the meaning of the statute and was therefore inappropriate. The entire statute reads as follows:

> No process of attachment, execution, sequestration, replevin, distress or any kind of seizure shall be served or levied upon any work of fine art while the same is en route to or from, or while on exhibition or deposited by a nonresident exhibitor at any exhibition held under the auspices or supervision of any museum, college, university or other nonprofit art gallery, institution or organization within any city or county of this state for any cultural, educational, charitable or other purpose not conducted for profit to the exhibitor, nor shall

such work of fine art be subject to attachment, seizure, levy or
sale, for any cause whatever in the hands of the authorities of
such exhibition or otherwise.

—NEW YORK ARTS AND CULTURAL AFFAIRS LAW § 12.03

The museum was successful: in May 1998 Justice Laura Drager of the
New York State Supreme Court[3] quashed the subpoena. Justice Drager
ruled that the subpoena constituted an improper seizure because it was
a meaningful interference with the Leopold's possessory rights, and was
therefore barred by the statute. Justice Drager held that any restriction of
the statute's broad and unambiguous language would be contrary to the
express legislative purpose of encouraging lenders to make art available
to the New York public. In addition, Justice Drager rejected the District
Attorney's contention that applying the statute to criminal matters
would improperly limit the grand jury's broad investigative authority,
noting that "[t]he Grand Jury is not precluded from proceeding with its
investigation; it simply cannot retain the [p]aintings."[4]

In her decision, Justice Drager also reviewed legislative history to
confirm that the law was intended to be all-encompassing. The bill's
sponsor, Attorney General Louis Lefkowitz, repeatedly asserted in mem-
oranda to Governor Nelson Rockefeller that that the law was intended
to be "full and unequivocal," and that "to puncture" the bill's sweeping
protection with even a single loophole would be "self-defeating." In his
Memorandum of Approval accompanying the bill, Governor Rockefeller
agreed: in order to "allay the fears of potential exhibitors and [to] enable
the State of New York to maintain its pre-eminent position in the arts,"
works of art must be absolutely exempt from any kind of seizure. Justice
Drager concluded that the legislature intended to provide absolute, un-
qualified protection for art loaned into New York for public exhibition.

The District Attorney appealed to the Appellate Division, First De-
partment, arguing, as he did in the court below, that the subpoena was
not a seizure and that, in any event, the statute was intended to address
only civil matters, not to shield works of art involved in a criminal
investigation.

In March 1999, the Appellate Division unanimously reversed the
decision of the Supreme Court, holding that for technical reasons never
argued by either party, the paintings had not been "seized" within the
meaning of the statute and that, even if a seizure had taken place, the

statute was addressed only to civil remedies and was never intended to include criminal matters.

MOMA asked New York State's highest court, the Court of Appeals, to review the Appellate Division's decision, and it agreed to do so. The museum argued to the Court of Appeals that the Appellate Division's decision was contrary to the intent and clear language of the statute and potentially disastrous to the ability of New York State museums to borrow works of art.

In its appeal, the museum presented three central points: first, section 12.03 of the Arts and Cultural Affairs Law applied to criminal proceedings as well as civil remedies; second, the District Attorney's subpoena was a seizure in that it effected a meaningful interference with the Leopold Museum's property; and third, even if section 12.03 did not apply to all criminal proceedings, it applied in this instance. (That is, the so-called criminal investigation could proceed without the paintings, and there was no need to keep the paintings in New York as evidence.)

The issue on appeal had nothing to do with Nazi spoliation of cultural property in the regions they occupied during World War II, or with the hideous consequences of Nazi genocide. MOMA has never addressed, and will not address, the merits of the families' claims.

Nor could it. An art museum is not the proper forum for adjudicating complex factual and legal questions about title to property allegedly misappropriated at a remove of thousands of miles and more than sixty years. Like all other major American art museums, MOMA fully endorses (and helped to draft) the guidelines promulgated in 1998 by the Association of Art Museum Directors[5] for dealing with art misappropriated during the Nazi period, but it has no basis for deciding, as between a lender and a third-party claimant, who has superior title.

Similarly, the case is not about a desire on the part of the Museum of Modern Art to exhibit stolen art of any kind, including that looted by the Nazis. No responsible museum knowingly exhibits stolen art. But when a museum has, in good faith, borrowed art for public exhibition from a reputable lender (in this case, art owned by a government-financed foundation, which has been repeatedly exhibited around the world over the last several decades), that exhibition ought to proceed without interference. Further, the lender should have confidence that the borrowing New York State museum will return the loaned works without interference from a local prosecutor or anyone else.

The Schiele case was one of *first impression;* before the museum litigated this issue, the statute had protected works of art on loan in New York without incident since its enactment in 1968.

New York offers specific protection to works of art loaned from outside the state for public, not-for-profit exhibition. The New York State statute was unique until Texas enacted legislation in 1999 that exempts from seizure fine art on loan for public exhibition, or while being transported to such exhibition. (Texas apparently acted after sheriff's deputies physically seized paintings by Robert Rauchenberg from a major Texas museum in order to satisfy a judgment creditor.)

The New York statute has a closely related counterpart in federal law, the 1965 Immunity from Seizure Act (22 USC. § 2459). Like the New York State statute, the federal law grants broad immunity for cultural objects and works of art imported for temporary exhibition in US museums. The federal statute, though invaluable from the point of view of lenders to American museum exhibitions, differs from the New York law in important respects. In contrast to the federal immunity statute, the New York law is automatic, and confers its protection without any special activity or application process by the borrowing institution. The mere fact that a work of art is in New York for public exhibition, at no profit to the lender, means that it is immune from interference.

In addition, New York protects *all* art on loan to institutions in the state, whether the source of the loans is domestic or foreign. The sole requirement is that the loan must originate outside the state. The New York statute and the federal law have worked harmoniously for thirty years to provide the public with art and cultural material from around the world, and to provide lenders with the assurance that their art is secure.

On September 21, 1999, the New York State Court of Appeals, by a 6–1 vote, quashed the District Attorney's subpoena and held that the state statute barred *any* sort of seizure, whether in a civil or criminal context. The court ruled that the Immunity from Seizure Act was all-encompassing and that any major loophole would thwart its purpose of encouraging loans of art to New York cultural institutions. As a matter of state law, therefore, the museum was free to return both *Wally* and *Dead City III* to the lender.

On the same day that the Court of Appeals rendered its decision, the US Attorney for the Southern District of New York (the federal

government's prosecutors in Manhattan and several counties to the north) obtained a seizure warrant and order, the effect of which was to bar MOMA from returning *Wally,* one of the two paintings seized by the District Attorney. The other painting, *Dead City III,* was returned to Vienna without objection, apparently because it had been restituted to the family of the pre-war owner, and later sold by the family. Based on their conclusion that *Wally* was stolen property under Austrian law, the US Attorney's Office commenced a forfeiture proceeding in the US District Court for the Southern District of New York.

As amended, the complaint in the forfeiture action asserted that the Leopold Museum had never acquired good title to the painting under Austrian law. The painting was therefore "stolen" within the meaning of the National Stolen Property Act (NSPA), a federal criminal statute that proscribes the transportation of stolen property in interstate or foreign commerce. Because of the NSPA violation, the amended complaint asserted, importing the painting into the United States was unlawful.

A forfeiture proceeding is a civil proceeding, although it is often based, as here, on the alleged violation of a criminal statute. The proceeding is unusual in that the person or entities claiming to be the owner of the property in question bears the burden of proving ownership. Also, no innocent-owner defense is allowed. If forfeiture is ordered, the government asserts that it has authority to deliver the painting to whomever it believes to be the true owner—even if that individual or entity has not successfully demonstrated title in the forfeiture trial.

The Museum of Modern Art asserted a claim in the forfeiture action, as did the Leopold Museum and a group of people purporting to be the heirs of Lea Bondi Jaray, the pre-war owner. In addition, a man from Australia named Ron Jaray, the grandson of the pre-war owner, came forward to dispute the claims of the other purported heirs.

MOMA did not claim any ownership rights in the picture. Instead, it asserted a claim based on its contractual rights and obligations as the borrower of the picture, and moved to dismiss the government's complaint. The basis of the motion was that where there is a genuine dispute over title to property, it is inappropriate to treat the property as contraband subject to forfeiture. Without addressing the merits of any of the claimants' positions on their ownership rights, the museum argued that the government misinterpreted and misapplied the NSPA by treating

an ownership dispute as a criminal matter. The government moved to dismiss MOMA's claim for lack of standing.

MOMA asserted that even assuming that the facts stated in the amended forfeiture complaint were true, the government violated the Constitution and laws of the United States when it seized the painting because the painting was not "stolen" within the meaning of the NSPA. As a result, there was no probable cause to issue the seizure warrant, and the forfeiture complaint must be dismissed as a matter of law.

The allegations in the amended forfeiture complaint are indistinguishable from those that might be made in a civil lawsuit to establish title. It is unprecedented for the US government to use its extraordinary forfeiture power to bring about a particular result for a private litigant. Moreover, the Justice Department inserted itself into a matter involving only foreign parties: the Leopold Museum is Austrian, and Lea Bondi Jaray's legal representative is English. Certainly, the government has an interest in preventing stolen property from entering the country, but it is less certain why the government would use public resources to recover private property on behalf of a foreign individual against a foreign museum, particularly where the foreign lender has abundant reason to believe that it actually owns the property, and the property—*Wally*—is in the United States for the sole purpose of non-profit public exhibition.

The central issue in this forfeiture proceeding is one of statutory construction: the meaning of the word "stolen" in the NSPA. The amended complaint alleged that under Austrian law the Bondis have superior title to that of the Leopold Museum and that this is enough to make the property "stolen." The forfeiture complaint alleged neither (1) that any person could be convicted of any offense under Austrian law in connection with the painting, nor (2) that the Leopold Museum lacks a genuine claim to ownership under Austrian law. Given the purposes of the NSPA, one or the other of these allegations is necessary to establish a violation of the statute.

The government's construction of the NSPA is unprecedented and contrary to the statute's purpose as enunciated by the Supreme Court of the United States: to prevent thieves from escaping state (and foreign) prosecution simply by taking the loot out of the relevant jurisdiction. Diligent search shows no instance in which an individual has been indicted, let alone convicted, under the NSPA in the presence of a plausible argument for disputed ownership.

Chief Judge Michael Mukasey dismissed the government's forfeiture complaint in July 2000. The court relied on the "recovery doctrine": when law-enforcement officials recover stolen property, they do so as agents for the owner, and the property ceases to have the character of stolen goods upon such recovery.

The recovery doctrine had not previously been raised in the case, but was relevant because of the picture's movements in the World War II years. According to the government, Mrs. Bondi, a Jewish art dealer in Vienna, sold her business in 1939, subject to "Aryanization" laws promulgated after the German annexation of Austria. Shortly before she and her husband left Vienna for London, the buyer, who later became a Nazi, visited her at home and asserted a right to *Wally*. Although the picture belonged to her personally and was not a business asset, Mrs. Bondi turned it over to avoid creating any obstacle that might hinder her departure. The US Army recovered *Wally* following the war but confused it with another painting by Schiele. As a result, *Wally* was placed with paintings belonging to a Holocaust victim named Dr. Heinrich Rieger. With the specific understanding that they had good title to all of the restituted art, the Rieger heirs sold some of these paintings to the Austrian government. *Wally* was shipped to the Belvedere Gallery (the modern art section of the Austrian National Gallery) as part of that sale. In 1954, Dr. Rudolf Leopold purchased *Wally* from the Austrian government in exchange for another Schiele painting. In 1994, Leopold sold *Wally*, along with the rest of his collection, to the Austrian government–financed Leopold Foundation.

The government quickly asked the court to reconsider the decision and to grant it permission to amend the complaint. At the end of December 2000, the court allowed the government to file a third amended complaint. This version of the complaint added the allegation that Rudolf Leopold had acquired *Wally* from the Belvedere Gallery (part of Austria's National Gallery) by means of conversion (the unlawful appropriation of another's property). This provided an additional basis for the alleged NSPA violation; if Dr. Leopold did not have legitimate title, no subsequent purchaser would have it either.

In April 2003, the court ruled. Expressly reversing its previous decision, the court held that the recovery doctrine—the basis for the initial dismissal—was inapplicable "because the United States armed forces cannot properly be deemed an agent of Bondi." In so ruling, the court

relied on the government's explanation that American armed forces gathering spoliated art and other material in postwar Europe had neither knowledge that the property was stolen nor a legally enforceable duty to return anything to its rightful owner. Specifically, when the US Army took possession of *Wally,* it did not know that the picture had been coercively taken from Lea Bondi Jaray, and, even if it had known, nothing required the Army to return property to owners like Mrs. Bondi.

The court also addressed the question of whether *Wally* was stolen property under Austrian law. To state a claim under the NSPA, the picture had to have been stolen, and it had to continue to have the character of stolen property when it entered the United States in 1997. Accepting the complaint's allegations as true, the court found sufficient basis for an allegation that *Wally* had been stolen. The court then rejected a number of arguments to the effect that even if *Wally* had been stolen in 1938, the Leopold Museum now had good title.

The court found, for instance, that neither the Leopold Museum nor the previous possessors of the painting (Rudolf Leopold and the Belvedere Gallery) had acquired title by prescriptive possession,[6] by expiration of the applicable statute of limitations, by operation of Austrian restitution laws, or by operation of New York State law.[7] Interestingly, while the court appropriately viewed the facts alleged in the complaint as true, the court also accepted, seemingly without question, the government's analysis of Austrian law, which was contradicted by both MOMA's and the Leopold's Austrian law experts, and by an analysis of Austrian law provided in an *amicus curiae* [friend of the court] brief submitted by the Republic of Austria.

Arguments about the *scienter* requirement of the NSPA (i.e., that one must act knowingly or willfully in seeking to carry stolen property into or out of the United States) were brushed aside by the court. The essence of MOMA's position was that "as a matter of Austrian law *Wally*'s ownership is in reasonable dispute, and the Leopold Museum has a colorable [plausible] claim to title." Without addressing whether the Leopold Museum has an ownership claim superior to any other, MOMA proposed simply that forfeiture under the NSPA is inappropriate where one has, at a minimum, a good-faith basis for believing that one has good title—even if that belief turns out to be wrong. This position seems particularly compelling where, as here, the only act subjecting the owner to the jurisdiction of US courts was a willingness to make important art

available to the American public at a not-for-profit exhibition. Wholly accepting the government's conclusion that "Bondi owns *Wally* under Austrian law," the court also accepted the late Mrs. Bondi's references to what she perceived to be Rudolf Leopold's self-consciousness as evidence of his guilty knowledge, and declined to dismiss the complaint for want of the NSPA's *scienter* requirement.

After rejecting the government's motion to dismiss MOMA's claim and the two motions to dismiss the complaint, the court granted the Bondi heirs' motion to substitute as claimants the administrators of Mrs. Bondi's estate, and rejected the Leopold Museum's motion to dismiss these heirs for failure to demonstrate a legally recognizable interest in *Wally*.

The court granted the Bondi heirs' motion for summary judgment in eliminating Ron Jaray, the *Wally* claimant from Australia, based on the lack of evidence proffered in support of Mr. Jaray's claim, and upon English law, which would have governed the disposition of the estates of Mrs. Bondi and her husband, who predeceased her.

Wally remains in limbo, languishing in federal court. No trial date has been set. This need not have been the result. Even in the context of Nazi-era claims, where claim resolution is complicated by memories of the ghastly horrors of the Holocaust, along with the passage of time and the cataclysmic destruction of war, museums have been remarkably successful at addressing claims. All of the dozen or so instances of American museums facing claims that they hold Nazi-spoliated works have been swiftly resolved, either by turning over the questioned art to the claimant, or by arranging with the claimant a purchase or gift that allows the art to remain in the museum's collection. In the Schiele case, on the other hand, claimants, perhaps emboldened by the prospect of having prosecutors do their work for them, with public funds and subpoena/forfeiture power at their disposal, were unwilling to address the matter directly with the possessor. No exchange of information took place, nor did any good-faith discussions about how best to proceed.

MOMA remains optimistic that it will be able to return *Wally* to its lender. Years of expensive litigation over the status of this picture have demonstrated what should have been clear all along: claims for art alleged to have been involved in Nazi looting should be addressed swiftly and responsibly by the parties concerned, using good faith and clear analysis to achieve an appropriate result. It is equally clear that

these questions, when they arise, should not be handled as criminal matters. Successive prosecutors have committed the resources of their offices to exploring the provenance of *Portrait of Wally* and *Dead City III,* though the art was unquestionably not in the possession of the people who stole it, and it has never been clear who might be prosecuted more than sixty years later, thousands of miles from where the relevant events took place. Instead of a rational, sympathetic response to a complex and painful question of ownership and history, there have been headlines, posturing, and years of expensive litigation.

For more than seven years, the painting has been packed in a crate, visible to no one, enjoyed by no one. None of the various people purporting to be the heirs of Lea Bondi Jaray have the picture, nor do they appear closer to having it than in the 1950s, when Mrs. Bondi learned that Dr. Leopold had acquired it. The Leopold Museum, which loaned the painting for its first-ever public exhibition in New York City, has been deprived of it for more than seven years. And the public, which came to the museum by the hundreds of thousands to see the 1997 Schiele exhibition, has lost the opportunity to see this picture, perhaps forever.

NOTES

1. A *subpoena duces tecum* is a writ issued by a court at the request of one of the parties to a suit; it requires a witness to bring to court or to a deposition any relevant documents under the witness's control.

2. Memorandum of Law in Opposition to the Museum of Modern Art's Application to Quash the Grand Jury Subpoena, February 13, 1998, *Schiele.*

3. Unlike the federal court system and most state courts, where the highest appellate court is called the Supreme Court, New York State's Supreme Court is the court of general jurisdiction: the trial court. Its decisions may be appealed to the Appellate Division in one of four geographic areas of the state (Manhattan is in the First Department). New York's highest court is the seven-judge Court of Appeals in Albany. In most cases, including the Schiele matter, the Court of Appeals must agree to hear an appeal.

4. Drager Decision dated May 13, 1998, *Schiele,* at 15.

5. The AAMD guidelines, drafted by a group of ten directors of major American art museums led by Philippe de Montebello from the Metropolitan Museum of Art, were issued in June 1998. Similar standards were articulated in the Principles with Respect to Nazi-Confiscated Art—the so-called "Washington Principles"—agreed upon at the State Department-sponsored Conference on Holocaust-Era Assets in December 1998, and the guidelines released by the American Association of Museums in December 1999.

6. Prescriptive possession is a means of acquiring ownership of property by possessing it for a period specified by law.

7. The court also held that it was premature to consider a *laches* defense. *Laches* is the equitable doctrine that bars claims when the claimant has neglected to assert rights, allowing time to pass to the prejudice of the adverse party. Addressing itself to the question of whether *Wally* was converted property, the court applied a broad definition of conversion, requiring no showing that one initially in lawful possession of property later acted to deprive the lawful owner of her possessory rights. The court rejected the argument that the Leopold Museum's possession did not affect whatever ownership rights Mrs. Bondi might have held (i.e., she could have brought a claim herself during the fifteen or so years she knew that Dr. Leopold possessed *Wally,* but specifically declined to do so) and that Rudolf Leopold lacked the level of intent necessary to support a claim of criminal conversion.

THE TRIAL OF THE SEVSO TREASURE
What a Nation Will Do in the Name of Its Heritage

HARVEY KURZWEIL, LEO V. GAGION, LUDOVIC DE WALDEN

IN THE FALL OF 1993, in a courtroom in New York City, two nations, the Republic of Croatia and the Republic of Hungary, attempted to wrest legal possession of what has come to be known as the Sevso Treasure from the Marquess of Northampton 1987 Settlement, the owner of the collection.[1] The Sevso Treasure is a fourteen-piece collection of fourth-century Roman silver and the copper cauldron in which the Treasure is believed to have been stored in antiquity.[2] Both Croatia and Hungary claimed that the Treasure had been discovered within their respective borders and, under their national property laws, was the property of the State.

After a seven-week trial in New York State Supreme Court, both of these nations failed. Within approximately three hours, the jury found that neither Croatia nor Hungary had established that the Sevso Treasure had been discovered within its borders, and thus neither had a right to possession. The jury's verdict was upheld on appeal and Lord Northampton, the beneficiary of the Settlement, after a legal battle lasting more than three years, was able to retain his property. Still, at least one of the claimant nations continues to press its claim to the Treasure in the international press.[3]

While the trial of the Sevso Treasure is a story of success in warding off legal challenges to the ownership of antiquities brought by source nations, it is also a textbook example of the perils of the antiquities trade. Indeed, the New York trial reveals how far and to what remarkable lengths source nations will go in attempting to secure possession of antiquities they rightly or wrongly believe form part of their cultural patrimony. The story that emanates from the trial is in many ways troubling. It includes the introduction by these governments of conflicting, alleged "eyewitness" testimony; efforts to recast what was previously viewed as an unfortunate suicide of a Hungarian soldier into a murder and then to attempt to tie the murder to the discovery of the Sevso Treasure; and incidents of alleged witness interference throughout the course of the trial. The Sevso Treasure case teaches that in the world of antiquities, the line between speculation and fact is a thin one.

How the Sevso Treasure Found Its Way from Antiquity into a New York Courtroom

Lord Northampton testified at trial that his involvement with the Sevso Treasure originated as a proposed investment opportunity. He claimed that in the early 1980s he was approached by his former trusts and estates solicitor with the idea of investing with a consortium in a newly discovered collection of fourth-century Roman silver. He was informed that the collection had been recently discovered in Lebanon and that valid export licenses for the items existed from Lebanon. The head of the consortium was Peter Wilson, former chairman of Sotheby's. Mr. Wilson, who had already begun purchasing individual pieces of the Treasure from a London antiquities dealer, wished to acquire more of the Treasure and was seeking a new source of funding. Relying upon Mr. Wilson's pedigree in the art world and his former solicitor's advice, Lord Northampton chose to invest.[4]

By 1984, the consortium had acquired ten pieces of the Treasure and had begun marketing the collection to the J. Paul Getty Museum for possible sale. The Getty retained a Beirut attorney to check the bona fides of the Lebanese export licenses; he reported back that the licenses were in fact not valid. By that time, Mr. Wilson had passed away and Lord Northampton was left to fend for himself in the antiquities world, a world he knew little about.

It was suggested to the remaining consortium members that a Lebanese businessman and client of Lord Northampton's former solicitor's firm, Ramiz Rizk, might be able to approach the Lebanese authorities and resolve the matter. In 1985, Philip Wilson, Peter Wilson's son, traveled to Beirut and met with Rizk and a National Museum official, who authorized the issuance of new export licenses for the collection. Buoyed by this apparent success, Lord Northampton invested in the final four pieces of the Treasure.

In early 1990, Lord Northampton consigned the Sevso Treasure to Sotheby's for private sale or auction. Sotheby's then brought the Treasure to New York to announce the upcoming sale. While the Treasure was in New York, the Republic of Lebanon filed suit in New York State Supreme Court claiming that the Treasure, notwithstanding the export licenses issued by the National Museum, had been illegally exported from Lebanon and, under Lebanon's cultural property laws, was the property

of the State. Soon thereafter, Lebanon was joined by the Socialist Federal Republic of Yugoslavia, which was making similar claims. When Yugoslavia dissolved, the Republic of Croatia took over the claim. Within approximately one year, the Republic of Hungary had joined the suit as well, making identical claims of ownership. Despite the fact that the nation claimants had competing claims, they successfully obtained a preliminary injunction preventing Sotheby's from removing the Treasure from New York pending resolution of their claims. Trial in New York became inevitable.

Over the next two years, each country conducted an extensive, state-sponsored investigation into the origin of the Sevso Treasure in an effort to uncover evidence that the Treasure had been discovered within its borders. Little hard evidence was known to exist at the time. For example, Lebanon commenced its lawsuit relying in part upon statements made in public marketing materials to the effect that it was believed that the Treasure had been discovered in Lebanon, a belief then shared by Lord Northampton. Lebanon ultimately abandoned its claim of ownership in the late summer of 1993, on the eve of trial.[5]

Croatia's case had been commenced in part upon the strength of an article that appeared in early 1990 in *The Independent,* a London newspaper. The writer claimed that a confidential source had told him that the Treasure had been discovered near a military installation in what was then Yugoslavia, between Pula and Rovinj, and had been smuggled out of the country via diplomatic pouch. Vesna Girardi-Jurkic, then a museum director in Pula, Croatia, was informed of the article by a colleague and contacted its author. Ms. Girardi-Jurkic filed a complaint with the local prosecutor's office and announced in a press conference that it had been established that the Sevso Treasure had been found within Croatia.[6] The story took hold, and the Yugoslavian/Croatian claim to the Treasure was born.

Agencies of both the Yugoslavian and Croatian governments knew, either then or soon thereafter, that the claim would be difficult to support. In early 1990, both the Yugoslavian Department of Defense and the Foreign Ministry investigated the claims made in *The Independent* and concluded that there was no evidence to support them.[7] Agencies of the Croatian government came to similar conclusions. In a report prepared by the Croatian Ministry of Internal Affairs in June 1991, the ministry admitted that it had "exhausted all possibilities in the direction of a

favorable resolution of the question of the origin of the Sevso Treasure."[8] By as early as December 1990, the Pula prosecutor's office itself issued a report noting that, while "a great deal of work is now being done," its investigation had "not revealed where and by whom the objects from the Sevso collection were found, and when and by what channels they were removed from our country."[9]

The Hungarian case was similar in many ways. Hungary claimed that the Treasure had been discovered by a Hungarian soldier named Jozsef Sumegh in a rock quarry, then hidden by Mr. Sumegh in his family home in Polgardi, Hungary. He later hid it again in a wine cellar, where in 1980 he was found hanged by his own military belt. Although his death was ruled a suicide at the time, a decade later the Hungarian government sought to reclassify it as a homicide connected to the Treasure. Hungary's evidence included an indentation in the soil of the wine cellar, which, it claimed, fit the size of the copper cauldron and could have been its resting place.

Hungary had arrived at the Sumegh conspiracy theory through an amalgam of art historical speculation and alleged eyewitness testimony connecting Mr. Sumegh to the Treasure. When the existence of the Sevso Treasure was first reported in the international press in 1990, Dr. Mihalay Nagy, a curator at the Hungarian National Museum in Budapest, saw a potential historical connection between Hungary and the Treasure, based in part on the word "Pelso," which appeared on one of the plates in the collection next to a picture of a horse. Among other things, Pelso is an ancient name for Lake Balaton, a lake in present-day Hungary.[10] Dr. Nagy began publishing articles about a possible Hungarian origin for the Treasure, first hypothesizing that Sevso had been a Celt, then a Thracian, and finally a member of the Hasdings, a long-lost and little-noted Hungarian tribe that ultimately settled in North Africa in the tenth or eleventh century.[11]

The Hungarian authorities were requested to open an investigation into the origin and illegal export of the Sevso Treasure from Hungary. The publication of the Treasure, its possible historical connection to Hungary, and its enormous value brought others forward. For example, in 1990, Jozsef Sumegh's elderly father wrote to the Hungarian authorities noting that his son had been a collector of "old coins and medals." He asked the Hungarian authorities to investigate whether his son's death was associated with the Treasure, which he had read about in the

press.[12] The Hungarian authorities thus commenced an investigation into the origin of the Sevso Treasure.

The New York Trial

The trial of the Sevso Treasure began in September 1993 in New York State Supreme Court before Justice Beatrice Shainswit, a jurist of fierce courage and great intellect. The cases the source nations wished to present were in effect divided into three parts: eyewitness testimony to prove that persons had seen the Treasure within the source nation; art historical testimony to suggest a historical connection between the collection and the source nation; and soil samples from various parts of Croatia and Hungary to establish that their soil was consistent with ancient encrustations found on pieces of the Treasure.

Ultimately both Croatia and Hungary were precluded by the court from introducing all or portions of their purported scientific evidence of soil samples. The court determined that Croatia had not been diligent in presenting the evidence, repeatedly changing the samples that it wished to proffer.[13] The court precluded Hungary also from using a sample from the wine cellar. At the trial, Bela Vukan, the Hungarian police official in charge of the Hungarian investigation, testified that no person had come forward to claim to have seen the Sevso Treasure in the wine cellar.[14] Officer Vukan admitted that the former owner of the cellar had informed the Hungarian authorities that the circular indentation in the floor of the cellar was where a wine vat had rested for many years.[15] Based upon the court's view of Hungary's lack of any evidence connecting the death of Jozsef Sumegh to the Sevso Treasure, the court precluded Hungary from mentioning Mr. Sumegh's death to the jury or claiming that it was somehow connected to the Treasure.[16]

The Croatian Case for Ownership

Despite Croatia's prior admissions in government documents of its lack of evidence regarding the origin of the Treasure, the country presented purported eyewitness testimony to the find at the trial. Croatia's primary witness was Anton Cvek, a retired police officer from the Adriatic coast city of Pula, who testified that in the early 1960s he had been called to a military installation known as Barbariga and had seen pieces of the

Sevso Treasure still in the ground. He also testified that later the same day he had been brought to a house in Barbariga where he saw other pieces on shelves in a particular room. Mr. Cvek said that he had seen pictures of the Sevso Treasure in *Arena* magazine in Pula in 1990 and thought he recognized the pieces from his experience some thirty years before.[17] Mr. Cvek's testimony was supported by that of Ivan Kauric, another retired Pula police officer, who testified that he had been with Mr. Cvek at Barbariga and had viewed many of the same pieces.[18]

On cross-examination it was determined that Mr. Cvek had given both a sworn written statement and a sworn video statement to the Croatian authorities in 1990, which were obtained through pre-trial discovery. In his written statement, he had told the Croatian authorities that he had remembered a "jug" of the same "shape" as one of the Sevso ewers depicted in *Arena* magazine, but was not certain that it was in fact one of the Sevso pieces.[19] In his videotaped statement to Croatian authorities Mr. Cvek was asked to describe with his hands how large the plates and ewers that he had seen in Barbariga had been. On the video, Mr. Cvek described the plates that he had seen as being the size of dinner plates and the ewers as being roughly the size of soda bottles. As the jury soon learned, the Sevso pieces dwarfed those described by Mr. Cvek.[20] Mr. Cvek admitted on cross-examination that he had seen pieces only similar to some of those in the Sevso Treasure and could not attest that he had actually seen pieces of the Treasure.[21]

The testimony of Mr. Kauric had similar issues. On cross-examination, it was pointed out that when interviewed by Croatian authorities in 1990, 1991, and 1992 Mr. Kauric had repeatedly stated that he knew nothing of any silver horde found in Barbariga. When Mr. Cvek personally approached Mr. Kauric in Croatia in 1990 to discuss the matter, Kauric also had told Cvek that he knew nothing about the matter. To justify his change in story, Kauric first proclaimed that he had been scared of the Croatian police, notwithstanding that he had been a Croatian policeman himself. He then claimed that he did not tell the truth to the Croatian authorities previously because he had not been in a location that required him to tell the truth. Finally, he claimed that he was free not to tell the truth because he was not speaking to the right police official when interviewed in Croatia. Kauric's testimony compelled his cross-examiner to inquire whether Kauric felt that the New York courtroom was finally a location in which he felt compelled to tell the truth.[22]

Croatia then called its Minister of Culture, Vesna Girardi-Jurkic, who opined that since some Romans had fled from the north to Istria in the fifth and sixth centuries and that other Roman objects had been discovered in Istria, the Sevso Treasure plausibly could have been there.[23] Ms. Girardi-Jurkic admitted that the same could be said of virtually any present-day country that had once been part of the Roman Empire.[24]

In the end, Croatia was left with a case built upon a seventy-odd-year-old retired police officer stating that he had seen similar pieces some thirty years before, though he could not be certain that they were the same pieces now before him at trial—pieces that he had identified as being a fraction of the size of the pieces of the Sevso Treasure.[25] Ultimately, Croatian documents confirmed that even some of the Croatian authorities questioned Mr. Cvek's story. In a report prepared by a government archaeologist in July, he noted that "[o]n the basis of everything presented above, we conclude that archaeological sites similar to those mentioned by A. Cvek in his statement to the investigating authorities are not likely."[26]

The Hungarian Case for Ownership

Hungary's claim to the Treasure was premised on much the same type of testimony as Croatia's. Hungary's lawyers called a series of individuals from the town of Polgardi, who testified that each had seen pieces of the Sevso Treasure at the Sumegh family home in the late 1970s, identifying specific pieces from the pictures of the Treasure.

The first of these witnesses was Istvan Strasszer, a Hungarian stone mason, who testified that he had seen several pieces of the Treasure in the Sumegh home in 1978 or 1979. He identified the Sevso Cosmetic Casket as one of the pieces he had seen.[27] When interviewed prior to trial by Hungarian authorities, Strasszer had drawn a picture of a piece that he had supposedly seen. This was very similar to the Sevso Cosmetic Casket, a remarkable feat for a stone mason who had purportedly seen the piece for only a brief time some twelve years previously.

When Strasszer had supposedly drawn the Sevso Cosmetic Casket in 1991, he had given it dimensions on his drawing. A scale model of what Strasszer had actually drawn for the authorities was then created for trial. This was roughly the size of a water glass. The Sevso Cosmetic Casket itself was roughly the size of a giant Clorox bottle, dwarfing

what Strasszer had described to the authorities prior to trial. One conclusion, which Strasszer conceded, was that when he met with Hungarian authorities, he had been shown pictures of the Sevso Treasure.[28]

Then came Jozsef Harmat, another resident of Polgardi, who testified among other things that he had seen the copper cauldron from the Treasure stored in a cupboard in the Sumegh home, saying that he remembered the cauldron in part because he considered buying it from Sumegh to mix concrete. He then identified the Sevso copper cauldron from a picture as the one he had seen.[29]

There was an issue with Mr. Harmat's identification: he had identified the cauldron from a picture in its fully restored state. The Sevso cauldron had gone through extensive restoration work in the late 1980s, before its consignment to Sotheby's. According to expert testimony, what Harmat claimed to identify simply did not exist in that form in 1978 or 1979. Dr. Anna Bennett, the conservator who performed the work on the cauldron in the late 1980s, testified that prior to restoration the cauldron was "in such fragile condition that if you put it on its side it would just collapse."[30]

Hungary then called to the stand one Maria Balogh, who described herself and her family as gypsies. She claimed to have purchased the Sevso bowl and other pieces of the Treasure from a person in Budapest in 1982 and purportedly sold them in 1983. At trial, Ms. Balogh identified these pieces from pictures of the Treasure.[31] Again, there were issues. First, Ms. Balogh admitted that the person she claimed had sold her the pieces, a Mr. Hatszeghi, had denied to the Hungarian authorities ever having seen any of the Sevso pieces.[32] Second, she initially told the Hungarian police when interviewed in January 1993 that she had acquired these pieces only "a couple of years ago," a story that she later amended to a decade ago, specifically 1982, when she testified at trial.[33] But the amended story had issues as well. According to the consortium's invoices for the pieces, two of the pieces that she identified as having purchased and held in Budapest throughout 1982 and 1983 had already been purchased by the consortium and were in a Swiss bank vault for safekeeping at that time.

Finally, Hungary called Istvan Fodelmesi, a retired schoolteacher. When questioned by the Hungarian authorities twice in 1991, he had denied under oath any knowledge of the Treasure or ever having seen any silver pieces in Sumegh's possession. Two weeks before trial, however,

Mr. Fodelmesi changed his story, claiming to have seen several of the Sevso pieces at the Sumegh home and even drawing some of them for the authorities. In his new statement to the Hungarian authorities before trial, he had described seeing an "oval" silver plate in the Sumegh home and drew an oval platter for the Hungarian authorities. When it was pointed out at trial that the plate he had identified to the jury was actually round and not oval, Mr. Fodelmesi claimed that it nonetheless looked oval to him. Mr. Fodelmesi wound up admitting that he could not say that the plate he supposedly had seen in the Sumegh home was the "same" plate he identified at trial.[34]

What Hungary did not choose to proffer was equally revealing. While several Sumegh family members remained alive at the time, Hungary failed to call as a witness any member of the Sumegh family who had actually lived in the Sumegh family home at the time these eyewitnesses claimed to have seen the Treasure there. Each living member of the Sumegh family had given a sworn statement to the Hungarian authorities, and none had mentioned seeing any silver pieces in their home. Each family member had denied ever having seen Jozsef with any silver antiquities (other than coins) at all.[35] This was quite striking, since the home was barely the size of a cottage, just two rooms and a kitchen,[36] and the Sevso Treasure was enormous, collectively weighing more than 180 pounds. Thus, for the jury to accept the witnesses Hungary proffered, it had to believe that Jozsef Sumegh could have hidden approximately 180 pounds of silver in this small home without any other family member noticing.

Hungary then retreated to its historical connection to the Sevso Treasure. Dr. Nagy testified to similar pieces having been found in Hungary and to the possibility that Sevso had been a Hasding.[37] What Dr. Nagy gave the jury was not fact but historical speculation.[38]

The New York Verdict

The jury took little time to conclude that neither Croatia nor Hungary had proven by a preponderance of the evidence that the Treasure had been discovered within its borders. After nearly three full years of litigation and a seven-week trial, the jury deliberated for approximately three hours before reaching its unanimous verdict in favor of Lord Northampton.

While the lack of any hard evidence of a find site limited Croatia's and Hungary's ability to successfully pursue their claims, that was not the full story of the trial. The trial record is rife with allegations of witness interference and fears (real or not) of government retaliation. For example, during the course of the trial, we were informed that our Croatian law expert had received a telephone call from a Croatian government representative informing him that it was not appreciated that he was assisting us.[39] Our expert, a Yale professor of Croatian birth, did not testify.

In the middle of trial we learned that one of our Roman art experts, Dr. Herman Cahn, had been called from his home in Switzerland by the Hungarian authorities and forced to sit for an interview in order to determine his knowledge of the origin of the Sevso Treasure.[40] We ultimately did not call Dr. Cahn to testify. Finally, in the course of the presentation of Hungary's case, a member of the gallery viewing the trial was removed from the court when she was caught by the Supreme Court Justice in the act of signaling one of the Hungarian eyewitnesses as to how to answer questions on cross-examination.[41]

Epilogue to the Trial

Hungary has continued to press its claims and persists in claiming a relationship between Mr. Sumegh's unfortunate death and the discovery of the Sevso Treasure, rejecting its own previous government finding that Mr. Sumegh's death was a suicide. Hungary's claim continues to be a topic of fanciful articles in the international press, which employ many of the same sources and evidence that were vetted in New York more than a decade ago.[42] As reported in the press, the stories of some of the alleged eyewitnesses who testified in New York have once again been amended.[43]

According to press reports, Isvan Sumegh, Jozsef's younger stepbrother, now claims to remember how he and Attila, Jozsef's other stepbrother, helped Jozsef clean the Treasure pieces with sandpaper. In the early 1990s, Isvan stated under oath to the Hungarian authorities that he knew nothing about any Treasure. In fact, Isvan told the authorities that, other than Jozsef's medal (coin) collection, he did not know whether Jozsef ever had "other antiquities in his possession" since "he had never spoken to me about having found some antiquities."[44] Attila had echoed this lack of knowledge in his interview with the Hungarian authorities

in 1990, telling them under oath that, other than Jozsef's medal collection, he had never seen any "other antiquities, old objects and things on [Jozsef]."[45] Taking his present age from press reports, Isvan was anyway claiming to remember something that supposedly took place when he was approximately seven years old.

A lesson learned from the Sevso Treasure experience is the need for extreme caution when purchasing antiquities in the open market. The power and resources of claimant nations in the context of these legal challenges is daunting, and the defense against such claims, even when they are weak, can be extraordinarily expensive and time-consuming, likely spanning years. It is rare to be able to meet head-on three national investigations into the origin of a collection and to be able to dissect them before a jury and argue their lack of evidentiary bases. Lord Northampton was resolute and fortunate enough to have been able to do so. Others might not be so fortunate.

93

1. A third nation, the Republic of Lebanon, was also a claimant in the case but withdrew its claim on the eve of trial.

2. The Treasure is believed to have taken its name from its owner in antiquity, Sevso or Seuso. The name is referenced on one of the plates (the Hunting Plate) that forms part of the collection. See Marlia Mundell Mango, "The Sevso Treasure Part One," *Journal of Roman Archaeology Supplemental Series,* No. 12, 11.

3. See Peter Landesman, "The Curse of the Sevso Treasure," *The Atlantic Monthly,* November 2001.

4. Trial Transcript, 1781-846.

5. Once the Republic of Lebanon abandoned its claim, the court precluded Croatia and Hungary from introducing at trial evidence regarding the validity of the Lebanese export licenses. While issues surrounding the export licenses had been relevant to Lebanon's claim of ownership, the court ruled that they were irrelevant to what both Croatia and Hungary needed to prove: that the Sevso Treasure had been discovered within their respective borders.

6. Trial Transcript, 216-17; 1304-8.

7. Trial Transcript, 1313-18.

8. Trial Transcript, 139.

9. Trial Transcript, 276-77.

10. Scholars have disputed the meaning of the word "Pelso" as it appears on the Hunting Plate. One has suggested that the reference could apply to any of the images immediately surrounding it on the Hunting Plate: "the water, the boar, the attendant gutting the boar or the dog seated just behind the latter." Mango, "The Sevso Treasure Part One," 78. Moreover, identification of the word "Pelso" with Lake Balaton is "difficult because the body of water on the plate is a river or stream, rather than a lake." Ibid.

11. Trial Transcript, 1012-28.

12. As Mr. Sumegh told the Hungarian authorities in a sworn statement in 1990, "[f]rom the beginning of this year, I have frequently seen in papers and I have frequently seen on TV, newscasts about treasures from the Roman age that were unearthed in our area, so I started to think and realized there must be a close co-relation between such treasures and my son as he was enthusiastically engaged in collecting old coins and medals. Therefore, I have written to the Prosecution about my son's death, to review the findings at that time...." Trial Exhibit CE (Statement of Jozsef Sumegh to Hungarian authorities, dated September 11, 1990).

13. Trial Transcript, 808-36.

14. Trial Transcript, 1436. This testimony was given outside the presence of the jury.

15. Trial Transcript, 1431-32.

16. Trial Transcript, 1446-48.

17. Trial Transcript, 345-404.

18. Trial Transcript, 544-75.

19. Trial Transcript, 422-23, 458-59.

20. Trial Transcript, 476-87.

21. Trial Transcript, 521-22.

22. Trial Transcript, 576-690.

23. Trial Transcript, 1266-97.

24. Trial Transcript, 1332-38.

25. Croatia also called as witnesses at trial Milan Ramljak, the head of the Croatian Commission investigating the origin of the Treasure, and Vojko Orlic, a representative of the Pula Prosecutor's Office.

26. Trial Transcript, 273.

27. Trial Transcript, 1148-77.

28. Trial Transcript, 1222-37.

29. Trial Transcript, 1356-84.

30. Trial Transcript, 2019-22.

31. Trial Transcript, 1480-98.

32. Trial Transcript, 1518.

33. Trial Transcript, 1511-12.

34. Trial Transcript, 1560.

35. Trial Transcript, 1581-88.

36. Trial Transcript, 1388.

37. Trial Transcript, 883-1113.

38. Indeed, Dr. Nagy testified that at the time of his pre-trial deposition he had "no accurate information" about where the Sevso Treasure actually had been found. Trial Transcript, 1009-11.

39. Trial Transcript, 874-80.

40. Trial Transcript, 1751-61, 2132-37.

41. Trial Transcript, 1393-94.

42. See Landesman, "The Curse of the Sevso Treasure."

43. It has also been reported in the international press that Anton Cvek, Croatia's primary witness, has amended his story as well, now claiming that Lord Northampton personally flew the Treasure out of Croatia upon its discovery in the early 1960s, this at a time when Lord Northampton would have been a teenager. See Landesman, "The Curse of the Sevso Treasure."

44. Trial Transcript, 1582.

45. Trial Transcript, 1583.

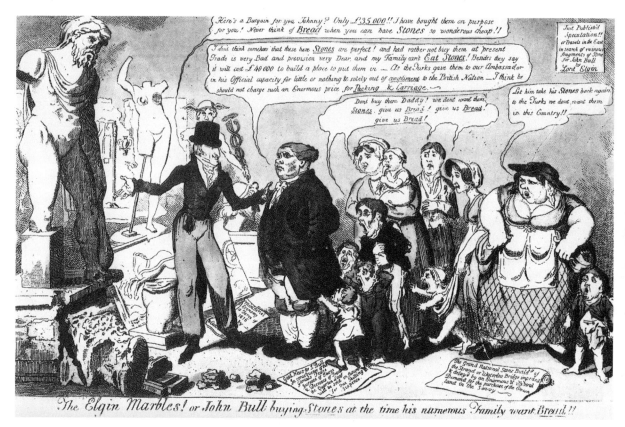

George Cruikshank, *The Elgin Marbles! or John Bull buying Stones
at the time his numerous Family want Bread!!*, 1816. Copyright ©
The Trustees of The British Museum.

THE ART MARKET IN THE UNITED KINGDOM AND RECENT DEVELOPMENTS IN BRITISH CULTURAL POLICY

ANTHONY BROWNE, PIERRE VALENTIN

IN THEIR APPROACH to new cultural legislation, British governments have long been mindful of the economic and cultural contribution made by the British art market. London ranks second only to New York in sales turnover in the competitive global market for art and antiques, and the United Kingdom accounts for more than half of the entire European art market. It is at the center of a global entrepot market that services both buyers and sellers throughout the world. In 2002 alone, art and antiques valued at £1,892 million were imported from outside the European Union, with £2,289 million exported.[1] The market provides employment for more than fifty thousand people directly and through the demand it creates for associated services.[2] The art and antiques business is larger than the British music industry, and foreign visitors attributing their visit to the art market accounted for expenditures of £2.8 billion.

The market's composition—consisting of many, often highly specialized small businesses, together with a few large auction houses and dealer companies—can make it difficult to communicate a coherent point of view to governments. To address this problem, the various elements of the art market combined in 1996 to form the British Art Market Federation (BAMF), a new body that could speak for the market as a whole. Since its inception, BAMF has involved itself in the many issues that affect the market, including taxation; heritage legislation; export licensing; concerns about the illicit market in cultural goods; money-laundering legislation; and European Union directives, most notably one that imposed artists' resale rights (*droit de suite*) throughout Europe. BAMF's aim has been to work closely with government ministers and officials to prevent any new legislative measures from causing unintended damage to the international competitiveness of Britain's highly successful art market.

A practical example of this was the role played by BAMF in the Illicit Trade Advisory Panel (ITAP), a body set up by the Minister for the Arts in May 2000. The panel's purpose was to "consider the nature and extent of the illicit international trade in art and antiques and the extent to

which the UK [was] involved" and "to consider how most effectively, both through legislative and non-legislative means, the UK [could] play its part in preventing and prohibiting the illicit trade, and to advise the government accordingly."[3] The panel, chaired by Professor Norman Palmer, was drawn from a wide range of interests, including archaeologists and museum directors as well as representatives of the art and antiquities market, among them a co-author of this chapter.

ITAP published its findings in a detailed report,[4] endorsed unanimously by the members of the panel. It contained numerous recommendations, many of which are discussed below. The recommendations were all approved by the British government and a number have since been implemented, notably Britain's accession to the UNESCO convention and the creation of a new criminal offense to address perceived gaps in existing legislation. These measures had the active support of BAMF, which was anxious to emphasize the clear distinction between the open and legitimate market, on the one hand, and activities that can bring the market as a whole into disrepute, on the other. In this context, ITAP also welcomed the "Principles of Conduct of the UK Art Market" adopted by BAMF, which brought together in one clear statement the key elements of existing codes of practice and company rules and which were included as an annex to the report.

The involvement of BAMF in the work of ITAP and other consultative and advisory bodies established by the British government in recent years has helped to ensure that the voice of the market has been heard whenever new cultural policy initiatives have been discussed. This dialogue has contributed to a greater recognition of the practical problems that the market faces and has fostered a consensual approach, resulting in targeted measures to deal with specific problems. The most significant example of this was the Dealing in Cultural Objects (Offences) Act 2003.

The Dealing in Cultural Objects (Offences) Act 2003

The ITAP report recommended that to the extent that this was not covered by existing legislation, "it [should] be a criminal offence to import, deal in or be in possession of any cultural object, knowing or believing that the object was stolen, or illegally excavated or removed from any monument or wreck contrary to local law" (Recommendation No. 2).[5]

This recommendation was presented in Parliament by Richard Allan, MP, as a private member's bill. It received the Royal Assent in October 2003, and it is known as the Dealing in Cultural Objects (Offences) Act 2003.

The purpose of the act is to "provide for an offence of acquiring, disposing of, importing or exporting tainted cultural objects, or agreeing or arranging to do so." In other words, it targets individuals who, in the United Kingdom, dishonestly handle "tainted" cultural property.

The act was designed to fill a gap in existing legislation. Handling stolen goods has been a criminal offense for many years (most recently, Section 22 of the Theft Act 1968). The offense of "handling" applies even when the property was stolen abroad. Handling includes storing a stolen object or participating as an agent in its sale. There have been successful prosecutions under the Theft Act for handling stolen works of art, such as the case of Jonathan Tokeley-Parry, which attracted considerable publicity. In 1998, the British Court of Appeal confirmed his conviction to six years' imprisonment for handling Egyptian antiquities, smuggled out of Egypt after they had been disguised to look like crude replicas, on the grounds that they had been stolen from the Egyptian state.

The new act makes it an offense to handle property unlawfully removed from a building or site, where theft cannot be proved and therefore the person handling the property cannot be prosecuted for handling stolen goods. For example, if a landowner excavates an object on his own land, assuming that title vests in him under local law, no offense of theft will have been committed. However, he may have committed another offense, for example by failing to report his find. Another example might be for the owner of a protected building to remove a statue or panel permanently attached to the building. Here again, the owner may not have stolen the item, but the removal of the object may have been illegal.

The principal elements of the new offense are:

a) It must involve a cultural object; cultural objects are defined broadly as objects of historical, architectural, or archaeological interest.

b) The alleged offender must have dealt with the object; dealing includes lending, borrowing, giving, accepting, exporting and importing, or agreeing with another or making arrangements to do such an act.

c) The alleged offender must have known or believed that the cultural object was tainted.

An object becomes tainted in three circumstances: (i) if it is excavated against local law; (ii) if at any time it formed part of a building or structure of historical, architectural, or archaeological interest and it is illegally removed from that building or structure; or (iii) if it is illegally removed from a monument.

Buildings and structures of historical, architectural, or archaeological interest may take different forms and could include structures as diverse as castles, churches, and village inns listed as being of architectural importance. In order to become tainted, the object must have once formed part of the structure. This means that the illegal detachment or amputation of structural, architectural, or ornamental elements of a building or structure will be tainted, but chairs, tables, and works of art hung on the walls will not become tainted if they are illegally removed, even though the building itself may be of historical, architectural, or archaeological interest. Illegal export does not, of itself, "taint" an object.

Monuments are defined as any work, cave, or excavation; any site comprising the remains of any vehicle, vessel, aircraft, or other movable structure, or part of any such thing. This wide definition includes prehistoric sites, cemeteries, battlefields, and ceremonial sites. Thus an object can become tainted if it is removed from a monument even where it is not, at the time of removal, attached to it.

d) The alleged offender must have dealt with the object dishonestly. This is a key element of the offense. The burden of proof falls on the prosecution. For example, if you take property on consignment on behalf of a third party and, when it later transpires that the property is tainted, you take immediate action (e.g., report it to the police), it is probable that you have not acted dishonestly. While you may have "dealt" in tainted cultural property within the meaning of the law, the lack of dishonest intent should mean that you will not be prosecuted.

The maximum sentence if convicted of the new offense is seven years in prison. The act is not retroactive. It applies

only to cultural property illicitly removed or excavated after December 30, 2003, the date of entry into force of the Act.

UK Accession to the 1970 UNESCO Convention

The ITAP report supported ratification of the 1970 UNESCO Convention on the Means of Prohibiting and Preventing the Illicit Import, Export and Transfer of Ownership of Cultural Property. It did not support ratification of the 1995 UNIDROIT Convention on Stolen or Illegally Exported Cultural Objects.

A key advantage of the UNESCO convention over the UNIDROIT convention is that the former allows reservations. Furthermore, the UNESCO convention permits contracting states a considerable degree of discretion as to how they implement it, in order to reflect local conditions and pre-existing obligations, notably under EU law.

The government followed ITAP's recommendation and acceded to the UNESCO convention on October 31, 2002. By ratifying the convention, the United Kingdom signaled its determination to support the British art market by "joining the international effort to stamp out illicit trade in cultural objects."[6]

Until then the United Kingdom had identified some obstacles in the way of accession to the UNESCO convention. These included its broad and rather vague definition of "cultural property" and the absence of defined periods of limitation. UK accession to the UNESCO convention was therefore qualified by the following reservations:

a) The UK will interpret the term "cultural property" in Article 1 of the convention as confined to the objects listed in the Annex to EU Regulation 3911/92 on the export of cultural goods[7] and EU Directive 93/7 on the return of cultural objects unlawfully removed from the territory of a Member State.[8] This Annex provides a detailed list of the categories of cultural objects to which the Regulation and Directive apply.

b) As between EU Member States, the UK will apply relevant EU law to the extent that legislation covers matters to which the convention applies.

c) The UK interprets Article 7(b)(ii) to the effect that it may continue to apply its existing rules on limitation to claims made under that Article for the recovery and return of cultural objects.

ITAP reviewed the interrelationship between English law and the requirements of the UNESCO convention and concluded that there was no need to introduce new legislation to implement the convention. There had been concerns in the past that certain provisions in the convention might have required new legislation to implement them. It was found that such concerns had been met, partly through legislative amendments in areas such as export licensing and partly because the earlier interpretation of the convention had been clarified, for example in relation to the supervision of archaeological excavations.

ITAP also recommended that UK accession to the UNESCO convention should not be restricted, or made conditional upon, any bilateral agreements between governments.

The British government endorsed ITAP's position on these two issues. This decision may be contrasted with the position recently adopted by the Swiss federal government, where a new national law has been passed to incorporate the UNESCO convention into Swiss law. The law will make the application of the convention subject to reciprocity under bilateral arrangements with other countries that are parties to the convention.

Database of Stolen and Illicitly Removed Art

ITAP recommended the creation of a "specialist national database of unlawfully removed cultural objects. The database would cover cultural objects unlawfully removed from any place in the world, whether in the UK or overseas" (Recommendation No. 6).[9]

The database is regarded as critical by both the British art market and British museums because without it, it is felt that collectors and the art trade lack the practical means to conduct effective due diligence over title of works of art. Indeed, one of the difficulties facing the art trade today is, on the one hand, the increasing pressure to investigate title to works of art before they are acquired and, on the other hand, the absence of a single publicly available, international source of information on stolen art.

Broadly, current databases on stolen art can be categorized as follows: commercial databases, e.g., the Art Loss Register; state-run databases, such as databases run by the police; publicly available databases; closed databases; international databases, e.g., the Holocaust Art Restitution Project and Interpol; and national databases.

Generally, commercial databases are run for profit, open to the public, and international, while police databases are closed and compiled on a national basis. The existence of many databases, some unavailable to the art trade, renders title inquiries a complex, unreliable, and time-consuming exercise.

The issue of a publicly available database has been raised in Parliament, where a member of the House of Lords stated that "it [was] unreasonable to place obligations on the legitimate art market without providing the information that it needs if it is to avoid inadvertently handling tainted objects." He expressed regret that "no progress so far appears to have been made towards achieving that objective."[10] The government was also criticized by the House of Commons Select Committee on Culture, Media and Sport, which deplored the lack of progress in developing the database.[11]

There are several reasons why an international database may take time to establish. The costs of creating and managing the database are said to be high; therefore, few governments will see it as a priority, and they are likely to look to the private sector to fund it. An agreement will be needed on uniform standards to describe and illustrate stolen works of art registered on the database. Agreement will also be needed on the language to be used, and if the database is to be used by national police forces, it is likely that more than one language will be needed.

Inevitably, there will be arguments over who will run the database, and how users will be charged for searching it. National police forces generally support confidential, police-run databases. They are reluctant to open their existing databases to the public and to participate in an open, international database. No doubt a compromise will be necessary between the requirements of openness to the trade and the concern of the police about public databases. Finally, creation of an international database is likely to give rise to concerns over national security and to a debate over the roles of national police forces and Interpol.

This does not mean, of course, that collectors and the art trade should not continue to put pressure on their governments to establish an open,

international database. A public–private partnership may be the solution. It is likely that the organization with responsibility for providing data to the users may have to be not-for-profit, if national police forces are to participate. The art trade will want to be involved in the design of the database to ensure that it is practical and user-friendly. Given the public policy aspects of such a database, it is difficult to envisage how a credible and comprehensive database can be established without involving national governments.

Interaction between UK Cultural Policy and European Union Law

The European Union has adopted a series of regulations affecting the art market. We have already mentioned two legal instruments, adopted in the early 1990s, that regulate the movement of cultural property within the European Union and between the EU and non-EU member states. Regulation 3911/92 on the export of cultural goods restricts the export of cultural goods to non-EU countries by introducing the need for an EU export license for antiques and works of art of a certain age and of a value exceeding defined monetary thresholds. Directive 93/7 on the return of cultural objects unlawfully removed from the territory of a member state provides that, subject to certain conditions, the object should be returned to that member state.

Other areas of EU involvement include VAT and intellectual property rights. In the name of "harmonization," the European Union imposed a uniform system of import VAT on cultural property that is imported into any EU country from outside the European Union. The artists' resale right (or *droit de suite*) has also been the subject of European Union harmonization. A directive on the resale right, agreed in 2001,[12] requires the seller of an original artwork under copyright to pay a percentage of the sale price to the artist or his or her heirs. The resale right is due to be introduced in the United Kingdom in 2006, although it will initially apply only to the works of living artists.

The program of harmonization can itself create unexpected difficulties. Both Directive 93/7/EEC on the return of cultural objects unlawfully removed from the territory of a member state and Regulation (EEC) No. 3911/92 on the export of cultural goods have in common an annex setting out categories of cultural objects covered, with each category

further defined by a value threshold below which the two measures would not apply. A provision was also included whereby the value thresholds would be updated periodically on "the basis of economic and monetary indicators." In any event, no such updating has taken place, thereby effectively extending the scope of the directive and regulation to cover cultural goods that would not have been affected when the measures were first agreed and introduced.

The existence of the EU export licensing system does not, however, prevent member states of the European Union from operating their own rules to protect their own cultural patrimony. The United Kingdom has long operated its own export licensing system, also based on value thresholds. Until 2002, the parallel EU and UK systems worked well, as the European Union and the United Kingdom applied broadly the same value thresholds to decide whether an antique or a work of art required an export license.

However, following the introduction of the euro, the European Union set the exchange rate from euros to pounds sterling as of December 31, 2001. Given the strength of the pound against the euro at that time, EU thresholds, when converted into pounds sterling, were considerably reduced. The threshold for paintings, for example, decreased from £119,000 to £91,200. Thresholds for other categories of art and antiques were also reduced, resulting in an increase in the number of export licenses needed.

Although the European Union appeared to be unwilling to reexamine the value thresholds originally set in 1992, the United Kingdom decided to increase its own export license thresholds, on the grounds that the original figures adopted in 1992 should be updated to take account of general increases in art prices since that date. The threshold for paintings, for example, rose from £119,000 to £180,000.

Quite apart from the fact that the European Union's failure to increase the financial thresholds to take account of inflation represents a *de facto* extension of the original regulation, it has also introduced new complications in the way of exporters from the United Kingdom. A painting worth £100,000, for example, does not now require a British export license to be moved from the United Kingdom to France or Germany. However, the same painting does require a European Union export license if it is to be moved from the United Kingdom to the United States. In the past, the painting would not have required any export

license, since its value would have fallen below both the EU and UK export license thresholds.

Conclusion

The last decade has seen a number of significant developments in British cultural policy. From a regulatory perspective, the United Kingdom must consider international conventions and European law when devising its own national laws and regulations. The United Kingdom may also take account of applicable laws in other countries (especially western Europe and the United States) when considering legislation on cultural issues. Separately, self-regulation through professional associations is encouraged. We have mentioned BAMF's "Principles of Conduct of the UK Art Market." Professional organizations representing the interests of art-market professionals such as art dealers or appraisers have their own codes of practice. As a result of careful consultation between the government and the art market, it has often been possible to reach general agreement about practical measures that do not cause unintentional and unnecessary damage to the open and legitimate market. Sadly, the same cannot always be said of European regulations. It is much more difficult to achieve a workable consensus when confronted with the different laws of the member states of the European Union. The relentless pursuit of harmonization of national laws has too often ended by embracing the lowest common denominator, without proper consideration being given to its consequence in a globally competitive art market.

NOTES

1. UK Overseas Trade Statistics, 2002, as analyzed by *Antiques Trade Gazette,* August 2003.

2. *The British Art Market,* 1997, study prepared by Market Tracking International. (See also *The European Art Market in 2002,* published by the European Fine Art Foundation.)

3. *Report of the Ministerial Advisory Panel on Illicit Trade of the Department for Culture, Media and Sport,* Executive Summary, December 2000, 1.

4. *Report of the Ministerial Advisory Panel,* December 2000.

5. Ibid., Executive Summary, 1.

6. Arts Minister Tessa Blackstone, press release, August 1, 2002, announcing that the British government had signed the UNESCO convention.

7. Council Regulation 3911/92/EEC, 1992 O.J. (L395) 1, on the export of cultural goods.

8. Council Directive 93/7/EEC, 1993 O.J. (L74) 74, on the return of cultural objects unlawfully removed from the territory of a Member State.

9. *Report of the Ministerial Advisory Panel,* Executive Summary, 2.

10. Lord Brooke of Sutton Mandeville, Parliamentary Debates, Lords, 5th ser., 230912-01 (2003), cols. 547-48.

11. House of Commons, "Cultural Objects: Developments since 2000," Sessional Papers, 2003-4, Culture, Media and Sport, vol. 5.

12. Directive 2001/84/EEC of the European Parliament and Council, 2001 O.J. (L272) 32, on the resale right for the benefit of the author of an original work of art.

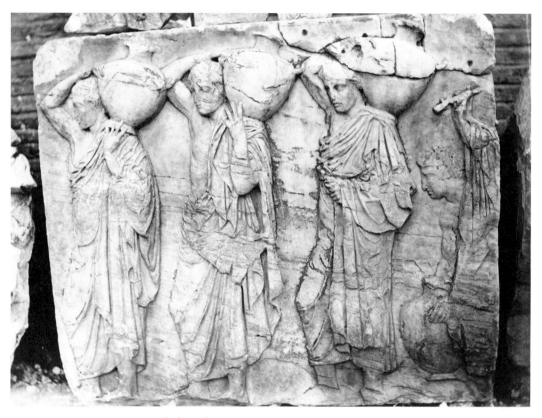

Fragment of a frieze from the Parthenon, c. 440 BCE, Athens, Greece.
Photo 1850-80, courtesy The Library of Congress, Prints and
Photographs Division, LC-USZ62-108948.

THE ELGIN MARBLES
A Summary

KATE FITZ GIBBON

But most the modern Pict's ignoble boast,

To rive what Goth, and Turk, and Time hath spared....

—LORD BYRON, *CHILDE HAROLD'S PILGRIMAGE*[1]

BETWEEN 1801 AND 1812, Thomas Bruce, seventh Earl of Elgin, removed approximately half of the remaining sculptures and decorative relief-carvings of the Parthenon, the most imposing temple structure on the Athenian Acropolis. The sculpted marbles were shipped to England, where they have been on exhibit in the British Museum for almost two hundred years.

The dispute over the Elgin Marbles is probably the most famous and longest-running debate over cultural property in the world. Public controversy over the marbles began in the early nineteenth century, when Elgin first offered the sculptures to the British nation. Even at the time, questions were raised about the legitimacy and morality of Elgin's actions. The controversy was also fueled by personal vendettas in the world of British arts, by the ongoing war with France, and by Britain's on-again, off-again alliance with Turkey.

Elgin had served as British ambassador to the government of the Ottomans in Constantinople from 1799 to 1803. He was a passionate enthusiast of the art of ancient Greece, and had sought the post of ambassador in order to indulge his antiquarian interests. Elgin hired an Italian artist, Giovanni Battista Lusieri, and a work crew; placed them under the direction of his chaplain and secretary, the Reverend Philip Hunt; and sent them to Athens while he took up his duties in Constantinople.

In ancient times, the Acropolis of Athens was the citadel as well as the religious center of the ancient town, a walled plateau enclosing several major sanctuaries and small temples, with altars and statues scattered throughout the complex. Pericles had ordered the building of the Parthenon at the highest point of the plateau under the direction of the great sculptor Phidias; it was completed in 438 BCE. The building's decoration was extraordinary: the upper platform was completely surrounded by

forty-six Doric columns; above them were two triangular pediments containing numerous sculptures in the round depicting the birth of Athena and her battle with Poseidon. The architrave included ninety-two metopes, on which scenes from mythological and historical battles were carved in high relief. Around the inner chamber, the final event of the Panathenaea festival was represented on a low-relief frieze: a procession of priests, citizens, warriors, women, and girls bringing sacrificial animals and a richly embroidered garment to adorn one of the statues of Athena on the Acropolis.

By 1800, when Elgin's men arrived, Greece had been ruled by the Ottomans for some four hundred years. Athens was a backwater of the empire, governed by a Voivode and a Disdar, the local representatives of Ottoman authority. What had once been the great city of Athens was a squalid settlement of huts and bazaars crowded onto the north and east slopes of the Acropolis. On the plateau, the Turkish garrison built houses and gardens, and laid out tented encampments and fortifications. William St. Clair states, "Everywhere it was obvious that for years the ruins had been a main source of building materials. Slabs of crisp-cut marble were built into rude modern walls, and here and there, pieces of sculpture could be seen among the fortifications."[2]

The Parthenon had remained in fairly good preservation through the Middle Ages, when it was converted into a church and then into a mosque. In 1687, however, the building was severely damaged by the explosion of a powder magazine stored in it by the Turks during a battle with the Venetians. The roof was destroyed, and architectural and sculptural remains were left strewn on the ground. Many of these were used as building materials to reconstruct the Acropolis's walls. Then followed centuries of attrition. Although the Turkish authorities did their best to protect some ancient structures, especially the Parthenon, Pentelic marble pieces from within the Acropolis were crushed and reduced to lime for construction by Turkish soldiers and local inhabitants. Tourists and other souvenir seekers removed fallen sculptural and architectural elements and chipped away at accessible bits of the frieze and metopes. The accelerated damage to the sculptures in the decades immediately prior to Elgin's arrival is shown in numerous drawings made by travelers.

Elgin's original intent was to take extensive measurements and make drawings and plaster casts from the Parthenon and other ancient ruins of the Acropolis complex. His plans, like those of most other contemporary

visitors to the site, included the collection of antiquities, but not the dismantling and removal of sculptures from existing monuments.

However, beginning when Elgin was residing in Constantinople, his workmen, under the direction of Rev. Hunt and Lusieri, were allowed by local authorities to dismantle a substantial proportion of the finest of the remaining decorative elements on the Parthenon. Over the course of eight years, they removed 274 feet of the frieze of marble blocks that surrounded the Parthenon's main inner chamber, fifteen of the ninety-two metopes from the outer colonnade, and seventeen figures in the round from the triangular pediments. Elgin's workmen further compromised the physical structure of the building by removing the large cornices above the frieze in order to sever the pins holding the marble slabs in place.

Elgin left the post of ambassador to the Porte in 1802. Although he had many political and military successes during his stay in Constantinople, his work as ambassador was jeopardized by reversals in British policy, and he himself suffered great personal frustration and distress. An illness one winter resulted in a terrible infection of his nose, which was almost completely eaten away within weeks, leaving a hideous, festering sore that refused to heal. At first, his young wife had been fascinated by their exotic surroundings, but she grew weary of the expense and tedium of diplomatic life and was dismayed, to say the least, at her husband's disfigurement.

Before heading back to England, Elgin traveled with his family to Athens to review the ongoing work on the Acropolis. From this point, his crew of workmen left, and Lusieri continued to work alone until 1808, concentrating on excavations to uncover buried sculptures and other antiquities.

En route to England through France, the Elgins were sequestered when war broke out again in 1803. Elgin had made an enemy of Napoleon by his role in driving the French from Egypt, and Napoleon was said to have been especially bitter that Britain, not France, had secured the marbles. During his house arrest and periodic imprisonment, Elgin was constantly fretting over his collection of antiquities. Several shipments had been sent to England, and over the next several years were installed by Elgin's mother in a temporary "museum," a shedlike building in the back of a house in Park Lane.

Elgin's wife was allowed to return to England in 1805 after the death of her infant son. She traveled in the company of a young and handsome

friend named Robert Fergusson. In Elgin's absence, she began an indiscreet affair with Fergusson that culminated in a humiliating divorce. When Elgin finally returned to England in 1806 he was deeply in debt, physically and psychologically damaged, and fixated upon the marbles as the one great achievement of his life.

In acquiring the marbles, Elgin claimed to have been motivated by a desire to raise the level of understanding and appreciation of Greek art, and to revitalize artistic endeavor in Britain. In this, at least, he succeeded. Roman art had been considered the artistic ideal. Many artists expressed astonishment at the beauty and naturalism of the marbles; the seventy-one-year-old Benjamin West said, "I have found in this collection of sculpture so much excellence in art, and a variety so magnificent and boundless, that every branch of science connected with the fine arts cannot fail to acquire something from this collection."[3] J. M. W. Turner wrote to Elgin "to pay my homage to your Lordship's exertions for this rescue from barbarism."[4] Among the less sophisticated examples of popular enthusiasm were a day-long display of a nude British sportsman posed next to the marbles and several boxing matches held in Elgin's Park Lane museum, both intended to "highlight the perfection of the human form."[5]

The presence of the marbles in Britain had far-reaching effects on the understanding of art history and the collection of antiquities. Previously, it had been commonplace to restore ancient sculpture by recarving broken areas. When the sculptor Canova was approached by Elgin to do this, he refused, and is reported to have said that it would be "sacrilege in him or any man to presume to touch them with a chisel."[6] In Britain and elsewhere in Europe, antiquities began to be viewed as timeless works of art rather than merely decorative objects.

Elgin had expected to enhance his political interests and his honor among his countrymen by securing the marbles for Britain at the expense of the French. Instead, Elgin's legal claim to the marbles was questioned almost immediately, and both his integrity and that of the marbles were attacked by some of the most eminent cultural figures of his day.[7] There was fierce debate in Parliament over the purchase of the marbles for the British Museum. Some argued for keeping them for their protection, others for holding them in trust; still others, a minority, wished to return them to the Ottoman government.

The most eloquent and effective arguments against the removal of the marbles were made in verse by Lord Byron. Byron had been at Athens and become friends with Lusieri, utilizing his services as a guide and even falling briefly in love with Lusieri's wife's young brother. Perhaps because of this acquaintance with Lusieri, Byron warned Elgin in 1812 that he would attack him in his new work, *Childe Harold's Pilgrimage*.[8] Elgin was not concerned, believing that public attention would further his cause with the government, but he vastly underestimated the poem's virulence and its effect. *Childe Harold* sold out several editions immediately and firmly established Byron's reputation as a serious writer. Public sympathy turned away from Elgin and toward the Romantic hero, who was to die during the last years of the Greek struggle for independence from the Turks. Byron's scathing if inaccurate attacks on Elgin have continued to resonate through the debate over the marbles.

In the end, the marbles were Elgin's social, financial, and political ruin. Parliament finally authorized the purchase of his collection and its placement in the British Museum in 1816, but Elgin recouped less than half of his expenses and died impoverished in France, where his name has become an epithet synonymous with the looting of art treasures, *elginisme*.

> This is our history, this is our soul.... You must understand us. You must love us. We have fought with you in the second war. Give them back and we will be proud of you. Give them back and they will be in good hands. —MELINA MERCOURI, 1983[9]

In 1982, Greek Minister of Culture Melina Mercouri made a dramatic call for the restoration of the marbles at an International Conference of Ministers of Culture. That year, for the first time, Greece made a formal request to Britain for their return. Minister Mercouri appealed to a public audience deeply suspicious of the taint of empire. Her plea for repatriation heightened public awareness of the issue of cultural patrimony, and grassroots organizations were formed to lobby for the marbles' return in both Britain and Greece.[10] In 1984, the British government refused the Greek request, stating that responsibility lay with the British Museum trustees. Since then, the trustees have stated several times that their duty to the public and interest in preserving the

sculptures precluded any consideration of return of the marbles, but that they were prepared to make long-term loans of other important works of Greek art to Greece.

When the Greek government announced plans to build a new museum to house the marbles along with the remaining sculptural elements from the Parthenon in time for the 2004 Olympic Games in Athens, the fate of the marbles became once again as public and controversial an issue as it had been in Lord Elgin's time. The case of the marbles not only embraced most of the conflicting moral, legal, national, and internationalist arguments over cultural property; it was also a matter of urgency. Lawsuits charging that building the museum would destroy additional archaeological sites[11] delayed construction and made it impossible to complete the project in a timely manner, but the Greek government has continued to request that the marbles be returned.

The Legal and Moral Arguments

There have been two basic approaches to the question of the proper place for the marbles. One has to do with the legality of the removal of the sculptures from the Parthenon by Lord Elgin. If the marbles were stolen, then neither Elgin nor the British Museum has title to them. Arguments have also been made for the future disposition of the marbles on ethical grounds, placing issues of cultural nationalism in opposition to internationalist positions.

Essentially, the legality of the removal is based on whether or not Elgin's actions were authorized by the Ottoman government. It is generally accepted that, rightly or wrongly, the granting of permission for the dismemberment of the Parthenon was within the rights of the Ottoman sovereign at the time.

During its first year, the Elgin expedition's work of drawing and making casts had been continually hindered by the local Ottoman officials in Athens; Lusieri's scaffolding was taken down, and he and his men were often refused permission to work on the site. At Hunt's request, Elgin obtained a *firman,* a document from the Ottoman government at Constantinople giving official authorization to allow Elgin's workers free access and to permit digging to expose the foundations of the buildings for study. In Athens, Hunt was able to utilize this document to obtain permission from the local authorities, the Disdar and Voivode, to remove

many large sculptural elements from the Parthenon itself. While most of the large sculptures were taken down by Elgin's team over the next two years, Lusieri continued to collect materials until 1808.

Hunt had also requested that a translation of the document be sent to him in order to be certain of its contents. When Parliament considered the purchase of the marbles, the terms of this *firman* were used to legitimate Elgin's removals. An English translation of this purported translation into Italian of the original *firman* was entered into the records of the parliamentary review committee.[12]

The crucial element of the document states, "[I]t is incumbent on us to provide that they meet no opposition in . . . [And here follows a long list of activities, from walking through to copying, drawing, molding, and measuring] and that no one meddle with their scaffolding or implements nor hinder them from taking away any pieces of stone with inscriptions and figures."

International legal scholar David Rudenstine[13] has questioned both the authenticity of the translated document and the existence of the original. The Italian "translation" has several omissions within the document and lacks a seal. He has been unable to locate any record of the original *firman* or of any related documents in the Ottoman archives. Rudenstine suggests that the parliamentary committee had an interest in obtaining the marbles for Britain and in clouding the legal issues. And he notes that many of the original records of the 1816 committee were lost in a fire.

However, the validity of the translated document supplied by Hunt is not as crucial as it might seem because, as legal scholar John Henry Merryman points out, Elgin did not limit his activities to drawing, measuring, casting, digging, and taking up fallen pieces. Rev. Hunt clearly exceeded the scope of any activity permitted in the document by actually dismantling sculptures from the Parthenon's walls. The translation presented by Hunt seems more rather than less likely to be authentic because Elgin clearly went beyond what it authorized. Elgin's legal position rests instead on the tacit acceptance of his actions by the local authorities during the eight years spent in physically removing the sculptures from the structure, and the fact that after a delay of some months during which permission was withheld, the Ottoman authorities in Constantinople authorized the shipping of the marbles to Britain.

According to Merryman, the legal norms, both at that time and today, allow a government to legitimate an action after the fact, and that

is what the Ottomans appear to have done. The accepted international law of the time allowed the Ottoman government to dispose of what was essentially state property. The higher authorities at the Porte seem to have been eager to offer favors to Elgin, whose position as ambassador allowed him tremendous influence after the defeat of the French in Egypt by British forces. The local Ottoman officials in Athens appear to have accepted bribes from Elgin and to have been afraid that they would be punished for allowing the work to continue, since Hunt requested that Elgin obtain additional letters of assurance to them from the Porte. Nonetheless, the Ottoman government was willing to overlook the local overstepping of authority, and the statues were eventually permitted to travel.

Time is also a factor in the legal argument. The Greeks gained their independence from Ottoman rule in 1828, and the first official diplomatic demand for the return of the marbles was made through Minister Mercouri in 1983. Greece has never sued in English court seeking the return of stolen property; if they did so now, the statute of limitations for such an action would definitely have run out.[14]

Passion, opportunity, and immediate circumstance determined Elgin's actions. The Ottoman position was based on political concerns having little to do with the actual removals. The case of the marbles seems to be an early example of a cultural property issue decided on the basis of temporary, political expedience.

The legal argument is of less moment today because the Greek government has declined to raise it in discussions with the British Museum. Rather than claiming ownership, the Greek government has asked that the marbles be returned on long-term loan.[15] The ethical argument now forms the core of the debate.

If, as it seems, the taking was legal, was it ethical? Is it morally correct for Britain to retain the marbles? Here the arguments have been identified by Merryman as falling into broadly *cultural nationalist* and *internationalist* categories.[16]

The essence of the *cultural nationalist* argument is that the sculptures are Greek and therefore belong in Greece, either restored to the Parthenon or in as close proximity to the Acropolis as possible. The marbles are an inalienable symbol of Greek identity, representing Greek history at a time of great cultural achievement. Their absence is a personal and

national loss to all Greek citizens. The fact that Greece still has enormous amounts of ancient art of exceptional quality may weaken the logical basis for this argument. Merryman asks if it is theoretically necessary that *all* Greek art be returned in order to make Greek identity whole. He also poses the question whether Greek identity suffers or is enhanced by the honored place given Greek art in many world museums.[17]

More political issues of Greek identity are raised in charges of unfair and unlawful deprivation of the Greek people of their national heritage. In this argument, British ownership of the marbles is a reminder of past political weakness and an affront to Greek pride. Greece has a legitimate interest in the preservation, study, and enjoyment of the marbles, and an interest in utilizing the marbles to enhance the country's prestige. It also has a right to exploit them commercially, as the British Museum now does, to increase tourism or in other ways. Without physical possession of the marbles, Greece has lost a part of its national wealth as well as its national identity.

Many organizations supporting the return of the marbles find the argument that Greek art belongs in Greece compelling. Organizations in Britain add another element to the mix, saying that the retention of the marbles by Britain demonstrates adherence to an imperialist ethos, a relic of an aggrandizing past that is no longer in keeping with *their* identity as Britons. Whether or not the marbles were legally removed, returning them would be an act of enlightened self-interest.

If the fate of the marbles is tied to nationalist political issues, it is equally tied to the place of Greek culture in the development of inter-connected civilizations that extended from the Mediterranean far into western Asia, and to a common European cultural heritage consciously founded on a Hellenic past. The *internationalist* argument is grounded on issues of preservation, education, and optimum use of this common cultural heritage.

One of the strongest arguments raised in the nineteenth century to justify Elgin's actions was that the wholesale removal and preservation of the marbles in a museum was the only way of preserving the Parthenon's sculptural elements, if not the building itself, intact. This argument is supported by evidence that the Parthenon and other structures on the Acropolis were being damaged by the depredations of visiting tourists, local antiquities dealers, and agents of other countries. Conversely, it

must be said that Elgin's workmen severely damaged the context for the sculptures, the Parthenon itself, even if removing the statues did preserve them.

It has also been argued that the marbles were sure to be removed by somebody—if not by the British, then by the French or the Bavarians. The French were very active in gathering art for their national collections at the time. In the last years of the eighteenth century, the French ambassador to the Porte had established his own agent at Athens, Fauvel, with instructions to "... enlever tout ce que vous pourrez."[18] Merryman points out, however, that this is a morally ambiguous argument; one person is not justified in a wrongful act just because another person will do it if he does not.[19]

The preservationist argument in favor of the removals has been challenged by pointing to an incident that took place between 1937 and 1938 in which the British Museum failed in its responsibilities to protect the marbles. The art dealer Lord Duveen, who was financing a new gallery for the British Museum, concealed his intention from curators and bribed museum staff to do an abrasive cleaning of the marbles in order to whiten them, thereby removing surface patina and traces of their original paint.[20]

The question of access or better use is weighted in turn by the arguments above. Is it more important for a smaller number of people, the majority of them Greeks, to have access to the marbles, as they would if they were stored in Athens, or for a larger number of people to see them in the British Museum? The marbles remain one of the most popular of all the British Museum's holdings, and are seen by almost all of the five million visitors a year who come to the museum from around the globe. Education, distribution, and access all seem to be favored by the retention of the marbles in the British Museum. In a recent paper, Merryman makes an important argument for the viewing of art within the humanist context of a world museum like the British Museum, in which the marbles are seen as part of the larger artistic endeavor of all humankind.[21]

The integrity argument has been rendered more difficult by structural and environmental concerns. The Greek government cannot at this time replace the marbles on the Parthenon. Not only did Elgin's workmen damage the building structurally in removing parts of the frieze and metopes, many of the remaining sculptures on the building have

been removed by the Greek government in order to protect them from Athens's Pentelic marble–consuming smog.[22] There may be an integrity argument for placing the British Museum marbles next to the remaining Athenian sculptures in a new Athenian museum. The question is whether the risks attendant on moving the Elgin Marbles, the risk associated with having all the Parthenon sculptures in a single location, and the reduction of access in terms of the number of people who will see them can be balanced against the advantages of placing all the marbles together in *another* museum with a view of the Parthenon.

119

Finally, Merryman points to the legal and ethical principle of repose. It seems clear that moving the marbles will not increase their protection, preservation, or access. At some level, it would place them at additional risk. Therefore, there is something to be said for simply leaving them where they are. This principle of repose is also tied to the potential consequences of a decision to return the marbles on the future of other objects that rest in museums and private collections outside of their country of origin. Because the issue of the marbles is the most famous of all cultural-property debates, it also has the highest symbolic value for those who argue for repatriation or retention of other artistic treasures in museums around the world.

This chapter draws on biographies of Elgin by William St. Clair and Theodore Vrettos, the work of legal scholars John Henry Merryman and David Rudenstine, publications of the Hellenic Ministry of Culture, and statements by the British Committee for the Restitution of the marbles. Particular thanks are due to John Merryman, who kindly allowed me early access to his essay "Whither the Elgin Marbles?," now in course of publication.

1. Lord Byron, *Childe Harold's Pilgrimage,* Canto II, 1812.

2. William St. Clair, *Lord Elgin and the Marbles: The Controversial History of the Parthenon Sculptures* (Oxford: Oxford University Press, 1983, republished 1998), 51.

3. Theodore Vrettos, *The Elgin Affair* (New York: Arcade Publishing, 1997), 163.

4. Ibid., 163.

5. Ibid., 137.

6. St. Clair, *Lord Elgin,* 152, citing *The Letters of Mary Nisbet, Countess of Elgin* (London: J. Murray, 1926).

7. Among his most formidable opponents was Richard Payne Knight, a leading member of the Society of Dilettanti.

8. Despite their apparent friendship, Lusieri was also harshly criticized by Byron. Vrettos, *The Elgin Affair,* 157. Byron appears to have made romantic conquests in the Mediterranean with the same avidity (and patronizing

smugness) with which Elgin collected antiquities. Ibid., 125–32.

9. John Henry Merryman, "Thinking About the Elgin Marbles," *Michigan Law Review* 83 (1985): 1883, quoting an article from the *San Francisco Chronicle,* May 26, 1983, 26, col. 1, reporting on a press conference by Minister Mercouri.

10. Active organizations include the British Committee for the Restitution of the Parthenon Marbles, www.parthenonuk.com; the Friends of the British Committee, www.uk .digiserve.com/mentor/marbles/ friends.htm; the US Committee on the Parthenon; The Canadian Committee for the Restitution of the Parthenon Marbles; and the International Organising Committee Australia for the Restitution of the Parthenon Marbles. Greek government efforts to recover the Marbles are described on the Web site of the Hellenic Ministry of Culture, www.culture.gr. The Melina Mercouri Foundation may also be accessed through the Hellenic Ministry of Culture Web site.

11. Both local residents of the Makriyianni district and the International Council on Monuments and Sites (ICOMOS) have requested annulment of the project. A lawsuit was filed by Petros Tatoulis (at the time, an opposition member of the Greek Parliament); in March 2004 Tatoulis became deputy culture minister, and the charges

are now being fought by his office. "Acropolis Museum OK," *Art Newspaper,* Issue 147, May 2004; "Greek Government Halts Construction of Acropolis Museum," *Art Newspaper,* Issue 146, April 2004.

12. St. Clair, *Lord Elgin,* 1983. St. Clair located a document in Italian expressed in the same terms among Lord Elgin's papers, and a facsimile was provided to Professor Merryman, who states that the English version accepted by Parliament appears to be an accurate translation of the Italian original.

13. Sources for this section include David Rudenstine, "A Tale of Three Documents: Lord Elgin and the Missing, Historic 1801 Ottoman Document," *Cardozo Law Review* 22 (July 2001): 1853; David Rudenstine, "Lord Elgin and the Ottoman: The Question of Permission," *Cardozo Law Review* 23 (January 2002): 449; and David Rudenstine, "Did Elgin Cheat at Marbles?" *The Nation,* May 29, 2000.

14. Merryman, "Elgin Marbles," 1901.

15. Hellenic Ministry of Culture, "The Official Greek Position on the Restitution of the Parthenon Marbles to Athens," www.culture.gr/6/68/682/e68202.html.

16. Merryman, "Elgin Marbles," 1911-20. Also see John Henry Merryman and Albert E. Elsen, *Law, Ethics, and the Visual Arts,* 4th ed. (The Hague and New York: Kluwer Law International, 2002).

17. Merryman, "Elgin Marbles," 1913.

18. St. Clair, *Lord Elgin.*

19. Merryman, "Elgin Marbles," 1905.

20. William St. Clair, "The Damage to the Marbles, 1937-1938," www.parthenonuk.com/articles/facts_elgin_damage.php, and St. Clair, *Lord Elgin.*

21. John Henry Merryman, "Whither the Elgin Marbles?" in course of publication.

22. "The Acropolis: Latest News," *Art Newspaper,* Issue 37, May 1994.

Late Roman bronze hoard, Licinius I-Constantine, 4th c.
Photo courtesy Classic Numismatic Group, Inc.

THE HAZARDS OF COMMON
LAW ADJUDICATION

JEREMY G. EPSTEIN

THE PRECEDING ESSAYS depict a crazy quilt of conflicting principles and decisions. There is nothing that approaches a coherent scheme for adjudicating the rights to a work of art whose title has been challenged. Although an admirable proposal has been made by Hawkins and Church (hereafter, "Hawkins et al."), there is no legislative or judicial authority likely to implement this scheme anytime soon. Similarly, there are pronounced inconsistencies in the ways courts have weighed the significance of foreign export controls, as Pearlstein points out. At the root of these inconsistencies is our process of common law adjudication, which is both the strength and the weakness of the US legal system.

Under the common law, doctrine is created not by legislative fiat but by the incremental accumulation of decisions. Common law adjudication is fact specific. It differs markedly from civil law adjudication, which relies on broad, overarching solutions created by statute and then applies those solutions to specific fact patterns. The common law has no preordained solutions; the solutions tend to vary and evolve with each new case. The application of this evolutionary process to art cases presents some unique problems.

The Benefits: Facts Matter

Because solutions often emerge from the facts rather than being imposed upon them, any common law system devotes enormous time and expense to development of those facts. Title disputes in art cases often involve facts that are decades old, and it is of critical importance that the facts be presented accurately. When witnesses have died, documents lost, and memories faded, that is no easy matter.

I draw two examples from my own experience to demonstrate how crucial facts can be, and how important a thorough investigation is to unearth those facts. Neither of the cases resulted in litigation, and I shall describe them without identifying details. In the first case, a historian untrained in art history held a press conference and announced that an

Old Master painting hanging in a major museum was the result of Nazi looting. What he said was true, but only half true. The picture had been looted, but after the end of the war it had been recovered by the Allies and returned to its original owner. That owner had subsequently sold it through a dealer to the museum. The matter was resolved without a skirmish. The museum's title claim thus turned on a single fact—the painting's return—which was forty years old at the time of the controversy. Had that fact not emerged, the museum's rights would have appeared quite different.

In another case, a collector had consigned an Impressionist painting to Auction House A for sale. Prior to the sale, the heirs of a European art dealer claimed that the painting had been stolen during World War II from their ancestor's collection and demanded its return. The sale was aborted. Upon inquiry, it was learned that the collector had purchased the painting at an auction held ten years earlier by Auction House B. The earlier auction took place in the 1980s, long after the war had ended and these same heirs were supposedly engaged in a search for their ancestor's lost property. However, at this earlier auction, the heirs never claimed the painting. Had they done so, the collector would never have bought it. The unexplained failure of the heirs to make any claim at the first auction gave the collector an excellent defense based on the doctrine of *laches,* which holds that a claimant's delay that prejudices an owner's rights may defeat the claim. Here, the fact of the prior auction reduced a very strong claim to something tenuous at best.

Both cases demonstrate that facts, especially old facts, are vital in ownership disputes, and painstaking efforts must be made to see that the facts are brought out. Common law adjudication, which gives the parties extensive opportunity for pretrial fact gathering, unquestionably helps the truth emerge.

The Detriments: Facts Can Matter Too Much

This system also has its flaws. First, the evolution of common law doctrine is most reliable when it is based on a substantial volume of cases. Patterns emerge and recur, and judges begin to understand how particular doctrines yield particular results. Art law litigation lacks the breadth of cases that can be found in, for example, personal injury litigation. The paucity of cases means that a single case involving unusually

sympathetic (or unsympathetic) facts can significantly skew the development of the law. Second, because advocates realize a case can turn on the significance of a single fact, there is a strong impulse to distortion. Third, common law mechanisms for resolving ownership disputes are regrettably crude; in a replevin action, only one winner emerges. Ownership disputes spanning sixty years or more do not lend themselves to such simplistic solutions.

The evolution of the law of replevin from *Menzel* to *Guggenheim,* and beyond, nicely illustrates all of these flaws. First, as Hawkins et al. describe, the law in New York has been largely shaped by only three decisions: *Menzel,*[1] *DeWeerth,*[2] and *Guggenheim.*[3] One later decision, the *Greek Orthodox Patriarchate of Jerusalem v. Christie's Inc.,*[4] modifies *Guggenheim* in important respects. In two of these cases (*Menzel* and *Guggenheim*), the claimant prevailed; in the other two (*DeWeerth* and *Patriarchate*), the claimant lost. The outcome of these cases demonstrates the extent to which legal doctrine has swerved from one extreme to another based on particularized facts.

In *Menzel,* the plaintiffs were a Jewish family whose Chagall painting had been confiscated by the Nazis from their apartment in Brussels. The New York courts, concluding that they had conducted a "continuous and diligent search" since the war's end, awarded them custody of the painting. The *Menzel* decision elongated New York's statute of limitations for replevin actions: it held that the statute did not begin to run until demand and refusal (see Hawkins et al.). In *DeWeerth,* the plaintiff was a non-Jewish German woman whose Monet painting had allegedly been stolen by American soldiers at the end of World War II. The Second Circuit, in denying recovery, found her postwar recovery efforts neither continuous nor diligent, and noted that her failure to consult a readily available Monet catalogue raisonné that would have led to discovery of the painting was "particularly inexcusable."

In *Patriarchate,* the plaintiff was a monastery in Constantinople owned by the Greek Orthodox Patriarchate of Jerusalem, an order of monks. It claimed ownership of a tenth-century manuscript allegedly stolen from the monastery in the 1920s. The trial court denied the claim, noting that nothing had been done to recover the painting for eighty years.

None of these cases was decided simply by the identity of the plaintiff; each decision involved a scrupulous examination of the facts.

Nevertheless, many believe that Holocaust claims are special and entitled to unusual deference. For example, in 2002 the California legislature passed a statute extending the statute of limitations for certain Holocaust-related claims (and only for such claims) until 2010. This action was a legislative effort to bend the law to accommodate the demands of a particular group; although some may question its wisdom, legislators have the power to do this. *Menzel* was a judicial effort to bend the law; a judge's mandate to act in this fashion is far less certain.

As in *Menzel,* common law courts respond to litigants with unusual claims on their sympathies. The problem with this responsiveness is that a particular decision based on particular facts becomes precedent, and thus available for application to situations where the facts are much less sympathetic. When the next court confronts a less sympathetic situation, it is likely to alter existing legal doctrine to fit those facts. This is the way the common law evolves, but where the sample is small, the results can be unsatisfactory.

Lawyers involved in this type of litigation know the way the world works.[5] Hence, when any of these cases arises, enormous effort is devoted to placing one's own client in the most sympathetic light. This inevitably leads to distortions for the reason suggested by the title of the Hawkins et al. chapter: ownership disputes between owners and claimants are almost inevitably between "two innocents." On one side is a theft victim, or the descendant of a theft victim; on the other, a good-faith purchaser, unaware of title problems that may have arisen decades ago.

The principal issue litigated in ownership disputes is timing. Since *Guggenheim,* the strongest defense available to an owner is often based on the doctrine of *laches;* that is, did the claimant delay unreasonably in asserting his claim, and did that delay prejudice the owner? The lawsuit thus evolves into a diligence contest: if a plaintiff is to overcome a *laches* defense, he must demonstrate that he and/or his ancestor undertook a continuous and diligent search for the work in question. The owner, in turn, must demonstrate that she too was diligent in her scrutiny of the work's provenance at the time of acquisition, and that she did not overlook any title flaws that a careful search would have uncovered. Each side strains in a race to find fault with the other when, in many cases, each party behaved appropriately given the expectations and level of knowledge available at the time. In a litigation between "two innocents," a court is often left to award the object to the party found slightly more innocent.

Many of the preceding problems flow from what is perhaps the central flaw in the common law mechanism of adjudicating ownership disputes: replevin. A replevin action, which is a suit to recover ownership of a chattel, is the classic zero-sum game. At the end of the litigation, one party emerges with the artwork, and the other party leaves with nothing. Although settlements can "split the baby," I have seen no judicial decision that apportions the value of a work between the claimants. The harshness of this result does push parties toward settlement, but there are always cases that cannot be settled.

There is no insuperable impediment to a more flexible judicial approach. Many cases would benefit from a court-ordered compromise. Suppose that a plaintiff demands the return of a work of art stolen from his family in the mid-twentieth century and supposedly lost for fifty years. The defendant owner demonstrates that, fifteen years prior to the commencement of the action, the work was publicly and notoriously displayed, either in a catalogue raisonné, a major exhibition, or a public auction. If a court concludes that a minimally diligent search would have located the work but the plaintiff failed to demonstrate such diligence, it could sustain a *laches* defense and deny recovery. There is another possible solution. What if the court were to award ownership of the painting to the plaintiff but require, as a condition of receipt, that the plaintiff pay the defendant the difference between the value of the painting fifteen years ago, when it should have been located (and the plaintiff should have sued), and the present value? Each side would then leave with something and, in the case of the defendant who has relinquished ownership, the something might be quite substantial, given appreciations in art prices. Cases are frequently settled according to formulas like this, but no court has ever mandated such an outcome, perhaps because none has been asked.

Solutions like this are worth considering because, in the absence of an overarching scheme of the sort suggested by Hawkins et al., we will be left with the same slow and steady case-by-case determination that has left the law in the state we find it today. This means that practitioners can look forward to further unpredictable, and often radical, doctrinal swings as the law continues to evolve.

NOTES

1. *Menzel v. List,* 22 A.D.2d 647, 253
N.Y.S.2d 43 (lst Dept. 1964) and *Menzel
V. List* 49 Misc.2d 300, 267 N.Y.S.2d 804
(Sup.Ct.N.Y. Co. 1966).

2. *DeWeerth v. Baldinger,* 836 F.2d 103
(2d Cir. 1987), *rev'd,* 658 F. Supp. 688
(S.D.N.Y. 1987), *cert. denied,* 486 US
1056 (1988).

3. *Solomon R. Guggenheim Foundation
v. Lubell,* 77 N.Y.2d 311, 569 N.E.2d 426
(1991), 567 N.Y.S.2d 623 (1991).

4. *Greek Orthodox Patriarchate of Jeru-
salem v. Christie's, Inc.,* 98 Civ. 7664
(KMW), 1999 WL 673347 (S.D.N.Y. 1999).

5. A good example of this in a slightly
different context is *US v. Schultz,* 333
F.3d 393 (2003), discussed at length by
Pearlstein. *Schultz* presented the very
difficult question of whether property
exported in violation of Egyptian cul-
tural patrimony laws could be deemed
stolen within the meaning of the
National Stolen Property Act, 18 USC.
§ 2315. The issue of Schultz's guilty
knowledge, however, was not even
remotely difficult. The government's
evidence, which the court of Appeals
was required to credit, demonstrated
convincingly that Schultz knew full
well that what he was doing was un-
lawful. He and a co-conspirator went
to great lengths to conceal that the
antiquities he sold had recently been
exported from Egypt. They deliberately
falsified the provenance by inventing a
fictitious English collection from which
the works were supposedly taken. The
government undoubtedly chose Schultz
for prosecution precisely because no
one would see him as the innocent vic-
tim of a technicality. The problem with
Schultz is that it may be used as a prec-
edent against those far less culpable
than Schultz.

EPSTEIN

PART II **COLLECTING AND THE TRADE**

Moffett Studio, *Panorama of Rome,* 1909. The Library of Congress,
Prints and Photographs Division, Copyright deposit; Moffett Studio;
1909; DLC/PP-1909:43873.

COLLECTING ANCIENT ART
A Historical Perspective

MARGARET ELLEN MAYO

COLLECTING ANCIENT ART has a long and distinguished tradition that began with the Greeks and Romans. Museums and indeed the world owe a great debt to those who have participated in this tradition, for until the advent of scientific archaeology in the nineteenth century, the discovery, recognition, and preservation of classical art were largely the responsibility of private collectors. The history of collecting ancient art is a vast and far-reaching subject touching on religion, politics, economics, and aesthetic sensibilities in the West for more than two thousand years. It is a mine of information for those who want to know how we have obtained our knowledge and opinions of the past, why we have collected art, how works of art have been interpreted at various periods, and how works of art have fared physically through the thousands of years since their creation.

Today, when virtually all categories of art made in any period are actively sought by many private collectors and museums, one might assume that art collecting has always been a natural accompaniment to artistic creation. This is not the case, nor do we today have the same expectations of art. Although from the beginning of their history the Greeks obviously valued beauty, there is no evidence of their collecting art for its own sake before the third century BCE. Architects, sculptors, and painters were commissioned to create lavish public buildings, but sumptuously decorated private homes were rare in the Greek world. Private luxuries existed, of course, but these were mainly functional items, such as fine dinnerware, decorated utensils, or tomb monuments, or they were treasures valued for their raw materials, such as jewelry, vessels of silver and gold, and coins. Greek artists of the fifth and fourth centuries were far from anonymous, but it was not until the third century BCE that the achievements of artists of the past were recorded by the world's first art historians, Duris of Samos and Xenocrates.

This essay was excerpted and updated from Dr. Mayo's introduction to *Wealth of the Ancient World*, Fort Worth: Kimbell Museum, 1983, revised edition, March 1990.

Xenocrates believed that the greatest art had been created in the fourth century and that in his time the quality of artistic creation was declining. Significantly, it was at this time that Attalus I of Pergamum, the world's first securely documented art collector, began to collect masterpieces by Greek artists of past eras.

Vying with the Ptolemies, who had established an enormous cultural complex at Alexandria, Attalus aimed to make Pergamum the most beautiful city in the world and a major cultural center. He endowed a library second only to the one in Alexandria and subsidized the scholars working in it; he commissioned lavish decoration on public buildings; and he adorned the city with his personal collection of masterpieces by Greek artists of the past. What made this patron of contemporary art collect antiques? It would seem likely that Attalus was familiar with Xenocrates' view of art history and that he agreed in admiring the art of past centuries. With the realization that this sort of art was no longer being produced may have come consciousness of its limited availability, spurring the desire of a collector to gather it before it disappeared.

The most avid collectors of Greek art were the Romans. Until the third century BCE, Rome had existed in relative isolation politically and culturally. Contact with Greek culture began with expansion into the wealthy Greek settlements in South Italy and Sicily. In 211 BCE the Roman general Marcellus defeated the Carthaginians at Syracuse and returned in triumph with dazzling treasures. In addition to the treasure and slaves, Marcellus brought all of the city's public statues and paintings. According to Plutarch, he was particularly proud of bringing back works of art because they enhanced his victory and beautified Rome. The public was delighted, and Marcellus claimed to have brought art appreciation to Rome.

The destruction of Corinth in 146 BCE changed the face of the Roman world by bringing massive amounts of the finest Greek art to Rome. Corinth was burned, and its entire population was sold into slavery. The best works of art were sent to Rome, the rest auctioned off. Pliny reports that the popularity of Greek paintings in Rome grew rapidly after the sack of Corinth because at this auction, the first extraordinarily high bid in history was placed on a painting—which was then withdrawn from the auction and sent as booty to Rome on the premise that it must be very good if someone was willing to pay so much for it.

By the first century BCE, Rome had a true art market complete with dealers, high prices, and eager clients. Roman collectors bought silverware, Corinthian bronzes, murrhine vases, antique furniture, engraved gems and cameos, paintings, and marble sculpture. Julius Caesar was an avid collector of gems, statues, and old paintings, and the emperor Augustus favored fine furniture and Corinthian vessels. The growth of the Roman building industry created a need for vast amounts of statuary as decoration. Villas in the country, palaces in the city, gardens, baths, and other public buildings—all required decoration, and rather than commission work from contemporary artists, many Romans preferred to purchase old Greek sculpture, preferably by well-known artists. Cicero's letters about acquiring statuary for his Tuscan villa show the great quantity needed for such an estate, and they demonstrate that collecting well, even in the first century BCE, was not always easy. Eventually the supply of appropriate pieces began to fall short of demand, and the copy industry was born. Some copies were faithful reproductions of popular original works; others were made larger, smaller, or in mirror reversal as the client required. Unlike today, copies, at least good copies, did not reflect poorly on the owner's taste or finances; for example, the emperor Hadrian, a well-bred connoisseur, made his villa near Tivoli a virtual museum of copies of famous Greek sculptures.

The Romans acquired their private collections in a number of ways. Cicero used dealers, such as the Greek Damasippus or his friend Atticus, who lived in Athens and acted as his agent in purchasing and shipping pieces to Italy. Art could also be acquired at auction. The most acquisitive Roman art collector used other methods, however. From 73 to 71 BCE, while proconsul of the wealthy province of Sicily, Gaius Verres systematically extorted and stole Greek art from temples, public buildings, and private collectors. He amassed great quantities of silver, bronze, statuary, and paintings; he even set up his own workshop where ornaments from plundered vessels could be reused on new vessels. When Cicero brought him to trial for his crimes, he fled Rome. When he refused to hand over his prized Corinthian bronzes on order of Mark Antony, he was killed.

In the Middle Ages much classical art was destroyed or disappeared, and there was little active collecting. During the Renaissance, first in Italy, then throughout Europe, nostalgia for the classical past combined with a new sense of the importance of man to produce a shift of emphasis

from the religious to the secular world and an outburst of creative activity in literature, painting, sculpture, and architecture. The humanists' intensified study of the classics contributed to the growth of important libraries; they sought and collected lost manuscripts of classical works to gain more reliable and direct knowledge of antiquity. In admiring ancient art for its beauty, style, and most especially its subject matter, the humanists stimulated the collecting of ancient art.

The main sources for classical art in the Renaissance were chance discoveries in Italy and the very active commerce conducted by the Italian maritime republics of Venice and Genoa with the eastern Mediterranean. Fourteenth-century evidence for collecting classical art is fragmentary, but it reveals a rapidly growing interest. Some collectors specialized in a few areas. Oliviero Forzetta, the earliest well-documented art collector of the period, included coins, medals, marble and bronze sculpture, and cameos in his collections, while the Italian scholar Petrarch, the first and greatest humanist, collected only coins and medals because of his interest in famous men of the classical past. In the Renaissance, as today, coins were often the base upon which collections of other types of ancient art were built. They satisfied the humanists' desire for direct sources of information about the past, and connoisseurs were attracted by their beauty and intrinsic value.

The most important centers for collecting ancient art during the Renaissance were Florence, which was dominated politically, economically, and culturally by the Medici family, and Rome, where the great papal collections were assembled. The Medici spent great amounts of money and energy in assembling spectacular collections of coins, cameos, engraved gems, and bronze and marble sculpture, but the collections did not survive the Renaissance intact, and today only a few pieces known to have belonged to the Medici remain in Florence.

Rome in the early Renaissance was a rather undistinguished city; it had suffered greatly from invasions and the plague during the Middle Ages, and even the popes had abandoned it for Avignon during the fourteenth century. When they returned and the economy became more vigorous, Rome began to share in the cultural life of the Renaissance.

One unexpected benefit of the intensive building activity in Rome in the late fifteenth and early sixteenth centuries was the discovery of great quantities of buried ancient art, especially large sculptures. As a

consequence, private collections in Rome grew rapidly. Pope Paul II, the first of many popes to collect ancient art, assembled a large collection of sculpture, coins, bronzes, gems, and cameos, but he seems to have considered the collections his private property, and since he did not leave any directions for their care after his death, his successor, Sixtus IV, sold them to Lorenzo de'Medici.

Pope Julius II, however, considered the future of his collections and founded the Vatican collections of ancient art. Under his leadership the papacy regained its power in Europe, and with his patronage the arts flourished in Rome. When he came to the Vatican, he brought his own collection of classical sculpture, including a marble statue of Apollo that had been found near Rome in the fifteenth century. To display this piece and others that he hoped to acquire, he incorporated the Belvedere Villa into the architectural complex of the Vatican and created a sculpture court, the Belvedere Court. For the next four hundred years the *Apollo Belvedere* was perhaps the most admired piece of sculpture in the world, inspiring Michelangelo, Goethe, Canova, and countless other lovers of art. In 1506 Julius II purchased another impressive ancient sculpture, the *Laocoön,* discovered that year in the palace of Nero on the Esquiline, and this came to be admired equally with the Apollo.

In the sixteenth and seventeenth centuries, the popularity of collecting ancient art spread through Europe, first among royalty, then among those who could afford royal prices, and much attention began to be paid to the decorative display of sculpture collections. About the middle of the sixteenth century, Duke Albert V of Bavaria built an impressive gallery, the Antiquarium, in Munich to house the large collection of classical sculpture that he had acquired through the notorious dealer Jacopo Strada, former court antiquary to the Hapsburg Holy Roman Emperors Ferdinand I and Maximilian II. In France, Francis I developed an intense interest in classical sculpture and acquired copies in bronze and marble as well as ancient pieces for Fontainebleau. Louis XIV collected ancient originals and modern copies for display at Versailles. In Antwerp Peter Paul Rubens, the great Flemish painter, assembled a collection of over 18,000 ancient coins and more than ninety pieces of classical sculpture that he displayed in a specially constructed gallery-wing of his house.

In England three major collectors of ancient art stand out in the first half of the seventeenth century. Thomas Howard, second Earl of Arundel,

formed a large and important collection of sculpture, much of which is now in the Ashmolean Museum at Oxford and in the British Museum, and he built the first English gallery at his home, Arundel House. George Villiers, Duke of Buckingham, was greatly impressed by Arundel's collection and near the end of his life also began to collect. Charles I collected actively from early adolescence until about 1640.

As British commercial power grew during the eighteenth century, British collectors rapidly became more numerous and more active, with the result that by the end of the century they could be considered second only to the Italians as collectors of ancient art. The excavations of Herculaneum, which began in earnest in 1738, and of Pompeii about ten years later produced a virtual mania among the English for classical art. All who could afford to do so traveled to Rome, where professional antiquarians could be hired as guides. The Italian guides were soon displaced by English artists and architects who needed another form of support while living in Rome. Inevitably, with easy access to excavations and Italian collections, the antiquarians became dealers. Gavin Hamilton, an English artist-dealer, James Byres, a Scot dealer-architect (who showed Gibbon Rome), and Thomas Jenkins, a dealer who was the richest and most influential Englishman in Rome in the second half of the eighteenth century, were instrumental in forming many of the greatest collections of ancient sculpture in England.

The classical art collections formed by Englishmen in the eighteenth and early nineteenth centuries were often installed in special galleries in grand London houses or country estates such as Wilton House, Oldham Hall, and Lansdowne House, where they became prestigious emblems of the wealth, power, and taste of their owners. Ancient art was also included in many of the miscellaneous collections of "natural and artificial curiosities" that were popular in England in the seventeenth and eighteenth centuries. The Ashmolean Museum at Oxford began in the late seventeenth century as a "closet of rarities" purchased by Elias Ashmole from two eminent botanists. Ashmole added his own antiquities, coins, medals, paintings, books, and manuscripts, and in the nineteenth century the museum acquired its major collections of ancient art. The British Museum, founded in 1753, was based on the large, miscellaneous collection left to the nation by Dr. Hans Sloane. Its first classical art of importance came in 1772 when Sir William Hamilton sold his

Greek vases to the museum, and ancient sculptures were acquired from the collection of Richard Townley in 1805.

The Townley marbles came to the British Museum at an important juncture in the appreciation and collecting of classical sculpture. Since the fall of Constantinople in 1453, the eastern Mediterranean had been closed to European and British trade. Mining for classical sculpture was limited mainly to Roman imperial sites in Italy, so most pieces available to collectors were Greco-Roman copies. The taste and admiration for Greco-Roman art was so strong that when Greek originals were found, they were sometimes "doctored" by restorers to make them look more like the familiar copies. During the eighteenth century, the scholars Johann Richardson (father and son) and J. J. Winckelmann began to suspect that most known sculptures were Roman copies of Greek originals and that the Greek products were superior, but it was not until the nineteenth century that quantities of Greek art became available. When Lord Elgin brought the Parthenon sculptures to London early in the nineteenth century, the style of these fifth-century Greek works was so unfamiliar that Parliament agreed to purchase them for the British Museum only after much debate, and then for a great deal less than Elgin had spent on them. They were seen as the antithesis of the recently acquired Greco-Roman Townley marbles, and for a time even their authenticity was called into question by those who found it difficult to synthesize the new understanding of Greek art with earlier assumptions about classical art.

The nineteenth century saw the rise of great public museums as major collectors of classical art. The British Museum's collection was already established when Napoleon invaded Italy in 1796 and began to send cartloads of paintings and classical sculptures back to the National Museum (later named the Musée Napoleon) in the Louvre in Paris. The Musée Napoleon was dissolved in 1815 after Napoleon's defeat; many of the pieces were sent back to Italy, while others stayed in Paris or were sold to collectors. One of the lasting effects of the short-lived Musée Napoleon was to raise the consciousness of other nations about the importance of major public collections.

Prince Ludwig of Bavaria, who purchased a number of the Italian pieces left in France at the end of the Napoleonic era as well as Greek sculpture from the Temple on Aegina, directed the construction of the

Glyptothek in Munich. An enormous museum was begun in Berlin early in the century, and both the Vatican and the British Museum undertook new construction to house their rapidly growing collections. In 1870, the United States took up the tradition of public collecting with the founding of the Metropolitan Museum of Art in New York and the Museum of Fine Arts in Boston.

Early in the nineteenth century classical art had begun to interest Americans, and sets of casts, especially of pieces that had traveled from Italy to the Musée Napoleon, were brought to Boston, New York, and Philadelphia. Even earlier, one illustrious American had dreamed of assembling a private collection of classical sculpture. In about 1771, as Thomas Jefferson was completing plans for Monticello, his mountain-top villa in Virginia, he recorded in his building notebook an ambitious wish list of thirteen famous classical sculptures and seven well-known paintings to be installed in a gallery there. As the nineteenth century progressed, Greek vases, coins, and sculpture traveled to the United States in increasing quantities. Many of these pieces were undoubtedly kept privately, but regarding the first half of the century we know most about those that were installed in public places. In 1805 President Jefferson donated 150 Roman coins to the American Philosophical Society in Philadelphia, and at various times tombstones, votive stelae, portraits, and sarcophagi were given to institutions in Boston, Brooklyn, Philadelphia, and Washington.

The great period of American collecting did not begin until the last decade of the nineteenth century. In this period it was not unusual for wealthy collectors to acquire classical art primarily as decoration for their grand homes. Isabella Stewart Gardner bought a few Greco-Roman sculptures for Fenway Court, her palazzo in Boston, and James Deering bought for his Villa Vizcaya near Miami.

For others, collecting was a more serious passion. William Randolph Hearst amassed great quantities of Greek vases and Greco-Roman sculpture from 1901 until his death in 1951. The collection was intended for his pleasure at his California estate, La Cuesta Encantada, but it grew so large that at Hearst's death many pieces still lay unpacked in warehouses. The Hearst sculptures were donated to the Los Angeles County Museum of Art, and the vases have entered various private and public collections. Henry Walters, a railroad baron from Baltimore, formed another important collection of classical art in the first half of the twentieth century.

Reportedly spending about a million dollars a year from 1899 until his death in 1931, Walters assembled an outstanding classical collection with major purchases in virtually every category of ancient art. He installed the collection in the Walters Art Gallery, built by his father in Baltimore and now a public museum.

From its very beginning, classical art collecting in America has been characterized by an atmosphere of cooperation between collectors and museums. Virtually every public collection in the United States has been founded or enriched by private collectors, the grandest gesture being the creation of the J. Paul Getty Museum in 1953. Since the 1950s, private collectors in America have been especially generous in making their property available to the public by lending to special exhibitions organized by museums.

This essay deals with simple facts; serious questions about the history of collecting remain. These questions are as important today as they were in Cicero's day. How do we differentiate between collectors and the rich seeking prestigious interior decoration? What qualifies an individual or an institution to be considered a collector? Is it taste, the number of objects, the quality of the art? Is a group of objects worthy of our attention because a collector is wealthy and might give their art to a public museum? My personal prejudice is to turn a deaf ear to anyone who views a work of art simply as a store of value against the future. The most important questions about collecting ancient art today revolve around the ethics, moralities, and legalities of ownership. I leave those to be addressed by others.

Bonfils, *Nubia, Temple de Dandour,* 1871-86. The Library of Congress,
Prints and Photographs Division, DIG ppmsca 04092.

MUSEUMS, ANTIQUITIES, CULTURAL PROPERTY, AND THE US LEGAL FRAMEWORK FOR MAKING ACQUISITIONS

JAMES CUNO

LIKE LAND TRUSTS or centers for the preservation of endangered species, museums are entrusted with the responsibility of preserving things—in this case, objects of human cultural and artistic manufacture—for all of time. And as with land trusts and centers for the preservation of endangered species, the museum's responsibility is a moral one. To preserve the cultural and artistic diversity of humankind is good, and to reduce it by the elimination of a species of cultural and artistic manufacture through negligence or choice is bad. In the United States, the museum is given such responsibility as a matter of trust.

The origins of such trust lay with the founding of the British Museum. On his death in 1753, the physician and collector Sir Hans Sloane offered to the British nation his collection of natural and artificial objects.[1] Like his French contemporaries, the *encyclopédistes* Denis Diderot and Jean le Rond d'Alembert, Sloane believed that access to the full diversity of human industry and natural creation would promote the polymathic ideal of discovering and understanding the whole of human knowledge, and thus improve and advance the condition of our species and the world we inhabit. Drawing on the English common-law device of the trust, Sloane's collection and the responsibility for its preservation and advancement were given by Parliament to trustees. These held the collection in trust, "not only for the Inspection and Entertainment of the learned and the curious, but for the general use and benefit of the Public," on the principle that "free Access to the said general Repository, and to the Collections therein contained, shall be given to all studious and curious persons."[2]

Collections at public museums in the United States are similarly held in trust. Museum trustees and members of professional staff are obliged to preserve and advance their collections for the benefit of the public. They are expected to disseminate learning and improve taste by encouraging refined and discriminating judgments between what is true and what is false. A prerequisite for this is access to objects representative of the world's diverse cultures. The principle that underlay

the formation of the British Museum—that its collections are a force for understanding, tolerance, and the dissipation of ignorance, superstition, and prejudice[3]—underlies the purpose of US museums. Any policy that inhibits the collecting—and through collecting the *preserving*—of antique works of art and cultural objects puts at risk the potential for good that collecting represents, and calls into question whether such policies are the result of judicious, scholarly caution or of political expediency.

Since UNESCO adopted the Convention on the Means of Prohibiting and Preventing the Illicit Import, Export and Transfer of Ownership of Cultural Property in 1970, the legality and morality of US museums' collecting of antiquities has been hotly debated. Too often, archaeological artifacts (antiquities, henceforth) have been confused with cultural property; the latter by definition is not limited to artifacts of antique origin, and may include even ceremonies, songs, language, and other forms of cultural expression. By including antiquities within the political construction "cultural property," nationalist retentionist cultural policies often claim all antiquities found beneath or on the soil of the lands within their borders as cultural property and of importance to their national identity and their citizens' collective and individual identities. This is the case, for example, for Iraqis, who are said to derive their identity in part from ancient objects found in the ground within their national borders, whether they be of Assyrian or Arab origin; for Afghans, whether the ancient works are of Buddhist, Islamic, or Hindu origin; for Italians, whether they are of Greek, Roman, or Etruscan origin; and for Greeks, whether they were made under Athenian or Ottoman rule.

Such nationalist interpretations of antiquities as cultural property, and such retentionist policies that restrict the international trade in antiquities, are counter to the principles on which museums in Britain and the United States were founded and are still held accountable. The legislation passed by the US Congress in 1983 implementing the UNESCO convention sought to preserve the right of US museums to acquire antiquities under certain circumstances and for the benefit of US citizens. Recent actions by the US Department of State and US courts have further restricted the circumstances within which US museums can acquire antiquities. These actions have been taken to enforce foreign nations' retentionist cultural policies at the expense of the Enlightenment principles on which public museums in the United States were established.

This essay seeks to analyze US law and policy on these matters from the point of view of US museums. In this respect, I should be clear. I am convinced of the values of the Enlightenment museum, just as I am convinced of the humanist values of such recent scholars as Edward Said. In his preface to the 2003 edition of his groundbreaking work *Orientalism*, Said wrote of "those of us who by force of circumstance actually live the pluri-cultural life as it entails Islam and the West"—but the same is true for those of us who live the pluri-cultural life as it entails any combination of cultures—"I think it is incumbent upon us to complicate and/or dismantle the reductive formulae and the abstract but potent kind of thought that leads the mind away from concrete human history and experience and into the realms of ideological fiction, metaphysical confrontation and collective passion. . . . Our role is to widen the field of discussion, not set limits in accord with the prevailing authority."[4] Museums have an important role to play in this regard. Those that include works of art from multiple time periods and cultures have the opportunity and obligation to present their visitors with experiences that encourage looking for connections between apparently disparate works and cultures rather than reaffirming distinctions that are often, as Said notes, the result of ideological fictions.

As Patrick Geary wrote in *The Myth of Nations: The Medieval Origins of Europe,* which explores the role the academic discipline of history has played in defining nations and substantiating their nationalist claims:

> Modern history was born in the nineteenth century, conceived and developed as an instrument of European nationalism. As a tool of nationalist ideology, the history of Europe's nations was a great success, but it has turned our understanding of the past into a toxic waste dump, filled with the poison of ethnic nationalism, and the poison has seeped deep into popular consciousness. Clearing up this waste is the most daunting challenge facing historians today.[5]

And facing museums, too, I would propose. At their best, museums do not affirm but complicate and challenge the easy and dangerous reliance on such simplistic definitions. They expand rather than narrow our view of the world and the history of its—and our *common*—artistic patrimony. And as Neil MacGregor, director of the British Museum, wrote recently, "All great works of art are surely the common inheritance of humanity. . . . This is a truth that it is surely more important

to proclaim now than ever before. In a world increasingly fractured by ethnic and religious identities, it is essential that there are places where the great creations of all civilizations can be seen together, and where the visitor can focus on what unites rather than what divides us."[6] As Said has said, "Rather than the manufactured clash of civilizations, we need to concentrate on the slow working together of cultures that overlap, borrow from each other, and live together in far more interesting ways than any abridged or inauthentic mode of understanding can allow. But for that kind of wider perception we need time and patient and sceptical inquiry, supported by faith in communities of interpretation that are difficult to sustain in a world demanding instant action and reaction."[7]

Museums are, or should be, instruments for encouraging our skeptical inquiry into the simplistic notions of cultural identities. National policies and laws should respect this all-important contribution of the world's museums by encouraging a licit trade in antiquities and cultural property. Increasingly, in my view, such policies and laws are doing just the opposite.

The core of the text that follows was written as a lecture delivered at the University of Connecticut Law School and later published in its *Journal of International Law* in the spring of 2001. Since then, the 9/11 terrorist attacks on the United States and the resulting war on Iraq, and specific legal cases against individuals accused of trafficking in stolen property as defined by foreign countries' national patrimony, have, in different ways, changed the way and reasons why US museums acquire antiquities. This essay takes these new circumstances into account.[8]

The US government takes an internationalist position with regard to culture.[9] It presumes that exposing our citizens to works of art from the world's many cultures is in their best interest and promotes cultural understanding. For similar reasons, the United States has made few laws restricting the export of our cultural property, limiting such laws to the protection of historically, architecturally, or archaeologically significant objects on land that is owned, controlled, or acquired by the federal government. Even the Native American Graves Protection and Repatriation Act "vests title to cultural objects discovered on tribal lands in

the individual descendent or tribe on whose tribal land the object was discovered, not in the US government. Native American cultural objects found on federal land become the property not of the government but of the tribe which has the 'closest affiliation' with the object."[10]

In short, our government believes that citizens of other countries benefit from exposure to American works of art just as we benefit from exposure to works of art from other cultures.

Efforts to restrict the international trade in cultural property have been the subject of much debate over the past thirty years. In 1970, UNESCO adopted a Convention on the Means of Prohibiting and Preventing the Illicit Import, Export and Transfer of Ownership of Cultural Property.[11] Only in 1983 did the US Congress pass legislation, the Convention on Cultural Property Implementation Act, committing the country to its principles. In debating the terms of our enacting the UNESCO convention, Congress wanted to make sure that US interests in the international exchange of cultural property were maintained and that any restrictions on such trade were the result of multilateral and not unilateral action.[12]

The 1983 legislation provides for a federal government review of requests from countries for US import restrictions on cultural property by the president's Cultural Property Advisory Committee (CPAC), which makes recommendations to the president. The CPAC is meant to be representative of US interests, from archaeologists to museums, collectors, art dealers, and other interested citizens.[13]

The CPAC bases its recommendations on four determinations: first, that the cultural patrimony of the requesting country is in jeopardy from pillage of archaeological or ethnological materials; second, that the requesting country has taken measures for the protection of its cultural patrimony; third, that import controls by the United States with respect to designated objects or classes of objects would be of substantial benefit in deterring such pillage; and fourth, that the establishment of such import controls is consistent with the general interest of the international community in the interchange of cultural property among nations for scientific, cultural, and educational purposes.

These are very serious considerations. They are intended to allow for the international exchange of cultural property within very specific situations: when a requesting country's cultural patrimony is not in jeopardy from pillage and when import restrictions are in keeping with the interests of the international exchange of cultural property.

When acquiring antiquities, US museums respect these principles. US museums acknowledge other countries' interests in their cultural property and abhor the loss to knowledge that results from the pillaging of archaeological sites. Equally, and in keeping with the 1983 legislation, US museums are opposed to the illicit trade in cultural property.

US museums practice "due diligence" when acquiring antiquities. This means, as set forth in Article 4 of the 1995 UNIDROIT Convention on Stolen or Illegally Exported Cultural Objects (of which the United States is not yet a signatory), that museums consider "the circumstances of the acquisition, including the character of the parties, the prices paid, whether the possessor consulted any reasonable accessible register of stolen cultural objects, and any relevant information and documentation which it could reasonably have obtained, and whether the possessor consulted accessible agencies or took any step that any reasonable person would have taken in the circumstances."[14]

Certain parties believe that museums should go further and not acquire antiquities without clear evidence of their archaeological circumstances (their *provenance*) and positive proof of their having been legally exported from their country of origin. Unfortunately, there are times when such documentation and evidence are not known, or even knowable, at the time of acquisition. What should an art museum do then?

US law permits museums to acquire antiquities unaccompanied by such evidence. Professional practice allows the same after due diligence has been performed. Once acquired, museums are then obliged to preserve, exhibit, and further study the works of art in question. Such further study may uncover evidence that a work of art was taken illegally from an archaeological site or important monument and/or was illegally exported and that it belongs to another party, perhaps in its country of origin. This may result in the return of that work of art to its country of origin, something more likely to occur when a work of art is held openly in a museum's collection than when it is held in a private collection.

Increasingly, countries are seeking bilateral agreements with the United States that forbid the import of cultural property unless accompanied by a valid export license. Universal prohibition of import without a valid export license (or "embargo") was proposed in the original draft of the UNESCO convention but was defeated.[15] In the words of Paul

Bator, then professor and associate dean of the Harvard Law School and a principal author of the US legislation, "Prohibiting imports in this manner . . . says to other countries, we will enforce your export laws *whatever* their content, without any judgment of our own whether these export rules are consistent with our substantive interests or those of the international community generally."[16]

This could mean, however, that one could legally import into the United States cultural property that may have been illegally exported from its country of origin. To this Bator replied that the fundamental general rule is clear: The fact that an art object has been illegally exported does not in itself bar it from lawful importation into the United States; illegal export does not itself render the importer (or one who took from him) in any way actionable in a US court; the possession of an art object cannot be lawfully disturbed in the United States solely because it was illegally exported from another country.[17]

Still, it is against the law to import or subsequently come into the possession of stolen art. How then should we regard foreign laws that claim all antiquities to be state property and the illicit exportation of such to be theft? The original conviction in the 1977 case of *US v. McClain*[18] found that the defendants had conspired "to transport and receive through interstate commerce certain Pre-Columbian artifacts . . . knowing these artifacts to have been stolen" based on a 1897 patrimony law. On appeal, the court ruled that "it was not until 1972 that Mexico unambiguously declared by statute that it was the owner of *all* pre-Columbian artifacts."[19] On a second appeal in 1979, the court ruled "that pre-1972 Mexican law was so ambiguous and unclear that 'our basic standards of due process and notice preclude us from characterizing the artifacts as stolen' if they were in fact exported before 1972.'"[20] Thus the convictions on the substantive offense were reversed, but those on the conspiracy count were affirmed.[21]

McClain came down as the US Congress was debating the legislation that would ultimately allow the country to sign the UNESCO convention. Of grave concern to Congress was the nature of US action (whether it should be unilateral or multilateral) and the convention's definition of stolen property. The report of the Senate Finance Committee underscored this point: "The concept of the US import controls should be part of a concerted international effort . . . a particularly nettlesome issue was how to formulate standards establishing that US controls would

not be administered unilaterally."[22] Congress concluded by granting "a limited exception to the requirement of concerted international effort[23] ... only in very specialized circumstances,"[24] and as recommended by the president's Cultural Property Advisory Committee.

The UNESCO convention also limited the definition of "stolen property" to "cultural property stolen from a museum or a religious or secular public monument or similar institution in another State Property to this convention after the entry into force of this convention for the States concerned, provided that such property is documented as appertaining to the inventory of that institution" (Art. 7b).[25]

The two points—multilateral action and a limited definition of stolen property—would seem to argue against the court's decision in the *McClain* case. As a part of the compromise that led to the adoption of the legislation implementing the UNESCO convention, it was agreed that the *McClain* doctrine would be modified legislatively to bring it into accord with the enabling legislation. Senators Dole, Matsunaga, and Moynihan introduced a bill to overturn *McClain* in the ninety-seventh Congress, and Moynihan and Dole did so again in the ninety-eighth Congress. Both times the bill was opposed by officials of the State Department and US Customs and was defeated.

While Congress was debating the terms of the UNESCO convention, US Customs was extending its authority over the importation of ancient and ethnographic art by construing the *McClain* case as an instrument of Customs' enforcement. On June 8, 1981, it issued an "Information Notice" that declared that "all types of pre-Columbian art or Ethnographic Antiques, may be the subject of violations of the National Stolen Property Act." And on October 5, 1982, it issued a supplement to its *Policies and Procedures Manual* entitled *Seizure and Detention of Pre-Columbian Artifacts,* which "appears to direct that *all* pre-Columbian materials be detained by Customs until it determines whether the country of origin wishes to assert a claim of ownership."[26] By these actions, US Customs preempted congressional action on the UNESCO convention and appeared to run counter to congressional intentions as expressed in the enabling legislation. These actions also raised the question as to which branch of government was establishing national policy with regard to regulating the import of cultural property.

The differences between congressional intent and US Customs policy continue, just as more and more foreign governments are asking

the United States to undertake unilateral actions against the import of cultural properties.

How does this affect a museum that wishes to acquire an object and does due diligence, but cannot determine whether it can retain clear title of that object? At that point, a museum has to weigh the extent of the risks involved. Acquisition of that object by purchase may result in its repatriation and the loss of all or some of the money invested in acquiring it. This does not in itself worry me, for it is part of the cost of doing business as a museum. It is not materially different from purchasing an object that purports to be a rare and important work of art but that turns out, after subsequent study, to be a less important work by a less important master or another version of the rare and important work that has subsequently turned up elsewhere. Museums weigh seriously the expenditure of acquisition funds; after all, these are in principle if not in fact public funds. But we are in the business of exercising best judgments and dealing with the consequences afterward.

In this respect, it is better to think of museums not as owning works of art but as being their stewards and holding them in trust for the public's sake, now and in the future. We are not in the business of taking works of art out of public circulation. Quite the contrary, we are in the business of keeping works of art in public circulation or, as is more often the case, of transferring them from private ownership to public stewardship.

It is also important not to think of acquisition as the end of a process. Rather, one should think of it as but an important step in an ongoing process of learning more about the work of art in question. It is often only through the act of acquiring an object, doing due diligence, exhibiting it, publishing it, and further studying it that one comes to know what is most important about it and sometimes what its legal standing is. Were one not to have acquired it, it is far less likely that anything more would be known about the work of art in question. It would likely remain in the invisible, or less than totally visible, world of private ownership.

Some parties hold that works of art whose original circumstances are not known have little value.[27] However, even if we cannot know the specific culture that produced the objects in question, we can examine the objects for their manufacture, form, style, iconography, and ornamentation, and place them in the larger context of all we know about such objects. A piece of Roman glass (identified by comparing it with

151

glass excavated from a Roman site) with a very peculiar decorative motif, or of a different size, color, or shape, tells us something about the range of Roman-glass types that we did not know before, even if we do not know where the specific piece of glass came from. Similarly, an object with an inscription may tell us something very important about the culture that produced it, even if we have no knowledge of the circumstances in which it was found.

Works of ancient art have many meanings, some of them historical, others aesthetic and philosophical. How, for example, can one inquire into the question of beauty without examples of beauty? By most definitions, works of art manifest beauty. To great benefit, they can be studied for this reason alone. But works of art need not be studied to have value in our culture. They can provide pleasure, inspiration, even spiritual or emotional renewal. And in their great variety, whether identifiable as Korean, Mexican, Malian, Greek, English, or Native American, they can remind us that the world is a very large and great place of which we, our culture, are an important part.

It is for all of these reasons, and on the terms that I have described, that museums in our country acquire works of art. Acquiring, preserving, and exhibiting works of ancient art is a very great responsibility, something museums must undertake with the greatest of care, conscious of our public's best interest, and within the context of our nation's high regard for the international exchange of cultural property and of our profession's insistence on best practices.

Whether a work of art should be repatriated and on what terms depends on the US court's interpretation of US law and on the current state of relations between congressional intent and US Customs actions. It also depends on the relations between a particular US museum or the US museum community as a whole and the governments of particular foreign countries. But this is another question, not strictly speaking a matter of the law but of personal and cultural diplomacy.

Since I wrote the article on which much of the preceding material is based, the president's Cultural Property Advisory Committee recommended in 2001 that the United States enter into a memorandum of

understanding with the government of Italy that restricts the import of stone sculpture, metal sculpture, metal vessels, metal ornaments, weapons/armor, inscribed/decorated sheet metal, ceramic sculpture, glass architectural elements and sculpture, and wall paintings dating from approximately the ninth century BCE to approximately the fourth century CE; that is, virtually every kind of art object produced in or imported to the land we now call Italy over twelve hundred years of recorded human history.[28] It is hard to accept that *all* of these objects are worthy of restriction because they are important archaeologically or as cultural property—unless, of course, one believes that every found old object is by definition of archaeological value, or that every found old object is culturally important to the people who now reside within the political boundaries of the land in which it was found. And this is more or less what the US–Italy memorandum of understanding says. It subsumes archaeological artifacts under the category of cultural property, and it assumes that everything—or almost everything—found in Italy, or *likely* to have been found in Italy, whether it was produced there or imported to there, is cultural property and thus crucial to the national identity and self-esteem of the Italian people.

For example, the memorandum states that (1) "the value of cultural property, whether archaeological or ethnological in nature, is immeasurable . . . [and that] such items often constitute the very essence of a society and convey important information concerning a people's origin, history, and traditional setting"; (2) "these materials are of cultural significance because they derive from cultures that developed autonomously in the region of present-day Italy . . . [and] the pillage of these materials from their context has prevented the fullest possible understanding of Italian cultural history by systematically destroying the archaeological record"; and (3) "the cultural patrimony represented by these materials is a source of identity and esteem for the modern Italian nation." In other words, as the memorandum would have it, the destruction of the archaeological record in modern-day Italy is problematic not because the world has lost vital information about humanity, about the way our human ancestors lived and ornamented their lives thousands of years ago, but because without it "the fullest possible understanding of Italian cultural history" is not possible and because the lost materials are "a source of identity and esteem for the modern Italian nation." This

line of reasoning runs counter to the intention of our 1983 legislation. It devalues the international exchange of archaeological artifacts and cultural property for the benefit of the world's peoples, and privileges instead the retention of cultural property by modern nation-states for the benefit of local peoples.

In 2001, a New York antiquities dealer, Frederick Schultz, was indicted on one count of conspiring to receive stolen Egyptian antiquities that had been transported in interstate and foreign commerce. The underlying offense was a violation of the National Stolen Property Act. Among Schultz's defenses was the claim that the NSPA does not apply to an object removed in violation of a national patrimony law, since such an object was not "stolen" in the commonly used sense of the word, but retained by an individual (and in this case removed from Egypt) without the Egyptian government's consent.[29] In the earlier *McClain* case, the court ruled that the pre-1972 Mexican law was too ambiguous to allow it to recognize the objects in question as stolen. In the *Schultz* case, the court ruled in favor of the 1983 Egyptian Law 117 that declares "all antiquities are considered to be public property. . . . It is impermissible to own, possess or dispose of antiquities except pursuant to the conditions set forth in this law and its implementing regulations."[30]

Schultz was convicted on the grounds that the court interpreted Egyptian Law 117 as an ownership law, not an export-restriction law. The court concluded "that the NSPA applies to property that is stolen from a foreign government, where the government asserts actual ownership of the property pursuant to a valid patrimony law."[31] Schultz lost on appeal and is serving a thirty-three-month sentence in federal prison.[32] Although he still disputes the facts of the case, his trial revealed the extent of his relations with a British agent, Jonathan Tokeley-Parry, and the extraordinary, duplicitous efforts undertaken by them to remove the object in question from Egypt. As far as museums are concerned, the shady nature of Schultz's dealings renders the substantive arguments of his defense meaningless. It is one thing to be offered an object with no provenance, and another to be offered one with fabricated provenance and false export and import papers.

The argument in favor of restricting free trade in antiquities is made on two counts: that antiquities are also cultural property and thus the inalienable property of the government and people of the modern nation in which they are thought or known to have originated; and that the free

trade in antiquities only encourages looting and pillaging of archaeological sites and results in the loss of the knowledge derived from them. But when an antiquity is offered to a museum for acquisition, the looting, if indeed there was any, has already occurred. Now the museum must decide whether to bring the object into its public collection, where it can be preserved, studied, and enjoyed, and where its whereabouts can be made widely known. Museums are havens for objects that are already, and for whatever reason, alienated from their original context. Museums do not alienate objects. They keep and preserve them, holding them in public trust for future generations.

A free and licit trade in antiquities should both protect archaeological sites and encourage the sharing of ancient objects with the world and for the purposes I cited at the start of this essay. The deceitful, and in the end unlawful, acts of individuals such as Schultz and Tokeley-Parry, from my point of view, were severely injurious to the legal and moral public ambitions of US museums. The appellate court's decision will stand for some time as an affirmation of the US government's increasing willingness to enforce the laws of foreign countries. And this bodes ill for the US museum community, which seeks to comply with the mandate of its Enlightenment origins and the polymathic ideal of discovering and understanding the whole of human knowledge, improving and advancing the condition of our human species and the world we inhabit. For it allows the nationalist retentionist cultural policies of foreign countries to maintain their parochial hold on "their" antiquities, and restricts the potential such artifacts hold to enable all of us to understand our common past. This undermines the grounds for creating a future of greater understanding and tolerance for the differences between us that comprise the rich diversity of our common cultural legacy.[33]

The task remains for museums to be vigilant in their search for information about the antiquities they buy or are offered as gifts, inform themselves of the latest state of legal play, and redouble their efforts to educate us all about the greater benefits of sharing the world's ancient artifacts with the world's populations.

1. Quoted in Kim Sloan, "'Aimed at Universality and Belonging to the Nation': The Enlightenment and the British Museum," in Kim Sloan, ed., *Enlightenment: Discovering the World in the Eighteenth Century* (London: The British Museum Press, 2003), 14.

2. From Parliament's British Museum Act of 7 June 1753, as quoted in Marjorie L. Caygill, "From Private Collection to Public Museum: The Sloane Collection at Chelsea and the British Museum in Montagu House," in R. G. W. Anderson et al., eds., *Enlightening the British: Knowledge, Discovery and the Museum in the Eighteenth Century* (London: The British Museum Press, 2003), 19.

3. Keith Thomas, "Afterword," in Anderson et al., eds., *Enlightening the British,* 186.

4. Edward W. Said, *Orientalism,* 1978 (London: Penguin Books, 2003 edition), xvii–xviii.

5. Patrick J. Geary, *The Myth of Nations: The Medieval Origins of Europe* (Princeton: Princeton University Press, 2003).

6. Neil MacGregor, "Oi, Hands Off Our Marbles," *London Sunday Times,* January 18, 2004, Section Five, 7.

7. Said, *Orientalism,* xxii.

8. See James Cuno, "US Art Museums and Cultural Property," *Connecticut Journal of International Law* 16 (2001): 189–96.

9. Compare Irvin Molotsky, "Donations May Be Sought to Send US Arts Abroad," *New York Times,* November 29, 2000, E3 (reporting on a conference on culture and diplomacy convened at the White House by President Bill Clinton and Secretary of State Madeleine Albright. The purpose of the conference was to promote the establishment of an endowment in the State Department for the distribution of American culture abroad), with John Henry Merryman, "Two Ways of Thinking About Cultural Property," *American Journal of International Law* 80 (1986): 831–32, and John Henry Merryman, "Thinking about the Elgin Marbles," *Michigan Legal Review* 83 (1985): 1911–21 (on the "internationalist viewpoint on cultural property issues").

10. Steinhardt Museum Brief at 14, *US v. Antique Platter of Gold,* 991 F. Supp. 222 (S.D.N.Y. 1997); *aff'd,* 184 F.3d 131 (2d Cir. 1999).

11. See "The Protection of Movable Cultural Property: Compendium of Legislative Texts," 1984, 1 UNESCO 357–63.

12. See Paul M. Bator, *The International Trade in Art* (Chicago: University of Chicago Press, 1983), 94–108, for an account of the UNESCO convention's legislative history, from drafting sessions to final approval.

13. See Leonard D. DuBoff, "Proceedings of the Panel on the US Enabling Legislation of the UNESCO Convention on the Means of Prohibiting and Preventing the Illicit Import, Export and Transfer of Ownership of Cultural Property," *Syracuse Journal of International Law & Commerce* 4 (1976): 97–139, for the text of the legislation, and of an Association of American Law Schools panel

discussion on the enabling legislation as proposed in the US House of Representatives Bill H.R. 14171, 94th Congress, 2nd Session (1976). The text of the 1983 implementing legislation regarding 19 U.S.C. § 2600 can be found on http://exchanges.state.gov/education/culprop//97-446.html.

14. *Final Act of the Diplomatic Conference for the Adoption of the Draft UNIDROIT Convention on the International Return of Stolen or Illegally Exported Cultural Objects,* June 24, 1994, art. 4, 52, UNIDROIT Proceedings and Papers (International Institute for the Unification of Private Law).

15. Bator, *International Trade,* 52.

16. Ibid.

17. Ibid., 11.

18. 545 F.2d 988 (5th Cir. 1977).

19. Bator, *International Trade,* 73 (citing *McClain,* 545 F.2d at 1000–1001.

20. *McClain,* 545 F. 2d at 1000–1001.

21. *McClain,* 545 F. 2d at 1000–1001.

22. S. Rep. No. 97-564 at 27 (1982), quoted in James F. Fitzpatrick, "A Wayward Course: The Lawless Customs Policy Toward Cultural Properties," *NYU Journal of International Law and Politics* 15 (1983) 857, 860-61.

23. S. Rep. No. 12, 128 Cong. Rec. 418, quoted in Fitzpatrick, "A Wayward Course," 862.

24. S. Rep. No. 12, 128 Cong. Rec. 418, quoted in Fitzpatrick, "A Wayward Course," 862.

25. 1 UNESCO, *Movable Cultural Property,* 359-60 (alteration in original).

26. James R. McAlee, "The McClain Case, Customs and Congress," *NYU Journal of International Law and Politics* 15 (1983): 813, 835.

27. Ricardo J. Elia, "Chopping Away Culture: Museums Routinely Accept Artifacts Stripped of Context by Looters," *Boston Globe,* December 21, 1997, D1.

28. Public Notice, 66 Fed. Reg. 15, 7399-7402 (2001), Import Restrictions Imposed on Archaeological Material Originating in Italy and Representing the Pre-Classical, Classical, and Imperial Roman Periods.

29. *US v. Frederick Schultz,* Docket No. 02-13575 (2nd Cir. 2003).

30. *Schultz,* No. 02-13575 (2nd Cir. 2003).

31. *Schultz,* No. 02-13575 (2nd Cir. 2003).

32. See the two-part article, Barry Meier and Martin Gottlieb, "An Egyptian Artifact Takes a Crooked Path," *International Herald Tribune,* February 23, 2004, 1 and 6, and February 24, 2004, 2.

33. As I write this, the Association of Art Museum Directors, an organization of North America's largest art museums, is drafting new principles for the acquisition of art and antiquities that complement and elaborate on AAMD's *Professional Practices in Art Museums* (2001), taking into account recent US legal and political developments in this area.

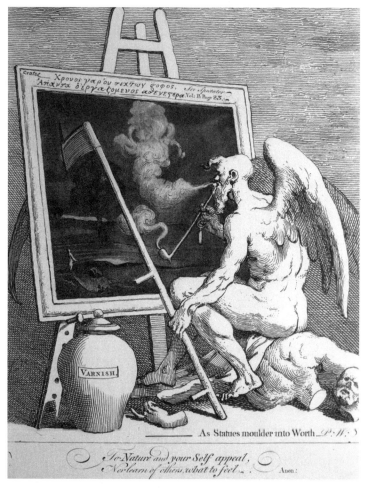

William Hogarth, *Time Smoking a Picture,* 1761. Courtesy The Charles Deering McCormick Library of Special Collections, Northwestern University.

THE EXPERT AND THE OBJECT

"IS IT REAL OR ORIGINAL?" is a perennial question in the art world. *Authentication* is the process by which experts—art historians, museum curators, archaeologists, art conservators, and others—*attribute* a work of art to a particular artist or specific culture, era, or origin. In the United States, public and private collections of art are organized on the basis of such attributions. Museums and other cultural institutions validate the importance of works of art simply by collecting and exhibiting them, but museum activities also include technical examination and scholarly historical research.

While extraordinary beauty or artistic strength—an object's consummate quality—may be the primary justification for purchasing a work of art, continuing critical analysis of the artworks in its collection is essential to fulfill a museum's public obligation to collect responsibly. This essay examines the process of authentication of art and antiquities and considers some of the difficulties inherent in the process as well as institutional and structural considerations that affect the process.

Three lines of inquiry are basic to determining authenticity: (1) a connoisseur's opinion, (2) historical documentation or provenance, and (3) technical or scientific testing.[1] A connoisseur evaluates the "rightness" of an object based on extensive study of an artist's works, the artist's normal manner of working, and the materials utilized (for a specific period and place, in the case of unattributed ancient art). Thus, by *connoisseurship* we mean that sensitivity of visual perception, historical training, technical awareness, and empirical experience needed by the expert to attribute the object. To determine an object's provenance, a researcher traces the physical object from the artist, culture, or geographic location (or all three) through a chain of ownership or possession to the current owner or possessor—simple enough in concept, assuming the documentation is not faked or inaccurate. The goal is to assure that the object under study is the same one that left the artist's hand.

159

Technical or scientific testing for age, structure, material, and method of manufacture is often longer on promise than result. Relatively few authentications of visual art are based on scientific tests; the majority are based on the connoisseurship of an expert. Dating paint or wood samples, for example, might show that a painting was made in Rembrandt's lifetime, but cannot prove that it is by Rembrandt's hand. At a more technical level, testing of ancient pottery to determine the date of kiln firing assumes that samples tested are representative of the entire object.

Fakes distort our understanding of a specific artist's work, as well as our understanding of an era or culture and thus the historical record itself. One important distortion is that fakes (as well as malicious, fraudulent, negligent, or simply mistaken attributions) very often contain current, era-specific characteristics. As Max J. Friedländer, the expert on Northern Renaissance and Baroque painting, wrote in his book *On Art and Connoisseurship:*

> A forgery done by a contemporary is not infrequently successful
> from being pleasant and plausible, precisely because something in it
> responds to our natural habit of vision; because the forger has under-
> stood, and misunderstood, the Old Master in the same way as ourselves.
> Here is, say, a "Jan van Eyck"–thus the great venerable name, and yet
> something that has attractiveness in conformity with taste linked up
> with our own time: how could it fail to gain applause under such cir-
> cumstances? To many lovers of art a false Memling is the first Memling
> that gave pleasure.[2]

As Christopher Reed noted recently in an essay in *Harvard Magazine,* entitled "Wrong!":

> Over the centuries when demand for a certain sort of artwork out-
> stripped supply, the forgers go to work. When ancient Romans
> conceived that owning an original Classical Greek sculpture was
> a step up in the good life, the supply of genuine pieces quickly
> vanished and Roman craftsmen churned out Greek statuary until
> the poet Horace could exclaim in the first century B.C.: "He who
> knows a thousand works of art, knows a thousand frauds."[3]

Horace notwithstanding, fakes—works created with intent to deceive—are but one facet of authenticity issues. More important and

far more frequent problems are works of unknown or wrongly attributed authorship or origin. Today, the difference between an attribution to a major artist and one to his student or follower can be measured in dollars, sometimes millions of dollars. In an increasingly litigious society, in which a fortune may rest on an attribution, a clear public understanding of the attribution process is essential.

The public places trust in "objective," scientific evidence and tends to regard connoisseurship as "subjective," meaning (only or primarily) personal taste and (perhaps) unsubstantiated opinion. This public skepticism, and the concern of experts regarding legal liability when they express their opinions, have combined to inhibit freedom of expression of scholarly opinion. This provides fertile ground in which fakes and false or mistaken attributions can flourish. Experts' concern over their legal liability has been intensified by several unfortunate court decisions in which a judge did not fully comprehend the attribution process or the expert's role. The point is illustrated by a litigation involving an object, said to be a Calder mobile, that had a well-documented ownership trail over twenty years from the artist, Alexander Calder, to the current owner. The mobile in question, however, had likely been substituted at some time during those twenty years for the one Calder had created.[4]

Do connoisseurs and other experts feel themselves free to render scholarly opinions without worry over their legal liability to an owner or seller? Anecdotal evidence suggests that they do not. Frances O'Connor, an independent art scholar, has stated, "For all practical purposes, the present defamation and product disparagement laws reject the authority of expert opinion in the arts. The US Supreme Court has ruled—in a non-art-related case—that an assertion of a negative 'opinion' can have the same defamatory effect as an assertion of unqualified fact."[5] Why, for instance, are there no false-attribution sections in almost all catalogues raisonnés of an artist's work? And why do most American museums have policies that prohibit or discourage their curators from expressing opinions on objects not already owned by the museum? Given the reluctance of scholars and experts who do not have the protection of an institutional affiliation to give opinions on authenticity, most expert inquiries will be made only by those affiliated with museums or governmental entities in source or importing countries—or not at all. One practical result of a clearer understanding of the process of authentication might be a change in the views of judges in future court decisions about expert

opinion, so that judgments on authenticity can be made without the expert's concern of being financially ruined in the process.

One response of the arts community to these concerns was the creation of the International Foundation for Art Research (IFAR). IFAR was designed to provide an "authoritative, objective . . . administrative framework bringing together the world's greatest scholars to render opinions on authenticity without fear of liability."[6] Owners submitting a work of art to IFAR for authentication must waive their right to sue for a negative opinion and permit IFAR to publish the results of its research.[7]

Research to establish provenance can also be crucial in respect to patrimony laws. Where source-country laws establish national ownership of artworks, questions of provenance can determine whether or not an artwork is considered "stolen" under US criminal law. Often, contemporary national boundaries do not correspond to the reach of ancient cultures, and here the subjective judgments of historians and art experts about the country of origin of an artwork may be a factor in determining the outcome of a court case.[8]

It is clear that for accuracy, connoisseurs, art historians, and scientists cannot work from visual images or written descriptions of an object but must have access to the object itself. Not necessarily so, one might say with respect to provenance research, that is, the chain of title, possession, ownership, and exhibition history. But the most careful analysis of this documentation is not helpful in attributing an object unless the expert can be reasonably sure that the provenance documentation being examined is for the specific object in hand.

Foundations such as the Getty Center have established excellent international cooperative models among conservators that facilitate basic research and provide the groundwork for object-specific analysis. The rigorous economic constraints under which most museums operate today encourage such cooperative models. In this regard, a system in which art is widely distributed can contribute to higher-quality scholarship because art is accessible to scholars with a wide range of experience and technical expertise.

An example of the need for dialogue is the absence of an international standard for restoration of works of art or monuments. Increasing concern for authenticity has led Western conservators to "restore" objects or buildings only to the point of regaining physical integrity. Whose

standards should be applied to the reconstruction of monuments—the restraint urged by UNESCO or the re-creation of former glory?

In some parts of the world, and at some periods, art has become a tool of political interests: a current political identity may be tied to a specific historical people or period of artistic excellence. Is there a conflict between international scholarship and the desire of a source country to regulate the examination and publication of artworks claimed as part of its national patrimony? Distinguished scholarship in the arts is no longer limited to the developed world, yet the resources for publication and study remain disproportionately outside source countries. These complex issues demand an open-ended and candid discussion.

In any era or culture the creation of a work of art includes an attempt to express, through images or actions, a respect for what is true and real, and a rejection of what is not. A recognition on the part of legislators and courts of the broad range of scholarly interests to be considered in laws regulating the ownership and transfer of art might well facilitate our improved understanding of art objects and the historical and artistic truths their creators were attempting to express.

NOTES

1. See Ronald D. Spencer, ed., *The Expert Versus the Object: Judging Fakes and False Attributions in the Visual Arts* (New York: Oxford University Press, 2004).

2. Max J. Friedländer, *On Art and Connoisseurship*, Chapter 46 (London: Bruno Caisirer, 1942), 262.

3. Christopher Reed, "Wrong!," *Harvard Magazine,* September / October 2004, 44.

4. *Greenberg Gallery v. Bauman,* 817 F. Supp. 167 (D.C. 1993), *affd. without opinion,* D.C. Cir. 194 US App. LEXIS 27175.

5. Frances V. O'Connor, "Authenticating the Attribution of Art," in Ronald D. Spencer, ed., *The Expert Versus the Object,* 16.

6. Sharon Flescher, "The International Foundation for Art Research," in Ronald D. Spencer, ed., *The Expert Versus the Object,* 95.

7. Ibid., 97–98.

8. See Harvey Kurzweil, Leo V. Gagion, and Ludovic de Walden, "The Trial of the Sevso Treasure: What a Nation Will Do in the Name of Its Heritage," in this volume.

Statuette of a veiled and masked dancer, 3rd-2nd c. BCE,
Greece, Hellenistic. Bequest of Walter C. Baker, 1971
(1972.118.95), copyright © The Metropolitan Museum
of Art, New York.

BUILDING AMERICAN MUSEUMS
The Role of the Private Collector

SHELBY WHITE

Foundations for US Collecting

Since the nineteenth century, American museums have played a unique role in preserving the history and culture of the past. The great European museums began as royal or state collections and operate today under national administrations with government support. American museums began, more often than not, as the effort of a group of private citizens to establish an institution open to the public and supported by private donations.

American museums have always had multiple roles. These include reflecting the desire for prestige among their founders and supporters; binding Americans of different backgrounds together in a public, educational environment; establishing a historical framework for America's place in the history of world art; and providing a critical perspective for viewing art and artifacts.

In the United States, important collections have almost always been built with the understanding that works of art should remain accessible to scholars and with the hope that they would end up, sooner rather than later, in a public museum. Collectors have sometimes brought more personal—even eccentric—goals to their collecting activities, but without the collector's passion and focus, US cultural life could not have achieved the richness and energy that characterize it today. As Eugene Thaw has said, "Each true collection achieves a personality beyond and apart from the sum of objects. This personality is definable and has a value in itself."[1]

The Metropolitan Museum of Art and the Getty Museum

By focusing on two American institutions and three private collections formed in the last fifty years, it is possible to demonstrate the ways in which a modern American collector differs from his European

predecessors. The Metropolitan Museum of Art in New York City is the greatest of the United States' encyclopedic collections of world art, comparable to the British Museum in England or the Louvre in France. The Metropolitan Museum was established in 1870 by a group of businessmen and civic leaders for the purpose "of encouraging and developing the study of the fine arts, and the application of arts to manufacture and practical life, of advancing the general knowledge of kindred subjects, and, to that end, of furnishing popular instruction."[2] After several years during which the museum demonstrated its value to the public through exhibitions, city government support came in the form of a donated parcel of land for a future building in Central Park.

The Metropolitan Museum's trustees were determined to build an institution to house and display all forms of fine art as it was known at the time. It is noteworthy that the museum's very first acquisition was a Roman sarcophagus donated in 1870 by Abdo Debbas, the US vice consul to the Ottoman Empire. In 1873, the trustees purchased the collection of Cypriot antiquities of the former American consul in Cyprus, General Luigi Palma di Cesnola, who later became director of the museum. Already, an American museum was stepping beyond the accepted formula of international collecting. This Cypriot material would not have been considered appropriate for a classical collection in a European museum, where classical collections centered on the Greek world of the fifth and fourth centuries BCE. Private donations of antiquities included an important collection of ancient glass bequeathed to the museum in 1881.

J. Pierpont Morgan helped to establish a department of Egyptian art in 1905, and to fund an archaeological expedition to Egypt.[3] In the late nineteenth and early twentieth centuries it was not unusual for museums to send expeditions to excavate sites and share in the division of the objects with the source country. The Metropolitan Museum, the Oriental Institute of Chicago, and the University of Pennsylvania all benefited from this practice of *partage.*

In 1906, the museum's director appointed a purchasing agent, John Marshall, who went abroad to acquire artworks for the museum's collections. Marshall's purchases between 1906 and 1928 truly launched the Metropolitan's collection. The director described the goal of the department as "to develop [the collection] along systematic lines, strengthening it where it was weak, rounding it out as a whole, and maintaining

a high standard of artistic excellence." These acquisitions were paid for by private donations and by the board of trustees, largely composed of prominent businessmen.

One of the Metropolitan's foremost curators, Gisela Richter, had great influence on its collection of ancient sculpture. Richter speaks modestly of her role when she writes, "After the death of Mr. Marshall and of Mr. Robinson in 1931, the responsibility for the development of the department fell first to myself, up to 1948, and then to my successors. The curator now became responsible for new acquisitions, which were mostly acquired singly as an opportunity arose."[4]

During Richter's tenure, among the major works of art the Met acquired was an archaic statue of a *kouros,* a sphinx that originally stood as a finial atop the Megakles stele, and an important statue of an Amazon from the Marquess of Lansdowne's collection, sold at auction in 1930.[5]

At this time, issues of cultural patrimony were not a factor in collecting. Richter was offered a marble sculpture of a lion attacking a bull that she thought remarkably similar to a group in Athens. She traveled to the National Museum in Greece, where she found a corresponding group in the storeroom, and discovered that the two pieces fit. A cast of the New York group was made and sent to the National Museum in Athens, and a photograph of the entire group was displayed at the Metropolitan Museum.[6]

In 1959, Dietrich von Bothmer became head of the Metropolitan's department of classical antiquities, and encouraged the collecting of Greek vases. Private collectors also continued to enrich the museum's collection, which by now was the beneficiary of hundreds of donations from individuals. One of the most important collectors of objects of supreme quality was Walter Baker, who bequeathed his greatest sculptures to the Metropolitan Museum, including a hauntingly beautiful bronze statue of a veiled lady.

The extraordinary scope and the size of the Metropolitan Museum's current collections—seventeen curatorial departments oversee more than two million objects and mount thirty exhibitions a year that are seen by over five million visitors—mean that the conservation and exhibition of antiquities are only a small part of the museum's total activities. Yet the museum has undertaken enormous projects focused around antiquities, from the rescue of the Temple of Dendur from

beneath the Nile, to the recent renovation of a massive space for the most comprehensive permanent installation of Greek, Hellenistic, and Roman art in the western hemisphere.

In contrast to the Metropolitan's history of many contributing donors and varied interests, the Getty Museum began as one man's private collection. John Paul Getty once wrote, "In my opinion, an individual without any love of the arts cannot be considered completely civilized."[7] Collections are a product not only of interest and means, but also of market availability, and when Getty was actively collecting, fine Greek objects were much more available than they are today. Getty acquired many works of outstanding quality, including three of the Parthenon marbles that had remained in the collection of Lord Elgin's family, but he was also very interested in objects used in daily life, and did not restrict himself to masterpieces.

Getty's vision was linked to that of an aesthete of ancient times. He purchased a Herakles from the Lansdowne collection, then visited Hadrian's villa at Tivoli to try to envision its original setting. He traveled to Greece with Pausinias' *Guide to Greece* beneath his arm, and imagined himself visiting Corinth before the city fell to Rome and seeing the Herakles as it originally stood.

Getty was fascinated by the excavations of the Villa Papyri, a Roman villa that was buried by the eruptions of Mount Vesuvius in 79 CE. The first Getty Museum was a reconstruction of the Villa Papyri, built overlooking the ocean in Malibu, California—exactly the sort of location that would have been favored by Roman nobility. Getty filled it with his collection and opened it to the public. He himself never saw the completed museum. While its classical columns, peristyle, murals, and tiled ornamentation were not admired by modernist critics, visitors found it a magical, entrancing place.[8]

At Getty's death, the museum was made the primary beneficiary of his vast fortune. The two curators who have supervised the collections since Getty's death have added greatly to the museum's holdings, and expanded the range of materials within the collections. Under its current curator, Dr. Marion True, the Getty has collected Greek vases of exceptional quality, sculptures, terra-cottas, bronzes, and a remarkable cult statue from the end of the fifth century BCE.[9] (Getty did not collect Greek vases; he allegedly had a fear of death and did not want to collect funerary objects.) In 1996, the museum acquired 300 Greek, Roman,

and Etruscan antiquities from the magnificent collection assembled by Lawrence and Barbara Fleischman. Through the Getty Trust, numerous archaeological and art conservation programs have been undertaken in conjunction with museums throughout the world, and the Getty Trust has devoted substantial funds to its Thesauri projects and other activities that benefit museums worldwide.

The holdings of both the Getty and the Metropolitan Museum continue to grow and to change through the contributions of individual collectors and curatorial acquisitions. In the case of the Metropolitan, the concept of an encyclopedic museum has expanded to include broader geographic regions and types of art, including ethnographic and tribal materials that were excluded from earlier concepts of fine art. The resources of the Getty have permitted not only the acquisition of exemplary works of art that extend the original collection, but also the establishment of entirely new departments, such as their photographic archive, now one of the finest in the world.

Collecting and Three Collectors

The earliest collecting of antiquities in the United States was limited to small personal collections, either used as decoration or intended to provide an atmosphere appropriate to scholarly study. Collections often began in art academies as collections of casts rather than original materials. Early US collectors commissioned sculptures for their gardens, in the manner of the ancient Romans, combining new and antique objects. There was no American parallel to what Retlinger calls "a species in England that did not exist in France, a kind of classically obsessed squire, who would spend up to two thousand guineas on a statue from Rome or Tivoli."[10]

Collecting expanded significantly in the nineteenth century, and by the mid-twentieth century, collecting in the United States had become much more widespread and, in a way, more democratic. Despite the vast resources of collectors such as the Rockefellers, Morgan, Mellon, and Kress, American collectors were never princes, popes, or even country squires. They were most often businessmen who became fascinated by the ancient world. Collecting ancient art has never earned the same public recognition and status as collecting Old Masters, Impressionists, or the work of contemporary artists. It is a demanding field that requires

the collector to bridge a gap of many centuries to understand the heart and hand of the artist. American collectors have often taken the lead in recognizing types of ancient art not previously regarded as worthy of museum or academic attention.

Contemporary taste in collecting ancient as well as modern art is preoccupied with questioning the opinions of the past. In recent decades, the long-held interest in Roman copies of Greek art has been augmented by an interest in Roman art for its own vitality and original qualities. There is less admiration today for the grandiose and more for the utilitarian as well as an expansion of the range of cultures encompassed by the collector. This fascination with the intellectual as well as the aesthetic pleasures of collecting led me and my husband, Leon Levy, to become devoted, passionate collectors of ancient art.

In the early 1970s, my husband's love of ancient history led us to admire and then to acquire at an auction our first object, a marble portrait that turned out to be a Roman copy of a Greek image of a philosopher. The portrait was followed by a small Greek bronze horse from the sixth century BCE, and a portrait of the Roman empress Julia Domna, who was known more for her beauty than her virtue.

Inspired by Gibbon's writing on the achievements of the Emperor Hadrian, we bought a portrait bust of the emperor in 1978. The bust is representative of early-second-century portraiture: the hair has raised curls and the eyes are not yet articulated by the drilled pupils of the later period. It is not a truly brilliant work of art, but we found this portrait's collection history fascinating. It had been discovered by Gavin Hamilton, a British dealer, at the royal villa in Tivoli in 1769.[11] Hamilton sold the portrait to the Talbot family of Margam, where it remained until 1941, when it was purchased at auction by Spencer Churchill. A Basel dealer purchased it in 1965, and in 1978 the head was exhibited at the New York gallery of André Emmerich, where we purchased it. Today, the portrait of Hadrian is displayed in the long hallway of our apartment, a space very much influenced by eighteenth-century architecture.[12]

Gradually, my husband and I came to see ourselves as part of a small community of scholars, dealers, museum curators, and collectors in New York. We met Norbert Schimmel, and were thrilled to be invited to the Upper East Side apartment where he kept his collection. In his introduction to the catalogue of the Schimmel Collection, Oscar

White Muscarella says, "One of the main characteristics of the Norbert Schimmel Collection, aside from its beauty and cultural wealth, is that it has functioned as a public collection. No scholar, student, or interested layman who desires to see the collection or even one object has ever been denied access. Thus it serves the public and functions as a museum and is not considered to be one man's personal possession, selfishly shown only to a few close friends."[13] Norbert Schimmel set a high standard for us as beginning collectors, not only for the quality of his collection but for his belief that it was to be shared with others.

In the 1970s, when we began collecting, it was impossible to acquire objects on the scale of earlier collectors, nor could we expect to see the same sort of objects that were available to eighteenth-century British collectors. Roman portraits were an early focal point of our collection. I was particularly interested in finding portraits of Roman women of all ranks because women played an important role in all levels of their society. Over time, our collection expanded to include objects from the Silk Route, China, and the Middle East, as we became aware that even in ancient times trade and cultural exchange was more global than the traditional art historical framework often acknowledges. We visited galleries in New York, London, and Switzerland, where we were shown a geographically broader selection of objects than those that had been available to earlier collectors—not just Greek and Roman artworks, but Iberian, Romano-Celtic, Near Eastern, and Central Asian material.

For my husband and me, collecting has meant pushing the cultural, chronological, and aesthetic boundaries wherever they led. A Gandhara head would not be out of place, since it reflected the influence of Alexander the Great's march across Asia. Our collection includes objects from the Neolithic that demonstrate early phases of man's artistic development. Our interest in the societies that flourished in the ancient world led us to support both excavations and archaeological publications. Since 1995, the White-Levy publications program, located at Harvard University's Semitic Museum, has given more than one hundred publication grants. We joined the board of an organization that worked to support excavation in Israel, Jordan, and Cyprus. We traveled to Greece, Italy, Syria, and Turkey to see ancient sites. Slowly, over the years, we added to our collection, seeking not only the most beautiful examples of ancient art available but also works that brought aesthetic and historic cohesion

to the collection as a whole. We frequently lend objects to museums and have organized several small traveling exhibitions, one of which traveled to museums in Greece and Israel.

The collection of ancient art built by our New York colleagues, Lawrence and Barbara Fleischman, was also highly personal but extraordinary in quality, size, and the rapidity with which it was assembled. Fleischman was as unlike the collectors who preceded him as the hot dog is to French cooking. His interest in ancient art began at age eighteen, when he saw Roman ruins in France and antiquities in the British Museum while serving in the US Army during World War II. Lawrence Fleischman lived for his collection and with it; he was passionate about refining and improving it. The Fleischmans had purchased a number of Greek vases in the 1950s from the William Randolph Hearst Collection, but none were masterpieces. When the couple became serious about collecting, they invited Dietrich von Bothmer to look at their vase collection. Dr. von Bothmer advised the Fleischmans to get rid of everything: they did.

Like J. Paul Getty, the Fleischmans had a predilection for objects that depicted everyday life (a favorite was a Greek vase with a drawing of a fishmonger) and for objects illustrating an unusual scene, such as the Garden of the Hesperides shown on a *lekythos* now in the Getty Museum. Barbara Fleischman had a great interest in the theater, and their collection of bronzes of actors, comic masks, and vases with representations of Greek dramas reflected that interest. In addition, Lawrence and Barbara Fleischman understood the importance of collectors to museums. They encouraged the formation of support groups for the antiquities departments at both the Metropolitan Museum of Art and the British Museum.

The 2002 gift of works from the Eurasian steppes to the Metropolitan Museum from a longtime benefactor, Eugene Thaw, is an example of the commitment of a private collector to the advancement of knowledge and to the public weal. Unlike the more comprehensive collecting of the Fleischmans or J. Paul Getty, Thaw has assembled several highly specialized collections (one of them of Native American art), which he has exhibited and then donated to various museums. The Metropolitan had not collected widely in the field of steppe art, so this gift added greatly to the scope of the museum's Asian art department. Art from the Central Asian steppe is highly focused and suited to the nomadic lifestyle, often

consisting of small, sometimes highly decorated personal ornaments, harnesses, and chariot fittings of bronze, gold, and silver. Initially, Thaw was attracted to the objects because of their dynamism and intrigued by the persistence of animal-style art through other cultures, such as the Celtic. He assembled the collection within six years at a time when large amounts of this material were being exported from China, exhibited it at the Metropolitan, and donated the collection soon after. Thaw sees his collecting as an intellectual activity—the putting of things in order—rather than as a manifestation of power or status. He feels that each collection has a personality that reflects the taste, judgment, and instincts of the collector, and that each collector should strive to make a contribution to the field.

Bringing Collections to the Public

There is no question that collecting has long been associated with wealth and power, but in America's mobile social and economic environment, collecting does not follow the old European cultural model or encourage dynastic hoarding of artistic wealth. Instead, there are well-recognized and widely embraced social roles based around the arts that distinguish the American system from others.

Federal government participation in cultural activities was hardly envisioned at America's founding. Except for the Smithsonian Institution's complex of museums, which themselves were established through private gifts to the nation, America's network of private, city, and university museums operate largely independently from government control and receive little government support. Funding of US museums from city, county, or state governments (most often through the donation of buildings, sites, or services) provides an average of only 18 percent of total operating cost.[14] Instead, the creation of the United States' cultural institutions has been left to its citizens.[15]

Along with the crucial part played by art collectors in building the collections of major US museums through donation, art collectors influence museum policy when they hold positions on museum boards. The responsibility of the museum trustee to act in the public interest and to safeguard and provide for the institution and its collections is a challenging task demanding professional acumen, knowledge of the art and business worlds, and substantial commitment of time and energy. Even

America's largest and best-run museum organizations face unprecedented competition, financial pressures, and public scrutiny today. The success of a number of younger American museums, particularly in the Western states, is in many ways the result of the business talents, desire to enrich the life of communities, and enthusiasm for art among members of their boards. In past years, important university museums such as the Oriental Institute in Chicago and the University Museum of the University of Pennsylvania participated in excavations that allowed them to share in some of the finds—an arrangement that is impossible under present national patrimony laws. In comparison, many of the university museums established since the 1960s are almost entirely dependent upon parent organizations for direction and support and upon alumni for donations of works of art.[16]

The US tax system allows two essential mechanisms that enhance the funding of museums and other charitable cultural institutions: the estate tax and the offsetting of a percentage of income taxes due through donations to charitable institutions. Americans made generous donations of art to museums long before the adoption of the Sixteenth Amendment introducing income taxes in 1913,[17] but today's laws encourage large-scale giving to museums. Americans do not usually pass on their passion for collecting or tastes in art to their children, and there is no tradition of maintaining family collections of art in the United States, as there is in Europe. Offering a tax benefit for the donation of art encourages art to move to public collections rather than back to the market. Estate taxes not only act to disperse cumulative wealth, they also offer the public the opportunity to "buy art at a substantial discount." In the case of larger estates, this may be at approximately one-fourth of the art's fair market value.[18]

The deduction allowed for charitable donations to museums is by no means a "free ride" for collectors, but the potential reduction of the tax burden that it offers has been crucial to the support of American museums. Just how crucial this mechanism was could be seen when the Tax Reform Act of 1986 established the alternative minimum tax, which reduced the appreciation allowed on donated artworks. In 1988, the American Association of Museums surveyed a sample of their 2,271 institutional members to determine the impact of the 1986 tax laws.[19] There had been an almost 30 percent drop in donations of objects in

the surveyed sample. When the change was rescinded to allow a greater benefit for donations in 1991,[20] donations increased. Does this mean that collectors are motivated to collect by the prospect of future tax advantage? No, but it does demonstrate that collectors are sensitive to tax issues and will make educated decisions on how and when to dispose of their materials.

During much of the twentieth century, America was the leader in collecting ancient art. As wealth moves around the world, other collectors become active, and in the small world of antiquities Americans may no longer be the most active buyers. Deep personal interest, a sense of historical relevance, and market availability continue to inspire the building of collections worldwide.

One of the greatest late-twentieth-century collectors of ancient art from all over the world is George Ortiz, heir to a fortune based on Bolivian tin. Other collections demonstrate the importance of historical and religious ties, such as the collection of antiquities assembled by the Shumei family now in the Miho Museum, outside Kyoto, which is rich in Silk Road and Buddhist material from Central Asia and China. Over the last decade, Sheikh Saud al-Thani of Qatar built major state and private collections of art from Egypt and the Near East, utilizing resources beyond that of any US collector. The evolution of a global antiquities market has certainly meant changes in American collecting practices and in the scale of donations that bring privately owned art to US museums, but it will not affect the deep commitment of American collectors to America's great public institutions.

According to Eugene Thaw, "Today, the odds are stacked against collectors of many kinds of art. National borders are rapidly closing. The United Nations is sponsoring ever more restrictive international treaties that discourage the collecting of any art except that of one's own country . . . the value that collectors and art markets create has been in most cases the only reason that much of the world's art has survived. . . . But possibly the tide will turn, and . . . art collecting and its adjuncts, connoisseurship and the search for quality, may once again see their reputations restored."[21] More than ever, US public policies reflect these changing currents. It is to be hoped that these divergent views can be brought into balance in order to preserve the heritage of all humanity.

NOTES

1. Eugene Thaw, "The Art of Collecting," *New Criterion,* December 2002, 12.

2. Charter of the Metropolitan Museum of Art, State of New York, Laws of 1870, Chapter 197, passed April 13, 1870, and amended L.1898, ch. 34; L. 1908, ch. 219.

3. In 1906, Herbert E. Winlock became the youngest member of the Metropolitan's archaeological team in Egypt. Winlock became a distinguished Egyptologist, continuing to excavate there until he became director of the Metropolitan Museum, a post he held from 1932 to 1939.

4. Gisela Richter, *My Memoirs: Recollections of an Archaeologist's Life,* 1972.

5. John D. Rockefeller purchased the Amazon and presented it to the Metropolitan Museum.

6. The story of the Megakles stele is another example of early-twentieth-century collecting practices. This grave monument was created in the third quarter of the sixth century BCE. It is an imposing object, more than thirteen feet tall, on which a youth and a girl are carved in relief. John Marshall had purchased the stele in 1911. Almost twenty years later, a New York dealer offered Richter a marble sphinx. She suspected that the sphinx might belong to the grave stele, so she arranged to have a cast made to see if the sphinx fit the traces of lion's paws that appeared on the top of the stele, a combination that was not uncommon in the sixth century. In reviewing Marshall's records, Richter realized that the stele had probably been broken into pieces shortly after its erection, and that some pieces had been reused to line other graves of the period. The head of the girl is in the Pergamon Museum, Berlin, and other fragments are in the National Museum in Athens; these elements have been added in plaster to the stele in the Metropolitan Museum in New York.

7. J. Paul Getty and Ethel Le Vane, *Collector's Choice: The Chronicle of an Artistic Odyssey through Europe* (London: W. H. Allen, 1955).

8. In 1997 the villa was closed for renovation and has reopened as a center for study, conservation training, and education in ancient art and comparative archaeology. The Getty collections are now displayed in the new Getty Center complex.

9. Other American museums have established major collections of ancient art through the donation of a single collection. The San Antonio Museum of Art has more than three thousand ancient objects that span five thousand years of collecting. The core of the holdings are from a single gift from Gilbert M. Denman, a longtime resident of San Antonio and an avid collector of ancient art.

10. Gerald Reitlinger, *The Economics of Taste* (New York: Holt, Rinehart & Winston, 1965). Eighteenth-century English collectors such as Charles Townley and William Beckford had vast inherited wealth and the leisure time to read the classics. They built homes emulating what was known of ancient style. So great was the enthusiasm of eighteenth-century collectors that

prices skyrocketed, as did the number of objects that were passed off as classical works of art but were made from bits and pieces of ancient sculpture.

11. *Journal of Hellenic Studies* (London: Society for Promotion of Hellenic Studies, 1901).

12. Particularly that of Thomas Hope, described in Hope's *Household Furniture and Interior Decoration: Classic Style Book of the Regency Period* (New York: Dover Publications, 1971).

13. Oscar White Mascarella, *Ancient Art: The Norbert Schimmel Collection* (P. von Zabern, 1974).

14. Even the Smithsonian Institution receives only 75 percent of its budget from the federal government. Since only one of the institution's museums charges admission, deficits must be largely made up through contributions solicited from private and corporate sources, museum shop sales, and contributions from members of the museum boards. *Fundraising at Art Museums,* Smithsonian Institution Office of Policy and Analysis, October 2001.

15. The Institute of Museum and Library Services (IMLS) is an independent federal agency dedicated to creating and sustaining a nation of learners. The Office of Museum Services (OMS) is responsible for museum programs within IMLS. The 2003 funding for the Office of Museum Services was only $28.6 million; fiscal year 2004 funding was $31.4 million. These very limited funds primarily support seed grants and educational activities in museums nationwide; www.nhalliance.org/had/2004/sourcebook/oms.04brief.pdf.

16. James Cuno, "Assets? Well, Yes—of a Kind, Collections in College and University Art Museums and Galleries," Occasional Paper No. 1, Fall 1992, Harvard University Occasional Papers.

17. The Revenue Act of 1917 allowed limited deductions to taxable income of contributions to organizations "operated exclusively for religious, charitable, scientific, literary, or educational purposes." For a discussion of the gifts of numerous major early-twentieth-century collections to US museums, see Jerome S. Rubin, "Art and Taxes," originally published in *Horizon,* winter 1966, excerpted in John Henry Merryman and Albert E. Elsen, *Law, Ethics, and the Visual Arts,* 4th ed. (The Hague and New York: Kluwer Law International, 2002).

18. Ibid., 1040.

19. The 1988 American Association of Museums Survey on Contributions of Objects and Dollars, American Association of Museums.

20. In 1991 the tax (up to 24 percent) on appreciation in charitable donations was temporarily rescinded, and in 1993 the change was made permanent.

21. Thaw, "The Art of Collecting," 15-16.

Wall relief at the Ishtar Gate, 604-562 BCE, Babylon, Iraq.
Photo by Hasan Bros., Baghdad, c. 1910, courtesy Anahita
Gallery, Inc. All rights reserved.

EDITOR'S NOTE
The Illicit Trade—Fac or Fiction?

KATE FITZ GIBBON

PRESS AND PUBLIC STATEMENTS about the antiquities market often cite estimates of a billion or more dollars per year for the illicit trade in "cultural property," a term equated with recently looted or stolen antiquities and associated dramatically with the looting of the Iraq National Museum, in Baghdad. These same estimates have been cited in hearings and reports to the US Congress and the British Parliament, impacting the course of legislation that will affect museums, dealers, and private collectors for many years to come. But this billion-dollar value is a myth.

Like many popular myths, the billion-dollar figure has been repeated so often that its origin is difficult to trace. So many citations claim to be based on an Interpol estimate produced in the late 1990s that Interpol has made the following statement: "We do not possess any figures which would enable us to claim that trafficking in cultural property is the third or fourth most common form of trafficking, although this is frequently mentioned at international conferences and in the media. In fact, it is very difficult to gain an exact idea of how many items of cultural property are stolen throughout the world and it is unlikely that there will ever be any accurate statistics."[1]

One source for widespread misapprehensions about the value of the illicit trade may come from the fact that when police agencies, including Interpol, use the phrase "cultural property," the term refers to paintings and sculptures from all periods, including contemporary works of art, silver and jewelry, antique furniture, carpets, and other non-manufactured items of value.

Collected data on stolen art indicates that the value of antiquities is a tiny fraction of the "cultural property" total. According to information published by the Art Loss Register, 54 percent of reported thefts of art and antiques are from private dwellings. Thefts of antiquities represent only 3 percent of total art thefts as compared to 51 percent for thefts of pictures, a category including paintings and drawings. The "cultural property theft" cited so often in the press as pertaining to looting of

antiquities actually refers primarily to losses from household burglaries and commercial theft.[2]

After a lengthy investigation, the Ministerial Advisory Panel on Illicit Trade of the Department for Culture, Media and Sport in the United Kingdom was able to state only, "Where attempts have been made to quantify all examples of a particular class of antiquity, the great majority of objects appear on the market without any stated provenance. . . . In the absence of evidence to the contrary it is reasonable to suspect that a proportion of such unprovenanced objects have been illegally excavated and illegally exported."[3]

Comparisons to illicit trade in drugs or armaments, also common, are even more tenuous. Armaments become obsolete. Drugs are consumed and must be replaced with fresh supplies. Art neither is consumed nor wears out, and has circulated in a worldwide market for centuries. The absurdity of these comparisons becomes obvious when one asks how many people take drugs and how many collect antiquities. A more realistic appraisal of the traffic in recently looted antiquities would represent a small percentage of the total worldwide trade in antiquities as a whole, a few millions, not a few billion dollars a year. Certainly, this number itself pales in comparison to the "value" of antiquities lost each year due to war, vandalism, development of archaeological sites, dam construction, and poor conservation of sites or archaeological collections.[4]

Art theft is a major problem that can begin to be addressed only through expansion of internationally available databases and cooperative action among archaeologists, museums, collectors, dealers, insurers, and law enforcement agencies. Archaeologists and others are right to be angry: the looting of archaeological sites is a tragedy, and represents a real loss of knowledge of the history of humankind. Finding working solutions to the problem of art theft, however, requires knowing the facts, not repeating a myth.

NOTES

I would like to thank Rena Neville, Arielle Kozloff, William Pearlstein, and Peter Tompa for their help in identifying sources.

1. Interpol, *Stolen Works of Art, Frequently Asked Questions,* www.interpol.int/Public/WorkOfArt/ woafaq.asp.

2. Art Loss Register, www.artloss.com/ Asp/TheftAndRecovery/mn_stats.asp.

3. *Report of the Ministerial Advisory Panel on Illicit Trade of the Department for Culture, Media and Sport, Annex A, The Scale of the Illicit Trade in Cultural Objects,* December 2000. The same panel report noted that the 2000 *Select Committee Report of the Culture, Media and Sport Committee of the Parliament of the United Kingdom* had taken evidence of estimates of the worldwide volume of the illicit trade that "ranged from £150 million to £4.5 billion . . . a year, an extremely wide margin of error."

4. The Antiquities Dealers Association has stated that the total worldwide turnover of classical antiquities from Europe and the Mediterranean is only £200 to £300 million. Readers are directed to Arielle Kozloff, "The Antiquities Market: When, What, Where, Who, Why . . . and How Much?," in this volume, for an examination of the worldwide trade in antiquities.

Animal figurines, 2300-2200 BCE, Harappa, Indus Valley, South Asia.
Photo 1927-30, courtesy Anahita Gallery, Inc. All rights reserved.

THE ANTIQUITIES MARKET
When, What, Where, Who, Why . . . and How Much?

ARIELLE KOZLOFF

THE DESIRE TO COLLECT ANTIQUITIES goes back thousands of years. In the fourteenth century BCE, Pharaoh Amenhotep III ordered the excavation of the tomb of King Djer (third millennium BCE) in Abydos, believing it was the burial of the legendary first king, the divine Osiris. Egyptian "heirlooms" from other ancient digs have appeared in second-millennium palace sites as far away as Crete and Ras Shamra.[1] During the Roman Empire, so many obelisks were transported from Egypt to Rome that there are now more obelisks in Italy than in Egypt. In each of these examples, even where collecting occurred by imperial fiat, some exchange took place. Pharaoh himself could not disturb a sacred site without propitiating the indigenous gods (through their priests), nor could the Roman emperor, who required the goodwill of the local deities and their priests for his continued success. These exchanges of favors or goods for excavation and transplantation of antiquities constituted an effective trade.

Examples of antiquarian interest appear in the Middle Ages—Abbot Suger of Saint-Denis had ancient Egyptian stone vessels ornamented with gold—but the widespread collecting of antiquities dates back only to the Renaissance. In the eighteenth century, particularly in England and France, the collecting of Greek and Roman art became a national pastime among the aristocracy. The recent sale to an American museum of a huge second-century CE Roman marble dog, purchased in the 1750s[2] and brought to England by the eccentric English collector Henry Constantine "Dog" Jennings, prompted its purchase in 2001 for the British Museum with a grant of £362,000 from the National Heritage Lottery Fund. The Jennings Dog is now considered part of the patrimony of England, not Italy. In the same way, Italy claims Greek vases acquired by trade twenty-five hundred years ago as her own. The possession of Egyptian antiquities abroad has become so common that, while Egypt's cultural ministry attempts to repatriate Egyptian masterpieces, Egypt's finance ministry imposes duty on such objects as incoming foreign goods.[3]

This article will examine the market in classical antiquities from Greek, Roman, and Etruscan cultures around the Mediterranean rim, and in the market in Egyptian and Near Eastern art from western Asia, the Tigris-Euphrates valley, the Arabian Peninsula, and North Africa. Most archaeologically rich countries have made it illegal or at least impractical to own, sell, or export antiquities. The ultimate market for these antiquities exists today almost entirely in urban centers of northern Europe (particularly in Germany, France, and Switzerland), in London, and in the United States, particularly in New York. This is where the dealers are concentrated, and this is where collectors, both private and institutional, come to find acquisitions. At this writing, antiquities buyers are fairly evenly distributed between Europe and the United States, with a few coming from the Middle East, Canada, Australia, South America, China, and Japan.

National economies and the exchange rates among currencies are major factors in the geographic distribution of the antiquities market. Japanese collectors were active antiquities collectors in the 1980s and 1990s, but with the decline of the Japanese economy, that market has nearly evaporated. In the 1980s, a strong dollar encouraged activity among American collectors. In 2003 and 2004, with the dollar sliding against the euro, the market strengthened in Europe.

The sellers are both private dealers and public auction houses. In many instances, both the dealers and the antiquities departments of the public auction houses work with a broader range of materials, including Pre-Columbian, Early Christian, Islamic, Asian, Byzantine, or later European decorative art, but the discussion in this chapter is limited to Classical and Near Eastern antiquities.

The major public auction houses are located in New York and London. Sotheby's and Christie's New York sales are held in June and December. In London, Christie's and Bonham's sales are in May and October (Sotheby's has only occasional antiquities sales). In 2003, public sales in Paris grew stronger. Occasional auctions also occur in Basel, Vienna, Munich, and other cities in Europe.

Auction houses sell works of art acquired on consignment from dealers, private individuals, and institutions. Sales may be organized by type of object, by period, or as collections. Each house deducts a percentage of the hammer price as commission before paying the consignor. In addition, a percentage is added onto the hammer price and paid by the

buyer to the auction house. These percentages are clearly spelled out in the auction catalogues available for each sale. Prospective buyers may bid in person, by telephone, by proxy, by mail, or on the Internet, after registering in advance in accordance with each house's rules.

Worldwide, there are about seventy-five private dealers who trade actively in antiquities, but only one-half to two-thirds of these restrict their business entirely to ancient art. Private galleries are usually small operations staffed on average by two or three people; in many instances they are operated by a couple, a parent and child, or siblings. Several galleries publish catalogues of their offerings, which they send out to clients. Private dealers also meet with the public at art fairs held in Basel, Maastricht, London, Paris, and New York. An increasing number of private dealers have Web sites through which antiquities can be viewed and purchased. In addition, there are private consultants who act as advisors to clients. Many dealers belong to professional trade organizations that meet regularly to discuss problems and issues in the field, and maintain codes of ethics and conduct for their members.[4]

There are three types of buyers: dealers, private collectors, and museums. There was a tremendous expansion in antiquities purchases between 1950 and 1995, especially among the younger museums, which needed to build collections. American museums of all sizes were active in the antiquities market in the 1980s and early 1990s, but purchasing has slowed since, as resources have dwindled in a poor economy and institutions have turned available funds to the construction of new wings, buildings, and parking lots.

The United States was late in adopting the private-collecting traditions of Europe. Until the 1950s, antiquities were considered more as curiosities than as works of art, but knowledgeable, expert curators at the Brooklyn Museum, the Metropolitan Museum of Art in New York, and the Museum of Fine Arts, Boston, built an audience for artistic masterpieces that are millennia-old. Interest was stirred by traveling exhibitions like *Tutankhamen's Treasures* and acquisitions such as the Euphronios vase by the Metropolitan. Politics also played a hand. The Camp David peace treaty between Israel and Egypt encouraged Americans not only to travel to Egypt but also to own Egyptian antiquities.

Most major private collectors of antiquities, with a few exceptions, have not become serious about their avocation until later in life. US private collectors rarely pass their passion for collecting on to their heirs, so

when the collector reaches a point in life when it is time to settle financial affairs, or after the owner's death, the collection is usually donated to a museum or sold and recirculated into the market. This means that the life expectancy of a private collection of antiquities is likely to be somewhere between twenty and forty years, and no collection remains secret for a long period of time.

In the last years of the twentieth century and the first years of the twenty-first, dealers have noted an increasingly broad middle market of private individuals spending between $10,000 and $200,000 per year. Some new buyers are brought into the antiquities market by the relatively high quality of works of art available at lower prices than in, for example, the contemporary art market. Recent publicity about the antiquities trade, both negative and positive, has educated individuals regarding the existence of a market about which they had previously been ignorant. People of diverse ethnic and racial backgrounds have a deep interest in their heritage and the financial means to collect. The ease and frequency of travel since the mid-twentieth century has also been an indirect inspiration to collectors.

In theory, the activities of dealers, private collectors, and museums are quite different, and yet they are often very similar. Many dealers have their own private collections of objects that they expect to keep for life. Some private collectors spend so much effort trading to upgrade their collections that they appear to be dealers. Museums, which theoretically buy for permanent collections, sometimes deaccession either to upgrade in a particular area or simply to raise cash.

Private dealers acquire their stock either by purchase, when a dealer buys an object outright, or through consignment, in which objects are deposited with the dealer for showing to clients. Objects on the market occasionally come from recent finds, like the site of Jiroft, Iran, where thousands of mid–third millennium BCE stone vessels with elaborate carved decorations were found. "Officials did not pay attention, since the peasants were poor because of the drought, and they thought that it was one way for them to get some money," said a local archaeologist in November 2003.[5] (In a reversal of this policy, in October 2004 two men convicted of smuggling from this site were sentenced to death by hanging.[6])

In contrast to the practices of just a few decades ago, few US or European dealers actually travel to source countries to make purchases—

the initial marketing of recent finds is now largely in the hands of source-country nationals. A dealer's stock is primarily made up of antiquities that have circulated through collections and the market for years. This trend is allied to the fact that the pedigree of an antiquity can substantially increase its value.[7] Archaeologically rich countries have limited trade, and archaeologists have become increasingly militant against private and institutional ownership of archaeological objects. According to London dealer James Ede, "For many years antiquities have been undervalued. We all welcome the fact that it is now almost impossible to sell unprovenanced pieces. It means the playing field is level, but museums and serious collectors are going to have to accept that prices for provenanced pieces will shoot up. They can't have it both ways."[8]

Still, annual sales of antiquities worldwide form only a small fraction of the total art market; they amount to somewhere between $100 million and $200 million at this time. These figures have been developed from consultation with the two larger auction houses—Sotheby's and Christie's—and with twenty private dealers in New York, London, Paris, Geneva, Montreal, Jerusalem, and Frankfurt, some of whom have, in the past few years, worked on developing such figures for their own understanding of the business. The estimates of all the private individuals as well as the public auction houses fell within this range.[9] A figure of $300 million suggested by one consultant included Islamic, Byzantine, and other materials. The lowest estimate contributed was $50 million.

Somewhere around 35 percent of all sales are from dealer to dealer, and are not end-of-market sales to private clients or institutions. This reduces the total end-market value of the antiquities trade to between $65 million and $130 million. Furthermore, one antiquity can easily be sold two or more times among dealers within the same year before reaching a final buyer. For instance, if Mr. X owns an Egyptian sculpture and sells it to dealer Y for $10,000, then dealer Y sells it to dealer X for $15,000, and dealer X sells it to Museum Z for $25,000, each seller would add the gross price into his annual sales figures. Thus, one object could be considered to have engendered $50,000 worth of sales, when its final sale value was only $25,000, and the total of profits made by the three individuals was $25,000 minus whatever Mr. X originally paid. Thus, the real annual value of an antiquities market with gross sales between $100 million and $200 million may be somewhere between $50 million and $100 million.

A handful of buyers spending $2 million to $5 million a year, or one buyer spending $10 million to $15 million, can make a huge impact on the market. This happened in the 1980s and early 1990s when the J. Paul Getty Museum and three private collectors were active in the classical area; in the late 1980s and the 1990s, when the Miho Museum in Japan was actively buying Egyptian and ancient Near Eastern antiquities; and in the past five years, when a single Middle Eastern buyer dominated the Egyptian market. At the same time, the withdrawal of one component from the market can have a powerful effect; after the death of one US classical collector in the 1990s and the reduced activity of two others, the market in classical bronzes and vases collapsed.

The market may also be gauged by auction activity. Many of the most active antiquities dealers and collectors attend the June and December public auctions in New York either in person or by proxy. The total amount of sales at these auctions ranges from less than $10 million in a typical year to more than $20 million in a very good year (less than one-twentieth the amount achieved annually in Impressionist painting auction sales in New York). Thus, a single auction season generating from $5 million to $10 million of business is a major event in such a small industry.

The antiquities market has received a number of blows in the past three decades. On the one hand, militant archaeologists are unwilling to surrender intellectual control of objects to nonspecialists—collectors, dealers, and curators—who often place higher value on aesthetics than on archaeological context. Political extremists play a hand as well; some feel that all art should be free and not traded commercially at all, while others insist on national retention of found objects. Those against the trade testify that it destroys archaeological sites by looting, which is true. Those in favor of continued trade say that war, pollution, natural disaster, and development for residential, commercial, recreational, or agricultural use are much greater culprits in site destruction.[10] This is also true. An accurate understanding of the impact of the antiquities market is hampered by popular notions that exaggerate its value, placing the annual market at multi-billions of dollars instead of the $50 million to $100 million actual value. If all parties who cherish ancient materials are someday able to come together for the common good of preserving the relics of the ancient past, then some form of an antiquities market will continue to flourish.[11] The alternative will be a dwindling market and an ever-increasing loss of interest in and affection for our ancient past.

1. Andrew Bevan, "Reconstructing the Role of Egyptian Culture in the Value Regimes of the Bronze Age Aegean: Stone Vessels and Their Social Contexts," in Roger Matthews and Cornelia Roemer, eds., *Ancient Perspectives on Egypt* (London: UCL Press, Institute of Archaeology; Portland, Ore.: Cavendish Publishing, 2003), 66-69.

2. Jennings acquired it in Rome in the 1750s for 400 *scudi,* about £80. "Appeal Earns the Jennings Dog a Home," *Art Newspaper,* international edition, November 11, 2001.

3. *Hebdomadaire Al-Ahram,* August 20, 2003: "Patrimonie. Akhenaton retenu à la douane ... Alors que le ministère de la Culture et le CSA s'evertuent à recuperer les richesses égyptiennes, le service des douanes impose des droits aux pièces de patrimoine égyptien recupe-rées de l'étranger." The amount billed on a coffin of Akhenaton sent by Germany to Egypt was equivalent to $1,627,700.

4. For example, International Association of Dealers in Ancient Art (IADAA), "A Code of Ethics for Dealers" and "The IADAA Code of Ethics and Practice," *Art Newspaper,* international edition, October 1994, 19-20.

5. "Looting Savages New Site," *Science* 302 (November 7, 2003), 974.

6. *Art Newspaper,* London, Issue 152, November 2004, 5.

7. Peter Cannon-Brookes, "Antiquities in the Market Place: Placing a Price on Documentation," *Antiquity* 68 (1994): 349-50; Cornelia Isler-Kerényi, "Are Collectors the Real Looters?," *Antiquity* 68 (1994): 350-52.

8. "Sale Report: Sadler Collection," *Art Newspaper,* December 2003, 44.

9. A similar study made four years ago for a presentation to the Association of Art Museum Directors yielded the same results.

10. In the past five years alone we can cite the Zeugma Dam in Turkey; the Three Gorges Dam in China; the Iraq War and destruction of the Baghdad museum and collections; the Afghan War and destruction of the Kabul museum and Bamiyan Buddhas; earthquakes in Athens and Sicily; the Janiculum parking lot in Rome; and the destruction of Agrippina's palace. See also "Heritage Sell-off by Italian State About to Become Law," *Art Newspaper,* December 2003, 6.

11. Peter Marks, "The Fallacy of Embargoes," *Orientations,* March 2000; Peter Marks, "Breaking the Cultural Policy Stalemate," *Orientations,* October 1995, 98; André Emmerich, "The Market Is the Key to Preserving the Past," *Wall Street Journal,* April 24, 2003.

Indian archaeologist at Harappa, Indus Valley, South Asia, 1929-30.

I INTERVIEWED THREE DEALERS in cultural objects to record their thoughts about their work, the development of their careers, and their feelings about the art objects and cultures that concern them as dealers and connoisseurs. Each dealer represents a particular field: André Emmerich, Pre-Columbian art; Michael Ward, antiquities; James J. Lally, Chinese art.

André Emmerich

I was born in Frankfurt, Germany, in 1924, spent my childhood in Amsterdam, and emigrated with my family to New York in 1940. I went to Oberlin, which had an excellent art history department in the forties. When I got out of college in 1945 it was a big, exciting world out there. While I was interested in art, I worked in public relations, then at *Time-Life,* and then as a freelance writer. UNESCO was a bright, new organization and I worked on a volunteer basis for the Visual Arts Advisory Committee for the US delegation. It was my first contact with the world of New York artists, particularly those I met through Bob Motherwell, who also served on the committee.

Finally I decided to become an art dealer, and after a brief time in Paris, which was then the center of the international art world, I returned to New York and opened a gallery. I met Nelson Rockefeller's secretary and she introduced me to what was then called primitive art, and I saw my first piece of Pre-Columbian art. A friend showed me a group of Nayarit terra-cottas he'd brought back from Mexico, which were very beautiful and very inexpensive; and to my surprise and delight I sold them immediately. I had met Gordon Eckholm, the curator of Middle American antiquities at the Museum of Natural History, and he became my mentor. Through him I had lots of introductions in Mexico. It was perfectly legal to buy antiquities in Mexico; I remember being in the house of a Mexican diplomat who used to go on Saturdays to Tlatilco, a brickyard and archaeological site in the suburbs of Mexico City where he and others—artists like Rivera, Orozco, and Covarrubias—would buy

things that the workers had found. Miguel Covarrubias was a great artist and scholar; he had identified the Olmecs as the mother culture of Middle America. He was also a dealer and made beautiful drawings of things he wanted to sell. Then there was Bill Spratling in Taxco, the American designer of silver and jewelry, who knew a lot and collected. These and other collector-dealers were always willing to sell last year's acquisitions because they needed money to buy new discoveries from the runners who'd show up at their doors. They were all competing; to get the best pieces they had to keep buying, so they always needed cash. That's where I came in.

In those days Gordon Eckholm and his colleague Junius Bird, who covered South America, were always available to collectors and dealers who wanted to show them what they had found. Gordon saw everything that was in the market as it came from Mexico. His authentication, which he readily gave to anyone, became necessary for any dealer to sell an object: "What does Gordon say?" Gordon and Junius were working, dirt archaeologists, but with a passionate interest in connoisseurship as well. Context, yes, but was it beautiful? There was an exciting, collegial sense of common purpose among collectors, dealers, and these two scholars, and we all benefited from their incredible generosity. It is really so sad that today most archaeologists, art historians, and even some curators are so adversarial toward the art market, because we accomplished so much back then when we worked together.

After my initial success I rented space at 17 East 65th Street. I was selling European and American painting as well as Pre-Columbian art. Everyone came around because I started having Saturday openings, a break with the traditional Wednesdays. It was a time for me to talk, to educate, to explain. It was a wonderful thing for people to walk up from 57th to 79th Street. There were a lot of dealers in antiquities and tribal art on Madison Avenue—no Italian fashion stores. I liked educating my clients. Eventually I wrote two books: *Art Before Columbus* in 1963, and *Sweat of the Sun and Tears of the Moon,* a scholarly study of Pre-Columbian gold and silver, in 1965.

People collected more eclectically in the early sixties than now: Pre-Columbian today, tribal art tomorrow, a French drawing next week. I think this taste for anything beautiful owes a large debt to the Surrealists. They opened our eyes to all kinds of things in art that we'd never seen before.

I never liked having all my eggs in one basket. I was fascinated with the best art of my time. The artists I met through Bob Motherwell liked Pre-Columbian art very much, so it became a logical get-together—contemporary and ancient New World art. As the painters became better known and their prices went up, it became a financial decision for me to shift decisively to contemporary art. As the field grew, new dealers came in who could devote all their time to Pre-Columbian art, while I had to see to my artists and spend time in Europe. I began to buy from American sources, taking their best pieces, and I had the courage to ask high prices, then outrageous prices. I missed going to Latin America, but I couldn't keep it up. The hostility to collecting that we see today was still a small cloud on the horizon, but I felt threatened by it. The publicity about looting of Mayan sites and the UNESCO convention of 1970 seemed to me to be the handwriting on the wall. Then the treaty with Mexico and the *McClain* case convinced me it was time to move on. I started to deal in Egyptian and Greco-Roman art, because I was in Europe anyway visiting my artists and there were antiquities dealers in London and Paris. I had always loved these things, but when they became difficult I also phased out.

Today, the cultural-property puritans seem to be ahead of the game. Perhaps a new generation will catch on and develop different attitudes, but at the moment I don't see much evidence of that. I took great pleasure in opening people's eyes to kinds of art they hadn't understood before. There is wonderful satisfaction when you bring a great object to the gallery, an immense satisfaction. I enjoyed having painting shows and having antiquities complement my artists' recent work. I enjoyed being in the art world; my business and personal lives were one and the same, and I loved that. And I really enjoy what we still have at home, the souvenirs of my career.

Michael Ward

From very early childhood I was always interested in collecting things. When I was ten or so, I had a museum in the basement of our house in Nebraska. There were Indian artifacts that my father and I collected along the roadsides and train tracks: pottery shards, arrowheads, minerals, all carefully labeled. I charged admission, ten cents, well before Tom Hoving started charging at the Met. I majored in art history in

college and then moved on to the Institute of Fine Arts at New York University. I was working on a PhD in medieval art, but I probably spent more time in J. J. Klejman's gallery. He dealt in ancient and tribal materials as well as European drawings and objects—it was a classroom of sorts. I had a Mellon Fellowship at the Met for two years, while I finished my dissertation. But there were no teaching jobs that interested me. I'd bought some things as a student, and a dealer I knew, Mathias Komor, suggested I take six months' internship with him, with the idea that I would take over his business. But when the time came to make a decision, I decided I wanted to start with my own stock and clients and do it my own way and not have a big debt to pay off. My wife, Stark, was always interested in the business, and we have worked together all these years. I began to deal from home in Brooklyn Heights but it was too far from the center of things, so in 1979 we opened a gallery in Manhattan.

Under Komor's influence I began dealing in antiquities, which were fairly available and reasonable. But Stark and I did a lot of unusual things; we had a lot of pioneering exhibitions in the eighties. We had one called *Jewels of the Barbarians—Migrations Period,* and an Eskimo show, and shows called *Origins of Design—Bronze Age and Celtic* and *Hidden Heritage—Bronze Age and Iron Age Art from Central Europe.* It was satisfying to draw people's attention to new things. We did very good catalogues and effective installations.

Then in 1993 we had what turned out to be our last show, of Mycenaean gold, which was a disaster, with the Greek government pursuing us in a lawsuit, although we had written to them and sent photographs asking if the objects were okay. That discouraged us from doing anything public again. If we had broken up the gold collection, sold things separately, and not had an exhibition or published a scholarly catalogue, we would never have had the problem. It paralyzed our business for more than a year. We realized that it was political; the Greeks had concocted a provenance for the pieces so they could be claimed as cultural patrimony. The fanatical political agenda was more important than the truth. American archaeologists had embarrassed the Greeks into doing something. The news media called the gold national treasures, and made that appear much more important than what the pieces could tell us about ancient Greece. Recently, a Greek minister said the whole thing shouldn't have happened, but it's ten years later and that doesn't help

me. We were lucky that it was a civil suit, not a criminal one: now the stakes have gotten a lot higher, riskier.

It's good to have my wife working with me, to have someone to talk to about purchases and issues and money. It's good to talk with someone you really trust, whose opinion you seek. She's been very helpful in acquiring things that she likes, that we both like. We met at the institute, the first day, in the medieval library, and we've been married since we were twenty-four, and it was she who pushed me to become a dealer. We have some things at home, but we decided we shouldn't collect against our clients. Now we have nineteenth-century drawings and paintings. Mostly we collect debts.

I think the public perception of collecting would change if the American museums would stand up to the small but vocal group that wants to stop dealing and collecting in ancient art. If antiquities belong only in the countries of origin, then why do we have them? Why not just close American museums down and collect American art? I think the American public would be shocked if they knew what's really going on, with countries making demands for repatriation of objects from our museums. They would want museums to stand up and fight these challenges.

The press is also anti-collecting. Jonathan Rosen, who has a great collection of Mesopotamian cylinder seals that will someday go to an institution, gets nothing but slaps from the press even though he's doing an exceptional thing for scholarship. If you walk up and down the Mall in Washington, you see the Freer and Sackler museums——Freer and Sackler were collectors; the Hirshhorn—a collector; the National Gallery—the Mellons, Kress; all collectors. There's a class war going on; people don't like the rich who buy works of art. They think that art is nothing more than a status symbol. Museums have contributed to this with the "Treasures of X" blockbuster shows. It gives a masterpiece mentality to the whole field of collecting, which is very different from how collecting was in the past. And the press covers the auctions as if they were major sports events, publishing record prices.

If there were no demand, no market, nobody would be looking for antiquities, but I think more damage is being done by modernization, construction, huge building projects. Dams have wiped out vast areas where there were cultures we'll never know about. That's what people should be thinking about, not a few cemeteries that get pillaged, which were pillaged from the time they were built. Context is important, but

to some people, objects have a meaning that transcends context: their humanity, their expression, something that we admire and that puts us in awe of the artist. And that's what we feel is important. These objects continue to live for that reason, and play a part in our spiritual lives.

James Lally

I grew up in Boston and was exposed to a superb museum with excellent Asian collections, but my first introduction was through an aunt who was fascinated with the China trade, rather than ancient China. My career began in 1969, when I was introduced to someone at Sotheby's and suddenly my eyes were opened. I realized that you actually could be in an environment where you were paid to constantly play with and learn about art. After a year or two at Sotheby's I wangled my way into the Chinese art department. There was no formal mentoring system. The management style was to take very young people and throw them in up to their necks. They'd put me in a room with a hundred pots and say, "Come out when you've finished cataloguing them." Then they'd say, "Right, what do you think about this; what about this?"

I spent a year in London, which was a great learning experience. The real benefit was that, with a little card that said "Sotheby's," I was immediately admitted into the community of those who loved Chinese art. The Chinese trade was thriving in London partly because of an American embargo on Chinese goods in the fifties after the Communist takeover.

I was at Sotheby's for fifteen years. After five years the learning curve began to flatten. I could see that dealers had freedom from the hassles that go with handling a volume of secondary material. I wanted to be able to concentrate on the best things. The politics at Sotheby's became a drag. I ended up being president of Sotheby's in New York, and before that executive vice president, which meant that I was doing everything the president didn't want to do and spending less time with the art and the people who loved it. Also I had Sotheby's stock, and when Alfred Taubman bought the company and my shares, it put a little capital in my pocket to start my business.

It's very difficult to explain the mainland Chinese government's attitude toward the trade in ancient objects currently being excavated in China. They have a horribly bad record in terms of preserving cultural

property within China in the years following the Revolution. Starting in 1949 there was more wholesale destruction of cultural property over the next twenty-five years than there had been in any other time. State-directed destruction of ancient temples, architecture, and works of art was followed by the Cultural Revolution, when there was persecution of anyone who showed any interest in works of art or preservation of ancient material. Art became of interest to the Chinese only in the seventies, when the use of cultural property for political ends became clear to them. They could bask in the glow of China's ancient glorious history, and earn hard cash, too.

In the eighties the market opened up in Hong Kong, and there was a very loose policy that was consistent with their previous policy, which was "Let's see what happens." A schizophrenia arose when the state's glorification of the past clashed with the problems of dealing with an enormous volume of material. The Chinese museum system is very small, and they can't even begin to count the number of Neolithic pots they have. China is not a country of law books like England or America; it's a law of men, and as it suits their purposes they cry patriotic or they act as practical men. For the Chinese, this ambiguity is a fact of life. They look at us and say, "How bizarre. They put a question to a law book." Their idea is just to let a policy grow. You'll get the party line from an official, but in practical application they are far more liberal. I've just received eleven beautifully produced catalogues from an auction house in China—bilingual, by the way. There are big auction houses in Beijing, in Shanghai, and elsewhere. These privately owned salesrooms started by selling the huge accumulations of objects, confiscated from landlords, that had been sitting in state warehouses for years. Those pieces are gone. And now they're actually coming to ask me whether I have anything I want to sell at auction in Beijing. The export policy for the sales is, again, ambiguous. Most lots are marked "not for export," but after the sale they get the buyer and his purchases a taxi to the airport.

Ma Chengyuan, the director emeritus of the Shanghai Museum, was in New York recently; he was at a New York collector's house to see his collection of Chinese bronzes. We all had dinner together and Ma Chengyuan praised the collection, which he knew had been formed in the last ten or fifteen years, and said wouldn't it be nice if it was in an American museum one day. He has so much archaic bronze material in Shanghai that there were only a handful of bronzes in the New York

collection that he has any interest in capturing. But he has no interest in upsetting the apple cart. He didn't insist that anything go back or that all Chinese art should remain in China.

In Hong Kong there was a large, very wealthy community of Chinese who had been forced out by the Communists in 1949. They had wonderful material and wonderful knowledge. I learned as much from collectors who had been active for many years as I did from my colleagues at Sotheby's or museum people. It's this community of many different people with different interests within the same general sphere that allows for hands-on experience and the exchange of opinions, ideas, and information. This is an essential process to understand artworks produced in a different world, many centuries ago.

Looking back, the sense of community seems to have changed for the worse, but that may be a function of aging: looking at the past through rosy glasses. I'm thinking of Pauline and Johnny Falk, great collectors of Chinese ceramics who passed away in the last decade. They had been head of the Oriental Ceramic Society in America. They were great hosts and brought people together so generously. Their shoes are very hard to fill. The game was more fun when there were fewer zeros because the market could involve people who were not necessarily from one highly moneyed class, and it was easier to involve people on an intellectual plane. The price of making a mistake wasn't so great, so there was less paranoia. It was easier to speak frankly about a piece when it cost a hundred dollars, not a million dollars.

I've tried to have a good catalogue once a year—to find the best objects I can. The quest is the most important pull on any dealer, to find a great object, whether that involves discovering it in plain sight because it had been previously misidentified or unappreciated, or paying more than anybody else to grab it when everybody knows it's the best. The first and most important thing for me is to have that unmediated firsthand encounter with a great work of art, then to present it in a way that brings it into the hands of the right collector. Finding that person gives me more satisfaction than placing a work of art in a museum. The museum experience of art is very different from the collector's experience. There are objects that are less suited to museums: a great Song ceramic is meant to be held in the hand. Its texture, the way it looks in different light, the weight of it, the balance, is something that is essential to the appreciation and the pleasure of a Song pot. A Chinese hand scroll is meant to

be interactive art that you walk through with your hands as you unroll it section by section.

What's the ultimate end for active dealers? I won't walk away from Chinese art. But rent and advertising and catalogues and travel are huge expenses—you pedal very fast just to make expenses. So I see myself quietly slowing down to a time when there is no need to have a gallery. I think more and more people are taking this tack, and some dealers whom I admire tremendously have been able to set up in a quiet countryside location where people come to them. It's unfortunate, or maybe fortunate, that as you get more esoteric in your taste and as prices become more forbidding, less is more.

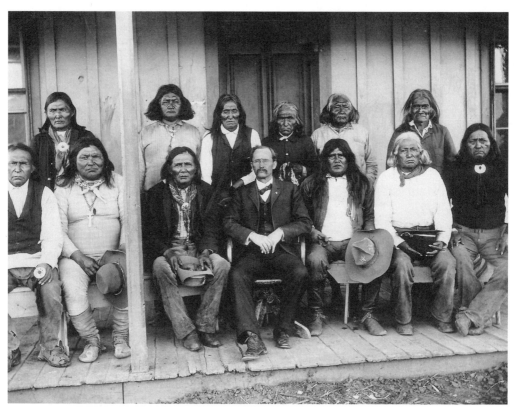

Trader Carl Harberg with Jicarilla Apache chiefs, Mora, New Mexico,
c. 1890. Photo courtesy Anahita Gallery, Inc. All rights reserved.

ATADA: BUILDING ETHICAL CONSENSUS THROUGH TRADE ORGANIZATION

IN 1988 A GROUP OF DEALERS of antique tribal art formed the Antique Tribal Art Dealers Association (ATADA). They recognized that tribal and ethnographic art was reaching a level of specialization and connoisseurship found in other fine art fields and were concerned by the proliferation of misidentified and pastiche materials on the market. They believed it was important to establish standards for documentation of ethnographic works in the market, and to foster appreciation for the important contribution of tribal and so-called "primitive" peoples to the cultural history of humanity. At that time, antiquities from some countries were protected but the trade in tribal art was largely unregulated, except for laws dealing with components made from protected birds or endangered species.[1] In forming the Antique Tribal Art Dealers Association, these dealers hoped to establish ethical standards and a greater respectability for the trade by guaranteeing the authenticity of objects, providing provenance where possible, and assuring that objects had good title and were properly acquired.

"Primitive Art" Collecting

To the bearers of Western culture in the late nineteenth and early twentieth centuries, human progress was considered a series of graded steps, with nomadic hunters at the bottom and Western/European civilization at the pinnacle. The most important consideration in dealing with native cultures was to integrate the children of those cultures into Western society, deemed a step up the ladder of civilization. To improve their perceived status, children of Native American cultures were often sent to government or mission boarding schools without regard to parents' wishes, and punished for speaking native languages at school.

In the United States and Canada, native religions were discouraged and legislated against. Missionaries from several Christian sects encouraged the destruction of paraphernalia used in tribal religious celebrations. The government and Western religions were not the only culprits.

In 1911, the Native American Church decreed that all relics of the older religion should be burned.[2] It was not until 1978 that the United States enacted the American Indian Religious Freedom Act, allowing native religions the same rights given to others.[3]

During the period of religious repression, objects were often collected to "save relics of dying cultures" with little thought as to how the native peoples would react to this concept. There was a flurry of activity by budding ethnologists, eager for specimens for competing museums. Objects were purchased when possible, but were also taken from religious shrines and deserted encampments and as war trophies, both in the United States and abroad.[4] An example of this occurred during the survey expedition from Seattle to Alaska sponsored by Union Pacific Railroad chairman Edward H. Harriman in 1899. A Tlingit village near Cape Fox, Alaska, "appeared abandoned." The inhabitants were away salmon fishing. The expedition took totem poles, an entire decorated clan chief's house, ceremonial blankets, boxes, drums, masks, and helmets. These were later distributed to some of the expedition members' affiliated museums and private collections.[5]

Tribal objects were generally considered artifacts of natural history rather than art when they became part of early museum collections. In 1923, Stuart Culin pioneered the first major exhibition in the United States of ethnographic objects as art rather than anthropology, with the exhibition *Primitive Negro Art* at the Brooklyn Museum. He then installed ethnographic collections as art in the Rainbow House gallery in 1925.

Greater public awareness followed the exhibition *Indian Art of the United States,* curated by Frederic H. Douglas and René d'Harnoncourt at the Museum of Modern Art, New York, in 1941. Nelson Rockefeller's collection, first shown by the Museum of Primitive Art, and later by the Metropolitan Museum, New York, is now considered a standard of aesthetic refinement in tribal art.

Market prices for ethnographic objects remained fairly low when compared with European art and antiquities. The sale of the Green collection of American Indian art by Parke-Bernet in 1971 is considered a benchmark, when prices began to reflect the quality of tribal objects as art.

Since that time, as with other valuable objects, fakes have proliferated. Hobbyists have made objects for their own use for many years, even re-creating tribal encampments using the most authentic materials

they could find. These artifacts began to turn up on the antiques market, appearing in major auctions and collections. Fortunately, some of the better craftsmen have had enough pride in their work to help identify those pieces not made by native artists. As prices rose, it became more important for serious collectors to study the history and details of manufacture of their pieces, or to deal with someone with experience whom they could trust.

203

ATADA and the Trade

ATADA is a self-policing organization. Under Article X of its bylaws, prices of objects at a show or gallery must be displayed. Upon request, dealers must supply purchasers with a written guarantee of title, condition, and authenticity. ATADA discourages members from selling objects accorded reverence by functioning religious or cultural communities. Information on ATADA's objectives, goals, bylaws, and membership, and a directory of full members and their specialties, can be found on its Web site, www.atada.org.

Full members must have been full-time dealers for at least two years and be recommended by two members of the organization. Only persons the membership feel have lived up to the standards ATADA has established are voted in as full members. Only full members have voting rights in the organization or the right to use the ATADA designation or logo. A majority of the dealers who formed ATADA dealt primarily in Native American material, but a growing number of members deal in world tribal art, and are bringing the same standards to this broader stage.

Any interested party, at the discretion of the board, may become an associate member, and there is a special discounted membership for museums. All are listed in the ATADA directory and receive the quarterly newsletter with minutes of the board meetings and articles of interest to the membership.

Since its inception, ATADA has sent its members regular notices of objects stolen from collectors, tribes, museums, or dealers. It maintains a theft alert on its Web site. This service is open to anyone who has had objects of tribal origin stolen. A police report and contact officer are required, and photographs are encouraged. Wide dissemination of images of stolen objects has proven very useful in their recovery.

While establishing ethical standards remains the basis on which ATADA was formed, of equal importance to the membership is its educational responsibility. The organization has sponsored symposiums and provided speakers on aspects of collecting tribal art, and has organized special exhibitions comparing genuine artifacts with tourist production and faked objects.

In 1997, ATADA initiated a scholarship grant for Native American students of Native American art, and continues to provide grants to various museums and scholars. ATADA also has provided funds toward clarification of legal issues affecting the trade. Initially, grants were provided from ATADA's general funds and donations. The ATADA Foundation was created in 2000 to provide grants to individual scholars, museums, and other entities. The foundation is a 501(c)(3) nonprofit corporation funded by tax-deductible donations. Information on the ATADA Foundation and the grant application process can be found on the ATADA Web site.

NOTES

1. Ron McCoy, "Feathers and the Law," www.atada.org.

2. Diana Fane, Ira Jaknis, and Lise M. Breen, *Objects of Myth and Memory* (Brooklyn Museum in association with University of Washington Press, 1991), 282.

3. 42 U.S.C. § 1996.

4. The Benin bronzes in the British Museum are examples of war trophies, collected by a British military force in Nigeria in 1897.

5. Although the true circumstances of the appropriation have been known for years, only under NAGPRA have any of the museums returned any of the items—four totem poles and five architectural fragments from the clan chief's decorated house.

A MODERN CHALLENGE TO AN AGE-OLD PURSUIT
Can Cultural Patrimony Claims and Coin Collecting Coexist?

PETER K. TOMPA, ANN M. BROSE

NUMISMATICS IS ONE OF THE FEW academic endeavors in which ideas are exchanged freely among collectors, academics, and museum professionals. Although pressure from source countries, field archaeologists, and government bureaucracies on collecting any ancient artifacts continues to threaten the hobby, the growing recognition of the benefits of cooperative approaches like that already implemented in Britain offers hope for the future.

Several unique factors argue against the imposition of legal restrictions on collecting historical coins:

- The wide circulation of historical coins makes them impossible to link to any one modern nation-state. No one, not even experts, can tell where or when a particular coin was found merely by looking at it.

- Most historical coins found in collectible condition are recovered outside archaeological sites.

- There are hundreds of thousands, if not millions, of historical coins extant—plenty to serve the needs of collectors, academics, and museums.

- Numismatists have contributed substantially to our understanding of ancient cultures, and should not be discouraged in their endeavors by unwarranted government regulation.

- Regulating use of metal detectors can drastically reduce looting of archaeological sites in search of coins. Great Britain's Treasure Act provides a model regulatory scheme that recognizes there are interests beyond those of archaeologists and the state.

Although these factors strongly suggest that coins should be treated differently from many other objects, numismatists face pressure to curtail collecting. The continued freedom to collect will ultimately depend on the efforts of collectors to press these arguments against those who would restrict their hobby.

Historical Coinage

History illustrates the wide distribution of coins since antiquity, and the vast quantities that were minted.[1] The first Western coins were struck in what is now Turkey around the seventh century BCE. Archaic Greek coinage was made of silver, gold, or electrum and was treated as bullion. Such coins circulated widely; the Asyut Hoard, buried circa 475 BCE in Egypt, contained an estimated nine hundred coins of Greek manufacture from more than seventy mints located throughout the Greek world.[2]

Athens became the dominant power in Greece after its victory over the Persians in 479 BCE. It controlled vast quantities of silver received in tribute and from the rich silver mines at Larium. The Athenian "Owl" took its name from the familiar of Athena on the coin's reverse. The type became a favored trade coin, and as a result it was copied widely as far to the east as Afghanistan. Due to its popularity, the design was not updated for two centuries.

During the reign of Alexander III ("the Great"), Macedonia conquered the Persian Empire, ushering in a transition from what we call the Classical to the Hellenistic era. A historical note provides some indication of the scale of the plunder that fell into Macedonian hands. When Alexander dispatched some ten thousand of his troops back to Macedonia from Susa (in what is now southwestern Iran), he gave each soldier a talent (approximately fifty-eight pounds of silver) from the Persian Great King's treasury.[3] This enormous payoff required the minting of approximately fifteen million silver tetradrachms, many of which have come down to us today.[4]

Alexander brought the regular use of coinage to the whole Near East. His Hellenistic successors continued striking his coin types until about 175 BCE. These coins circulated with others with the portraits of Alexander or the Greek dynasts that emerged after Alexander's death. Some of the most interesting types come from the periphery of the Greek world in Bactria (modern Afghanistan) and attest to the vibrancy of Hellenic culture thousands of miles from mainland Greece.

Rome did not produce coins until about 300 BCE. By the time of Augustus, Rome had created a monetary system that included token bronze coins, the silver denarius, and the gold denarius aureus. This system remained remarkably stable for some 250 years, with huge numbers of Roman coins traded as far west as England and as far east

as Sri Lanka. Changes in coinage in the sixth century accompanied the gradual emergence of the Byzantine Empire. Large copper coins replaced small Roman ones, pagan symbolism disappeared, the facing bust was introduced, and Greek, rather than Latin, was used in titulature. A link to the late-Roman coinage system continued with the striking of large numbers of gold solidi. For more than five hundred years, this coin, known as the bezant, was the principal trade coin of the Mediterranean world.

The barbarian peoples of the West became familiar with coinage through trade and tribute and in payment for services as mercenaries. As Rome faltered, the scale of tribute increased dramatically, and by 437 CE the annual subsidy Rome paid the Huns was as much as twenty-one hundred pounds of gold, most of it probably in the form of coin.[5] Eventually, the barbarian peoples began striking their own coinages based on late Roman denominations. In the eighth century, as economic activity increased, a new silver coin called the penny began to circulate in northern Europe. By the fourteenth century, the exploitation of new mines allowed heavier silver coins to be issued. Around the same time, the Italian mercantile states began striking gold trade coins, called florins. Such coins were copied widely, notably by the kings of Hungary, who controlled rich gold deposits.

A huge influx of precious metal from the Spanish conquest of Mexico and South America in the sixteenth century completely altered the economic balance between the Christian and Muslim worlds. European-style coinage was spread throughout the world. So much gold and silver entered the market that coins were no longer struck by hand but by machine. Ultimately, increases in the money supply and the beginnings of modern credit and banking systems led to the use of paper money for large transactions. Two world wars and the Depression helped end use of precious-metal coins in day-to-day transactions. Fiat coinage used today circulates freely only within national boundaries or distinct economic zones like that of the euro. As a result, only collectors' coins continue to pass across national borders.

Collectors and Their Coins

The older the coin, the more likely that it originates from a large group saved together in a hoard. Before modern banking systems, hoarding

was extremely common; it exists even today where conditions are unsettled. If the owner is prevented from returning, such a hoard may not be rediscovered for hundreds, even thousands, of years. Hoards need not be buried, but the practice of secreting coins in protective containers in the ground has been a boon for collectors. Most ancient coins found in collectable condition come from hoards found in pots that may contain hundreds, even thousands, of coins. One hoard found near Modena, Italy, in the eighteenth century contained some eighty thousand gold coins of the Roman Republic. Another found at Reka Devnia in Bulgaria contained more than one hundred thousand Roman silver coins.

Archaeologists classify hoards based on an interpretation of what caused the coins to be brought together in the first place. An emergency hoard consists of coins and other valuable objects, hastily deposited together in response to a threat. In a savings hoard, the sequence of coin types indicates that it was accumulated over a longer period of time. The purse hoard represents lost spending money. Frequently, coins in such a hoard are found fused together in the shape of the purse, which disintegrated long ago.

Hoards found at archaeological sites are often limited to purse hoards containing relatively few numbers of coins. Why? The reason is intuitive. An individual would strive to hide his savings away from the prying eyes of neighbors. Aristophanes, the Athenian dramatist, captures this point in the following line: "No one knows of my treasure, except perhaps a bird."[6]

In contrast, the vast majority of coins that archaeologists uncover are scattered finds of ancient "small change" or, as one archaeologist has quipped, "those coins most readily lost with the least regret."[7] The numbers can be staggering. At excavations at the Athenian Agora, more than 120,000 coins were found, but only a few were valuable gold or silver.[8] Again, the reason comports with human nature: even today, one is more likely to pick up a quarter than a penny.

The fact that archaeologists find mainly single coins is of some significance because coins found outside of protective containers are far less likely to be desirable to collectors. Generally speaking, coins embedded in loamy or chalky soil may be well preserved;[9] those found in wet, humid, salty, sandy, or acidic environments are likely to be so corroded or abraded as to be unidentifiable.[10] The increasing use of modern fertilizers in source countries exacerbates such problems and exposes more

and more unexcavated coins to severe damage through chemical inter-
action with the soil every year.

Even in ancient times, people collected old coins as curiosities. The
practice of Greek, Roman, and Medieval authorities of striking coins
derived from earlier designs suggests that such coins were readily avail-
able to serve as prototypes.

During the Middle Ages, most coins that were discovered were
melted to recover their precious-metal content. Early coins began to
be appreciated as historical relics and works of art during the Renais-
sance. Initially, serious coin collecting was identified with the nobility.
For example, the Hapsburg Emperor Charles VI was such an avid collec-
tor that he brought his coins along with him on campaigns in specially
constructed traveling cases.[11]

The nineteenth century saw the creation of numismatic clubs that
have given important stimulus to serious collecting and study of coins.
The two most important groups in the United States are the American
Numismatic Society (ANS) (founded 1858) and the American Numis-
matic Association (ANA) (chartered 1912). While the ANS maintains an
academic emphasis, the ANA aims to popularize numismatics for all.

Coins are purchased from auctions, wholesalers, collectors and
estates, on the Internet, or at domestic and foreign coin shows. A particu-
lar coin may be traded multiple times among dealers before being sold
to a collector. The very nature of this trade—added to the original wide
dispersion of the coins themselves—makes determining the provenance
of any particular coin virtually impossible.

Numismatics remains one of the few pursuits where collectors and
dealers collaborate freely with scholars in an effort to further knowledge
in the field. Serious numismatic studies were first published in the six-
teenth century. The earliest works focused on imperial portraits found on
Roman coins. From the sixteenth to nineteenth centuries, most efforts
were devoted to publishing the collections of European monarchies.
Later in the nineteenth century, catalogues were published that allowed
collectors to easily identify coins in their possession.

In the twentieth century, collector-funded journals, magazines, and
newspapers appeared with frequency. Auction catalogues also became
extremely important tools for study and identification. The *Syllogue
Numorum Graecorum* series illustrates public and private collections of
Greek coins. Since 1975, the Royal Numismatic Society has published

the *Coin Hoards* series, which lists hoards reported from both official and non-official sources. The ANS has also published a long series of monographs on coins, and individual collectors have written extensively about areas in their own expertise. These range from modest efforts in periodicals aimed at collectors to scholarly tomes on entire series.

Numismatics has embraced the Internet. Amateurs have created many Web sites; they range from minimally descriptive visual catalogs to scholarly studies of whole coin series. The potential for scholarly research over the Internet also calls into question the practice of museums that keep large stores of coins in their collections. With the ability to digitize and display the coins on the Internet,[12] it may no longer be necessary to retain large numbers of duplicates for study purposes.

Challenges to Coin Collecting

Why do collectors collect? It is often said that individuals collect Greek coins for their beauty and Roman coins for their historical value, and certainly both considerations are important. Collectors of Medieval, Islamic, and Oriental coins often take a scholarly approach to collecting. These issues are particularly difficult to identify without developing specialized knowledge that becomes its own reward. Devotees of more modern issues tend to collect for the history and the geographical diversity these coins represent.

The archaeological establishment is not sympathetic to such pursuits. Rather, it advocates restrictions on the collection of all ancient artifacts, including items as common as coins. The charge leveled against numismatists is that purchasing historical coins without a provenance encourages looting of archaeological sites. The damage is said to be twofold. First, removing coins from their archaeological context without properly recording them leads to the loss of important historical information. Second, digging for coins disturbs the archaeological sites themselves, damage that will only increase as improved metal detectors allow coins to be located at ever-greater depths.

The archaeological community's obsession with context puzzles numismatists. Numismatists believe that *all* coins carry useful information about the political, military, and economic situation at the time they were issued. Indeed, numismatists derive their own context from the study of design devices used on coins, the number and chronology

of dies used to strike given series, and the metallurgical content of various issues. For that reason, numismatists categorically reject the claim that coins lose value as historical objects if the circumstances of their discovery are not preserved.

In any event, numismatists believe that it is unrealistic to ask collectors to purchase only provenanced coins when there are hundreds of thousands, if not millions, of historical coins already circulating in trade with no known provenance. Numismatists also question the archaeological establishment's failure to record the provenance of many coins typically found at archaeological sites. Indeed, because archaeologists do not ordinarily use metal detectors or sieve the earth that they excavate, coins smaller than a US dime in size may not ever be recovered in the first place.

Numismatists also question the claim that their activities encourage destruction of archaeological sites, pointing out that most coins in collectable condition probably originate from large hoards that tend to be found outside archaeological sites.[13] In contrast, the coins that are found on archaeological sites are likely to be too corroded from exposure to the elements to be of interest to collectors.[14]

Source countries' arguments for restrictions are somewhat distinct. Many argue that all archaeological items found within their borders represent the nation's cultural patrimony, and should be subject to restrictions for the nation's own protection. In many such countries, collecting even common items like coins is illegal or restricted in some fashion. American collectors are affected to the extent that these countries ask the United States to restrict imports of coins or to return coins that were allegedly illicitly removed from these countries.

Numismatists argue that such restrictions place a cloud on the title to hundreds of thousands, if not millions, of coins already in private hands with no known provenance. They state that it is impossible to tie artifacts like coins to one particular modern nation-state's cultural patrimony, because coins have circulated widely across national borders as hard currency for centuries.

Numismatists also dispute the assertion that returning objects to their supposed country of origin encourages their protection and study. Wartime looting of museums in Iraq and Afghanistan, and less recent but no less devastating losses in Bosnia, Croatia, and Lebanon, should give pause to anyone who thinks that museums always provide the best

protection for artifacts. In any event, many national museums in source countries already hold far more coins than they can properly study, preserve, and display. For example, the Museum of Anatolian Civilizations in Turkey holds some seventy thousand coins, the Iraq National Museum holds more than one hundred thousand coins, and the Numismatic Museum of Athens holds some six hundred thousand coins. It is not surprising that thousands upon thousands of coins in source-country museums never leave storage. Easily forgotten, such coins may suffer deterioration due to poor conservation techniques (especially in humid environments) or even theft from underpaid staff or corrupt officials. Certainly, source countries have not always treated coins as "national treasures."

Britain's Treasure Act of 1996—An Alternative Way Forward

Rather than seek restrictions on US collectors, foreign states and archaeologists should investigate the success of the United Kingdom's Treasure Act, and determine if adoption of a similar law could help limit looting of coins and other artifacts from archaeological sites. The Treasure Act of 1996 provides a system of incentives not usually found in source-country legislation. It gives museums a right of first refusal, finders the prospect of a reward, and dealers and collectors the prospect of access to coins with a demonstrable provenance; it also provides archaeologists with reports on finds that may lead to the discovery of otherwise unknown archaeological sites. In contrast, many source countries declare all finds state property and offer little or no reward to finders.

The large rise in the number of finds attributed to the use of metal detectors[15] in the last three decades prompted codification of common law Treasure Trove that dates from Anglo-Saxon times. The act regulates all historic finds made after September 24, 1997. As the definition currently stands,[16] classification of an object as "Treasure" turns on the age, composition, and finding location of an object. Five categories of objects are classified as Treasure:

1. Any metallic object other than coin, provided that at least 10 percent by weight of metal is precious metal (i.e., gold or silver) and that it is at least three hundred years old when found. If the object is of prehistoric date, it will be Treasure provided any part of it is metal.

2. Any group of two or more metallic objects of any composition of prehistoric date that comes from the same find.[17]

3. All coins from the same find, provided they are at least three hundred years old when found, but if less than 10 percent precious metal, there must be at least ten of them.[18]

4. Any object, whatever it is made of, that is found in the same place as, or had previously been together with, another object that is Treasure.

5. Any object that would previously have been Treasure Trove but does not fall within the other four specific categories, provided that the object is: a) less than three hundred years old; b) made substantially of precious metal; c) deliberately hidden with the intention of recovery; and d) without known owners or heirs.

Unlike common law Treasure Trove, there is no need to establish that the items were hidden with the intention of recovery. Items that do not meet the above criteria are not Treasure under the act. Specifically not included in the law are (1) objects whose owner can be traced; (2) unworked natural objects, including human and animal remains; (3) objects from the foreshore that is a wreck; (4) single coins found on their own; and (5) groups of coins lost one by one over time.

All suspected Treasure must be reported. The obligation to report extends to everyone, including professional archaeologists, and it is taken seriously by the state—the penalty for failure to report is imprisonment for up to three months and/or a fine of up to £5,000. Once the find is reported, an expert then determines whether it is actually Treasure and, if so, informs the British Museum, the National Museums and Galleries of Wales, or the Environment and Heritage Service, Northern Ireland. If these organizations or any other museum wishes to accession the find, a Treasure Valuation Committee holds an inquest to determine the value of the find, and the finder will receive just compensation. However, if the finder is an archaeologist or committed an offense in relation to the find (e.g., trespass), that person will receive a reduced award or no reward at all; the reward will go instead to the landowner or occupier. If no museum wants to accession either all or part of the find, the finder retains ownership with all of the accompanying rights.

While there is some anecdotal evidence of noncompliance by so-called "nighthawks," efforts at outreach appealing to national pride and publicizing the act's system of rewards and punishments appear to have had the desired effect. Proof is in the number and significance of finds recorded.[19] Prior to 1997, the government recorded an average of 25 finds declared Treasure Trove per year; in the last four years of reporting, the average has been around 240 finds annually, with the numbers trending upward each year.[20] Moreover, recent reported discoveries include an early Bronze Age gold cup worth £270,000,[21] a collection of Iron Age gold jewelry,[22] a coin of a little-known Roman usurper,[23] a hoard of up to twenty thousand Roman coins,[24] and a bronze bowl bearing the names of forts along Hadrian's wall.[25] Indeed, recently the British Museum put on display some of the more spectacular finds made under the act.[26] Whether this type of statute could be successfully applied outside the United Kingdom remains to be seen; however, the numbers suggest that other countries should investigate the act's success closely.

Conclusion

Coins are different from many other ancient artifacts. To date, such differences have helped convince the US government to decline to impose import restrictions on ancient coins based on separate requests from the Republic of Cyprus and from Italy. It remains to be seen whether other import restrictions will be imposed in the future or whether collectors will face seizures based on foreign patrimony laws.[27] Ultimately, whether these pressures can be resisted successfully will depend on the commitment of collectors themselves to help shape the debate.

NOTES

The author would like to thank his wife, Kelly Goode, and Jonathan Metzger, a fellow numismatist, for their suggestions, and to dedicate this article to his late father, Robert J. Tompa, PhD.

1. This chapter focuses on coins struck by Western civilizations. China and the East have their own traditions. Although space limitations do not allow us to discuss this coinage, many of the same observations apply.

2. See Martin Price and Nancy Waggoner, *Archaic Greek Coinage: The Asyūt Hoard* (London: V.C. Vecchi, 1975); see also Ian Carradice and Martin Price, *Coinage in the Greek World* (London: B.A. Seaby, 1988), 35.

3. Carradice and Price, *Coinage in the Greek World,* 112.

4. Ibid.

5. Jonathan Williams, ed., *Money: A History* (New York: St. Martin's Press, 1997), 63.

6. Aristophanes, *Birds,* 599–602, quoted in John R. Melville Jones, *Testimonia Numaria* (London: Spink & Son, 1993), 369.

7. Peter K. Tompa (unattributed author), "Mary Washington College Presents Symposium on Ancient Numismatics," *American Numismatic Society Magazine* 8, no. 10 (spring 2002).

8. Letter from Alan Walker reproduced in *The Celator,* August 2003, 4.

9. P. J. Casey, *Understanding Ancient Coins: An Introduction for Archaeologists and Historians* (London: B.T. Batsford, 1986), 88.

10. Ibid.

11. Elvira and Vladimir Clain-Stefanelli, *The Beauty and Lore of Coins: Currency and Medals* (Newmarket, Ontario: Riverwood Publishers, 1974), 219.

12. For example, the Celtic Coin Index at the Institute of Archaeology, Oxford, currently maintains a database of thirty-five thousand coins in public and private collections.

13. Of the forty coin finds reported in the *Treasure Annual Report 2001,* only three were in controlled archaeological surveys. Although several were found during building excavations, the vast majority were discovered by individuals with metal detectors. Department for Culture, Media and Sport (DCMS), *Treasure Annual Report 2001,* www.culture.gov.uk/global/publications/archive_2003/TreasureAR_2001.htm.

14. See John H. Kroll with Alan S. Walker, *The Greek Coins* (Princeton, N.J.: American School of Classical Studies at Athens, 1993), 1. ("In comparison with museum or hoard specimens, it is in the area of absolute metrology that the Agora specimens are most deficient. Most are worn to some degree; almost all were found in a heavily corroded state.")

15. In the 2001 annual report, 93 percent of the finds were made by metal detectors. See DCMS, *Treasure Annual Report 2001.*

16. It was extended in January 2003.

17. An object or coin is from the "same find" if it is found in the same place as, or had been previously together with, the other object.

18. Groups of coins normally regarded as from the same find include hoards that have been deliberately hidden, or smaller groups of coins, such as the content of purses, votives, or natural deposits.

19. The results of the act are documented in the *Treasure Annual Report to Parliament,* which provides descriptions of the finds by period, type, and method of discovery, in addition to a catalogue of the artifacts with descriptions and images. The report also details the disposition of each find (i.e., whether the objects were declared Treasure for the state or returned to the finder).

20. See DCMS, *Treasure Annual Report 2001.* Coin finds make up only part of the total number of reported finds. For example, the *Treasure Annual Report 2001* lists 214 finds, of which 40 were coin finds. Finds were down somewhat from the prior year because a foot-and-mouth disease crisis restricted access to the countryside.

21. "Large Increase in Treasure Finds on the Way Says Arts Minister Estelle Morris," DCMS press release, October 15, 2003.

22. "Treasure Law Successful in Getting More Finds on Show," DCMS press release, August 14, 2002.

23. John Andrew, "Roman Coin Find Confirms Ruler," *Coin World,* March 15, 2004, 1.

24. Jeff Stark, "Roman Bronze Coin Hoard Excites UK Archaeologists," *Coin World,* April 5, 2004, 1.

25. Peter A. Clayton, "Roman Bronze Bowl Depicts Map of Hadrian's Wall," *Minerva* 15, no. 1 (January/February 2004): 4.

26. Peter A. Clayton, *"Treasure: Finding Our Past," Minerva* 15, no. 1 (2004): 8.

27. One publicized incident involving a hoard that included valuable Athenian decadrachm coins ended with the coins being sent to Turkey as part of a confidential settlement. Although such a settlement provides little legal precedent, the trend certainly is toward returns of more significant artifacts.

PART III **ART IN PERIL**

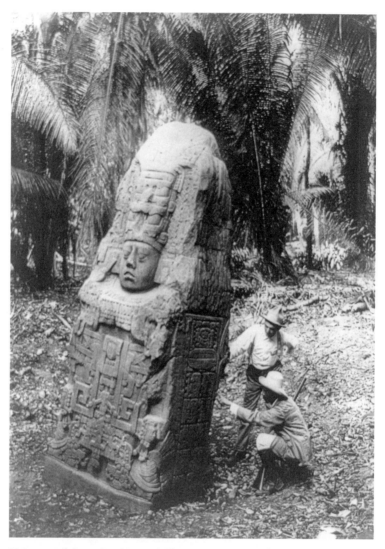

Monument of the ancient Mayan civilization, 350 BCE–900 CE, Quirigua, Guatemala. Photo 1890–1925, courtesy The Library of Congress, Prints and Photographs Division, LC-USZ62-97814.

ARCHAEOLOGY AND THE ART MARKET

CLEMENCY CHASE COGGINS

AN ILLEGAL INTERNATIONAL TRADE in antiquities is obliterating the record of ancient American civilization. In 1971, the international antiquities market was recognized as a major destructive force in world civilization. A handful of men specializing in what seems an almost scholarly trade are financing the wholesale destruction of the remains of a number of ancient civilizations and primitive cultures. In the Old World, the apparently limitless archaeological riches of the shores of the Mediterranean have been coveted and exploited since the Renaissance, and they continue to serve as a major source of antiquities. In other parts of the world, a new sophistication has led dealers and collectors into an appreciation of all art-producing cultures, ancient and modern. This eclectic taste has created an expanding art market that has in recent years turned its disastrous attentions to Southeast Asia, India, and the Pre-Columbian cultures of Mexico, Guatemala, Peru, and others.

Despite a new public awareness of the gravity of the situation created by the illegal traffic in antiquities, despite a UNESCO convention designed to alleviate the problem, and despite US legislation restricting certain aspects of this commerce, there are more and more sites plundered and more and more illegal excavations made. Unlike many natural resources, our archaeological resources are not renewable. Once a site has been worked over by looters in order to remove a few salable objects, the fragile fabric of its history is largely destroyed. Changes in soil color, the traces of ancient floors and fires, the imprint of vanished textiles and foodstuffs, the relation between one object and another, and the position of a skeleton—all of these sources of fugitive information are ignored and obliterated by archaeological looters. The casual destruction of a site produces perhaps a few pots, jades, or even sculptures, for which the robbers are paid very little but for which an American collector pays a great deal. The collector buys a beautiful object about which he knows

This essay has been reprinted with permission from *Science* 175 (January 21, 1972): 263-66.

virtually nothing, and no one ever mentions to him the devastation that was created in order to deliver it.

> Most of the stelae have been cut up and shipped out. The large, stucco facade panels ... have been torn apart and often completely removed. And the vandalism of pot-hunters, who travel in large gangs and methodically destroy architecture in search of tombs and caches, is incredible. Hormiguero, which was until recently untouched, was exploited by such a gang in recent weeks—and now it looks like a lunar landscape.

This description, by E. Wyllys Andrews IV, an archaeologist at Tulane University,[1] refers to the situation on the Yucatan Peninsula in Mexico, part of the territory of the ancient Maya.

The Looting of Mayan Sites

The remains of ancient Mayan civilization lie in the jungles of northern Guatemala and southeastern Mexico. The Maya built ceremonial centers with elaborate, stucco-covered stone pyramids, temples, and palaces between about 300 and 900 CE. They had evolved a beautiful system of writing that is still largely undeciphered, as well as a complicated and extraordinarily accurate calendar. Their consummate skill in sculpture is evidenced by carved stelae. (A stela is a slab of stone that was erected commemoratively and in Mayan cultures was usually carved with one or more figures and inscriptions. Stelae may be as high as seven meters, by about one meter wide and one meter thick, although they are generally smaller. They may weigh many tons.) The Maya were also skilled painters, but very few frescoes remain, and their style of painting is known principally from polychrome ceramics and from two very late manuscripts.

The Maya organized and oriented their ceremonial centers according to strict astronomical and religious principles, and their stelae were erected for historic and dynastic reasons in highly symbolic locations. The long inscriptions on each stela relate to the astronomical and historical significance of both the monument and its erection. When these stelae are removed from their context, they lose much of their historical meaning in relation to the ceremonial center. As the result of modern plundering, they are losing a great deal more.

Stelae are much too heavy to remove intact from a site. They are usually found in remote jungle areas that must be reached by mule or dugout. For this reason they must be cut or broken up. The robbers, with varying degrees of skill, use power saws, chisels, acid, or, more primitively, heat in order to crack the stone into pieces. If a stela is in good condition, the aim is to saw off the sculptured face of the stone. This common method, even at its most efficient, sacrifices the inscriptions found on the sides of the stela and sometimes also on the back. When this method does not work, which is frequently, the face of the stela is left as a pile of chips on the ground, with any salable bits removed.

How do we know that this is happening? In the past ten years, American museums and collectors have been buying the broken and sawed fragments of Mayan stelae. Some of these are well-known monuments that, even in their reduced state, bear eloquent, and legally verifiable, testimony to their original locations. Such evidence of the traffic comes from those objects that have been traced to collections. Much more abundant evidence comes from the reports of those who find one archaeological site after another that has been recently plundered. These reports come from all parts of Guatemala and Mexico, as well as from countries to the south. I have emphasized the Mayan area only because it is a segment of the problem that has been documented.

As a result of recent efforts to document the nature and the extent of the traffic in monumental Mayan sculpture, the United States and Mexico ratified on February 10, 1970, a treaty that ensures the return to Mexico of any important sculpture or frescoes, stolen after the date of the treaty, that Mexico requests. Legislation with similar provisions that will apply to other Latin American countries has been submitted to Congress. As a result of the Mexican treaty, there has been a sharp drop in the number of stelae and other important Pre-Columbian sculpture available on the New York art market. This was its intention. There have, however, been a few unforeseen consequences.

Pre-Columbian Art and the Market

In the past few years, a number of major exhibitions of Pre-Columbian art have been held in New York and in Europe. These have created a lively demand for Pre-Columbian objects. Art dealers are making every effort to fill that demand, as they are legally free to do in this country,

with whatever small, portable objects that are not covered by the treaty with Mexico. While the excavations that these objects come from are illegal, and while exporting them from their countries of origin is illegal, once these objects reach the United States, they may be sold legally (as they may in most European countries).

In order to compensate for the loss of major sculpture, art dealers have increased their volume of ceramics and jade, and they have raised the prices of these small objects to those once asked for sculpture. Now there is big money in pots. Not long ago, there were very few fine Mayan polychrome vessels on the market. A beautifully painted potsherd once brought a good price. Now, suddenly, there are a great many fine whole vessels available. Last spring in New York, there was a stunning exhibition that included forty or fifty carved and polychrome vessels of the highest quality. None of them had any indication of their places of origin. Each of them probably represents one largely destroyed building; indeed, such a concentration of superlative objects probably represents countless unproductive and destructive excavations by looters. Whole vessels and jades can be found in tombs and caches that are usually buried well inside buildings. The wanton destruction that is inevitable in the search for small objects is in many ways worse than the plundering of larger monuments. Most collectors of Pre-Columbian art are primarily concerned with the beauty of the object they have bought; they are encouraged by the dealer to consider it a wise investment—the more expensive the wiser—and if they have any museum connections, they may consider it a potential tax-deductible gift. There are few people who explain to the collector what the object may mean in terms of its own civilization and how much has been lost in the process of robbing it from its historical context. Are there then no specialists associated with museum collections who will emphasize the more scholarly values on which museum collections are founded?

As far as many American museums are concerned, a bird in the hand is worth everything. Museum people are schooled in the acquisition, conservation, and practical aesthetics of objects in relation to museum collections. They believe that any object that is acquired by a museum is necessarily in a better place than it was before, in the jungle or in a tomb. Actually, no Mayan stelae, nor even their fragments, have reached the art market in as good a condition as they were in the jungle. Few ceramic vessels survive exportation without inexpert mending jobs.

The Scholar and the Art Dealer

Many museum curators and archaeologists serve in advisory roles to art dealers and collectors, in a relationship that emphasizes the aesthetic and monetary values of objects on the market. Recently, however, the nature and the success of the antiquities business have imposed a great strain on that relationship, which has, in the past, been largely benign and cordial. There is a sense of betrayal, and of confusion, on the part of many archaeologists and art historians whose contacts with dealers have always been correct and carried on in an atmosphere of both antiquarian scholarship and aesthetic pleasure. Their opinions, freely given, have usually been offered in the hope of enhancing objects in a historical sense and ferreting out forgeries. In return for such information, art dealers have traditionally kept such specialists informed on the location of important pieces. They have given them photographs, and not infrequently they have given them objects for their collections as well. Somehow this time-honored symbiotic relationship has gone bad.

The size, the destructiveness, and the money now involved in what used to be a relatively innocuous trade have turned the scholar, who would only authenticate an object, into an accomplice. His opinion, however cautiously given, may determine an object's market value. For many people who have mediated for years between dealers and collectors and museums, the new turn this relationship has taken is a source of agonizing and perhaps insoluble conflict, often compelling a choice between abstract ethical points and long-term friendships. The time, however, has come for all those who have contact with the trade to reevaluate the relationship. Is it possible to give opinions or authentications without setting prices and without encouraging an expanding market, with all its consequences? Is it possible to accept works of art, photographs, and secret information from dealers without contracting obligations, no matter how subtle? Finally, is one's personal obligation to an archaeological area and its culture greater or less than one's obligation to a museum collection, or to the acquisition of beautiful objects? This last question is apparently considered infrequently and is seldom, if ever, mentioned to students as a potential hazard in the fields of archaeology, ethnology, and art history.

Surely a sense of obligation to a country's cultures, past and present, should be developed in students. Most American art historians and

225

many American archaeologists and ethnologists must depend on the hospitality and aid of those foreign countries whose cultures provide their livelihood. If a specialist is willing to live off the ancient or modern culture of another country and then to cooperate in the illegal traffic of that country's art, his can only be termed exploitative scholarship. One disastrous corollary of such exploitation arises when the aggrieved country retaliates by excluding American scholars, as has happened selectively in Turkey and may soon happen in India.

Toward a Solution

No one pretends that there are easy solutions to this problem. UNESCO has struggled for decades with the irreconcilable national attitudes and laws that must be considered in creating any sort of solution. Last year (1970) a UNESCO convention was passed that included many admirable provisions for reform as well as a recognition of those positive factors inherent in the legal international trade in antiquities. It is important to emphasize that it is the destructive aspects of this commerce that must be curbed, not the beneficial interchange of cultural properties. The UNESCO convention must, however, be ratified by the legislatures of all signatory countries, and no one anticipates that it will be in effect in the near future.[2]

Within the United States in the past year, a number of professional organizations in archaeology, art, and the museum field have concerned themselves with the antiquities market and have passed resolutions supporting the UNESCO convention. These symposiums and resolutions followed the University of Pennsylvania's announcement on April 7, 1970, of a new acquisitions policy. The policy stated that the University Museum would no longer buy works of art that do not have a pedigree (legal export papers and information about previous owners and place of origin). It went on to state that such information would be made public. The decision to make acquisition information public is of paramount importance. If all museums were to adopt such a policy, there would be a significant diminution of the number of illegally exported objects acquired by museums. Perhaps more important, there would be a radical change in the relationship between museum curators and art dealers. Finally, the availability of information on acquisition enhances the historical significance of an object, thus increasing its value for all scholars.

Until recently, no other museum had followed the lead of the University of Pennsylvania, and its action has been received with a certain amount of cynicism by many American museums. It was pointed out that the Pennsylvania statement spoke only of purchased objects, even though the University Museum, as an academic institution, buys objects infrequently, relative to the number it receives as gifts or acquires through exchange and excavation. It is important to note that such a policy, in order to be most effective, must refer to the acquisition of all objects, not just those that are purchased.

Harvard University has recently worked out an acquisitions policy that went into effect as of November 30, 1971. Harvard's policy is particularly significant because it applies to a number of very different Harvard institutions and collections, not just to the Peabody Museum of Archaeology and Ethnology. All collections are included, as well as libraries, the Fogg Museum of Art, and Dumbarton Oaks, a Washington, D.C., collection of Mediterranean and Pre-Columbian antiquities. Because the Harvard policy is only the second of its kind, and because its provisions have been so carefully devised, it is given below as a potential source of discussion, and perhaps as a stimulus to other museums.[3]

Harvard Policy

1) The museum director, librarian, curator, or other University officer (hereinafter to be referred to as "Curator") responsible for making an acquisition or who will have custody of the acquisition should assure himself that the University can acquire valid title to the object in question. This means that the circumstances of the transaction and/or his knowledge of the object's provenance must be such as to give him adequate assurance that the seller or dealer has valid title to convey.

2) In making a significant acquisition, the Curator should have reasonable assurance under the circumstances that the object has not, within a recent time, been exported from its country of origin (and/or the country where it was last legally owned) in violation of that country's laws.

3) In any event, the Curator should have reasonable assurance under the circumstances that the object was not exported after July 1,

1971, in violation of the laws of the country of origin and/or the country where it was last legally owned.

4) In cases of doubt in making the relevant determinations under paragraphs 1-3, the Curator should consult as widely as possible. Particular care should be taken to consult colleagues in other parts of the University whose collecting, research, or other activities may be affected by a decision to acquire an object. The Curator should also consult the General Counsel to the University where appropriate, and, where helpful, a special panel should be created to help pass on the questions raised.

5) The University will not acquire (by purchase, bequest, or gift) objects that do not meet the foregoing tests. If appropriate and feasible, the same tests should be taken into account in determining whether to accept loans for exhibition or other purposes.

6) Curators will be responsible to the President and Fellows for the observance of these rules. All information obtained about the provenance of an acquisition must be preserved, and unless in the opinion of the relevant Curator and the General Counsel to the University special circumstances exist in a specific instance, all such information shall be available as a public record. Prospective vendors and donors should be informed of this policy.

7) If the University should in the future come into the possession of an object that can be demonstrated to have been exported in violation of the principles expressed in Rules 1-3 above, the University should, if legally free to do so, seek to return the object to the donor or vendor. Further, if with respect to such an object a public museum or collection or agency of a foreign country seeks its return and demonstrates that it is a part of that country's national patrimony, the University should, if legally free to do so, take responsible steps to cooperate in the return of the object to that country.

In the broadest sense, the problem is two-sided: on one hand, the increasingly destructive nature of the international trade in antiquities must be controlled; on the other hand, every effort must be made to create a healthy, if diminished, legal market. The United States accounts

228

COGGINS

for a large percentage of the illegal market—perhaps we can reduce that percentage, but we cannot expect the entire world to change entirely on the basis of our example. It is time that we stopped holding meetings to acquaint ourselves with the problem and started mobilizing public and scholarly opinion for real action. One important first step is the description and documentation of the problem within any particular cultural area. Not until the anatomy of the problem is understood can constructive action be taken. In order to do this, it will be necessary to cooperate with specialists in each cultural area throughout the world. Then it will be necessary to study all of the laws and exporting systems within the countries affected and to work to develop imaginative and locally acceptable legislation. There is no doubt that such efforts will meet with innumerable obstacles, but since no such cooperative ventures have been attempted in the past, there is reason for hope.

The illegal antiquities market is financing the destruction of the remains of Pre-Columbian civilization. In the United States, this process has often been aided by museums, collectors, and scholars who have unwittingly collaborated. Recently, initiatives toward reform have been taken by UNESCO, professional organizations, and two academic institutions. Further organized action is recommended.

NOTES

1. The late E. Wyllys Andrews IV, personal communication (1969).

2. For a review of the UNESCO convention and of the action taken by different organizations, as well as for a brief bibliography of the topic, see A. Zelle, *Museum News* 49, no. 8 (1971): 19.

3. *Harvard University Gazette* 66, no. 39 (1971): 4.

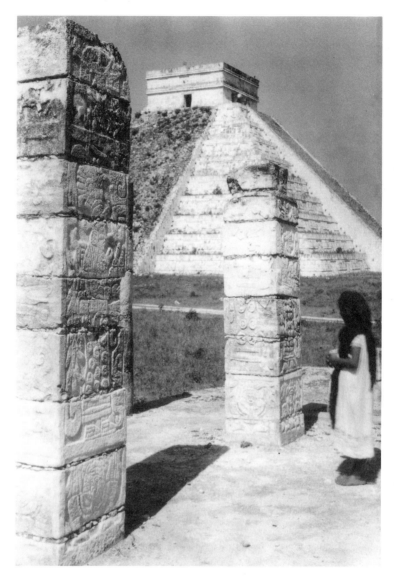

Laura Gilpin, *Temple of the Warriors, from the Castillo, Chichen Itza, Yucatan*, c. 1932. Copyright © The Amon Carter Museum.

OBSERVATIONS OF A COMBATANT

CLEMENCY CHASE COGGINS

ALMOST THIRTY YEARS AGO the resounding declaration "Not since the sixteenth century has Latin America been so ruthlessly plundered" appeared in an article in the *Art Journal*.[1] As an art historian I had written a jeremiad directed at my own profession, which seemed to me implicated in the burgeoning traffic in plundered Pre-Columbian antiquities. This was news, and the dramatic assertion and subsequent enumeration of looted monuments in American museums was picked up by the press, with its appetite for scandalous and illegal enterprises, especially if they involve revered institutions like museums.

Some university and research museums responded, in the next few years, to this problem of the acquisition of plundered antiquities by adopting acquisition policies that followed the principles of the new UNESCO Convention on Cultural Property (1970).[2] More museums went underground and stopped publishing, or even exhibiting, their questionable new acquisitions from the New World and the Old. These acquisitions, it must be emphasized, were not illegal in the United States, although such objects had, in most cases, been exported illegally from their countries of origin. The acquisition of plundered, illegally exported antiquities is a time-honored practice that art museums are exceedingly reluctant to eschew.

The Black Market

What drives the black market that supplies museums and private collectors? Is it the poverty of the looters? This is a popular explanation that is apparently supported by the devastated economies of most archaeologically rich countries, but it is more of a rationalization than an explanation, since casual finds are worth very little locally. It is only when looters are employed or approached by a middleman that they may earn a wage, however small, and dispose of their finds, which will be shipped to a city or smuggled out of the country. Is the looting driven by the antiquities market's desire to improve the economy by employing the local citizenry? No.

Is the black market driven by the helpless cravings of collectors, as some dealers assert? Many collectors have been cultivated and selectively educated by dealers to collect certain things. These are the magnificent unique objects that can come only from new, clandestine excavations. The dealers whet the desire for these, and then they supply them. This is addiction only as long as the supply continues—withdrawal is not injurious to a collector's health.

Is the black market caused by export controls, as is asserted by Professor Paul Bator[3] and John Merryman[4]? Yes and no. If the free export of cultural property were possible, then there would by definition be no black market. However, as long as the robust international antiquities market exists, the lack of controls would simply expedite the complete plunder of a country. If export were selectively possible, the most unusual and desirable pieces would never be allowed to leave because most archaeologically rich countries do not have such objects in their own impoverished national museums. If, however, the country were to sell legally excavated objects of less significance and beauty, the high end of the market would never want them.

It is the antiquities market itself that drives and thrives on the black market. The modern international antiquities market is a black market.[5] The American ideal of free trade is entirely misplaced in this context. The highest prices may induce competition, but the highest prices are paid for the newest and finest objects, so more extensive plunder is necessary in order to compete. The result is the bargain employment of a gang of impoverished looters in a remote country, the devastation of a cultural heritage, a happy collector and an enriched dealer, and finally, perhaps, a tax-deductible role for the object in the local museum, where the citizenry gets to subsidize the entire operation. This is free trade?

The Two Cultures

In the 1960s the English scientist C. P. Snow wrote a book, *The Two Cultures,* that described the estrangement between scientific and more humanistic (in his case literary) points of view.[6] To some degree this is the kind of division that characterizes the intractable debate over the role of antiquities in modern society, where it has to do with the purpose and the meaning of cultural property. In an effort to mediate between these cultures, the legal mind treats antiquities as a commodity that must be

shared, Solomonically, between "interests." All of these are accorded equal validity, and may each consider itself of primary importance: the country of origin, archaeologists, the market, collectors, art historians.[7]

The oldest of these interests are certainly the collector and the dealer—a chronological priority that is seen to justify the roles as inevitable. Next came the antiquarians who at first were neither art historians nor archaeologists, or were both. The discipline of the history of art grew from the neo-classical European passion for ancient art. Most of this ancient art in Italy was simply there, and had been cherished since the Renaissance, but covetous admiration led to the removal of the Elgin Marbles and the altar of Pergamon, among many other items. These monuments and smaller sculptures and vessels were admired for their ancient classical beauty—their original contexts were secondary. The national museums of Europe became filled with collections of such items, often removed in war and by occupation. The discipline of the history of art was born and developed within these collections, whose intrinsic beauty and grandeur were emphasized, while their provenience and circumstances of removal were lost or suppressed amid the focus on the surviving fragments of a glorious mythical past.

European antiquarianism spread to the United States and Mexico around 1800, but it lacked the historical and textual framework of Greece and Rome, and thus foundered in the unwritten mysteries of the indigenous cultures. In this century, however, anthropology has preempted archaeology in the United States and entirely changed its focus, from monuments and texts to the ancient cultures themselves and the people who created them. In the United States archaeology is usually taught in anthropology departments, with some classics and Near Eastern departments training their own archaeologists.

In the classic *Method and Theory in American Archaeology,* Gordon Willey and Philip Phillips asserted, "American archaeology is anthropology or it is nothing."[8] This seemed to be a primitive territory-marking statement to those working in ancient American art. As a student of the art historian George Kubler, who disagreed strongly with Willey and insisted that a work of art transcends culture,[9] I resisted this formulation of the anthropologists. I have, however, come to see that they were exactly right, and that the statement applies to all archaeology, not only American. "The subject matter of anthropology is both society and culture,"[10] and "archaeology, of necessity, deals very largely with

patterned behavior in its cultural aspect."[11] The work of art is the expression of extraordinary patterned human behavior; it can be no more. The principles of scientifically designed, problem-oriented anthropological archaeology are now practiced around the world—but the antiquarian, object-oriented view of the ancient world persists in museums and many art history departments, and in the antiquities trade.

These are the two basic cultures that define the interests. They might be described as scientific versus humanistic, but they are closer to cultural versus aesthetic. The switch from the classical monument and text interests in the 1972 US law (as defined by mutilated figural stelae with inscriptions) to the anthropological cultural and contextual interests represented by plundered burials lost the attention and support of museums and art historians, who tend to be more focused on the isolated object than on what has been lost. This is a matter of *formación,* or education and training. The differences are exemplified by the difference between the stark English *provenience,* meaning the original context of an object, and the more melodious French *provenance* used by the art world, which may include the original source but is primarily concerned with a history of ownership.

Among these interests, the countries of origin tend, increasingly, to embrace the anthropological view, since it focuses on cultural heritage in the broadest sense.[12] In the principal archaeologically rich countries of Latin America—Mexico, Guatemala, and Peru—antiquarian pursuits were traditionally found among the wealthy and educated, and these still represent the most powerful constituencies against the prohibitions of national cultural-property laws. In this century, however, the indigenous cultures of these countries have acquired potent new political meaning—especially in Mexico, where the attempt to forge a national consciousness emphasized native Mexican cultures and their ancient roots in a movement originally called *indigenismo. Indigenismo* is a concept that provided a framework for anthropological archaeology as the discovery and reconstruction of the common Mexican past. In recent years, as a government policy, it has been subordinated to the overwhelming demands of tourism, which represents an updated antiquarianism in which the money for archaeology is spent on consolidating monuments and displaying isolated objects in museums.

Conservationist interests in all archaeologically rich countries—anthropological, archaeological, governmental—operate in conflict with

the property interests that express the rights of collectors and dealers to buy and own and sell cultural heritage because they appreciate it, because they believe they are preserving it, because they want to share it with the world, and because they always have. John Merryman, from within the commodifying constraints of the law, calls the first interests "retentive" and the second "internationalist."[13] But cultural heritage is a seamless tapestry that cannot be cut into little squares and shared around internationally.

235

Conclusions

As far as the law is concerned, the three archaeologically richest, and most seriously plundered, countries in Latin America—Guatemala, Peru, and Mexico—now have some kind of US import controls in effect for all their archaeological heritage. This is the grand experiment. Will the international art market saturate Europe and Japan with Pre-Columbian antiquities, and then turn to the endangered patrimonies of Africa and the Pacific until those doors are closed? Many dealers will likely go out of business; others will confine themselves to recycling old collections, as do most art dealers, who do not expect a limitless supply of cheap new material to sell. Will other market countries such as Great Britain, Germany, Belgium, and Switzerland, follow our lead in signing the UNESCO convention, as France has? However flawed, the convention has had a catalytic effect on international awareness.

The lobbying group for American antiquities dealers would like to amend the US UNESCO implementing legislation or perhaps do away with it, even though this law was originally made as weak as possible, and only six countries have had agreements with the United States out of eighty-eight UNESCO convention signatory countries.[14] The United States commands 47 percent of the world's auction sales,[15] yet the antiquities market cannot tolerate even this much limitation of trade. Perhaps this is the surest indication of the law's success. But it is much too late to try to rescind US efforts to alleviate the still-expanding international loss. The public understands much better now what is at stake, and museums are beginning to realize that they must change. The hardest part will be the coming years, when new acquisition policies will be at odds with long-accepted practices and with the realities of a continuing, if perhaps waning, market in antiquities.

OBSERVATIONS OF A COMBATANT

In this essay I have tried to adapt the legal concept of "interests" to my own perception of the "cultures" or conceptual orientations in conflict in the current international traffic in antiquities, and more particularly in its control. In this hemisphere, an anthropological or social and contextual kind of archaeology has prevailed over the traditional classical archaeological focus on objects. This worldview is integrating, and it is at odds with the study of the self-sufficient beauty of isolated works of art as traditionally pursued in art history, which may see a work of art as beyond culture, so that it makes no difference where it is; whereas the first view believes that a work of art is inextricably bound to and forever signifies its culture. These views cannot agree—but here the law intercedes and declares the work of art to be property. Most archaeologically rich countries adopt the integrating contextual view of their cultural heritage; and since it is their property, they are prevailing on the legal front, and may yet prevail in their struggle to preserve their cultures intact.

US efforts to discourage the market have been piecemeal and not yet effective in this goal, although there have been significant changes in attitude and in institutional controls in every country that has made a request. I believe there is progress, but it is very slow; meanwhile, more cultural property is being consumed, more history irretrievably lost. What is necessary is new legislation to amend the US implementation law so as to prohibit the importation of all of the protected archaeological and ethnographic cultural property of all UNESCO signatory countries, as stipulated by the 1970 convention itself. The United States must still fulfill the goals and realize the principles that impelled it to sign the UNESCO convention in 1972.

NOTES

This is an updated and condensed version of an article published in the *International Journal of Cultural Property* 8, no. 1 (1998). Although my own impressions and opinions are reflected in this essay, I wish to acknowledge the contributions of the following archaeologists: Fabio Amador B., Fred Bove, Karen Bruhns, Miguel Covarrubias, Ricardo Elia, Ian Graham, Ruben Maldonado, John Rick, Payson Sheets, Carlos Zea Flores (also Guatemalan Vice Minister of Culture), and Maria Papageorge Kouroupas, executive director of the Cultural Property Advisory Committee.

1. "Illicit Traffic of Pre-Columbian Antiquities" *Art Journal* 29 (1969): 94.

2. University Museum, University of Pennsylvania (1971); Harvard University Museums (1972); Field Museum of Natural History, Chicago (1972).

3. Paul M. Bator, *The International Trade in Art* (Chicago: University of Chicago Press, 1983), 41–43.

4. John Henry Merryman, "A Licit International Trade in Cultural Objects," in this volume.

5. Except for the very small percentage of objects in old collections, acquisition of antiquities in the international market is virtually impossible without breaking some law, and that was true even of most objects in old collections. A black market is "an illicit market in which goods are sold in violation of price controls, rationing or other restrictions," *American Heritage Dictionary of the English Language,* 1976.

6. C. P. Snow, *The Two Cultures and a Second Look* (Cambridge: Cambridge University Press, 1964).

7. Bator, *The International Trade in Art,* describes these conflicting interests in terms of underlying "values," but an important problem is that these values (preservation, integrity, accessibility) are cherished by all of the interests.

8. Gordon R. Willey and Philip Phillips, *Method and Theory in American Archaeology* (Chicago: University of Chicago Press, 1958), 2.

9. George Kubler, "History—or Anthropology—of Art," in Thomas F. Reese, ed., *Studies in Ancient American and European Art: The Collected Essays of George Kubler* (New Haven, Conn.: Yale, 1985), 409.

10. Ibid.

11. Bator, *The International Trade in Art,* 3.

12. Prott and O'Keefe have pointed out that "cultural heritage" is a better, broader, and more accurate term for "the manifestations of human life" in a country than is "cultural property" (L. V. Prott and P. J. O'Keefe, "Cultural Heritage or Cultural Property," *International Journal of Cultural Property* 1, no. 2 (1992): 307–20. I would argue that "cultural heritage" should replace "cultural patrimony," but that "cultural property" will continue to be a useful term as long as anyone can own parts of the cultural heritage.

13. "The Retention of Cultural Property," *UC Davis Law Review* 21, no. 3 (1988): 477–513.

14. Nicaragua has also made a request. [Ed. note: By early 2005, eleven nations had established agreements with the US regarding import restrictions.]

15. "US and UK Share 75% of Turnover," *Art Newspaper,* Issue 77, January 1998, 27.

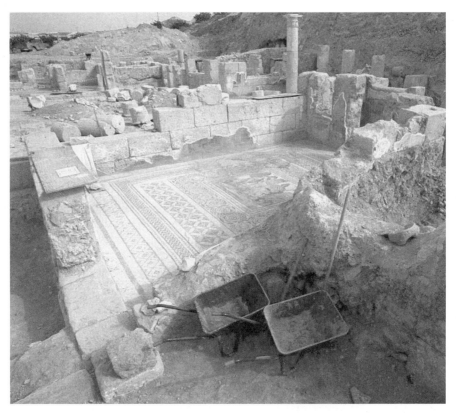

Mosaic of Perseus and Andromeda, c. 1st c. BCE, Zeugma, Turkey.
Photo by Stanton R. Winter, May 7, 2000, before inundation,
copyright © The New York Times Agency.

ART IN JEOPARDY

ANDREW SOLOMON

There are now black holes in history.

—MICHAEL BARRY, ON THE DESTRUCTION OF
THE NATIONAL MUSEUM COLLECTIONS IN KABUL

WHERE TO PLACE ART is one of the art world's most problematic issues. The UNESCO policy is that cultural patrimony should stay in its country of origin, and that such material, if already exported, should be returned to the land in which it was produced—sometimes decades or even centuries after its removal. Archaeologists, whose licenses depend on the goodwill of foreign governments and whose prejudice is toward sites, tend to support this notion and to press for leaving materials as close as possible to the locations where they have been excavated. In an era of multiculturalism, the notion that any cultural group owns all of its production has a faddish appeal, and repatriation has taken on the trappings of political correctness. The nationalist supporters of this view say that all Egyptian material should be in Egypt, all British art in Britain, all Benin masks in Benin.

Museums, prejudiced toward display of portable material away from sites of excavation, and collectors have found themselves in conflict with these policies. Internationalists believe that works should be distributed around the world, so that people everywhere can see the material culture of other countries. There are excesses associated with this idea; restraints must be placed on an open market that encourages the rape of historic sites, where sculptural elements are chiseled off great buildings so that they can be transferred to private hands. The idea of art without frontiers is dangerous. But the idea of repatriation is even more dangerous. The rage to return artworks to source countries is considered enlightened by many American intellectuals, but it is in fact provincial. The history of culture is catholic and international, and our policies on collecting should reflect that.

The policy that important art should never be removed from its country of origin has been upheld with ludicrous literalism in recent

years, to sometimes disastrous effect. The most dramatic recent example is Afghanistan. The art treasures in the National Museum in Kabul were destroyed not by irresponsible American bombing but by irresponsible Western noninterventionism. In early 2001, the museum's director, Omara Khan Masoodi, contacted UNESCO and warned that the Taliban was likely to destroy the collections. He asked UNESCO to take the work out of the country and find a safe repository for it. UNESCO replied that it was against its policy to remove from any country art that might be described as part of that country's cultural heritage. Masoodi protested that the work was going to be destroyed, but UNESCO stood by its position, declining to help. Indeed, all of the pre-Islamic art remaining in the museum and its storerooms was destroyed six months later—including fragile ceramic and stucco finds from Fondukistan and a monumental Kushan stone sculpture that ranked among the most important artworks of Central Asia. Provincial repositories of art and site museums were opened and the artifacts smashed by Taliban wielding sledgehammers, while the great Buddhas carved from the cliffs of the Bamiyan Valley were shattered by explosives—the most spectacular if not the most artistically significant loss. Fortunately, a previous director of the museum and a former minister of culture had hidden much of the collection in the early 1980s to protect it from vandalism and pillage during the Soviet occupation and the ensuing chaos. Masoodi managed to keep the fact of these buried stores private, and so a great deal of important work was saved. It came as a welcome surprise to all in the field when these holdings were announced in 2004. All the records and cultural treasures of this region would surely have been lost forever if it were not for this subterfuge, and many were lost despite it.

Those losses could and should have been avoided. "I wept when I ran up against this policy," Masoodi said, weeping again when we met in Kabul. "I saw my collection smashed to pieces by brutal thugs with angry hammers because policy dictated that what had lasted a thousand years not be saved for the next thousand." Visiting the National Museum is a heartbreaking experience. In an unheated back room, archaeologists sort the rubble that the Taliban left behind. Large trays are heaped with pebble-sized fragments of the life-size statue of Kanishka, a second-century king, that once stood inside the museum's entrance, and of the long Buddhist panels that were among the collection's highlights. "I saw them do this," says Masoodi. "It was like watching the slaughter

of my children." It is difficult even to catalogue what was destroyed by the Taliban because they also burned the museum's archives. Where the most important works were once displayed, Masoodi has posted black-and-white photographs of them, above the broken plinths and shattered remains. A large part of Afghanistan's artistic record has been lost. It is a tragedy of indescribable proportions.

Archaeology followed an unusual pattern of development in Afghanistan. The country was never colonized, and until the early twentieth century, few foreigners ventured outside Kabul to look for evidence of Afghanistan's past. Local interest in archaeology began around the time of World War I, and always rested on essentially nationalist concerns. Early in his reign, King Amanullah signed a protocol with France creating the Délégation Archéologique Française en Afghanistan. For the next fifty years, France remained the primary partner in excavation in Afghanistan, and French excavations were the source of many of the materials in the National Museum. The field expanded after World War II, and Japanese, British, Italian, American, and Soviet archaeologists conducted excavations at sites spanning Afghanistan's four-thousand-year historical record. The first Afghan-directed archaeological mission was at Hadda in 1965. Virtually all excavated objects from these archaeological missions were deposited with the government of Afghanistan. Afghanistan's first National Museum was inaugurated by Amanullah in 1924, and in 1931 it was permanently established in Darulaman, on the outskirts of Kabul. The museum collections contained materials from the Bronze Age through the Achaemenid, Hellenistic, Mauryan, Kushan, Sasanian, Samanid, Ghorid, Seljuk, Timurid, and Safavid periods. Although its galleries were sparsely attended and sometimes poorly lit, with masterpieces displayed in relatively humble settings, the quality of the collections made the Kabul museum one of the great art repositories in the world.

Peace ended with the Soviet invasion of 1979. Many important materials disappeared. It was thought that the twenty thousand pieces of worked gold excavated at Tillya Tepe by the Soviet archaeologist Victor Sarianidi had been taken by the military to Russia, though this proved untrue; the hoard was shown to diplomats in 1991 before being packed in boxes and placed in a vault beneath the palace. (In 2003, after the fall of the Taliban, the boxes that held the Tillya Tepe hoard were recovered by the Karzai government. The Taliban had located the buried vaults,

but were unable to open or destroy the heavy safes in which the material was stored.) The museum's position at the periphery of Kabul left it periodically on the front lines throughout decades of chaos, and in the wake of the Soviet departure in 1989, the museum staff began to crate the collections to be removed to the museum's storerooms.

The mujahideen groups that formed the first post-Soviet coalition governments in Kabul quickly fell into internecine battles. The Hezbe Wahdat, a Hazara-based ethnic alliance, challenged the Rabbani government and seized territory that included the museum, which thereafter suffered chronic damage from military confrontations and looting during periods of unrest. All parties in the fighting agreed that the collections were at serious risk, and attempted to find solutions. The leader of Hezbe Wahdat, Ustad Ali Mazari, agreed to provide security and repair serious rocket damage to the building; in 1992 and 1993 the ground floors were bricked up and steel doors installed. However, the area in which the museum was located continued to change hands. At some times, government soldiers guarded the museum; at others, fighters from Hezbe Wahdat secured the building. As Afghanistan slid into chaos, there were periodic episodes of looting.

Large portions of the packed collections were moved from the museum to the Kabul Hotel in 1996. Almost immediately afterward, the Rabbani government collapsed and the Taliban moved into Kabul. Although the Taliban initially expressed strong concern for the preservation of Afghanistan's art, declarations from the top were not always heeded in the countryside, where some local leaders profited from smuggling antiquities and others, strongly influenced by Arab Wahabists from Al-Qaeda, destroyed pre-Islamic monuments and sites.

Already efforts had been made to secure Afghanistan's art treasures outside the country. According to Paul Bucherer, the director of the Afghanistan Institute and Museum in Switzerland, "The museum was started at the request of all the parties of the Afghan civil war: the Northern Alliance as well as the Taliban. Professor Burhanuddin Rabbani [former Afghan president and Northern Alliance leader] himself came to Switzerland to discuss this, as did Abdullah Jamal, the Taliban minister of culture and information, who discussed this matter in his official capacity. It was really at the request of the Afghan people that this began. . . . The original idea of the Afghans was to bring to Switzerland all the holdings of the Kabul Museum and so to create primarily an

archaeological museum."[1] By 2000, the Afghanistan Museum in Exile was ready to receive the packed collections and had received urgent requests from many Taliban officials and members of the Northern Alliance to take the materials out of Afghanistan. Dr. Bucherer made several trips to Afghanistan to prepare their journey for safekeeping in Switzerland until Afghanistan was at peace—but the Swiss government insisted that it have international sanction to receive the materials. It was at this point that UNESCO refused permission for their removal from their country of origin.

In March 2001, the great Buddhas of Bamiyan were blown to bits by Al-Qaeda and Taliban members brought from outside the valley after local Taliban refused to destroy them. Soon after, members of the Taliban entered the museum and Culture Ministry rooms where many of Central Asia's greatest artworks lay packed in shipping crates, still stalled by UN intransigence. They broke them open and pulverized the objects.

At a British Museum conference in November 2002, Dr. Bucherer displayed the letter in which UNESCO finally gave permission for the removal of Afghanistan's art to safekeeping. It was dated several months after the Bamiyan Buddhas had been destroyed, and the treasures of the Kabul Museum smashed into fragments with sledgehammers. The Central Asian scholar Michael Barry said, "To have been able to move these things under UNESCO auspices could have saved these pieces and ultimately allowed for their return to a civilized Afghanistan again. Now what is destroyed is destroyed, irrevocably."[2] This story vividly illustrates the danger of insisting that work stay in its country of origin.

In light of the events in Afghanistan, the validity of the internationalist museum concept cannot be overstated. In December 2002, the directors of some twenty major American and European museums—including the Metropolitan Museum in New York, the National Gallery in Washington, the Louvre in Paris, the Prado in Madrid, and the Hermitage in St. Petersburg—were signatories to a joint statement that said in part: "Museums, too, provide a valid and valuable context for objects that were long ago displaced from their original source. The universal admiration for ancient civilizations would not be so deeply established today were it not for the influence exercised by the artifacts of these cultures, widely available to an international public in major museums. We should acknowledge that museums serve not just the citizens of one nation,

243

but the people of every nation. Museums are agents in the development of culture [and] each object contributes to that process. To narrow the focus of museums whose collections are diverse and multifaceted would therefore be a disservice to all."[3]

We have largely given up on removing significant work from its country of origin. Meanwhile, the question of repatriation—whether, when, and how—roils on. A major issue is American recognition of highly restrictive foreign patrimony laws by which we have not traditionally been bound and for which we have demanded no reciprocity. In general, our legal system sees as repugnant the enforcement of foreign law—especially foreign criminal law—that is not congruent with American law. Why should the field of cultural property be different? A rational cultural policy should be determined by an informed legislature that understands the ramifications of its acts and that recognizes that the interests of American museums and collectors, public and private, are essential freedoms that warrant protection.

We find ourselves lost without a coherent, consistent policy; buffeted by political and intellectual currents; profoundly unresolved about what belongs where. We should continue to respect and assist foreign countries—Iraq and Afghanistan, for example—in their legitimate efforts to protect and preserve their cultural treasures. We should be open to taking work out of those countries when it is necessary to do so in order for that work to be preserved. At the same time we should resist the increasingly militant demands from stable foreign nations—such as Italy—to give back cultural property that has been in museum collections in the United States and elsewhere for decades. US cultural policy and the laws that govern in this area should be consistent in seeking to protect the destruction of cultural artifacts from war, neglect, theft, and industrial and infrastructure construction and development, while supporting the international museum system that continues to do the most to protect and preserve the world's cultural heritage. There is no surer guarantee of profound understanding between peoples than the display of works of art across national boundaries.

NOTES

1. Nermeen Shaikh, "Interview with Paul Bucherer," *AsiaSource,* April 9, 2002, www.asiasource.org.

2. Barbara Crossette, "UN, In Shift, Moves to Save Art for Afghans," *New York Times,* March 31, 2001.

3. "Declaration on the Importance and Value of Universal Museums," drafted in Munich, October 2002, published by the British Museum, December 2002.

Winston Churchill walks through the ruins of Coventry Cathedral,
bombed by the Germans in 1940. Photo January 23, 1942, courtesy
The Library of Congress, Prints and Photographs Division,
LC-USZ62-16191.

IMPROVING THE ODDS
Preservation through Distribution

ANDRÉ EMMERICH

THE WORLD WEPT over the wanton destruction of the treasures of the
ill-guarded National Museum of Iraq and the burning of Baghdad's
unique Islamic library. It is an irreplaceable loss for all humanity. Despite
the recovery of many of the major pieces carried off by vandals and the
discovery of many more hidden by museum staff prior to the invasion
by coalition forces, the loss can never be replaced.

Worldwide, the media devoted much time and space to this tragedy
and brought it into our living rooms in all its horrifying details. However,
there is one aspect whose mention seems to be taboo: the implied warn-
ing of the grave danger of having too large a part of a culture's heritage
gathered in a single place on earth.

The history of the twentieth century is replete with records of de-
struction both from the forces of nature and from the uncaring actions
of man. In the case of Iraq, there fortunately are major holdings of the
earliest Mesopotamian art in Philadelphia. This was the result of the
University of Pennsylvania's involvement with the great excavations of
the Royal Tombs at Ur (the Ur of the Chaldeans of Abraham). In return,
the University of Pennsylvania Museum received half of the objects
excavated. In addition, there are major holdings of Babylonian art in
museums in London, Paris, Berlin, and New York.

Vital lessons can be learned from the Iraq disasters. The most
important of these is the desirability of dispersing widely the art of past
civilizations. The preachings of much of the archaeological community
notwithstanding, the retentionist program they advocate is a prescrip-
tion for future disasters. As folk wisdom has it, "Don't put all your eggs
in one basket."

The events in Iraq should remind us that there are practical as well as
ethical arguments for the dispersal of art. These arguments are founded
on international agreements crafted in response to tragic human and
cultural losses suffered in aggressive wars. The 1954 Hague convention
states: "Damage to cultural property belonging to any people whatsoever
means damage to the cultural heritage of all mankind, since each people

makes its contribution to the culture of the world." The benefits deriving from the free circulation of objects of art in facilitating scientific study, in promoting understanding between peoples, and in giving pleasure and enriching cultural life worldwide are real and should be self-evident.

Man has been a very effective destroyer of his own past, not only through the accidents of war but in deliberate, political acts of cultural annihilation. There is no need to go back as far as the Huns or Genghis Khan for examples. In World War I there was widespread destruction in Belgium and northern France that included the shelling of the library at Louvain, Belgium, and the Gothic cathedral of Rheims in France.

World War II saw the so-called Baedeker Guidebook raids of historic British cities by the Luftwaffe in 1940, followed by the indiscriminate bombardment of London by German rockets later in the war. In return, the Allied aerial bombing reduced many German cities to rubble. In Russia and Poland, the Germans followed a deliberate policy of destroying palaces, churches, and synagogues wherever they could, and totally flattened the old city of Warsaw. In Italy, the Allies bombed the monastery of Monte Cassino, which had become a German artillery emplacement. By a hair, Florence's Ponte Vecchio survived, as did the city of Paris, which Hitler had wanted to see burn.

In China, Mao Zedong's Cultural Revolution produced destruction that is still unmeasured. Mao attacked culture from the ground up; he understood that culture rests in people, in poets and scholars, not just in objects. At Partition in 1947, fighting between Hindus and Muslims in India and the newly created Pakistan resulted not only in terrible loss of life but in major destruction of religious monuments. The wars in Southeast Asia led to the Khmer Rouge taking power in Cambodia. Along with vast massacres, the great temples of Angkor Wat were looted. In the Balkans, the breakup of Yugoslavia in the 1990s led to the wanton destruction of the ancient city of Dubrovnik and the Mostar Bridge, as well as most of the country's historic mosques, in a cultural "cleansing" that paralleled genocidal attacks on the Muslim population.

The worst act of barbarity to inaugurate the new millennium was the horrifying destruction in 2001 by the Taliban and Al-Qaeda in Afghanistan of the giant statues of Buddha at Bamiyan, and the smashing of every piece of figurative art that could be found in the National Museum. The unprecedented, deliberate destruction has left nothing but photographs of the art of entire cultural epochs.

The construction of dams and other massive development schemes have inevitably resulted in the destruction of thousands of archaeological sites. The construction of Egypt's Aswan High Dam in the 1960s was the first to draw world attention to the impact of development on archaeological sites, and resulted in a major rescue effort. The Birecek Dam in Turkey has flooded remnants of Zeugma, a two-thousand-year-old city that held one of the world's richest collections of Roman mosaics. The current Three Gorges Dam construction in China has prompted a major salvage archaeological effort along the 375-mile-long reservoir basin of the Yangtze River. As many as thirteen hundred sites are now submerged, ranging from Paleolithic and Neolithic sites to imperial Ming- and Qing-dynasty structures. Although hundreds of archaeologists were eventually sent to work at the dam site, recognition of the archaeological importance and value to Chinese cultural history came far too late for effective funding and organization of rescue efforts.

Before recent hostilities, the important site of Assur in northern Iraq was under threat of almost complete inundation with the impending completion of a new dam. Will Assur's recent World Heritage listing deter the governing authorities (whoever they may be) from completing construction of the dam on the Tigris?

Threats from natural disasters and erosion are treated as calculated risks, even within the developed world. When the river Arno flooded Florence in 1966, it caused immense destruction in a city considered the cradle of the Renaissance. In 1997, an earthquake that hit Assisi destroyed irreplaceable murals by Giotto. Meanwhile, continually rising high waters eat away at the foundations of Venice while Italy's bureaucracy appears paralyzed in the face of growing danger. A little-publicized earthquake that hit Athens on September 7, 1999, destroyed a significant part of the National Museum's holdings of ancient Greek ceramic vases. They had been displayed on glass shelves, which shattered, turning the vases and the glass into mounds of irreparable pottery shards and glass splinters. Among the most important acquirers of art in the postwar decades have been Japanese museums and the Getty Museum in Los Angeles. Both are situated atop major geological fault lines, simply hoping that the Big One will not affect them.

In Iraq, recognition of the usefulness of the art market in reclaiming what could be saved came with a proposal by Philippe de Montebello, director of the Metropolitan Museum in New York, and others to offer

looters amnesty and a stipend for turning in stolen objects. As for the larger world market outside of Iraq, it is clear that no responsible museum, art dealer, or auction house will touch any Mesopotamian object unless there is positive proof of provenance dating to prior to the Iraqi wars. During my fifty years as an art dealer in archaeological as well as contemporary art, I have yet to encounter a collector who did not want to share the pleasures of ownership with friends and particularly with scholars and experts. The image of the hermitlike individual gloating over illicit treasures in his castle is a fantasy.

Archaeologists continue to advocate prohibition of exports of archaeological art from their countries of origin by means of nationalization and the restriction of imports into this country. They support laws and treaties that will slowly but surely strangle the art market and access to such art for museums and collectors. They effectively support the efforts of foreign countries to reclaim objects and denude the holdings of our museums and private art collectors.

By using such terms as "stolen art," "smuggled," "looted," and so forth, and impugning the motives of collectors and dedicated museum scholars, the retentionists are wrongfully claiming the moral high ground. To the contrary, the proper ethical stance is concerned with the widest possible preservation and survival of the art and archaeology of past civilizations.

Within each culture, the objects yielded by excavating tombs often tend to be quite repetitive. Even the inventive ancient Greeks developed only thirty-two major forms of ceramic offertory vases and cups. As a result, the storerooms of museums in ancient regions are overflowing with duplicates, many from old collections or found as a result of construction, not from scientific excavations. Any scholar who has visited the back rooms of museums in major centers such as Rome, Athens, Cairo, Mexico City, or Lima can testify to this. Objects are often poorly cared for and suffer from all the vagaries of benign neglect.

The great contribution that the art market makes to preservation is to endow works of art with value. When objects have no value, they are inevitably at risk of destruction because preserving them is a costly enterprise. Storing, safeguarding, heating and air conditioning, and conserving art in public institutions can be done for only a relatively few objects. In practice, there is constant triage, which saves a few treasured objects but consigns the remainder to slow deterioration.

An obvious solution would be to deaccession the masses of repetitive minor objects now stored under deplorable conditions. Under locally prevailing political conditions, it is risky for officials to grant export permits for even the most redundant of objects. What would be invaluable and instructive additions to the collections of many of the world's museums are left unseen and endangered in local premises supposedly dedicated to their preservation.

This backlog of unpublished, often inaccessible materials in many art-rich nations stands in mute reproach to the outcry by some field archaeologists concerning objects that lack context and provenance, sometimes accompanied by outright refusals to study or exhibit such objects. Such misplaced prudishness contrasts with the spectacular 2004 exhibition *Courtly Art of the Ancient Maya,* organized by the National Gallery of Art in Washington, D.C., and the Fine Arts Museums of San Francisco. The show was accompanied by a magisterial catalogue, produced by Mary Miller, Simon Martin, and Kathleen Berrin, with essays by fifteen additional scholars. More than forty lenders from seven countries are listed. Significantly, twenty-three lenders were American museums and institutions.

One of the great strengths of this exhibition is the inclusion of masterpieces without provenance, such as the ceramic vessel known as the "Princeton vase." The catalogue describes it as "perhaps the most famous of all Mayan painted ceramic scenes—a true masterpiece of the codex-style painting." The vase has been studied and displayed in the Princeton University Art Museum since 1975. Inscriptions on this vessel give us a sense of what writing in Mayan books looked like. Its glyphs describe the vessel's function as a container for a chocolate drink; a separate band of glyphs identifies the owner and includes the artist's signature, a great rarity in antiquities anywhere. Many Mayan vessels, adorned with inscriptions, now carry their own contextual information. If the many unprovenanced Mayan vessels were to be ignored, their messages would be lost.

The catalogue's dramatic jacket features two objects. The first is a superb image of a Palenque lord lent by the Museo de Sitio de Palenque. The other is a charming but unprovenanced Jaina figurine of a trumpeter from the Robert and Lisa Sainsbury Collection, now owned by the University of East Anglia, England. Both objects are given equal treatment and comparable descriptions.

251

The international scope of the exhibition is an appropriate reflection of the contribution to Mayan research by scholars from many corners of the world. This is nicely illustrated by the work of the Russian specialist Yuri Knorosov, whose 1952 breakthrough advanced the decipherment of glyphs by demonstrating that some were phonetic signs for syllables while others stood for entire words. His achievement is all the more remarkable considering that for many years he was not allowed to leave Russia to visit Mexico and Central America. Based on Knorosov's discoveries, the reading of glyphs progressed rapidly, largely through the work of American scholars and epigraphers.

The supporters of import restrictions believe in the desirability of leaving ancient art in the same location where it is found. They endorse the stance of many art-rich nations who, for reasons of nationalism, do not want to share with the world the art of their ancient past and who continue to denounce as "stolen" any work thought to be from their soil that is found abroad. It is ironic that so many archaeologically well-endowed regions are populated today by the descendants of the invaders who destroyed the very cultures whose remnants their modern governments claim as exclusively their own. Turkey's Adriatic coast is rich in ancient Greek art—but in the 1920s, the remnant of its Greek population was expelled in an early instance of ethnic cleansing. Many Latin Americans are descendants of the Spanish conquistadors who destroyed the Aztec and Inca empires. Do these descendants have a more exclusive moral claim to the buried artifacts of earlier civilizations than the rest of humanity?

Throughout the twentieth century there has been an increasing trend toward collecting historical materials in source nations themselves. A market that originally directed art into the West is now also operating in reverse. The grand example set by the Mexican collector Josué Saenz has been followed by many others in South and Central America. The most important buyers of Japanese, Chinese, and Southeast Asian materials are located in those regions. The Dolly Goulandris collection of archaic Cycladic art is now displayed in a world-famous museum in Athens. For the past decade, Sheikh Saud al-Thani of Qatar was ranked among the top ten collectors in the world, outbidding the Western world's richest museums in the fields of ancient Egyptian and Islamic art.

A related collecting paradigm buttresses the historic case for American exceptionalism. We are a country of immigrants, coming from

countries all over the world, and as such may claim reasonable access to the buried treasures of our common ancestors. At the same time that American museums and collectors have purchased a part of our international cultural heritage, American scientists and scholars have richly fulfilled moral obligations connected with such acquisitions.

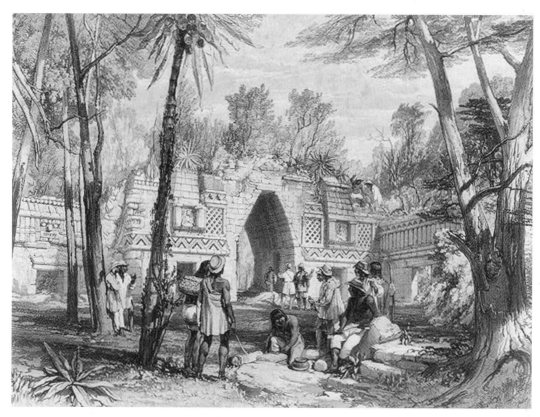

Frederick Catherwood, *Gateway at Labnah,* Views of ancient monuments in
Central America & Yucatan. The Library of Congress, Prints and Photographs
Division, LC-USZ62-47896.

SUBSISTENCE DIGGERS

DAVID MATSUDA

"ARTIFACT LOOTING" is one of the most controversial phrases in Latin American archaeological research. For the purpose of this article, the phrase refers to the clandestine, illicit removal of material remains from archaeological sites in Mexico and Central and South America. For nearly four decades, Latin American specialists have denounced the trade in Pre-Columbian antiquities. Despite impassioned discussions about whether artifacts are national heritage or international commodity, those who do the actual digging have received little attention, and the destruction of Pre-Columbian archaeological sites continues at an alarming pace. The effort to solve the problem of site despoliation is best served when we understand its root causes. My fieldwork in Belize, El Salvador, Guatemala, Honduras, and southern Mexico is an investigation of subsistence digging by rural peoples and its integration into the international art market.

Framing the Debate

In 1973, as the United States considered the adoption of legislation prohibiting the importation of Pre-Columbian monumental sculpture and murals, archaeologist Karen Bruhns wrote, "Today almost every male in the Central Cordillera [region of Colombia] . . . is involved in illegally opening and looting ancient tombs" . . . [i]f *quaqueros* are not digging on their own land, and many are not, the owner may appear and force them to abandon their work or yield any finds."[1] Unfortunately, Bruhns did not address the fact that these impoverished people dig for artifacts for subsistence because they are otherwise barred from profitable enterprise.

The research of Thomas Weil and others who worked in Colombia before Bruhns looks at the socioeconomic circumstances that make "subsistence digging"[2] for artifacts a viable means of supplementing agricultural shortfalls. "In the early seventeenth century the crown expressed its concern for the Indians through the establishment of *resguardos* [communal landholdings]. The Indians enjoyed the rights of

255

use but not ownership, and could not sell their plots. Many of the Indians, however, can no longer gain an adequate subsistence from *resguardo* lands and are . . . entering the fields of neighboring landlords as sharecroppers, tenant farmers or laborers. The cyclical pattern of poverty, indebtedness, and lack of education has perpetuated itself for generations and has prevented *campesinos* [peasant farmers] from changing their way of life."[3]

Solon Kimball and William Partridge, who worked in the highlands of Colombia some seven years after Bruhns, came to much the same conclusion: "The combination of population pressure, advance purchase credit at usurious rates . . . and the successful expansion of townspeople's land holdings results in a steady outmigration of indigenous offspring in search of work. The *Mestizo* [people of mixed indigenous and European blood] townspeople cultivate the land of the fertile valleys, while indigenous farmers are pushed into more remote mountain regions."[4]

Ignorance of the causes of subsistence digging leads many purely contextually oriented archaeologists and art historians to misunderstand the reasons for the continued tempo and mode of site destruction. Focusing attention on anti-crime legislation diverts attention from subsistence diggers' need to supplement agricultural incomes. Small landholders, landless tenant farmers, seasonal plantation workers, underpaid wage and contract laborers, and refugees become diggers because they have no other way to survive. Subsistence digging is not the cause of social ills. Rather, it is the result of basic human rights denied.

The Artifact Economy

The vast majority of the people who make up Mexico and Central America's underground artifact economy are, in local parlance, *huecheros* (humans who leave tell-tale holes like a *hueche,* a burrowing animal). When they are not subsistence digging, *huecheros* are primarily farmers, drawn from indigenous populations (i.e., descendants of Pre-Columbian peoples), lower-class *ladinos* (those who identify with European conquerors and Western ways of life), and mestizos. Because of endemic land shortage and agricultural shortfalls, these *milperos* (small-scale farmers) are unable to make ends meet. Subsistence artifact looting supplements their traditional agricultural practices and enables them to avoid malnutrition and starvation.

During my fieldwork in Belize I gained access to the higher levels of *huechero* organizations and an introduction to their methods of operation. Financiers (those who sponsor and profit from looting) and *esteleros* and *patrons* (the heads and the local bosses, respectively, of ruling councils of looting consortiums) often have a legitimate business or occupation that fronts for their illegal activities. These individuals launder profits and finance the ongoing operation of the mafia-like consortiums. Armed guards, *jefes,* are fourth in command, and protect on-site operations. They manage the laborers and motivate them, by force if necessary, not to steal. This upper echelon represents a scant fraction of those involved in the procurement of Pre-Columbian antiquities. As the command and control structure of artifact looting consortiums, the members of this upper-level echelon are the distributors and, in part, the consumers of the underground artifact economy. They loot artifacts full-time for profit and a living wage, move contraband from outback to urban areas, and secure passage across national and international borders.

Each *huechero* council is comprised of an *estelero* and four or more *patrons* from villages ten to twenty miles apart. Council members contribute four to twenty workers to a labor pool, or consortium. As a territorial organization, the council has intelligence about and access to the archaeological sites on several hundred square miles of land. Sizable consortiums of a hundred or more diggers can loot the ceremonial edifices of a single Mayan site within weeks. More commonly, small groups of four or five *huecheros* dig in a number of different ruins over a longer period of time. Ruins are located for the council by a complex network of scouts and spies. Chicle hunters, marijuana growers, hunters, and traditional healers scout for uncharted ruins on their regular treks to remote forests and mountains. The scouts pass information on to corrupt local officials, bush pilots, long-distance truckers, and foremen in isolated timber stands, who act as paid informants for the consortiums.

When promising ruins are located, the informants notify the *patron* from a nearby town. To avoid exposure, this local *patron* remains behind the scenes, covertly instructing non-local council members as to how they might bribe, influence, or intimidate those able to grant access to a particular ruin. After any objections have been quelled, council members meet to plan the looting of the nearby archaeological site. When all intelligence has been evaluated, the non-local *patrons* make plans to mobilize, provision, and clandestinely transport their laborers. At the ruins, the

activity of the *huecheros* comes under the direction of *patrons* or site bosses, who secure a site being looted from intruders.

The Failure of Subsistence Farming

Why do the *huecheros* dig for subsistence? To answer this question, I look to the historical context and contemporary regional circumstances that force indigenous and lower-income peoples to become subsistence diggers, and examine how *huecherismo* has become an integral part of the yearly subsistence cycle. While anti-looting advocates often fail to look beyond the stereotyped portrayals of those involved in subsistence digging, I wanted to focus on the needs of those at the bottom of this socioeconomic hierarchy, rather than the greed at the top.

The integration of subsistence digging into traditional farming expanded exponentially when prolonged civil violence in Central America turned *milperos* and small landholders into refugees and forced them into unfamiliar ecosystems. In these outback areas with marginal land, no seed crops, and unstable weather patterns, the demand for artifacts found in uncharted archaeological ruins offered a viable alternative to starvation, and a preferred way to rebuild subsistence living.

Joint research by Americas Watch and the American Civil Liberties Union emphasizes the economic plight of farmers in El Salvador, an area typical of the region: "El Salvador has experienced a dynamic process of land concentration and land eviction in the last century. It began during the coffee boom of the late 19th century, when communal lands farmed by indigenous peasants were abolished in favor of private property. . . . One researcher estimates that landless rural workers rose from 11% of the labor force in 1961 to 29% in 1971 and 40% in 1975."[5]

And in Guatemala, according to Americas Watch: "In the mid to late seventies, when export prices rose and the Guatemalan economy as a whole grew rapidly, peasant living standards actually declined as speculators and military officers seized increasing amounts of their lands. . . . Most of the nation's land, including the most easily cultivable holdings, is concentrated in the hands of less than 2% of the population."[6]

Grant Jones's work in Belize (arguably the nation most sensitive to the rights of its indigenous and lower-income populations) underscores the desperate straits of traditional farmers: "The average thirty-acre plot is, in the opinion of the government, sufficient for a small farmer to

make a decent living from the cultivation of sugar cane and subsistence crops. . . . The average rural agriculturalist . . . has . . . in any given year, about ten acres in production. . . . He must keep in fallow an amount of land equal to that planted in sugar cane, as the cane must be replanted . . . every six to seven years . . . the farmer finds that about four acres are uncultivable due to swampy patches or large amounts of rock. Only eight acres remain . . . [and] this amount of land would be insufficient for even two further crops. . . . He could hope for no more than a two-year fallow [in an area where four to seven years may be required]."[7]

The definition of subsistence agriculture in the everyday lives of the Maya of Central America is elastic; climactic variation, insect and animal damage, disease, taxes, and other forms of overhead all take their toll on agricultural income. Subsistence agriculturalists recognize these risks and, land permitting, plant more than they need in hopes of breaking even. In a good year, *milperos* may have a small surplus; in an average year, just enough to feed their families. In a bad year they may salvage little or nothing from their crop.

What happens when *milpa* agriculture does not provide sufficient crops for subsistence, when there is nothing left to share, no one to borrow from, and what little cash there was has run out? The peasant farmers do what their ancestors have done for thousands of years; they supplement subsistence agriculture by hunting and gathering. Guatemalan, Honduran, and Salvadoran refugees I met in Belize told me about extended families without seed corn or other resources who fled military strife to outback regions and survived by hunting and gathering for up to three years. More common are stories of Maya and other low-income rural people who periodically run out of corn and other staples between summer and winter harvests; they take to the forests, where they hunt, gather, and forage for "earth" and "country" foods.

There are dramatic differences between harvesting subsistence staples and cash cropping. Shifting crops and fallowing land make it possible to grow subsistence staples in thin, nutrient-poor soil. However, cash crops like coffee, citrus, and cane cannot be periodically replanted, and the poor soil they inhabit must be enriched with expensive chemical fertilizers. Subsistence farmers keep insects in check by patiently picking them off staple crops. Cash-cropping farmers must use expensive pesticides to keep pests from burrowing into their produce. Coffee and citrus plants take from five to ten years to mature, and farmers must

provide a steady input of fertilizers and insecticides for nearly a decade before realizing any profit from their investment. Once committed to cash cropping, traditional anti-starvation strategies are no longer viable, and farmers need money to protect their significant investment in cash crops. If the harvest fails or the market price falls below the cost of overhead, *milperos* cannot survive on their reduced subsistence staple parcels and garden plots.

In these circumstances, cash-cropping farmers have few options. They can work for the petty capitalists who produce arts and crafts for tourist and export markets, but if they are non-local or ethnic outsiders, they are often locked out of piece-rate networks and factory jobs. They can return to plantations, but the owners have developed schemes to subvert their goals. One field manager I interviewed explained, "You can only get so much from these undernourished workers, you know. The slightest thing and they are out sick. If you pay them too much, they go into business for themselves and stay away. If you pay them too little, well, they are useless. You have to underpay them so they borrow from you to eat. That is the way you keep them."

Plantation owners are continually on the lookout for sources of labor to undercut their current workers. "What we need is a war someplace and lots of refugees from there to work. That refugee-shit, they work. . . . They have nowhere to go, no other possibilities. They are not like the peasants from my country. You pay them and right away they leave for home and their fields. Foreigner-shit, you don't have to pay them as much and like a dog they come back when you call them. If there was a war and refugees came here to work, I would fire that peasant-shit."

It is no surprise, given the plantation official's commitment to exploitation, that low-income rural peoples prefer to plant their own crops and seek other means to sustain traditional life-ways.

How have so many *campesinos* climbed back from bankruptcy and starvation? Governmental and nongovernmental aid programs, though few, have helped to rejuvenate local agriculture by encouraging cooperatives and offering direct-contract assistance. Extended families, religious networks, and municipal redistributions provide important safety nets during lean years. But these methods alone cannot account for the continued survival of Maya and lower-income rural smallholders, who must deal with widely fluctuating market prices and bad harvests three of every ten years. The goal of most Maya and low-income rural peoples

260

is to achieve a blend of resource procurement strategies in which the income from commodities such as cash crops and antique artifacts supplements the traditional mode of life associated with subsistence agriculture. Once farmers have established a steady revenue stream through subsistence digging, their profits—after paying maintenance costs and family and community obligations—are reinvested in agriculture. This reinvestment restores the basic pattern of subsistence activities to something approximating pre-contact life. In this way, hunting and gathering artifacts fits neatly into the continuing tradition of *milpa* agriculture.

The *Huechero* Life

The removal of artifacts from ancient Mayan sites dates back to Classic (600–900 CE) and Terminal Classic (900–1200 CE) Pre-Columbian periods.[8] Centuries after the collapse of the Mayan city-states, farmers continue to uncover ancient objects when they turn over soil and till their fields. A *milpero* relates: "One day, after I had cleared and burned my field, I was returning to a place where I left some tools. Then I was underground. I had fallen through the . . . [roof] of an ancestor's tomb. I thought the devil was coming for me until the dust cleared and light came through the hole in the roof. I took some things home and soon people came to hear my story for themselves and look at the precious things. Many began to tell me that these *semillitos* [a combination of words for seeds and artifacts meaning ancestors' gifts] are worth money."

Farmers who return to their fields after a rain often find the ground covered with shimmering stone and ceramic artifacts. Most farmers keep a small collection of artifacts, either hidden, on public display, or for sale. Special artifacts usually adorn the family shrine, next to the portraits of Christian saints, deceased family members, and mythological ancestors. On rare occasions, villagers use stone idols as doorstops, small vases for target practice, and figurines as children's toys.

Huecherismo enables several million Mexicans and Central Americans to maintain traditional lifestyles by using looted artifacts as a cash commodity to supplement subsistence agricultural income. The seasonal round begins when small farmers select a plot of land and slash and burn the naturally occurring biomass during April and May. In June, groups of patrilineally related men form work-gangs to finish preparing the land and to plant the summer subsistence and cash crops. In late June, they

decide who will stay behind to tend maturing crops, as preparations for the first of three looting seasons begin.

From July through late September, farmers become *huecheros* and venture into outback regions in search of ruins, tombs, and artifacts. Other groups of subsistence diggers, from one to more than one hundred, operate for prolonged periods as semi-nomadic hunter-gatherers who stay close to home and fields during the week and forage for artifacts on odd days and weekends.

By late September, subsistence diggers are again *milperos.* Summer crops are harvested, and throughout October until mid-November the work-gangs prepare the fields and plant winter crops. Following *fagina* (reciprocal communal labor) patterns, a few workers are again assigned to tend the crops and provide support to the families of *huecheros* who set out to scour the countryside for artifacts. The *huecheros* are home to harvest the winter crop in March, they are back hunting and gathering cash commodities during April, and in May they return to the fields to begin the seasonal round again.

Often, subsistence-digging patterns are similar to those employed in shifting agriculture. Diggers harvest an archaeological site until it no longer produces sufficient artifacts or the danger from armed competition is too great. Subsistence diggers then let one ruin lie fallow while they harvest another. When conditions are no longer profitable or safe, *huecheros* shift to another site, or they rotate back to a previous ruin.

Subsistence digging by *huecheros* can become a full-time occupation when the seasonal round is interrupted by the sensationalized discoveries of media-savvy archaeologists. Headlines like "Arthur Demarest and the Temple of Doom" confer cachet and add dollar value to artifacts from specific sites, as this telephone conversation between a *patron* and his antiquarian connection illustrates:

"You have heard about the new places and rich things," says the *patron.*

"Yes," replies the antiquarian, "the news about an ancient Mayan jade source has been in the papers, magazines, and on TV.... Do you have access to the sites?"

"Not yet, but soon," the *patron* says.

"I need artifacts, jade artifacts," says the antiquarian. "I don't care from where. They will do until you can get to the new sites."

Sensationalized accounts encourage not just site-specific subsistence digging but region-wide artifact looting as well, and link archaeologists and their funding institutions to the clandestine, illicit removal of material remains from Pre-Columbian archaeological sites.

Conclusion

The stereotype of the artifact looter in the popular press is of an ignorant peasant. In this portrayal, the *huecheros* clandestinely loot their ancestors' graves because they do not know any better, are wantonly criminal, or are too inept or lazy to conduct legitimate business. In covering archaeological issues, the media portray beleaguered law enforcement engaged in running gun battles against evildoers who are reaping profits on a scale surpassed only by the illegal trade in drugs and weapons. Archaeologists play the hero's role, reserving for themselves and their institutions the mantle of science. Yet archaeologists are beholden to funding interests and tenure tracks, and many are loath to criticize the human-rights abuses of governments that grant their excavation permits. Too many archaeologists have forgone serious publication of their excavations in peer-reviewed journals, writing for the general public and working lecture circuits instead—and thereby helping to stimulate collecting.

Education in local heritage is recommended as the solution to site destruction, yet the governing elite within these source countries often actively discourages education for the poorest in their population. Strict enforcement of international trade restrictions is held to be essential, yet as the artifacts leave the countryside for private collections and national museums, the same elite have become some of the primary collectors of indigenous artifacts, and only the *huecheros* suffer under enforcement of patrimony laws.

A more complex, multi-perspectival reality is hidden behind the sensationalized coverage. Participation in cash economies such as artifact looting within these Latin American source countries is motivated not by the attractiveness of wage labor but by severe economic realities. The fact that artifact looting is a way of life practiced for subsistence is discomfiting to some archaeologists and art historians. For if these are not "artifact looters" but survival-oriented subsistence diggers, then the

justification for their excavation of material remains is as compelling as that of the archaeologists and art historians themselves.

In fact, many of the subsistence diggers regard the debate over who may or may not loot artifacts as an aspect of class warfare. To paraphrase one perspective expressed by my informants: "Every year the archaeologists dig up the artifacts and take them away. The next year they come back with more money, people, and equipment. They talk of our ancestors with reverence, but treat us like ignorant peasants. The excavations are often run like plantations where we are exploited. The archaeologists want strong backs and weak minds. When we work for them, they pay us little and do not treat us with respect. We are never asked what we think, and there is no chance for advancement. The artifacts represent money and power to archaeologists. That is how they make their upper-class living. To us, these gifts from our ancestors mean seed corn, food, clothes, and security. This is how we live our lower-class lives."

The indigenous peoples of Central America are the populations most affected by neocolonial policies and practices that result in glutted markets, mechanized agriculture, and unstable employment as corporations seek cheaper labor. As familiar, sustainable environments and technologies are replaced by unsustainable cash-crop economies, *milperos* lose knowledge of subsistence life-ways, and the safety nets provided by communal social relations disappear. In these dire straits, subsistence digging puts food on the table. A broader understanding of the diggers' plight is basic to resolving the issues of subsistence looting. Solutions must address the *huecheros'* contemporary needs and respect their traditional life-ways if they are to succeed.

Subsistence diggers are not "my people," nor do I condone what they do. Like my anthropological and archaeological colleagues, I work to end the need for clandestine removal of material remains from Pre-Columbian sites. To paraphrase John Henry Merryman, in the past four decades much has been written on illicit digging that appeals primarily to the emotions, diverts attention from the facts, and discourages reasoned discussion of the issues. I attempt to challenge the prevalent stereotypes through anthropological research, asking instead, "Who is clandestinely digging up Pre-Columbian artifacts, and what are their motives?" The people I found were, with few exceptions, not artifact looters but survival-oriented subsistence diggers.

1. Karen Olsen Bruhns, "The Methods of Guaquería: Illicit Tomb Looting in Colombia," *Archaeology* 25, no. 2 (1972): 140-43.

2. David P. Staley, "St. Lawrence Island's Subsistence Diggers: A New Perspective on Human Effects of Archeological Sites," *Journal of Field Archeology* 20, no. 3 (Fall 1993): 247-55.

3. Thomas E. Weil et al. *Area Handbook for Colombia* (Washington, D.C.: U.S. Government Printing Office, 1970).

4. William L. Partridge and Solon T. Kimball, *The Craft of Community Study: Fieldwork Dialogues* (Gainesville: University of Florida Press, 1979).

5. Americas Watch Committee and American Civil Liberties Union, *Report on Human Rights in El Salvador* (New York: Vintage Books, 1982).

6. Cynthia Brown, ed., *With Friends Like These: The Americas Watch Report on Human Rights and US Policy in Latin America* (New York: Pantheon Books, 1981).

7. Grant Jones, *The Politics of Agricultural Development in Northern British Honduras,* Monograph Series 1, no. IV (Winston-Salem, N.C.: Overseas Research Center, Wake Forest University, 1971).

8. Descriptions of ancient looting practices may be found in William Coe, *Tikal: A Handbook of the Ancient Maya Ruins* (Philadelphia: University Museum, University of Pennsylvania, 1967; Guatemala: Centro Impresor Piedra Santa, 1998), and William Fash, *Scribes, Warriors, and Kings: The City of Copan and the Ancient Maya* (New York: Thames and Hudson, 2001).

PART IV **THE UNIVERSAL MUSEUM**

Parthenon frieze, c. 440 BCE, Athens, Greece. Photo by Arnold Genthe, c. 1900, courtesy The Library of Congress, Prints and Photographs Division, Arnold Genthe Collection: Negatives and Transparencies, LC-USZ62-68253.

A LICIT INTERNATIONAL TRADE
IN CULTURAL OBJECTS

JOHN HENRY MERRYMAN

IN DISCUSSING THE INTERNATIONAL TRADE in cultural objects, it is important to understand that the trade consists almost exclusively of the voluntary transfer of privately held works. Artworks, antiquities, historical objects, and other articles of cultural property in museums, monuments, and other public collections do not figure significantly in international trade. Cultural objects in private hands—principally individual and corporate collections and the stocks of dealers and auction houses—dominate the market.

Three separate but mutually supportive forces combine to inhibit the licit international trade in art and antiquities: an anti-market bias in UNESCO; excessive source-nation retention; and what I call the archaeologists' Crusade. In the first part of this essay I briefly describe these forces and their effects on trade in art and antiquities. In the second part I describe the possible incompatibility of excessive source-nation export controls with (1) the international trade liberalization structure created by the World Trade Organization Treaty, the European Union Treaty, and related international arrangements; and (2) prevailing human rights protections in national constitutions and international legislation.

– I –

Market Aversion in UNESCO

UNESCO cultural-property conventions and recommendations typically profess support for the international circulation of cultural property.[1] One might suppose that this support would extend to circulation through market transactions, which are the principal medium for the international circulation of goods of all kinds. But in its 1976 Recommendation Concerning the International Exchange of Cultural Property, UNESCO, while supporting the international *exchange* of cultural property, opposed international *trade,* stating that "the international circulation of cultural property is still largely dependent on the activities of

269

self-seeking parties and so tends to lead to speculation which causes the price of such property to rise, making it inaccessible to poorer countries and institutions while at the same time encouraging the spread of illicit trading."

This statement combines anti-capitalist and anti-market sentiments, referring, with evident disapproval, to buyers and sellers engaged in market transactions as "self-seeking parties"; engaging in the pejorative use of "speculation" for the normal human tendency to base present action on assumptions about the future; and making the economically naive assumption that speculation causes the prices of works of art and other cultural objects to rise.

Knowledgeable observers would argue instead that constricting the licit supply of cultural objects by prohibiting their export is far more likely to cause prices to rise and to encourage the spread of illicit trading than would "speculation" by museums, collectors, dealers, and auction houses trading in a licit market. As to "poorer countries," many of which are source nations, the orderly marketing of surplus cultural objects could *pro tanto* displace the black market, while providing a significant source of income to the source nation and its citizens. That major source nations typically hold stocks of marketable surplus objects is confirmed by another paragraph in the Recommendation's preamble: "Many cultural institutions, whatever their financial resources, possess several identical or similar specimens of cultural objects of indisputable quality and origin which are amply documented, and . . . some of these items, which are of only minor or secondary importance for these institutions because of their plurality, would be welcomed as valuable accessions by institutions in other countries."[2]

Such objects would also be welcomed to the international market by museums, collectors, and the art trade. The Recommendation, however, rejects the market and relies exclusively on interinstitutional (government-to-government and museum-to-museum) exchanges as the medium through which to promote enrichment of cultures and mutual understanding and appreciation among nations. Such exchanges are a commonly used tool of museum collections management. They are, however, a form of barter, with all of barter's considerable limitations. The market is a much more efficient and productive mechanism for the international circulation of cultural property, and to exclude it seems perverse.

In its exclusive preference for interinstitutional exchanges, the Recommendation contemplates a cultural-property world that is populated solely by governments and "institutions." There is no place in it for private collectors or an active art trade and no scope for a licit market. There is no recognition of the pivotal roles of collectors, dealers, and auction houses in supporting artists and promoting their work; in building great private collections that ultimately enrich museums; in pioneering the collection of antiquities, experimental artworks, and other objects that eventually are recognized for their cultural importance.

What can explain such an impoverished vision of the international art world? One possible explanation is that when the Recommendation was promulgated in 1976, the Soviet empire still existed. State socialism still could be perceived by Third World nations as a plausible alternative to private capitalism and trade liberalization. In a UNESCO numerically dominated by Socialist and Third World representatives, finding evidence of an anti-market bias may have been unsurprising. But with the fall of the Soviet empire, disillusioning revelations of the failures of that extended experiment with state socialism, and the apparent success of the movement toward international trade liberalization, one might have expected this bias to be moderated or to disappear. Not so in UNESCO.

Instead, its anti-market bias appears to have grown stronger. Its most recent, and most extreme, demonstration appears in the 2001 UNESCO Convention on the Protection of the Underwater Cultural Heritage. Article 2(7) of the convention states in its entirety: "Underwater cultural heritage shall not be commercially exploited." This breathtaking provision is elucidated in Rule 2 of the rules concerning the activities directed at underwater cultural heritage annexed to the convention: "The commercial exploitation of underwater cultural heritage for trade or speculation or its irretrievable dispersal is fundamentally incompatible with the protection and proper management of underwater cultural heritage. Underwater cultural heritage shall not be traded, sold, bought or bartered as commercial goods." The explicit statement that market transactions are "fundamentally incompatible with the protection and proper management of underwater cultural heritage" expresses an extreme position that, as will be shown below, is broadly embraced by the archaeological establishment in the United Kingdom and the United States.

Commodification: An Effete Prejudice?

A related form of market aversion exists in the world of ideas about art, where "commodification" has emerged as a modish epithet, and any sample of news stories about major art sales may include the lament that art has become a commodity. Thus a *Los Angeles Times* editorial complains: "When a culture's common aesthetic patrimony becomes just another commodity, everyone is made poorer."[3] Another journalist refers to "today's commercially driven art world . . . [that] has become a commodity marketplace."[4] Even noted art critic Robert Hughes is quoted as saying that art has become a hot commodity, and the public has come to view it as a commodity, which "works against the sense of the aesthetic in the American mind. . . . Art has been turned into bullion."[5]

It is not always clear what people mean by commodification or why they think it is undesirable. One possible meaning—that the work of art is itself somehow reduced or sullied by being bought and sold[6]—surely does not bear scrutiny. On the contrary, if van Gogh's *Irises* brings a high price at auction, that is an indication that the work is highly regarded by the art world: by art historians, critics, connoisseurs, and museum curators, as well as by dealers and collectors. The painting is hardly demeaned by market confirmation of this high opinion of the artist and his work. But suppose that the work were bought by someone whose art interest includes an investment motive or the desire to capture a trophy. That may not be what the artist had in mind when he made the painting or sculpture, and it is not what most people think art is for. But if the acquisition does not endanger the work or make it less available for study and enjoyment, what is the harm?

Mr. Hughes, in the quotation above, seems to be saying something different: that when a great work of art commands a high price, it distorts the viewer's perception of the work. Instead of a pure aesthetic experience, what the viewer receives is affected by awareness that the painting brought a record price at a public auction. The market information is treated as "noise," as extraneous data that adulterate appreciation of the work as art. But why should awareness that a painting brought a high (or low) price at auction be a less legitimate part of what the viewer brings to it than knowledge that the painter died young or that the work was commissioned by a certain wealthy patron or that it was taken by Napoleon during his Italian campaign or that it was badly torn in transit to a

museum show and has been skillfully repaired? There is no immaculate perception, no pure aesthetic experience. The work has a history. Everything that is known about it affects the viewer's perception of it. Why should the work's history artificially exclude its market history?

A third, more interesting possibility is that the commodification charge is based on the belief that market values diverge significantly from art historical or aesthetic values, and that a public eagerly informed of prices by the media is too easily misled into supposing that the market price equates with the work's true value, that expensive art equals great art. This proposition raises interesting and ultimately profound questions about the nature of art and about how artistic value, as distinguished from market value, is established. In practice, however, the nearest thing to "true" artistic value is determined by an art-world consensus, a convergence of opinion among art historians, critics, experts, museum professionals, and knowledgeable collectors and dealers. This consensus will seldom agree entirely with the market because both the art world and the market have access to imperfect information, both are subject to the vagaries of human behavior, and neither is entirely immune from fads and trends. But the variance between them is seldom great and will usually be readily explainable.

Someone may pay too much for an uninteresting Renoir because of the artist's name, out of ignorance about the uneven quality of his works. Media hype and too much wine at dinner may lead a wealthy collector to overbid for a work at auction (but there must have been an underbidder). Successful marketing by a skillful dealer may stimulate the demand for works by an artist with a gimmick. The art-world consensus, however, sets limits on such variations between market price and art-world judgment of quality, if only because the art market operates within the art world and is part of it. Normally there is a close relation between art-world consensus about artistic value and market value, and when opinion about artistic value changes over time, market performance changes with it.

Opponents of market capitalism may have a principled basis for opposing the art market but, for the rest of us, it is difficult to avoid the conclusion that the commodification objection expresses little more than an effete prejudice. This prejudice denigrates dealers and collectors as investors and speculators who contribute to the impairment of unspecified artistic values. Even museums, when they sell off works from their collections, become soulless commodifiers. Contact with the market soils

the work of art, and participation in the market sullies the participant (although artists who sell their works mysteriously remain unsullied). The people who invest their time, talent, and resources in activities that make and maintain the market for works of art and help to build important private and museum collections are demonized, made into enemies of art. Such an attitude does not deserve to be taken seriously by serious people.

Excessive Retention

Most source nations prohibit the export of privately held cultural objects (embargo laws) or declare that they are property of the state or the people (expropriation laws). In a few major source nations (the United Kingdom, Japan, Canada) the export restrictions are moderate and apply only to a limited group of objects of outstanding importance to the nation's history and culture. But in the majority of source nations the laws are broadly inclusive, extending to wholesale categories of objects whose retention is clearly inconsistent with the international interest in the circulation of cultural property.

The ostensible purpose of these over-retentive laws is commonly phrased as "protection of the national cultural heritage" or "patrimony." In source-nation and UNESCO rhetoric, these terms have taken on special meanings: "protection" means retention; any desirable object within the jurisdiction is "national"; and even unremarkable and redundant objects are somehow "important" to the cultural heritage.

Protection

As the European Court of Justice held in *Commission v. Italy,*[7] retention and protection are different concepts; there is no necessary relation between them. Normally, when we speak of protection we mean taking measures to preserve something or keep it safe from harm: to preserve fragile objects from physical damage or destruction; to preserve meaning and information that would be lost by separating objects from their contexts; and to preserve the integrity of complex objects by preventing their dismemberment. But many kinds of cultural objects—including easel paintings, freestanding sculptures, coin collections, books and manuscripts, and ceramics—can be exported without significant risk of

damage, loss of meaning/information, or impairment of integrity. Yet source nations routinely deny export permission for such objects, not to protect them but to retain them.

Conversely, retaining an object does not necessarily protect it. Many of the hoarded antiquities deteriorating unattended in source-nation storehouses would have greater prospects of survival and be put to more beneficial use in foreign private or museum collections. A Poussin painting, formerly in a private collection in France and now in the collection of the Cleveland Museum of Art,[8] receives more professional attention and care than its private French owner could be expected to give it.

Was the French cultural heritage itself diminished or otherwise damaged by the export of the Poussin? Clearly not. A great work of art from a private collection in France, where it was unavailable for public enjoyment, today hangs in a public room in a great museum, properly identified as a Poussin and honored as a great work of art by the important French artist. In the Cleveland Museum the Poussin is still a Poussin. It is seen and admired by thousands of visitors annually. The French cultural heritage has not been damaged by this export; it has been enhanced by it.

Related considerations guided Austria's response to the proposed export of one of Egon Schiele's most important paintings, which was being sold to an American museum. In overruling the competent ministry's denial of export permission, the Austrian Administrative Court ruled that the state's interest in retaining the Schiele was outweighed by its interest in propagating Austrian art abroad.[9] Art is a good ambassador.

National

In source-nation rhetoric, any cultural object present in the national territory is part of the national heritage. For example, Italy has denied their owners export permission for watercolors painted in Austria by Adolf Hitler and for Matisse and van Gogh paintings painted in France. The French have refused to permit their owners to export a collection of drawings by Italian masters, a Yuan-dynasty vase, and a painting of a Turkish scene by a Swiss artist. Such examples abound. Source nations routinely prohibit the export of privately held works that bear no significant relation to their cultures. It abuses logic to call such objects "national" cultural heritage or patrimony.

Cultural Heritage / Patrimony

To call an object cultural "heritage" or "patrimony" means, under the 1970 UNESCO and 1995 UNIDROIT conventions, that it is distinguished from the ordinary run of human artifacts by its cultural "importance." And, as we shall see below, the exceptional treatment given cultural property under the WTO and EU treaties applies only to "cultural treasures."

The use of such terms necessarily implies discrimination; not every work of art or antiquity qualifies as "important" or as a "cultural treasure." Designation as part of the national heritage or patrimony signifies for most people a way of distinguishing treasures—objects of outstanding artistic or historical value—from the common run of human artifacts. But, as we have seen, major source nations prohibit the export of undistinguished works of art and retain stores of deteriorating antiquities that are not "important" enough to be studied, published, or exhibited.

Most national retentive schemes are in this sense excessive; they retain too much and justify the excessive retention by supplying euphemistic meanings to "protection," national," and "heritage." In this they are supported by UNESCO, whose 1970 Convention on the Means of Prohibiting and Preventing the Illicit Import, Export and Transfer of Ownership of Cultural Property states in Article 1: "For the purposes of this convention, the term 'cultural property' means property which . . . is specifically designated by each State as being of importance for archaeology, prehistory, history literature, art or science." This definition, rather than imposing some discipline on the inclusion of objects in a nation's cultural heritage or patrimony, issues a "blank check" by accepting whatever the nation designates, officially licensing the prevailing habit of excessive retention.

Since cultural-property export controls are "public laws," the courts of other nations had no obligation, under classical international law, to enforce them, and so excessive controls were less troublesome. Beginning in 1970, however, excessively retentive national legislation has become entitled to foreign enforcement through a series of international measures, notably including the 1970 UNESCO Convention on the Means of Prohibiting and Preventing the Illicit Import, Export and Transfer of Ownership of Cultural Property; the 1994 UNIDROIT Convention on Stolen or Illegally Exported Cultural Objects; EC Regulation No. 3911/92

of 9 December 1992 on the Export of Cultural Goods; and EC Council Directive 93/7 of 15 March 1993 on the Return of Cultural Objects Unlawfully Removed from the Territory of a Member State. During the same period, a few market nations, most prominently the United States, have adopted judicial decisions, legislation, and enforcement policies that support excessive source-nation retention of cultural objects.

The resulting international regime is significantly skewed; it tilts strongly in favor of source nations and, as we shall see below, archaeologists, and against the interests of the other major participants in the international art and antiquity worlds. It supports cultural nationalism and excessive retention while displaying little sensitivity to the international interest in the circulation of cultural objects. The regime inadequately responds to the legitimate interests of museums in collecting, preserving, studying, and displaying works of art and antiquities. It undervalues the legitimate interests of collectors, whose acquisition, preservation, and enjoyment of works of art and antiquities nourish the collections of the world's museums. And it ignores, where it does not revile, the interests of the art trade, whose activities are essential to the formation and enrichment of private and museum collections. As will be shown below, the regime also appears to support source-nation violations of their obligations under the World Trade Organization and European Union treaties and to condone governmental violation of rights guaranteed by modern constitutions and human rights conventions.

The Archaeologists' Crusade

A number of prominent archaeologists have announced that they are "at war" with collectors, museums, and the antiquities trade, whom they accuse of market-motivated "rape," "pillage," and "plunder" (one also encounters adjectives such as "pernicious," "corrupt," "tainted," and "grubby"). Less flamboyantly, the Principles of Ethics in Archaeology of the Society for American Archaeology state that: "The buying and selling of objects from archaeological contexts contributes to the destruction of the archaeological record. . . . Commercialization of these objects results in their unscientific removal from sites, destroying contextual information."

In either form, the argument reduces to this: the antiquities market ("buying and selling" and "commercialization") causes destruction

of the archaeological record and the loss of contextual information. Acquisitors (museums, collectors, and the art trade) are the enemy; they are the source of the antiquities problem. To be fair, many individual archaeologists, particularly those who work with museums, take a more nuanced view of the antiquities problem, which is real and complex. The archaeological establishment, however, appears to have embraced one or the other form of the simplistic argument and, full of passionate intensity, has set out on a Crusade to impose its version of archaeological correctness on the rest of the art and antiquities world.

Hence the antiquities problem. It is true that many antiquities that newly appear on the market are undocumented. It is true that archaeological sites are abused, contexts destroyed, and information about the human past irretrievably lost. But it is also true that museums and collectors would much prefer to acquire, and the antiquities trade would strongly prefer to deal in, legitimately excavated and properly documented objects. They are disabled from doing so, however, because excessive source-nation restrictions, which archaeologists strongly support, have shut off the supply.

Archaeologists have intensified the antiquities problem by demanding that museums, collectors, and the art market acquire only properly documented objects.[10] Elaborate due-diligence procedures are not enough to satisfy them.[11] These Crusaders presume that an antiquity that is not fully and properly documented is illicit: guilty, in other words, until proved innocent. Employing this inversion of the normal burden of proof, collectors who acquire antiquities and museums that show them are acting criminally, even if no source nation claims the antiquities and no one has shown that they were improperly acquired.

As a predictable result, much antiquities traffic is diverted from legitimate dealers and purchasers to the black market, which risks the mistreatment of objects and sites and the destruction of context (as well as other evils, including the confusion caused by counterfeit antiquities and forged provenances and export documents). If one set out to encourage harm to the archaeological record, it might be difficult to contrive a more effective way of doing so than the present one. As Quentin Byrne-Sutton has observed, the result is "a ridiculous situation in which regulation nourishes what it seeks to eliminate."[12]

The antiquities problem, a consequence of the serious imbalance between the small supply of legitimated, documented antiquities and

the large and growing demand for them, can be ameliorated only by increasing the supply and/or reducing the demand. Further restricting the supply—for example, by the imposition of more restrictive source-nation laws or market-nation import controls—will increase the disparity between demand and legitimated supply and further nourish the black market. Increasing the supply would, *pro tanto,* nourish a licit market and weaken the black market.

Recipes for increasing the supply of legitimated antiquities have been published by Paul Bator,[13] Karl Meyer,[14] and other eminent, knowledgeable, disinterested observers. Public institutions in source nations could release some of the reputedly large supplies of duplicate marketable antiquities they now hoard. Export controls could be amended to permit privately held objects to enter the international antiquities market. The archaeological principles that control professional legitimation could be made less restrictive, and known sites could be more expeditiously excavated, documented, and conserved. Builders and landowners—the principal finders of antiquities—could be more fairly compensated for reporting their finds. Museums, collectors, and dealers who exercise due diligence might be respected rather than bullied by crusading archaeologists. Despite the apparent reasonableness of such proposals, however, they are ignored or opposed by the archaeological establishment.

Archaeologists have instead chosen to try to quell the demand for antiquities through their Crusade against museums, collectors, and the antiquities trade. Archaeologists speak with a respected voice and command sympathetic ears, and their influence has affected governmental and institutional policies, particularly in the United States. In doing so, archaeologists have effectively reduced the supply of antiquities to the licit market. But the world demand for antiquities stubbornly persists, and the black market flourishes.

It is unlikely that the archaeologists' Crusade against trade in antiquities will succeed. The record of other, more highly organized and better-financed attempts to suppress the trade in controlled goods for which there is a strong demand (e.g., arms, strategic materials, technology, narcotics, alcohol) is well known: disappointing progress toward an ever-receding objective, unanticipated expense, and a variety of unforeseen, often seriously damaging secondary effects.

Nor is it clear that the archaeologists' Crusade against the market *should* succeed. Archaeologists are an interest group pursuing their own

interest. It is an important interest, which most good people support, but there is no neutral principle that elevates the archaeological interest to a higher level than the other important competing interests. Those competing interests prominently include the international interest, expressed in a number of international instruments, in the circulation of cultural objects, which "increases the knowledge of the civilization of Man, enriches the cultural life of all peoples and insures mutual respect and appreciation among nations,"[15] and leads to "a better use of the international community's cultural heritage."[16] Collectors have an interest in possessing and enjoying works of art and antiquities; museums have an interest in collecting, preserving, studying, and displaying them; dealers and auction houses have an interest in trading in them.

All of these interests are legitimate. That they sometimes conflict with the interests of archaeologists or source nations or other market opponents merely reflects the reality that the antiquities problem is complex and admits of no simple solution. The reasonable course is for the interested parties to seek the best mutual accommodation of their interests, and this requires that the parties recognize, speak, and listen to each other.

The prominent archaeologists quoted at the beginning of this section project a more simplistic, adversarial version of the antiquities problem in which they are right; collectors, museums, and the art trade are iniquitously wrong; and the international interest, if it is considered at all, is inadequately served by rhetoric about interinstitutional exchange. Like other Crusaders, these archaeologists are not interested in a dialogue. For them, there is nothing to discuss.

The archaeologists' Crusade allies them with retentive source nations in supporting repression of the antiquities trade. This has the unfortunate secondary effect of reinforcing exaggerated cultural nationalism, excessive source-nation retention and the atmosphere of sentiment, romance, and rhetoric that sustains them. This further impedes any effort to increase the supply of legitimated antiquities. It also impedes efforts to raise the level and moderate the tone of discussions about the antiquities problem.

None of this is new. Some archaeologists fully understand and, at least in principle, agree. Agreement in principle, however, is relatively easy. It is more difficult to work out a resolution of the competing interests in the antiquities problem. That process should begin with a

dialogue in which the interested parties talk and listen to each other. Little will be accomplished until the politics prevailing within the archaeological profession change.

– II –

Trade Liberalization

The World Trade Organization and European Union treaties prohibit export controls on "goods,"[17] a category that the European Court of Justice has held includes works of art and other cultural objects.[18] Both treaties—WTO in Article 130 and EC in Article 30—admit exceptions for "the protection of national cultural treasures,"[19] a key phrase that has yet to receive judicial interpretation. Eminent commentators agree, however, that the phrase should be treated as restrictive.[20] "The exception's purpose is not to preserve the totality of an artistic patrimony," but to safeguard its "essential and fundamental elements."[21]

Assuming that these scholars are right, would an ancient vase of no particular distinction, one of many that for most purposes are unremarkable and fungible, be considered a "treasure"? What about the allegedly huge numbers of duplicate antiquities in storehouses in major source nations? Picasso made thousands of paintings and sculptures. Is every one of them a "treasure"? Every Fra Angelico? Every Monet? Or, as Dr. Carducci, speaking of France, has put it: "La question reste posée de savoir si ce vaste ensemble d'objets peut rentrer dans la notion, en soi assez élitaire, de 'tresor national' au sens de l'article 36."[22]

Would the Hitler watercolors for which Italy denied an export permit qualify as cultural "treasures"? In what sense are they, or the van Gogh painting for which Italy also denied an export permit, *national* treasures? If artworks can be moved without danger to the works themselves and without impairment of context or loss of information, in what way do export controls *protect* them?[23]

Suppose an Italian collector is prosecuted in Italy for sending his Goya painting to Spain without export permission. He objects that application of the Italian export control would violate Italy's obligations under the WTO and EC treaties because a) the painting is not in any sense an Italian *national* treasure and b) the Italian law does not *protect* the Goya against anything except export. Or suppose Italy sought the return of

the painting from Spain under European Council Directive 93/7 of 15 March 1993, which is expressly made subject to the limits of Article 30. We do not know whether restrictions like these on the export of cultural objects that do not meet the definition of "national treasures," or do not "protect" those that do, will ultimately be enforced by the EU Court of Justice and WTO Dispute Resolution Panels. At this writing, no such cases have been adjudicated.

Human Rights

It is an established principle of private international law that courts will judicially enforce foreign "private law" rights, including rights of owner-ship of movable property.[24] If a thief steals a Jackson Pollock painting in California and takes it to London or Paris or Hamburg, the appropriate British or French or German court will hear the owner's case and decide it on its merits. A different rule applies to "public law" rights; foreign courts generally do not enforce them. Thus, if a London dealer fails to pay income tax owed to the United States, a British court, in the absence of treaty, would not provide a forum for an action by the United States to compel payment.

Now suppose that a nation enacts a typical "national ownership" law stating that all works of art more than fifty years old in private hands are property of "the state," or "the nation," or "the people," as a growing number of nations have done since World War II. Although it is clearly a "public law," it purports to create a "private law" right of property in the state. Can the state now successfully sue in a foreign court as "owner" to recover an illegally exported work of art?

The issue can be phrased as one of characterization: does the law make the state the owner of the work, or is it merely a disguised form of export control, as the trial court found on the facts in *Peru v. Johnson*?[25] In private international law, questions of characterization are for the forum, which may or may not choose to adopt the characterization employed in the foreign statute. Should the "national ownership" statute cause the foreign court to treat as "stolen" a painting that the alleged "thief" legally purchased from its owner but illegally exported?

The reigning international legislation affecting trade in works of art does not support such a characterization. The UNESCO convention, in Article 7(b), limits the term "stolen" to objects "stolen from a museum

or a religious or secular public monument or similar institution . . . provided that such property is documented as appertaining to the inventory of that institution." The UNIDROIT convention, which is intended to supplement rather than replace the UNESCO convention, expressly characterizes improperly excavated objects as stolen in Article 3(2) but otherwise leaves the term "stolen" undefined.

Still, the apparently clear distinction between theft and illegal export has been clouded by these national ownership laws, particularly in the United States. The leading case is *US v. McClain*.[26] Archaeological objects illegally removed from an undocumented Mexican site were imported by Americans into the United States for sale. The applicable Mexican law stated that all Pre-Columbian objects found anywhere in Mexico were the property of the Mexican people. The US government prosecuted McClain under a federal statute—the National Stolen Property Act—making it a crime to transport "stolen" property in interstate or foreign commerce.

Should these objects be characterized as "stolen" within the meaning of the US statute? The court, looking to the Mexican national-ownership law, held that they were stolen, and the looters went to prison. Despite its arguable inconsistency with the language of the 1970 UNESCO convention and American implementing legislation, and with the principle that one nation will not enforce another's public laws, the *McClain* case has not been overruled.[27]

Important unanswered questions remain about the foreign legal effects of national-ownership laws. Do such laws mean what they appear to say? Should the forum look behind the words of the foreign law to determine its meaning in application in the source nation, as the court did in *Peru v. Johnson*?[28] Do such laws actually convert private property to public ownership? If so, do they satisfy constitutional and international convention requirements of notice, hearing, and compensation? If the source nation seeks to exert its own law claiming generic ownership in a foreign action, should the defendant be permitted to question the constitutionality of the law on which the plaintiff's action is based?

These are interesting questions. Some of them were faced in 1983, when the Supreme Court of Costa Rica held that a Costa Rican law declaring national ownership of cultural property was unconstitutional.[29] Similar questions provided a subtext in the *Walter* litigation[30] and subsequent legislation in France. More recently, such questions have been

illuminated by the European Court of Human Rights decision in *Beyeler v. Italy*,[31] in which the court found that Italy's preemption of a van Gogh painting violated Beyeler's right of property as guaranteed in Article 1 of the First Protocol to the European Convention on Human Rights.

Finally, the European Convention on Human Rights, in Article 2 of the Fourth Protocol, states that "Everyone shall be free to leave any country, including his own." Professor Erik Jayme, a leading scholar, has suggested that this "right of travel" necessarily includes the right to take along one's goods, because one who must leave her goods behind if she leaves a country is not truly free to leave it. According to Professor Jayme's reasoning, a Peruvian collector who for business or personal reasons moves to Spain and an Italian dealer who decides to reestablish his business in Switzerland must be free to take their art with them.[32] It is an interesting proposal. Will the European Court of Human Rights agree with Professor Jayme when a case presenting this argument is properly presented to it? We do not know.

Conclusion

I have described three separate but mutually supporting forces—a naive and misguided anti-market prejudice, excessive source-nation retention-ism, and the excesses of the archaeologists' Crusade—that combine to produce a flawed international cultural-property regime. Specifically, that regime

1. promotes excessive national retention of works of art and antiquities;

2. recognizes and professes support for the international interest in the circulation of cultural objects but limits that support to interinstitutional barter transactions;

3. adopts and propagates a prejudice against the licit market in art and antiquities;

4. has been infected by an inversion of the normal presumption that a transaction is licit unless proved otherwise; archaeologists aggressively promote this "guilty unless proved innocent" propo-sition and dismiss elaborate due-diligence measures undertaken in good faith as disingenuous;

5. unduly hampers museums in their legitimate and socially impor-
 tant work of collecting, preserving, studying, and displaying
 works of art and antiquities;

6. unduly hampers the legitimate and socially valuable activities
 of collectors, whose acquisition, preservation, and enjoyment of
 works of art and antiquities nourish the collections of the world's
 museums;

7. ignores, where it does not denigrate or vilify, the legitimate
 interests of the licit art trade, whose activities are essential to
 the formation and enrichment of private and public collections;

8. supports source-nation actions that violate the cultural-property
 provisions of the WTO and EU treaties and related international
 arrangements;

9. supports national measures that appear to courts and scholars to
 violate rights guaranteed by modern national constitutions and
 international human rights conventions.

Of course reasonable national and international controls over trade
in works of art and antiquities deserve the support of museums, collec-
tors, and the art and antiquities trades. The World Trade Organization
and European Union treaties and related international arrangements,
while they support the free international movement of goods, rightly
authorize reasonable export controls for the protection of cultural trea-
sures. Archaeologists and other good people properly want to protect
sites and objects and the information they can provide about the human
past. Museum personnel, collectors, and the art and antiquities trade
should share those concerns and support reasonable measures to enforce
them, as most do.

The existing international cultural-property regime, however, dis-
torted by prejudice and excess, harms what it purports to protect and
ill serves the international interest it is supposed to advance. We find
ourselves in one of those periods of history in which a pendulum has
swung too far. It is time to restore the balance.

NOTES

This article originally appeared in *Art Market Matters* (Helvoirt, Netherlands: European Fine Art Foundation, 2004).

1. The premise is that, as stated in the 1954 Hague Convention for the Protection of Cultural Property in the Event of Armed Conflict, cultural property is "the cultural heritage of all mankind." It is not of exclusively national concern; there is also an important international interest to be considered in making policy about international trade in art and antiquities.

UNESCO is the international agency primarily responsible for advancing this international interest. It does so through conventions and recommendations that build on the premise. Thus the preamble to the 1970 UNESCO Convention on the Means of Prohibiting and Preventing the Illicit Import, Export and Transfer of Ownership of Cultural Property states that "the interchange of cultural property among nations for scientific, cultural and educational purposes increases the knowledge of the civilization of man, enriches the cultural life of all peoples and inspires mutual respect and appreciation among nations," and that "the protection of the cultural heritage can be effective only if organized both nationally and internationally among states working in close cooperation."

The preamble to the 1976 UNESCO Recommendation Concerning the International Exchange of Cultural Property echoes the 1954 Hague premise of "the cultural heritage of all mankind" and states that the international circulation of cultural property "is a powerful means of promoting mutual understanding and appreciation among nations" and "would also lead to a better use of the international community's cultural heritage which is the sum of all the national heritages."

2. Gordon Gaskill makes the point more strongly in "They Smuggle History," *Illustrated London News,* June 14, 1969, 21: "Almost nobody has any idea what enormous, fantastic mountains of such 'duplicates' exist in the state-owned museums around the Mediterranean. Italian archeologists laugh hollowly when newspapers report the theft of some 'unique, priceless' Etruscan vase. They know, but the public does not, how many thousands of the 'unique, priceless' vases they already have in storage and quite literally don't know what to do with."

3. *Los Angeles Times,* October 24, 1989, Metro, Part B, 6.

4. Noreen O'Leary, "Charles Saatchi: Collector as Commodity Broker," *Adweek,* April 17, 1989, 34.

5. Quoted in Peter S. Canellos, "Art Museums Also Are Prey to Legitimate Plundering," *Boston Globe,* March 25, 1990, Metro/Region Section, 25.

6. "We could not allow something which we consider part of our historical artistic heritage ... to become the object of common trade...." Statement attributed to Spanish Minister of Culture Javier Solana in Jo Thomas, "Goya

Portrait to Go Back to Spain," *New York Times,* April 11, 1986, C30, col. 4.

7. *Commission of the European Communities v. The Italian Republic, Court of Justice of the European Communities,* Judgment of December 10, 1968, case 7-68; Comm. Mkt. L. Rep. [1969] Part 35, 1.

8. The Cleveland Poussin *affaire* never reached the courts. It is discussed in "Dispute with Louvre Ends," *New York Times,* March 28, 1987, L11, col. 4.

9. Austria, Administrative Court. Decision No. 2031 (A)/1951.

10. "Proper documentation" establishes that the object was either (a) in circulation before 1970 or (b) legally removed and circulated.

11. In 1987 Dr. Marion True, then curator of antiquities at the Getty Museum, worked with Getty legal counsel to establish a rigorous due-diligence procedure that was adopted by the Getty board of trustees. If Dr. True recognized an object offered to her to have been stolen or suspected that it might have been, she informed the authorities of the nation concerned. When offered something that might interest the museum but that was not fully documented, the museum would send a dossier of information and photographs to the antiquities authorities of all plausible nations of origin and, if there were any objection, would decline to acquire it. At a private international conference held at the museum in 1989, archaeologists attacked the Getty procedure as disingenuous. They insisted that an antiquity that was not fully and properly documented be treated as illicit. Eventually the museum, for institutional reasons, adopted that position, and a number of other museums in Europe and the United States have followed suit.

12. Quentin Byrne-Sutton, "Le trafic international des biens culturels sous l'angle de leur revendication par l'Etat d'origine," *Etudes suisses de droit international* 52 (1988): 1.

13. Paul M. Bator, *The International Trade in Art* (Chicago: University of Chicago Press, 1983), 49–50.

14. Karl E. Meyer, *The Plundered Past* (New York: Atheneum, 1973).

15. Preamble, 1970 UNESCO Convention on the Means of Prohibiting and Preventing the Illicit Import, Export and Transfer of Ownership of Cultural Property.

16. Preamble, 1976 UNESCO Recommendation Concerning the International Exchange of Cultural Property.

17. Article 30 of the Treaty of Rome provides: "Quantitative restrictions on exports, and all measures having equivalent effect, shall be prohibited between Member States." The equivalent GATT provision appears in Article XI. The North American Free Trade Agreement (NAFTA) and other international trade agreements incorporate the same provisions by reference.

18. The European Court of Justice held, in *Commission v. Italy,* that works of art are "goods" within the meaning of the Treaty of Rome and thus, in

principle, subject to the same trade-liberalizing rules as other "goods."

19. The English version of the Treaty of Rome uses "national treasures," and the French version uses the equivalent. The German version is *nationales Kulturgut,* and the Italian is *patrimonio nazionale.* Commenting on these differences in nomenclature, Andrea Biondi, "The Merchant, the Thief and the Citizen: The Circulation of Works of Art within the European Union," *Common Market Law Review* 34 (1997): 1173 n. 27, states: "However, there is no doubt that the definition should be uniform, and considering the ECJ's case law on other exceptions, it might be argued that [for Italy] the expression 'national treasures' should be preferred as it is narrower."

20. This topic is explored in Pierre Pescatore, "Le commerce de l'art et le Marché commun," *Revue trimestrielle de droit Européenne* 21 (1985): 451; Biondi, "The Merchant"; John Henry Merryman, "National Treasures: International Trade in Cultural Property in the Third Millennium," *Rivista di diritto commerciale* (2000): 385; John Henry Merryman, "Cultural Property, International Trade and Human Rights," *Cardozo Arts and Entertainment Law Journal* 19 (2000): 51.

21. Judge Pescatore wrote the decision of the European Court of Justice in the *Commission v. Italy* case.

22. Guido Carducci, *La restitution internationale des biens culturels et des objets d'art* (Paris: LGDJ, 1997), 90.

23. In *Commission v. Italy,* in rejecting Italy's claim that the export tax on works of art was a protective measure, the court stated that the tax had "the sole effect of rendering more onerous the exportation" of works of art "without ensuring attainment of the aim

intended by [Article 36], which is to protect the artistic, historical or archaeological heritage." The court thus recognized that retention and protection are quite different concepts.

24. *Kunstsammlungen zu Weimar v. Elicofon,* 678 F.2d 1150 (2d Cir. 1982) is a leading case. This rule is universally recognized but is, of course, subject to the rules protecting good-faith purchasers. See *French Minister of Cultural Heritage v. Italian Minister of Cultural Heritage and De Contessini,* Cass. Sez. I, November 24, 1995.

25. *Government of Peru v. Johnson,* 720 F. Supp. 810 (C. D. Cal. 1989).

26. *US v. McClain,* 545 F.2d 988 (5th Cir. 1977), 593 F.2d 658 (5th Cir. 1979). An earlier case, *US v. Hollinshead,* 495 F.2d 1154 (9th Cir. 1974), concerning a Mayan stela illegally removed from Guatemala, had resulted in a similar conviction, but the *McClain* decision more fully considered the legal questions and is the leading precedent.

27. John Henry Merryman and Albert E. Elsen, "The McClain Case and Its Implications," in *Law, Ethics, and the Visual Arts,* 4th ed. (The Hague and New York: Kluwer Law International, 2002), 201–46.

28. *Government of Peru v. Johnson,* 720 F. Supp. 810 (C. D. Cal. 1989).

29. The decision is published in Costa Rica, *Boletín Judicial* no. 90 (May 12, 1983).

30. Cass. 1st Civ., 20 Févr. 1996, D. 1996, jur. p. 511, note B. Edelman. The case is discussed in Timothy P. Ramier, "*Agent Judiciaire v. Walter:* Fait du Prince and a King's Ransom," *International Journal of Cultural Property* 6 (1997): 337. Subsequently the French adopted new legislation that has

brought them somewhat closer to the British and Canadian legislation.

31. *Beyeler v. Italy,* European Court of Human Rights, App. no. 33202/96, Judgment of January 5, 2000.

32. Erik Jayme, *Nationales Kunstwerk und Internationales Privatrecht,* vol. 1 (Gesammelte Schriften Heidelberg, Germany: C. F. Müller, 1999), 201.

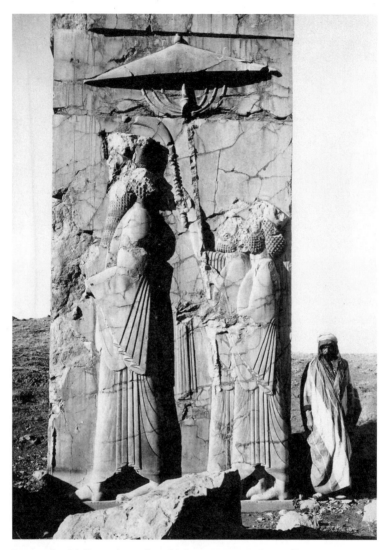

Large stele with figures beneath umbrella, 550-330 BCE, Persepolis,
Iran. Photo c. 1922, courtesy Anahita Gallery, Inc. All rights reserved.

ALTERNATIVES TO EMBARGO

KATE FITZ GIBBON

BLANKET EXPORT PROHIBITION, nationalization of "cultural heritage," and even criminalization of the art trade are accepted strategies for the regulation of cultural property in source countries today. Even those who are strong advocates of the retention of all art within source nations would find it difficult to claim that these strategies are working.

The current legal frameworks rest on the notion that both long-unearthed objects and untouched archaeological sites can be preserved through laws aimed at stemming the trade. This approach conceals the fact that the majority of finds of antiquities are accidental or the result of infrastructure development and construction, and that widespread digging for artifacts in the developing world occurs when other means of subsistence are unavailable, and in situations of war or civil strife. The trickle-down effect of criminalization of the market in a few countries at the consumer end of the trade will do nothing to change the circumstances of accidental encounter or desperate need that brought the object to market in the first place.

The primary beneficiaries of the present system are corrupt source-country officials at all levels of government, and middlemen, most of whom are source-country nationals who exploit the working digger. The main losers are source-country cultural institutions, legitimate government interests, and dealers, scholars, collectors, museums, and even archaeologists throughout the world.

Although local laws in many art-rich nations make it a crime to despoil an archaeological site or to loot a grave, more attention and more funds are generally directed toward the prevention of illegal export than to either site protection or the care of objects in museums. Currently, the same enforcement procedures are applied to illicitly exported art as to other forms of contraband. In part, this is because out-of-country funding and assistance from the United States or Europe are available to stop the flow of illegal drugs and armaments, and export control of artwork is undertaken as ancillary to these efforts.

291

Many developing countries have signed on to ambitious national programs or international agreements establishing retentionist regimes for cultural heritage. In reality, if they have not taken practical steps toward building an inventory of their collections, these nations are no closer to implementation of any regime—be it retentionist or internationalist—than they were ten, twenty, or even thirty years before. Instead, they must rely on import nations to do their policing and tracking for them.

Alternative systems of licensed export have been tested for many years in the developed world. The most successful have attempted to strike a balance between national, universal, public, and private interests in their export control policies, weighing arguments for the retention of cultural objects against the benefits of sharing of these objects with an international public. The operation of all export-licensing systems is dependent upon the existence of an inventory, whether it is a general inventory for purposes of documentation or includes evaluation criteria to facilitate decisions regarding export.

While the United States has never regulated art export, Canada, Great Britain, and Japan all have effective export-permitting systems. In Canada, for example, all forms of cultural property (including ordinary antiques) must be licensed for export. While most items are granted a license immediately, the Canadian Cultural Property Export Review Board may determine that an item is of "outstanding significance and national importance." The board can establish a delay period during which the property must remain in Canada pending purchase by a local cultural institution. Museums and public authorities are notified of the availability of the property and may request a Cultural Property Grant to assist with its purchase. If it is not purchased, it is allowed export.

In Great Britain, works of art over a specific monetary value require an export permit; items that are deemed of great artistic or historical value may be temporarily withheld from export in order to give in-country private or public collections the opportunity to purchase them. If interest is lacking and funding for purchase unavailable, they are allowed export.[1]

Under the Japanese Law for the Protection of Cultural Properties, works of art are classified within a hierarchy of importance by the government's Agency of Cultural Affairs. Items designated "National Treasures" and "Important Cultural Properties" are permitted temporary

export only for exhibition and return. Other items may be exported. A similar law in Korea also mandates public as well as expert review of objects under consideration for "National Treasure" status.[2]

Whether or not a regulated flow of art is considered desirable, the management of cultural heritage is at base a resource-management issue. The first requirement of a system that regulates the movement, preservation, and optimal utilization of any resource is that it *function,* and function reasonably well. A really good resource-management system is one that not only works well under present circumstances but has the ability to adapt to changes in order to maximize efficiency, minimize potential harm, and provide the greatest possible benefit to all those who are affected by it.

Management practices may be nuanced and given direction by current political, ethical, and practical considerations, but systems must be based first on functionality, and second on ideological concerns. There is a very real conjunction between national independence, national identity, and cultural heritage. However, acknowledging and even celebrating this relationship does not require a policy aimed at retaining all antiquities or ethnological materials within a country's borders. On the contrary, such a policy places a tremendous burden upon the source country. It must preserve, house, and hopefully document an ever-increasing volume of cultural heritage materials on the basis of a single, fixed policy, without the flexibility of managing these materials as a resource for the general benefit.

The primary utility of digitalization and Internet-accessible documentation within art-source countries would be in the general management of art resources through the establishment of an inventory database. Such a database would allow the creation of cultural resources for local education, expansion of scholarly contacts, and promotion of tourism. It would also, to paraphrase the preamble of the 1970 UNESCO convention, do much to "enrich the cultural life of all peoples and inspire mutual respect and appreciation among nations."

At the same time, digitalized, documented inventories could provide the necessary oversight to a regulated, government-supervised trade that meshed fully with modern collections-management practices. A licensing system allowing certain items to be exported but not others could use museum-inventory technologies to ensure compliance with export criteria and to track and link important works of art already outside

source countries. Funds generated by a regulated art trade could support archaeological and museum activities in source countries, including the enrichment of local museum collections by the addition of artworks from other countries. Cultural institutions could utilize limited resources more efficiently and operate with greater independence and flexibility. Corruption and black-market activities would be stemmed. Last but certainly not least, a reduction of extremist national political rhetoric through arts cooperation could encourage other cooperative activities between nations.

Advances in computing power and storage capacity have dramatically changed the prospects for cataloguing the world's art resources. The volume of materials now included in collections databases worldwide is staggering. One of the most outstanding examples of a general inventory network is the Canadian Heritage Information Network (CHIN). Since 1972, CHIN has operated as a centralized service bureau hosting national inventories and archives. More than twenty-five million objects and eighty thousand archaeological sites are included in these databases. In the last decade, CHIN has directed its efforts toward increasing public access to the collective resources of Canadian heritage through the Internet.[3]

Another centrally organized national inventory is being undertaken in Taiwan, as part of the government's e-Taiwan Plan.[4] All 650,000 pieces in the collection of the National Palace Museum as well as the museum's 400,000 Qing-dynasty documents and rare books will be available as digital images with descriptive text, forming a major component in the "digitized easy-life environment" envisioned by the e-Taiwan program, and making these cultural resources available worldwide through the Internet.

The primary function of all museum collections-management software is to track items in the collection, and to link information about an item within its record—its digital image, physical description, source, ownership and exhibition history, and condition. Museum software also links individual objects to similar objects in the collection, media related to the objects, and supplementary texts about them or about related objects: everything that is known about the objects or that establishes a relationship to other objects.

An accurate inventory makes it possible to choose items for exhibition, plan for storage or conservation, compare materials for study,

identify redundant objects, and safely lend or borrow works of art. An inventory is the best hope for retrieval of lost or stolen items. If disaster, man-made or natural, strikes your museum or a thief steals your valuables, and you have no inventory of your property, you have no way of even knowing what you have lost.

Early digitalization systems were often designed for specific institutions or types of collections. All of these are now obsolete. Not only have the types of software and storage media vastly altered in the last decade, but the goals of digitalization have changed. The continued viability of commercial museum-software products depends upon their ability to interconnect with other systems and to be updated to meet new forms of transmission, storage, and reproduction. Consequently, software products are similarly organized. They collect and store data in similar ways. Increasingly, software includes thesauri and other vocabulary standards as tools that allow users to simplify searches across different networks and employ the users' own descriptive terms.[5]

The consequence of this new focus on standards and compatibility is that the establishment of a global network of digitalized museum images and textual resources is now a realistic goal. It should now be equally possible to document items licensed for legitimate export and items stolen from an individual or institution. Such a system could, in effect, remove the concern that has most hampered a liberalized global trade in works of art: the fear that lack of tracking ability, bribery, forging of documents, and other forms of loss of authority by the source countries would allow important art treasures to reach a market into which they would disappear.

In proposing that source nations consider undertaking licensing regimes, I have made several assumptions. The first is that the nations concerned would be art-rich and cash-poor, but that international funding for cultural activities and educational outreach might be available to them. The second is that European and US museums would find it in their interest to provide expertise and equipment to help such projects get started; assistance from the developed world would be amply repaid in the ready availability of information to curators, scholars, students, law enforcement, and the public. My third assumption is that the market is the most efficient mechanism for distributing art, and that both art dealers exporting objects and art consumers purchasing them would be

delighted to pay a premium for a certification of legal export from the source country.

A cultural institution in a source country or, better still, a networked group of cultural institutions (such as a national museum, library, and archive) would review items for export. A valuation would be placed on each item, either by a committee of review or by the person wishing to export it. The institutions could either purchase the item for the given valuation or issue an export permit for a fee based on the item's valuation. A fee system is essential in order to secure funding for the purchase of objects considered worthy of retention and to provide rewards to persons bringing chance finds to the institution. Otherwise, finders have neither a positive incentive to submit items to the institution nor, if trading in artifacts is illegal, any reason for preserving them.

The contribution of digital technology to this scenario is in providing secure documentation and transparency to the permitting process. When records are available for easy reference, materials can no longer be switched or documents forged. The marketing of permitted items could be open and legitimate title easily established, and an image and description of the item and its find-spot, if known, could be retained for scholarly research.

It takes very little to build a basic collections-management system: a few computers, a server, networking connections, and a steady supply of electricity. Complete museum-management software suites capable of organizing the complex relationships between tens of thousands of objects, images, text, conservation records, exhibitions, and storage are currently available for only a few thousand dollars per user license.[6] It is likely that fewer than five computers would actually be used to input data in a specific developing-world situation, even if multiple cultural institutions participated in a national, networked program. There would be additional costs for software applications establishing Internet access and for digital photography and scanning. All together, start-up costs for computer hardware, digital photographic equipment, software, and Internet access could be kept well below $30,000, plus the cost of a trained operator to provide information for the records and to update and maintain software, and workers to move objects, input data, photograph objects, and properly store them.[7]

An example of a low-budget, high-return system is the Royal Tropical Institute (KIT), Netherlands, program to digitize museum collections

in the Third World. The KIT Object ID project does hands-on training in basic documentation programs and provides museums with computer hardware, software, a back-up battery, and a digital camera.[8] Active programs are in place at eighteen museums worldwide, including seven in Africa, three in South Asia, and three in Vietnam.[9] This excellent program could serve as a model for use of more current software that would offer sophisticated but user-friendly management capacity.

In Peru, the National Institute of Culture, the Pontifical Catholic University, and IBM have begun research on methodologies to "ease the job of registration, catalogue and control of cultural objects that are part of the cultural patrimony of Peru," using a state-of-the-art museum-management system to document items in the inventory of the Catholic Church. While this project is designed to "control" inventories and prevent theft within a closed system of church property, it obviously offers wider opportunities in collections management than simply tracking items for law enforcement.[10]

Today, collections-management systems follow established international descriptive standards to catalogue objects, images, and associated text, and technical standards for digital-image capture, storage, and transmission of data. Museum professionals have long recognized that the use of standards is the key to long-term availability and wide electronic access to information.[11] Virtually all current museum-documentation programs generate fully translatable data that meet or go well beyond standards such as Object ID.

The most exciting possibility afforded by use of these standards is the *distributed-query* network. In the past, museums have tended to think primarily in terms of their own collections, rather than in terms of relationships to comparable materials in other collections. In a number of experimental projects, groups of museums have formed consortiums to provide a far broader range of resources to the public through Internet access. A search through a single Internet portal for the work of a particular artist or for art from a particular geographical area or period will be distributed through a network of museums, and the results will include all materials fitting the query from all the institutions. This system has huge potential for museums worldwide because it does not depend upon the use of a particular museum software program but is designed to accommodate a variety of systems in different institutions, and uses standard http Internet protocol.[12]

So far, distributed-query networks are still in the experimental stage. The George Eastman House (GEH) and the International Center of Photography (ICP) have established a joint Web site as a portal into the databases of both institutions, bringing together images and textual information from both collections.[13] A far larger project is now under way to allow distributed-query searches through the collections of at least eight major US museums, together representing a wide range of collection types and a vast number of objects.[14]

Unlike the Canadian Heritage project or central repositories of digital images such as the Art Museum Image Consortium, which depend upon a central authority over data from many museums in a single database, a distributed-query system could access the individual databases of multiple institutions worldwide at the same time with a single query.[15] A distributed-query search capacity within a global network of museums could also allow a search for missing or stolen works of art or provide documentation for licit export of specific items. Art registries have proven to be an extremely effective means of stemming the trade in stolen art, and of facilitating recovery of lost and stolen objects.[16] The cost involved to establish such a global network, which would also provide vast cultural resources to anyone within reach of a computer, would be far less than that currently expended by law enforcement simply to stem the illicit art trade.

Every situation in which cultural institutions make digitalized resources available to the public, whether it is a massive project of global connection or a matter of helping a few museums to start documenting their materials, raises questions about how museum authority can be maintained, and how to deal with issues of copyright and licensing. While these are valid issues, they are very minor concerns in comparison to the everyday management problems faced by impoverished institutions in the developing world. In a way, the very desperation of the situation makes these sorts of decisions far less crucial than they might be in a stable, well-funded museum environment.[17]

To put it bluntly, without an inventory, a museum has no "authority" to speak of, and there is nothing to license in the first place. Since even the most elaborate security systems can be hacked, a compromise position of sensible precautions such as digital watermarking or tagging with copyright notices would be sufficient to establish legal claim to images and text. Unauthorized downloads and use of images are

most likely to take place in the context of the educational activities that museum-software systems are designed to serve in the first place. An Internet-accessible collections database in a developing country (without broadband or other high-speed transmission capacity) would not use the kind of high-resolution digital images that are useful to pirates. In any case, even in the most developed countries, fears of commercial success among museums have been, for the most part, unwarranted.[18]

Digitalization of resources and public access to them is by far the fastest and most comprehensive means of achieving transparency in the operation of a cultural institution. Offering a clear view into management and operating practices may lead to revelations of mistakes and potentially alienate funding and donor support: abuses are made more difficult, but sometimes so are legitimate actions necessary to the running of an institution. If an export licensing system is established, then the responsibility for those decisions may invite public criticism on a politically sensitive issue.

Inevitably, transparency, along with the widespread availability of resources, is a democratizing influence that may not initially be welcomed into an institutional bureaucracy, but that is, nonetheless, a force for good. The potential benefits of an accessible cultural resource network so far outweigh the risks associated with transparency that it would be disingenuous to consider them serious barriers to implementation. In addition, the assurance of transparency in a licensing scheme should allay any concerns of the public and of international scholars that valuable materials and information were being lost or mishandled.

Comparing the availability of information through digital sources today to that of only twenty years ago is like comparing the volume of information available in printed-book form to what was available before the invention of printing. The vast increase in information capacity has the potential to change the way we understand art history as well as the way we see individual works of art. Networked systems encourage the creative use of a global pool of information; for a time, there may be more comparing of materials and sharing of information, and less single-focused detailed analysis. Some museums may see the digital context—and the removal of the physical museum environment from the scholarly equation—as a loss of authority. But museums are the institutions best positioned to ensure global visual literacy and the democratic principle of education for all. Familiarity should lead to

affection, and to broader acceptance of the communal and national value of all museums.

Among the essential questions that remain is, who should or would be willing to take on the monumental task of digitalizing the cultural heritage of the developing world? International organizations dedicated to documenting world heritage have done magnificent work, sometimes on a grand scale.[19] The involvement of international institutions such as UNESCO would be of great benefit to any project. In the recent past, international organizations have looked askance at a regulated trade in art objects. Yet a truly regulated trade could be established as a minor element within a museum digitalization program, and could offer art-rich countries a necessary source of revenue and encourage cooperation in conservation, curatorial, and archaeological activities. As has been shown in countries that have established licensing regimes, a legitimate trade would very rapidly take the illegitimate trade entirely out of business.

The new technologies outlined above enable us to address a global problem on a very local scale, one country or one museum at a time. Why not develop model programs such as those initiated by KIT in countries like Afghanistan, where infrastructure is entirely absent and the need for assistance is unparalleled, in light of the terrible destruction so recently suffered?

Commercial-sector digital technologies now place documentation and inventory systems within the economic reach of almost any cultural institution in the world. Helping source countries to use Internet-compatible museum databases not only would serve the interests of scholarship and promote intermuseum cooperation on a global scale, but would offer source countries security in tracking permitted objects and facilitate a rapid response in cases of art theft. Here also is a tremendous opportunity for museums in the developed world to establish the cooperative, interinstitutional relationships that could make a Universal Museum a reality.

NOTES

I would like to thank Marcia Finkelstein of Gallery Systems for her generous assistance in making contacts and locating sources for this article.

1. A similar two-tier system applies to the discovery of antiquities in Britain. Under the 1996 British Treasure Act, persons discovering archaeological items must, by law, report their find to the authorities, and finders are either granted a reward or permitted to keep the items. See Peter Tompa and Ann Brose, "A Modern Challenge to an Age-Old Pursuit," in this volume, for a discussion of the successful implementation of this British statute.

2. According to Dr. Park Youngbok, director of the Gyeongju National Museum, there are currently about fourteen hundred Important Cultural Objects and three hundred items designated National Treasures in Korea. Transcript, *Cultural Property Forum: The Export Policies of China, Korea and Japan* (New York: Japan Society, April 9, 2003).

3. Diane M. Zorich, "Beyond Bitslag: Integrating Museum Resources on the Internet," in Katherine Jones-Garmil, ed., *The Wired Museum: Emerging Technology and Changing Pardigms* (Washington, D.C.: American Association of Museums, 1997). By early 2004 there were 160,000 text entries and 5,000 digitized images from the Canadian National Archives Collection of Documentary Art, and 400,000 descriptions of images and 10,000 digitized photographs depicting "Canadian reality" available online.

4. The e-Taiwan plan is part of the Challenge 2008: National Development Plan, launched in 2002, and is aimed at making Taiwan "Asia's most e-oriented country by the year 2008." Other participating institutions in Taiwan include the Academica Sinica, the National Museum of History, the National Central Library, and the Academica Historica. Rita Fang, "Virtual Museums Spring to Life in Taiwan," *China News Digest,* October 3, 2003.

5. Among these are the *Art and Architecture Thesaurus* developed by the Getty Information Institute, the *Union List of Artists' Names,* and the *Geographical Names Thesaurus.*

6. The currently top-rated (by CHIN) software's single license cost for a small museum program is about $1,800 US. Use of MSDE means that no Sequel Server database license would be required. Of sixteen widely used museum software systems available for survey through CHIN, most had excellent system administration, collections and data management, query and search capability, user interface, and report generation. Four or five of these systems were almost evenly bunched at the top of the ratings heap, and all of these had component or allied systems to permit Internet access. All such systems also allow user generation of additional fields in areas of documentation and tracking that could be used for systems of licensed export. Their differences, for the relatively simple museum needs of developing countries, would be in the "friendliness" of the user interface.

7. Technology moves so rapidly that it is essential for the success of any project to make long-range plans that include basic maintenance, training, and update services from the software provider at the additional cost of a few thousand dollars a year. Most software maintenance is now done via the Internet, but at least one person must be available in-country with basic computer skills.

8. Object ID is a widely used descriptive standard. In the United States, the FBI has adopted Object ID for its National Stolen Art File; in the United Kingdom, it is used by Scotland Yard. Object ID is now slightly antiquated, but the standard descriptions and XML (Extensible Mark-up Language) tagging used in commercial museum software would be easily translatable to the existing Object ID system for input into existing registries. Any updated registry system would also include XML tagging.

9. The project has been financed by the Dutch Ministry for Development Cooperation, but KIT is seeking sponsors for additional museum projects. The Royal Tropical Institute/Koninklijk Instituut voor de Tropen (KIT), www.kit.nl.

10. The pilot plan will document a sample of around two thousand cultural objects of the Cathedral of Lima, representing a wide range of items. The second stage is to develop a Peru Cultural Inventory Web site that will access the sample data. Personal communication, Alfredo Remy, IBM del Peru, SAC, 2004.

11. The search for an appropriate universal descriptive and procedural system for museum collection-management systems began with CIMI's SGML (Standard General Markup Language) for structuring information and ANSI Z39.50 for search and retrieval, and continued with the Museum Documentation Association's XML Schema, based on an international museum standard for describing objects called SPECTRUM. XML defines content and is descended from SGML, itself related to the familiar HTML, which defines layout. SPECTRUM is designed to provide a universal exchange format when museums migrate from one collection-management system to another. Most current systems utilize a core element based on the Dublin Core, with XML tagging.

12. This differs from the Z39.50 protocol that has been used for distributed searches within a group of institutions registered by address and port number in the software.

13. The project will install and implement the Museum System (GEH migrated more than 140,000 records with images; ICP transcribed an initial 3,500 records from index cards and began original cataloguing and imaging in 2001; ICP now has about 25,000 records linked to images). Personal communication, Marcia Finkelstein, Gallery Systems, April 2004, and www.photomuse.org.

14. Personal communication, Marcia Finkelstein, Gallery Systems, April 2004.

15. Such a system would have a much-expanded utility in comparison to central repositories such as the Art Museum Image Consortium, ArtSTOR, and Euromuse, which have each created a "union database" of information and provide a search facility for the single database.

16. See Appendix 2, Cultural Property Information Resources.

17. The potential drawbacks of the commercialization of museum databases should also be considered in the context

of a global network. Museums can offer a full range of materials for research and cataloguing, whereas commercial ventures tend to deliberately filter materials and limit the inventory of reproduction. Commercial ventures sometimes focus on iconic, well-known objects, and lessen museum authority by reducing the amount of textual and other background material associated with each object. Other questions of authority are related to museums' basic responsibilities to their collections and to the public. For some museums, the easy ability to manipulate digital images by a user may compromise the original and threaten the innate authority of the work. This is akin to the fear that repeated reproduction will lessen appreciation for the original and reduce fine art to illustration. Curatorial and institutional unwillingness to share information is sometimes characterized as fear for the authority of scholarly information.

18. Commercial use of museum images is made economically viable only through highly structured environments such as the Museum Educational Site Licensing Project of the Getty Information Institute, which is implemented through the Art Museum Network, a project of the Association of Art Museum Directors, www.AMN.org, in which copyright is reduced to an ASCAP-like formula.

19. A major international database on monuments and sites exists thanks to the International Council on Monuments and Sites (ICOMOS). Other major heritage documentation efforts include the International Committee for Architectural Photogrammetry, one of the international committees of ICOMOS, established to improve all methods for surveying of cultural monuments and sites.

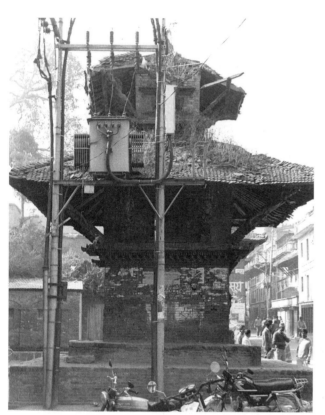
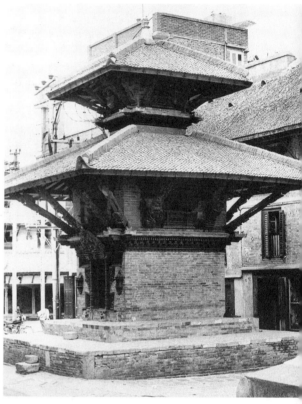

Uma Maheswar Temple restoration, Patan Darbar World Heritage Site,
Nepal, 1992. Restoration of the 16th-century shrine was completed in
six months. Photos courtesy Kathmandu Valley Preservation Trust.

THE KATHMANDU VALLEY PRESERVATION TRUST

ERICH THEOPHILE, CYNTHIA ROSENFELD

ALONGSIDE ITS COLORFUL REPUTATION as a haven for hippies, trekkers, and budget backpackers, Nepal's Kathmandu Valley has been a magnet for international scholarship and architectural restoration projects since the 1970s. However, no mechanism existed to channel private American support to this treasure trove of global heritage, a crossroads of civilization for centuries and home to seven UNESCO World Heritage Sites. For this reason, the Kathmandu Valley Preservation Trust was founded in 1991 by Dr. Eduard F. Sekler, then team leader of the UNESCO Campaign to Safeguard the Cultural Heritage of the Kathmandu Valley, and conservation architect Erich Theophile, both of whom were passionately committed to the notion that relatively small amounts of aid money could save historic buildings that would otherwise be lost to looters and the environment. Dr. Sekler established the geographic boundaries of Patan Darbar Square (the oldest of three royal squares in the Kathmandu Valley) in which to carry out the trust's mission, in order to make the most direct impact in terms of architectural restoration and community development. By concentrating its efforts geographically, the Trust has successfully established itself as a model program in architectural restoration. Lessons from the Trust can be applied to almost any preservation program around the world and have had an immediate influence on the numerous local and international initiatives currently under way elsewhere in the Kathmandu Valley.

In parallel with detailed planning and research exercises, Theophile and his team of Nepalese architects and craftsmen set about to "learn by doing." In 1991, they identified the Radha Krishna Temple as an ideal case study for the nascent organization. Structurally threatened but with enormous original detail intact, Radha Krishna had been established by royal donation in the seventeenth century. After the demise of the Malla Kings in Patan, this temple, like many of the royal medieval donations, was left without a local population to worship and provide support. The temple, which stands on the edge of the World Heritage Site, had

305

similarly fallen through the cracks of action plans overseen by international conservation experts.

With seed funding from the Canada Fund, the Trust completed its first project with a total budget of $55,000. Expenditures were modest compared to other foreign-managed projects across the Kathmandu Valley but significant as Nepal's first "turnkey" preservation project. This innovative model was funded, implemented, and then handed over to the Nepalese Department of Archaeology, creating a valuable continuity that had been lost in previous international aid projects, in which funding and implementation were split between foreign government donors and the Department of Archaeology. As a private-sector enterprise, the Trust was able to circumvent intergovernmental protocol and produce an effective, low-cost, comprehensive program that set the trend for future Trust initiatives.

The Trust has successfully completed more than two dozen architectural preservation projects since Radha Krishna, establishing an impressive track record that offers a concrete set of lessons for students of conservation architecture. However, a discussion of the obstacles faced by the Trust provides equally valuable insight into some of the challenges faced by anyone committed to preserving the tangible past for future generations. Because it was the only international nongovernmental organization registered in the field of cultural heritage in Nepal, no criteria existed within His Majesty's Government to review nongovernment projects. Introducing the Trust's private-sector model meant identifying and working closely with a few motivated and creative Nepalese civil servants who were willing to put aside government-established criteria that were based on Indian archaeological guidelines and had little relevance to architectural preservation.

Like the Trust itself, Nepal was relatively new to monument preservation, despite its deep inventory of buildings and townscapes of significance to all humanity. Additionally, the Nepalese government had few resources to direct toward this field; its gross national product has long been among Asia's lowest, and most international aid money is strictly earmarked toward direct humanitarian relief efforts. The Trust was able to initiate its Patan restoration program without the intrusive participation by local bureaucrats that often characterizes foreign-directed aid projects. In this small kingdom, home to more than a thousand world-class monuments, the Nepalese government's budget for

heritage conservation was roughly $100,000 per year when the Trust came on the scene. This disparity allowed Sekler and Theophile to select strategically important buildings for restoration that would make an important impact locally and globally with relatively little political oversight, unrestricted by government agenda.

In addition to this freedom from above, the Trust greatly benefited from the existing conservation expertise in the valley in its early years of operation. The first internationally aided preservation projects, Pujari Math and Hanuman Dhoka, were completed by the Department of Archaeology in 1972 with aid from Germany and UNESCO, respectively, and launched modern conservation in Nepal. The Trust convened a world-class team of preservationists familiar with local conditions and eager to play a more ongoing role by participating in these unique turnkey projects. Starting with a small string of single-building projects similar in size to Radha Krishna, the Trust's flexible institutional framework grew organically, limited only by geography, to buildings of historic importance in and around Patan Darbar Square. This is perhaps Dr. Sekler's most significant philosophical legacy to the Trust: one small, lean organization can multiply its effect on the field of conservation by not spreading itself too thin on the ground.

Another guiding principle for the Trust was to act not only as caretaker but also as catalyst, developing different kinds of projects that would take the local field of conservation in innovative directions. Advisor Niels Gutschow emphasized that since the valley's threatened monuments far outnumbered available resources, the Trust would fail in trying to do everything but rather should identify new challenges with every additional architectural project and, wherever possible, should empower Nepali organizations to take up implementation. By setting local precedent with each building, such as bringing world-class seismic strengthening to the earthquake-prone valley or undertaking the first restoration program for Nepali historic homes, the Trust would inspire local architects and artisans to think creatively about their heritage. By approaching old buildings in new ways, the Trust could establish precedents that could apply to any conservation setting around the world.

Setting precedent occasionally thrusts the Trust into controversy. Three years ago, in response to the increasing number of Nepali objects of worship turning up for auction and in museum shows overseas,

307

the Trust began documenting stolen Nepali art on its Web site (www .kvptnepal.org). Among the artworks to come to the attention of Trust scholars were three paintings stolen in 1979 from Kathmandu's Itum Baha monastery and included in an exhibition organized by the Art Institute of Chicago in 2003. One of the oldest and most important surviving Buddhist institutions in Kathmandu, Itum Baha is known for its unique rituals, such as the Buddhist New Year teachings that have been delivered at this shrine since the thirteenth century. The structure retains significant historic fabric, which is unusual for its age and given the seismic activity of the region. However, as it sits outside the World Heritage Site monument zones of the Kathmandu Valley and is privately held by the Itum *sangha,* a governing body of Buddhist community leadership, the Trust became involved in lobbying for its inclusion on the World Monuments Watch List of 100 Most Endangered Sites in 1999 and again in 2002. When the paintings surfaced in the United States, the Trust had already committed itself to this restoration project, having secured a Robert W. Wilson Challenge Grant and funds from the German Foreign Ministry and the *sangha.*

Working with international art historians and scholars, the Trust learned that photographic evidence uncovered by a member of the *sangha* documented the three paintings in the monastery during its annual festival in August 1978. All three had been reported missing to the Nepalese authorities at the time of the 1979 theft. The three images appear in color in the 2003 exhibition catalogue with detailed captions,[1] but were not included in the exhibition when the show traveled to the Arthur M. Sackler Gallery in Washington, D.C.

The board of directors of the Trust has consulted with noted Himalayan art historians on the subject and supports repatriation of these artworks as an integral part of the architectural conservation program under way. This is a rare opportunity to restore the original decoration to an ancient building, a possibility that has not often been an option in Nepal—or elsewhere around the world, as in the well-documented case of the Elgin Marbles. The Itum paintings could be returned to their original setting and overseen by the architects and scholars who have safely repatriated Nepali antiquities from the Berlin Museum to the highly regarded Patan Museum.[2]

Because the Itum paintings are among the most valuable pieces stolen from the Himalayan kingdom in the last thirty years, the Trust

has been placed at the center of Nepal's own Elgin-like debate. The most recent Trust innovation has been its proposal to act as a private, third-party charity to which the current possessor of the paintings could donate them and thus be guaranteed their return to the monastery rather than to the National Museum or its storerooms. While the Trust and local authorities work with Interpol and through private channels to secure repatriation of these important artworks, the Itum Baha restoration project has been designed to accommodate their return. Until such time, digital reproductions will hold the place of the originals to carry out the spirit of a comprehensive restoration.

While it is still too early to know if the next generation of conservationists working in the Kathmandu Valley will follow the Trust's approaches as outlined above, the Trust has already had a measurable and meaningful impact in Nepal. Staffed largely by foreign architects and funded exclusively from overseas in its early days, the Patan headquarters is now managed and operated locally under Nepal program director Dr. Rohit Ranjitkar, with ongoing supervision from Erich Theophile, who now resides in New York. Local businesspeople and concerned citizens have taken up the conservation challenge, so that one-third of the Trust's annual funds are raised locally. A new generation of internationally trained Nepalese conservation architects are returning to Nepal eager to participate in the Trust's activities. Equally important, a local docent program was established in 2000, the first in South Asia, so that those who grew up around the historically rich but threatened buildings of Patan Darbar Square can introduce foreigners and locals alike to its history, integrating age-old tales of god-kings with observations about the ongoing, daily ritual worship that has continued uninterrupted in the Kathmandu Valley for millennia.

Over the past thirteen years, the Trust has trained a Nepali team of private-sector professionals skilled in architecture, traditional woodcarving, repair, documentation, fundraising, and publicity. Looking ahead, the Trust's goals remain local in nature and scale. It is not the intention of the Trust to hand over the organization to these young professionals and conservation advocates but rather to continue invigorating local talent with international expertise to create a valuable global partnership, balancing the best of both traditions.

Within the roughly ten square miles that comprise the Kathmandu Valley, the sheer number of worthy projects has barely declined since

the Trust's first successful endeavor with Radha Krishna. On the positive side, the valley's small scale means that as a teaching laboratory the Trust could not have picked a better environment to learn and practice conservation for generations into the future.

NOTES

1. Pratapaditya Pal, *Himalayas, An Aesthetic Adventure* (Chicago: Art Institute of Chicago in association with University of California Press, 2003), 84, 283.

2. Götz Hagmüller, *Patan Museum: The Transformation of a Royal Palace in Nepal* (London: Serindia Press in association with the Patan Museum, 2002).

THE ACQUISITION AND OWNERSHIP OF
ANTIQUITIES IN TODAY'S AGE OF TRANSITION

EMMA C. BUNKER

THE ART WORLD needs to wake up. We have painted ourselves into an untenable corner in which two impassioned groups are embroiled in a bitter dispute over the acquisition and ownership of archaeological material. On one side are dealers, private collectors, and public collectors (museum curators), who ardently promote the private acquisition, ownership, and preservation of antiquities. On the other side are archaeologists, anthropologists, and government officials, who regard dealers and collectors as felons akin to drug traffickers and arms dealers.

Until recently, collectors were considered culture heroes who rescued and preserved artifacts from ancient cultures and shared them with the scholars, academics, and connoisseurs of their day. This passion for the past was inspired by a search for knowledge about the diverse cultures of the world that blossomed during the Age of Enlightenment of the eighteenth century. This antiquarian viewpoint was the impetus for the establishment of some of the great institutions of the world, such as the British Museum, where antiquities were cherished and admired as visual embodiments of the ancient civilizations that produced them. The ideas of the Enlightenment led to the formation of significant private collections—those of George Eumorfopoulos, Anthony Benaki, John Crawford, Myron Falk, Charles Lang Freer, Emile Guimet, Desmond Gure, Arthur Sackler, and Grenville Winthrop, to name a few. Many older academics and archaeologists alive today cut their scholarly teeth on just such collections, this author among them. These collectors were not despoilers of the past but people of great intellectual curiosity who cherished the past long before the world was peopled by a multitude of scientifically trained archaeologists.

The last decades have marked the beginning of an Age of Transition between the antiquarian philosophy of the past and the anti-collecting philosophy of today. At the heart of the anti-collecting philosophy is the idea that Western collectors, dealers, and museums are directly responsible for the looting of archaeological sites. Usually, however, the looting process is initiated by local people and minor officials in the source

countries, who seek out international connections because they are desperate for cash. By and large, archaeologists have failed to protest local involvement for fear of losing the excavation permissions given by source-country officials. Instead, the war of words is directed against collectors and dealers, a situation that could ultimately drive collectors and dealers underground.

Today, art historians, archaeologists, museum curators, and private collectors face critical decisions concerning the ownership of antiquities. Most museums have accepted the responsibility of researching the provenance and history of any antiquities they might acquire, either by gift or by purchase. Current museum codes of ethics acknowledge the risk that as a result of research into an object's history, the object may be deemed stolen and have to be returned. The application of due-diligence practices lets museums off the hook and assures maintenance of the public trust, but what of private collectors, upon whom US museums depend for the establishment and enrichment of their collections?

An unbiased dialogue between private collectors, dealers, academics, archaeologists, source-country academics, and government officials must be developed in order to achieve an equitable solution to the dilemma of private ownership and acquisition of antiquities in today's political climate. It is imperative that these groups work together, as the preservation of world culture must be a concern for us all.

Some archaeologists believe that people will stop collecting if reputable scholars refuse to publish artifacts in private collections that do not have proper provenience. This position is based on the theory that collectors collect only in order to achieve social and cultural recognition when their treasures are exhibited in a museum or published in a learned journal.

I do not agree with this opinion, or with statements made by my colleagues that "an artifact without provenance has no value." Ignoring works of art for lack of documentation is a disservice to scholarship. We have an obligation to the object and to the acquisition of any knowledge that it might hold.

There is a vast difference, too, between *provenance* and *provenience.* Provenance refers to an object's ownership history, which could typically include only previous collections and dealers; provenience refers to an object's find spot, that is, its cultural context. It is the latter, provenience, that concerns us today, and not necessarily an object's provenance.

Identifying provenance and evidence regarding export can be a serious problem. Collectors of long standing may not have received documentation of origin when objects were acquired decades ago. Often, collectors lend and share their antiquities anonymously for security and privacy reasons. When their objects are listed anonymously, they are accused of hiding their complicity in a supposedly illegal acquisition, and if they allow their names to be used, they are attacked personally and publicly for being part of the looting process. Archaeologists and source countries should be happy to know where objects are located, in case they want to request access, negotiate a possible future return, or lodge a claim that the object was stolen. The more public an object and its history, the better it is for everyone.

All possible care should be enlisted to stop the looting and desecration of recognized archaeological sites as well as potential ones. It is true that much valuable information is lost when the original cultural context of an artifact is unknown, whether it rests in a museum or in a private collection. I have published objects that have been scientifically excavated as well as those that do not have such documentation, and I am well aware of the difficulties in providing an "archaeological orphan" with a cultural context. How can we satisfy our desire for antiquities and still preserve the cultural context of objects in private collections?

The real dilemma, as I see it today, is with the many older collectors who operated under a different set of cultural-property laws when they began collecting decades ago, soon after World War II, when the market was flooded with Asian and other artifacts. Most acquired their objects legally on the open market during a time when collecting was a very respectable activity, and art galleries in London, Bangkok, Beijing, Paris, Hong Kong, and New York sold antiquities openly. In many instances, these objects have been promised or have already been given to museums. When antiquities in long-standing private collections have been properly identified, some owners have donated antiquities in their care back to the country of origin, because they were shown to have a specific historical meaning and formed an important part of the source country's national heritage. This is exciting, and should be encouraged, but it will not continue to happen if present owners are made to feel guilty for collecting activities for which they were praised when they first began to form their collections.

I have been privileged to be involved in several such restitution efforts. For example, a small Khmer partially gilded silver bowl in a private collection was discovered to have an inscription that carried a date of 1138 *shaka*, equivalent to 1216 CE in the Western calendar. This inscription linked it to Jayavarman VII, one of the last great Khmer rulers. Jayavarman VII was the first Khmer ruler to be Buddhist, and was responsible for the construction of Angkor Thom and the Bayon, the two most famous late-Khmer architectural monuments. He began his rule in 1181, but there is no confirmed record of his death, and he seems to have slipped off the historical stage sometime before 1218. According to the inscription, Jayavarman VII had this bowl made as an offering to the Bodhisattva Lokeshvara, his patron deity. Not only is the bowl beautiful in its simplicity, but it is historically important as an indication that Jayavarman VII was still alive and active in 1216. With this knowledge, the owner, Douglas Latchford, agreed to donate the bowl to the National Museum of Cambodia, where it was presented as a gift to the Cambodian people on July 16, 2004. This is the second time that Douglas Latchford has donated a work of art back to Cambodia, the first being a massive stone figure of a hunchback that was discovered *in situ* at Koh Ker by the French scholar Parmentier, who published it in 1939. When it disappeared from Cambodia is unclear, but by the time it surfaced in a London gallery later in the twentieth century, its earlier history was unknown. During research, its provenience was realized, so Mr. Latchford arranged to have it returned to Cambodia, where it was accepted at a museum reception on October 17, 2002.[1]

There are also instances where Western institutions have instigated joint cooperative relationships with an Asian museum to resolve a question of ownership of an antiquity. One of the most successful examples is that between the Abegg-Stiftung, a Swiss museum and conservation center devoted to scientific and technical research on textiles, and the Xinjiang Institute of Cultural and Historical Relics and Archaeology in Urumchi, China. The Abegg acquired several textiles over the years that had been associated with Siberia and Central Asia. Recently, in the process of researching them, I was able to inform the Abegg that they had in fact come from specific sites in Xinjiang. Visits by Abegg-Stiftung trustee Dominik Keller, Regula Schorta, and myself to Urumchi resulted in the creation of a successful joint venture between the Abegg and their counterparts in Urumchi that has been highly beneficial to both parties.[2]

Several joint publications have resulted, and the Abegg has sent well-trained conservation experts to help the Chinese conserve and preserve their textile treasures. None of this could have happened if the Abegg had not owned a few fragments of ancient textiles and had not had the wisdom to initiate a working relationship with the Chinese.

After a meeting with National Museum of Cambodia director Khun Samen and deputy director Hab Touch on a trip to Phnom Penh in January 2004, New York collector Shelby White offered to fund an inventory of the museum's collection. The museum had suffered substantial physical damage and loss to its collections during the civil war and subsequent Khmer Rouge rule. Only ten of the seventy staff working at the museum before 1975 survived the Khmer Rouge program of execution of educated people. Beginning in the 1990s, Australians Darryl Collins and Catherine Millikan worked with museum staff to collect and preserve the original museum inventory datasheets (organized in three separate systems since 1920), but funding was not available to proceed with any systematic documentation. The Leon Levy Foundation and Shelby White Inventory Project for the National Museum of Cambodia commenced in August 2004. All the previous and current catalog sheets and information related to the collection will be scanned and integrated into a database. Objects known to have been stolen during the 1980s and other works that have disappeared will be listed on international registers of lost and stolen artifacts. Digital images and data will eventually be available on the Internet. In addition to speeding the recovery of lost objects and safeguarding the current collections, the project will help to train a new generation of museum professionals in Cambodia and provide a model for recovery efforts in other regions where museums and cultural institutions have suffered destruction during war and civil unrest.[3]

All the initiatives described above can serve as models of cooperative interaction between Western collectors and institutions and source-country administrations. Collectors and dealers are responsible for much that is good in the art world. They have funded research, archaeological digs, publications, and other work important for scholarship. Dealers and collectors often know important information that is unavailable to scholars and should not be lost. We should seek to recapture the adventurous spirit that governed research in the past, work diligently toward positive relationships that serve the interests of all parties, and stop the attacks that distract us from the preservation and study of antiquity.

315

There are ways in which the present war of words can be halted. If a country with valuable antiquities were to offer rewards to local finders for artifacts found accidentally, the need to steal, smuggle, and lie could be avoided. Both finders and scholars would benefit, as new archaeological sites could be protected before they are looted. Source countries must educate their people to care for the past more than for illegal gains from looting and smuggling. This will work only if people are rewarded for handing things over to their country's cultural authorities.

Another possible solution could be a system in which the source countries would evaluate their archaeological material and allow duplicate objects to be deaccessioned and offered for sale to collectors, overseas museums, and dealers, instead of being relocated to dusty basement storerooms where they are inaccessible to anyone. This would result in genuine material for sale and bring needed revenue to a source country. The revenue could be used to pay for further excavations, policing of cultural sites, and careful inventories of the many objects in the country's museums. The development of a legal art market would discourage looting and forgeries, because there would be enough genuine material around with proper export papers, with the result that collectors and museums would not have to risk acquiring pieces without proper provenience.

Perhaps the most attractive system is one in which source museums would lease small groups of cultural treasures for extended loan to other museums around the world, negating the need for such institutions to continue to collect material without provenience. A long-term lease of objects from culturally rich source countries would provide much-needed access for scientific research concerning materials and production methods, which is often hampered by a lack of scientific facilities in the source countries.

The possibility of leasing cultural treasures from Asian source countries is currently being considered by several major museums, which would like to present works of art that represent the many cultures that make up Asia but are hampered by international cultural-property restrictions. This type of arrangement could greatly benefit both the lending and the borrowing institutions, as the source country would receive financial remuneration for leasing its material, and the loaned materials would receive international exposure that could lead to increased tourism and more financial aid.

Collecting is a passion, and collectors' passionate pursuit of antiquities has spurred tremendous advances in our knowledge of many world cultures. There must be intelligent, alternative means for dealers and collectors to continue making these contributions to our understanding of culture through activities that support source-country efforts to build cultural institutions and prevent damage to the archaeological record.

Most of the action against the plundering of antiquities has been taken by Western governments rather than by source countries. The latter should now take a more active role. Deaccession of duplicative material and long-term loans of archaeological artifacts from source countries to accredited museums around the world would provide legal certainty over title and allow access to students and scholars who do not have the resources to travel to source countries. Another alternative might be to make the highest-quality photographs and excellent reproductions of important antiquities available to collectors.

In a world searching for international understanding and peace, what better way to attain them than by learning about the multifaceted cultural and religious traditions that define the world? This essay is not an apology for collecting: it is a plea for rational discussion and understanding between two seriously divided groups. Archaeologists and academics need to discuss the situation with people involved in dealing and collecting rather than denigrating their antiquarian impulses. Collectors, both public and private, are custodians of other people's culture and have an obligation to share the fruits of that culture with the world. Perhaps we should strive for a New Age of Enlightenment, in which we work together to resolve our present differences.

NOTES

1. Emma C. Bunker and Douglas A. J. Latchford, "Jayavarman IV's Grandiose Capital at Koh Ker and the Recovery of an Important Lost Sculpture," *Arts of Asia* 33, no. 3 (May–June 2003): 71–85.

2. "Interview with Dominik Keller," *Orientations* 35, no. 4 (May 2004): 63–68.

3. Melanie Eastburn, "Moving Forward, Looking Back: The Leon Levy and Shelby White Inventory Project for the National Museum of Cambodia," *Orientations* 36, no. 2 (March 2005).

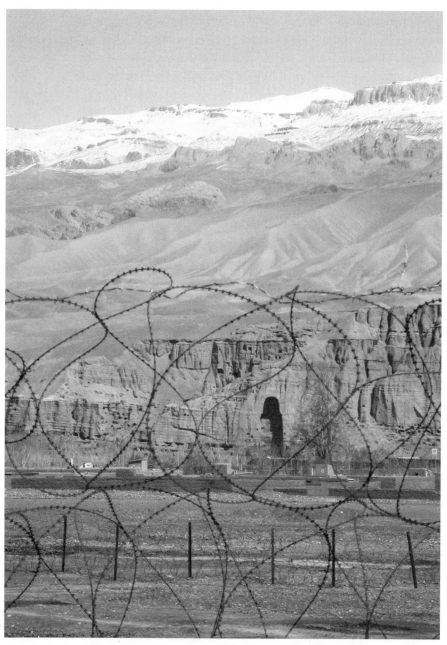

Don Meier, Empty Buddha niche seen through barbed wire, Bamiyan,
Afghanistan, April 21, 2003. Copyright © Don Meier.

CONCLUSION
Museums at the Center of Public Policy

ACCP EDITORIAL BOARD

EACH ARTICLE IN THIS BOOK deals with a problem: a collision between a common goal of preserving art and artifacts and sharp differences over how best to preserve them. The conflict sometimes begins with opposing definitions of preservation. An archaeologist wants to preserve and protect not only objects but also archaeological sites that provide context. A source nation wants to preserve the right to control the objects and benefit from their monetary, cultural, and historical value. A collector wants to establish a personal relationship with a work of art while preserving it for the next owner, and ultimately for scholarly publication and public display. Museums wish to educate, inform, and entertain the public while preserving art and artifacts for future generations.

Other, secondary goals attach themselves to the goal of preservation. These can be individually practical or geopolitical in scope. Professional archaeologists, dealers, and art historians wish to serve and earn a living in their chosen fields. Source-nation governments need to balance development needs (and consequent site destruction through road building and hydroelectric projects) against the political advantages of identification with artistic greatness or with powerful ancient regimes. Religious groups want to control access to objects and images. The US government sees international agreements on art as aids to diplomacy and the battle against terrorism and drug trafficking.

Law is the essential tool for governing the preservation and movement of art and antiquities, but current laws do not work consistently or in harmony. Articles in Part I of this book discuss questions of competing legal principle with respect to art and artifacts, and note that the interests of US individuals and institutions are not adequately protected in the current legal and legislative environment:

> Does the Cultural Property Implementation Act represent a carefully
> balanced compromise of divergent positions and US government
> policy, or is it merely one avenue available to source nations seeking

319

repatriation of art or artifacts? In a society where rules have been developed over centuries to protect an individual's right to own property, should other countries' rules be given greater effect than local law? What do the due process clauses of the Fifth and Fourteenth Amendments to the US Constitution really require before a person can be deprived of liberty or property? How much are Americans required to know about a foreign law before that law can be applied to them in the United States?

US law with respect to cultural property has to be clarified, and must be aligned with American constitutional principles and common law property rights. Two practical strategies are urgently needed to address these concerns.

The first involves developing a registration system for stolen art that could establish a minimum course of action for a victim of art theft and thereby allow for a class of truly innocent purchasers. Such a system would be a boon to owners, prospective buyers, insurers, and law enforcement.

The second is for legislation that would eliminate *McClain* as a cause for prosecution and limit the application of foreign statutes' blanket declaration of property interest in objects of cultural heritage to accepted definitions of ownership and theft under US law.

Some authors have suggested that concerns among the archaeological community over the removal of *McClain* could be allayed by enactment of US legislation that would make it a crime to knowingly deal in objects that were recently and illicitly excavated from an archaeological site. The recently enacted British Dealing in Cultural Objects (Offences) Act could serve as a model for such legislation. No single interest group within the cultural-policy discussion would be happy with all of these changes, nor would one group be the sole beneficiary. Still, all could be confident that criminal penalties could be sought against those trading in recently looted materials and that US property rights would be preserved. There are enormous practical benefits to all sides simply in having the legal rules clearly defined.

Cultural-property policies are also controversial because they focus on moral duties, and sometimes on religious, cultural, and political belief systems that are not universally held. Naturally, each position claims the moral high ground. One group aims to preserve virgin stratigraphy

in archaeological sites, another to reinforce cultural identity, a third to ensure access to art of the world's diverse cultures to US citizens of all backgrounds. It can be very difficult to find common ground when one laudable objective appears to be in direct contradiction to another. For example:

> Is the Native American Graves Protection and Repatriation Act a significant piece of human rights legislation or a clear and present danger to the humanist values of Western civilization? Should religious beliefs be given more weight than democratic secular principles? Is the public at large being given an opportunity to participate in the debate? Is it possible to measure and put a value on pleasure or increased knowledge or understanding resulting from exposure to the art and cultural property of other times and societies? How do we balance US interest in education, access, and preserving international cultural heritage with both US property rights and national ownership claims from other countries? How do we reconcile the many benefits of collecting with the perceived damage to source nations?

Some of these questions have been asked for decades, with increasing stridency and a depressing lack of resolution. It is a further, unhelpful complication that divisive, nationalist politics are in many instances the first avenue of discussion in issues of *human* heritage.

Common sense should direct us elsewhere for solutions. We should seek guidance first from successful examples of public policy embodied within the American museum system and the cooperative efforts by the public and private sectors that have sustained its organic growth. We should focus our attention on strengthening and expanding the role of American museums, the cultural institutions that have so successfully served our citizens.

Today, our US museums form the foundation of a vast visual-arts network. They are the permanent, public places where the threads of our cultural life intersect. There are many strands within the arts network—artists, collectors, dealers, scholars, critics. Museums bring all these diverse elements together to form the fabric of America's artistic life. Tastes change with each generation, political passions rise and fall, but museums remain.

More than a quarter of all adult Americans visit museums and art galleries on a regular basis. According to the *2002 Survey of Public*

Participation in the Arts,[1] conducted under the auspices of the National Endowment for the Arts, of the seven top benchmark arts activities, including jazz or classical music events, musical and non-musical plays, opera, ballet, and other dance, attendance at museums ranked the highest. In 2002, 26.5 percent of the US population—or 54.3 million Americans—visited museums and galleries. They also visited them more frequently (3.5 times in the past twelve months) than they participated in any other arts activity.

As impressive in measuring the level of commitment to cultural activities in the United States, 4.8 percent of Americans over the age of twenty-one volunteered for arts, culture, and humanities organizations during the twelve months preceding the 2001 survey "Giving and Volunteering in the United States."[2] This percentage represents approximately nine million people who donated their time and energy to such projects.

For these millions of Americans, museums are an invaluable medium through which they experience the art, customs, and history of cultures. For the majority of the American public, museums are the institutions best placed to undertake cultural education. In a time of hostility and international distrust, it is more important than ever for the next generation of young people to understand the diversity of world culture.

In the last fifty years, museums and museum exhibitions have undergone radical changes as they endeavor to reach the general public without sacrificing scholarly standards. The range of materials and variety of cultures represented in America's larger museums has become far broader. Loans and sharing of materials happen more frequently. Introspective, self-conscious questioning of the museum role is itself a common subject for exhibitions, some more successful than others.[3]

As the essays in Part II make clear, there can be no discussion of cultural heritage that does not recognize the role of the American museum as both guardian and transmitter of cultural understanding to our own multiethnic, multicultural population. At the same time, our greatest encyclopedic museums have defined their function as providing access to the world's culture to visitors of all ages, social levels, races, religions, and nationalities.

It is our hope that in the future this traditional role will expand to include the active support of Third World cultural institutions and a wide range of cooperative activities. Strategies for preserving cultural

heritage must go far beyond the development of more equitable and practical legal structures for regulating the transfer of art if they are to provide grounds for reconciliation between collectors, dealers, scholars, and archaeologists; and between source countries and major art museums. A primary goal must be the establishment of a political and social agenda that explicitly recognizes the rights and obligations of each of these constituencies, and that values both cultural diversity and the preservation of our shared human past. It is imperative to acknowledge that there are far worse things that can befall a work of art or cultural property than being preserved in the collection of a private collector or a public museum.

This requires rethinking a number of current politically correct positions. The desire to recast history in light of independence and political self-determination has given new impetus to exclusionary notions of ethnic, religious, and national identity. In some quarters, internationalism has become suspect as a neo-imperialist agenda. Humanism is now hopelessly behind the times.

As it is expressed today, the cultural-property debate is not really about content vs. context, or balancing the interests of various factions. It is a political argument with moral roots, in which the West is portrayed as plundering cultural heritage from a defenseless Third World: the possessions of others are being hoarded in museums that do not truly serve the public but are the playthings of a wealthy elite. In the most nationalist formulation of this argument, only the geographically defined descendants of ancient peoples have the ability to ascribe true meaning to these artifacts; therefore, only they should own them, interpret them, control them.

Before accepting this dangerously divisive goal, we should look to the recent past and try to determine where we have made progress in crafting cultural policy and where mistaken theories have led us astray. Has the twentieth century really shown that there is a higher moral order in furthering nationalism, in stressing our differences rather than our interconnectedness?

It is only in recent decades that "science" has ceased to regard human civilization as an evolutionary development in which the peoples of the West were the primary carriers of culture. Since the end of the nineteenth century, the disciplines of archaeology, anthropology, art history, and museum studies have worked together to bring the rich variety of human

culture before the public through education, publication, discussion, and exhibition. Truly equal value has begun to be placed on the cultural achievements of all societies. This contribution to human thought has been of immeasurable value. It has taken the principles of the Enlightenment and extended them to the peoples of the entire world.

Articles in Part III of the book have addressed recent examples of destructive polemic: in Cambodia, in Afghanistan, in the former Yugoslavia. There is no need to reiterate the barbarities of totalitarian regimes throughout the twentieth century. We should know by now that the uncritical adoption of nationalist programs has encouraged the falsification of history and the promotion of religious and ethnic prejudice. Not once but many times, it has resulted in the destruction of an important part of mankind's historical record. Today's nationalist arguments are slicker, hipper, and cloaked in political correctness. But should we be willing to define "culture" as if it were a sort of national corporate brand, with governments holding the rights to reproduction and dissemination? It is politically perilous, intellectually degrading, and morally wrong to accede to such isolationist values.

A major argument against the antiquities trade is that objects taken out of context are archaeological orphans, stripped of meaning. They have no worth to science, nothing to give us. This is simply not true. Can we reduce the power of the artist by saying that his work is not meaningful unless it has been blessed by the archaeologist's spade? Certainly, loss of context is a real loss, but our understanding of culture is based in part on groups of objects, on artistic styles and movements. Ancient societies produced multiple objects that can be organized by typology and iconography, by form and content. It is the job of scholars and museums to treat all ancient materials as scientific and educational resources, to take the circumstances of acquisition into consideration, not to refuse to look at art because it lacks the proper parents.

Two different arguments—the archaeological position that collecting and the trade destroy archaeological context, and the nationalist position that no object should leave its source country—have become blurred in the eyes of the public and the press. There needs to be greater public recognition of the hidden reasoning behind these positions, that only the descendants of those who made the art should interpret it, and only properly excavated art should be subjected to interpretation at all. This is also the subtext of the recent announcement by the Egyptian

Supreme Council of Antiquities that foreign excavation will be severely restricted after 2007,[4] and of the increased demands for restitution of art to source countries.

Alternatives to retentionist policies are discussed in Part IV of the book. An active, engaged cultural diplomacy offers real opportunities to break down the barriers of mutual distrust and hostility. Equally important, the developed world must deal openly with the fact that political instability, poverty, and lack of basic human rights are the root causes of looting in source countries, and that in most countries construction and development activities—often encouraged and funded by the First World and international institutions—are far more damaging to the archaeological record than plunder for profit.

Criminalization of the art trade is an attempt to deal with only one element of the situation while ignoring the others. This is counterproductive and extremely naive. The likely result is to place the artifacts that are accidentally discovered (as well as ones that are deliberately looted) in the hands of thugs and corrupted source-country officials. It will foster an even larger black market, and inhibit knowledge by discouraging publication and exhibition. Whatever provenience that exists will be lost.

Regulatory schemes applicable to art and antiquities must be built on the need both to preserve mankind's cultural heritage and to make the best possible use of it. We can benefit society as a whole through honoring our differences and at the same time appreciating that which we share. We must demonstrate the value we place on our neighbors' concerns by crafting policies that support their cultural institutions as well as our own. Having taken much, we should make restitution, not by returning mummies or amphorae but by sharing our own riches: technology and expertise in management and conservation. We must focus on building cultural institutions within the developing world and provide generous financial support for failing and endangered local museums, archaeological tourism, and site excavation. A true cultural internationalism is the best hope of preserving mankind's heritage for all.

NOTES

The conclusion was principally developed and written by Judith Church, Kate Fitz Gibbon, and Ashton Hawkins on behalf of the ACCP Editorial Board.

1. "2002 Survey of Public Participation in the Arts," Washington, D.C.: National Endowment for the Arts, 2003.

2. See www.cpanda.org/arts-culture-facts/policy/volunteer.html.

3. For an extensive discussion of these issues, particularly as they relate to anthropological exhibitions, see Enid Schildkrout, "Ambiguous Messages and Ironic Twists: Into the Heart of Africa and the Other Museum," *Museum Anthropology* 15, no. 2 (1991): 16-23.

4. Supreme Council of Antiquities, Ministry of Culture, Egypt, *Supreme Council of Antiquities Regulations for Foreign Archeological Missions*, July 2002.

PART V **APPENDICES AND LINKS**

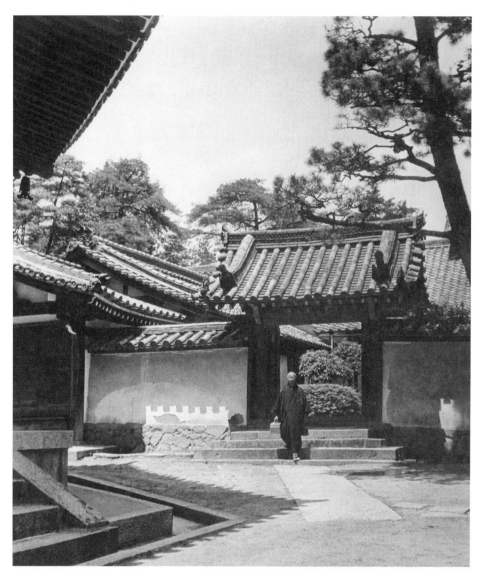

Francis Haar, *Monk in Horiyuji Temple Complex, Japan,* 1940-50.
Copyright © Estate of Francis Haar.

APPENDIX 1
Japan's Protection of Its Cultural Heritage—A Model

> The purpose of this Law is to preserve and utilize cultural proper-
> ties, so that the culture of the Japanese people may be furthered
> and a contribution be made to the evolution of world culture.
>
> —LAW FOR THE PROTECTION OF CULTURAL PROPERTIES[1]

JAPAN'S SYSTEM for the protection of its cultural heritage is a comprehen-
sive, workable model for countries that wish to preserve and protect
important cultural heritage within their borders. At the same time, the
system promotes Japanese culture worldwide through museum exhibi-
tions, a liberal trade regimen, grants for scholarship, and conservation
assistance for important works of art of Japanese origin in collections
throughout the world.

The protection of cultural heritage became an issue in Japan soon
after the Meiji restoration in 1868. Japanese policies focused on main-
taining military and economic independence from the West, using
Western-style education, science, and technology as the means to mod-
ernize Japanese society. The process of defining a new, uniquely Japa-
nese cultural model caused great stress in society. The emperor was
associated with Shinto ideology; Shintoism had fused with Buddhist
worship over the centuries in Japan, and efforts to separate them after
the Meiji Restoration led to violent attacks on Buddhist temples. Images
were destroyed, monastery lands were confiscated, and nearly eighteen
thousand Buddhist temples were closed.[2]

In 1871, in the environment of these attacks, the Grand Council
established a policy of protecting monuments and works of art through
its Plan for the Preservation of Antiques and Old Properties, adminis-
tered through the Department of Home Affairs. The Old Shrines and
Temples Preservation Law followed in 1897, the Law for the Preserva-
tion of Historic Sites, Places of Scenic Beauty and Natural Monuments
in 1919, and the National Treasures Preservation Law in 1929, which
expanded protection of cultural heritage to a wider range of historic
objects and places.

In 1949, the destruction by fire of the wall paintings within the Golden Hall (Kondō) at the Hōriyūji monastery, the oldest complete wooden structure in the world, focused Japanese attention on the need for comprehensive legal protection and administrative oversight for Japan's important cultural treasures. The Law for the Protection of Cultural Properties, Bunkazai Hogo-hō, was passed the following year, revising and uniting previous legislation in a broadly inclusive framework. By this time the administration of cultural-property protection laws had been transferred to the Ministry of Education, today the Ministry of Education, Culture, Sports, Science and Technology (MEXT). The MEXT administers cultural-property laws through the National Commission for the Protection of Cultural Properties and the Agency for Cultural Affairs (ACA), the supervising body within MEXT that oversees implementation of the Law for the Protection of Cultural Properties.

Since 1954, registered cultural properties in Japan have been divided into four categories: tangible cultural properties, intangible cultural properties, folk materials, and monuments. Later amendments have extended additional protections to archaeological sites and buried cultural properties that have been threatened by Japan's rapid industrialization.

The process of registration is as follows: the owner or custodian of an artwork, site, or historic building contacts or is contacted by the ACA to exchange advice and information about registration. Owners of important cultural property may seek designated status. Not only is it prestigious to own a registered cultural property, but ownership offers tax advantages and opportunities to receive conservation grants, and properties generally become more valuable when registered.[3]

If, after a preliminary consultation, the ACA believes that the cultural property merits protection, there are consultations with the five-member Cultural Affairs Council (CAC), who are appointed by the Minister of Education for their "wide and eminent views on and knowledge of culture."[4] If the CAC's findings support registration, the cultural property is placed on the Registration List of Cultural Properties and an announcement is made in the official Gazette. After registration the owner is obliged to consult with the Commissioner for Cultural Affairs over any proposed transfer, alteration, change of condition, or damage to the cultural property. The ACA provides the owner of the cultural property with advice and assistance on a continuing basis on matters of conservation, management, and public access.

Tangible cultural properties in the fine arts (paintings, sculptures, applied arts, manuscripts, calligraphy, and archaeological and historical materials) are designated according to a three-tiered system. Categories include Registered Tangible Cultural Properties, Important Cultural Properties, and National Treasures. Tangible cultural properties such as buildings may be either Registered or Important.

Historic sites, places of scenic beauty, and monuments are classified under two levels of importance (Registered and Special), as are groups of historic buildings. Rare or endangered plants and animals that are important to Japanese heritage may be included in the category of Monuments; the Okinawan *dugong* recently received this designation.

As of April 2004, the Agency for Cultural Affairs had designated as Important Cultural Properties a total of 10,120 objects of fine and applied art, 2,250 buildings and other structures, and 2,711 historic sites and places of scenic beauty. Of these, only 853 objects, 211 buildings, and 161 historic sites were categorized as National Treasures. These are more restricted in transfer and in most cases ineligible for export outside of Japan. In addition, there were 4,046 Registered Tangible Cultural Properties.

Intangible cultural properties include stage arts, music, and applied art techniques. Altogether, support for practitioners, performance, and documentation is extended to 114 individuals and 24 groups that include performing artists and craft practitioners. In the category of folk arts, tangible materials (clothing implements, furniture) are described as Important Tangible Folk Cultural Properties (201 items); intangible cultural properties (folk performing arts, manners, and customs) are described as Important Intangible Folk Cultural Properties (229).

The official cultural-property policy is deliberately restrained. Although the largest number of official cultural-property designations are applied to works of art, the number of such designated objects of art is minuscule in comparison to the total number of artworks of superb quality within public and private collections in Japan. For almost every registered important work of art, there are many unregistered works of comparable age and quality. The designated works set a standard of quality; the registration system supports preservation, documentation, and a high level of care for a select proportion of Japanese works of art.[5]

In some art-rich countries the term "protection" becomes a euphemism for nationalization of cultural property. In Japan, "protection"

is defined entirely on the basis of physical protection and necessary conservation of the art object, site, or monument. Because owners have no reason to hide their art, the art is at less risk of improper storage, deterioration, and damage. Only in cases in which an owner cannot be located, damages or fails to adequately protect a designated cultural property, or is unwilling to cooperate with the law's provisions for public access (limited-time public access to the cultural property or loan to a museum for a specific time period is mandated through the legislation), does the government have the authority to name a custodian (usually a local governing body) for the cultural property.

Sections of the law dealing with tangible cultural properties such as fine and applied arts, buildings, and folk art materials provide conservation grants and assistance programs for disaster protection and emergencies to both institutional and private owners. The law makes funds available for purchase of works and historic properties by the government and, in cases of proposed transfer of ownership of a National Treasure, requires that the government be given an option to purchase the item at the sale price.

Intangible cultural properties, which include both fine and folk performing arts and techniques of applied arts, are preserved through subsidies for performance, grants for living expenses of distinguished artists, funds for training students and successors, and documentation programs to preserve the knowledge of cultural heritage.

The policies established under Japan's laws are flexible enough to allow for the free movement of art objects within Japan, so long as the art is carefully preserved, and with the exception of objects classified as National Treasures, to allow temporary export with appropriate documentation, physical safeguards, and review by the ACA. Unregistered objects may be traded freely, transported, and sold without restriction other than compliance with standard export documentation procedures.

Aside from the legal provisions of the Law for the Protection of Cultural Properties, there are other factors that help to protect Japanese works of art and to preserve them within Japan. The vast majority of Japanese citizens place a high value on the preservation of historical monuments, works of art, and traditional artistic practices. This protective attitude supports government actions under cultural-property legislation and also acts to restrain the wholesale export of

the majority of Japanese works of art that are not registered or restricted from export.

The Japanese government appears confident that many objects not registered under the laws will continue to remain in Japan and that, except under extraordinary circumstances, they will be properly cared for and maintained without the necessity of government intervention. The desire of the public to have materials in Japanese museums or to own individual artworks bolsters the local market in Japan and makes it stronger than any other for Japanese artworks. There are many thousands of unregistered objects in temples and shrines in Japan. The veneration in which many Japanese people hold these objects provides greater assurance that they will not be let go than even the most restrictive legislation.

Archaeological sites in Japan also receive substantial protection in the form of legislation governing development. In 2000, almost $600 million was spent on archaeological excavations, primarily contract projects related to construction. Japan has more than fifty-five hundred archaeologists, only a small percentage of whom work abroad. Every year there are more than seven thousand specialists employed in field work, and an estimated twenty thousand to thirty thousand regular field workers (mostly middle-aged housewives) employed on approximately eight thousand excavations. About four hundred actual research projects are conducted in any one year, but many of the contract excavations also result in the publication of excavation reports, about two thousand each year.[6]

Japanese cultural-heritage laws do not pertain exclusively to Japanese materials and sites. A number of Chinese and Korean artworks held in Japan have also received National Treasure and Important Cultural Property designations. As relationships between Japan and Korea become more harmonious, art loans and cultural exchanges become more likely. It is noteworthy that Korea has a system of cultural-property protection that in some ways resembles Japan's and, as in Japan, only a relatively small percentage of artworks are designated as protected works.[7]

Although the Japanese Imperial collections contain many artworks of great importance to Japan's cultural heritage, they are not classified or registered under the Law for the Protection of Cultural Properties; the Imperial collections are under the supervision of the Imperial Household Agency.[8]

A relatively recent component of Japan's cultural-property legislation is the Law Concerning Controls on the Illicit Export and Import of Cultural Property.[9] This was passed in order to implement the 1970 UNESCO Convention on the Means of Prohibition and Preventing the Illicit Import, Export and Transfer of Ownership of Cultural Property.

The portions of this law applicable to the import of foreign cultural property are as follows: when informed by a foreign government that cultural property has been stolen from an institution (as stipulated in Article 7B of the UNESCO convention), the MEXT *designates* the cultural property. Even without such a designation by the MEXT, and under circumstances in which the importer or purchaser of an object had obtained it in good faith, a foreign government that has reported the loss to the government of Japan may make a claim for an object stolen from an inventory or institution up to ten years from the time of the theft.[10] (Under Japanese civil law, the time period allowed for a claim for recovery against a good-faith purchaser of a stolen object is only two years.) In such a case the victim of the theft must reimburse the possessor for the price paid.

The same Illicit Export and Import statute contains reciprocal provisions related to the theft or loss of Japanese cultural properties, requiring notification of the loss to foreign governments that are signatory to the UNESCO convention by the Japanese Minister of Foreign Affairs. The provisions of the Illicit Export and Import law that are related to imports of foreign objects do not apply to objects stolen prior to its enforcement, which is specified as the date that the UNESCO convention came into force in Japan, September 9, 2002.

At the same time that the Illicit Export and Import law was passed, the Law for the Protection of Cultural Properties was amended to require permission of the commissioner of the Agency for Cultural Affairs to alter or to export tangible folk cultural property.

Since the signing of the UNESCO convention, the administrators of Japanese cultural-heritage laws have recognized the practical necessity of having access to the cultural-property laws of other countries. A Database on Laws for Protection of Cultural Property has been established, with collections of foreign laws translated into Japanese.[11]

Cultural exchange is an important element of Japanese cultural-property policies. The Agency for Cultural Affairs has cooperated with US museums to produce a number of important traveling shows. The

exhibitions *Japan: The Shaping of Daimyo Culture 1185–1868* (1989) and the 1999 *Edo: Art in Japan 1615–1868* [12] were organized by the Agency for Cultural Affairs and shown at the National Gallery of Art in Washington, D.C. They contained not only many Important Cultural Properties but also a number of National Treasures, including artworks that had never before left Japan. The 2003 exhibition of early Buddhist work from Korea and Japan at the Japan Society in New York, *Transmitting the Forms of Divinity: Early Buddhist Art from Korea and Japan,* was a groundbreaking cooperative effort between the Korean and Japanese governments in the joint presentation of works from the two Asian nations. This exhibition included a number of works from the Nara Museum that were Korean in origin but were registered cultural properties in Japan. [13]

Since 2003, the Agency for Cultural Affairs and the Ministry of Public Management, Home Affairs, Posts and Telecommunications have coordinated efforts to make information on Japanese cultural heritage available on the Internet through the National Cultural Heritage Online System. The Ministry of Education, Culture, Sports, Science and Technology has stated that it recognizes that "outstanding cultural properties around the world are the common property of humanity," and that the ministry is "engaged in international cooperation for the preservation and restoration of cultural properties in places including Afghanistan." [14] Through this cooperative approach—agency to agency, government to public, and nation to nation—the Japanese government demonstrates its deep commitment to the preservation of cultural heritage for the future.

K. F. G.

NOTES

The Web- and print-based publications of the Ministry of Education, Culture, Sports, Science and Technology were major sources for this appendix. I wish to express my thanks to John Stevenson for suggesting this topic and providing background materials, and to Dr. Ann Yonemura, senior associate curator of Japanese art at the Arthur M. Sackler Gallery, Smithsonian Institution, for her assistance and information regarding Japan-US cooperation in the museum world.

1. Chapter 1, Article 1, Law for the Protection of Cultural Properties, *Bunka-zai Hogo-hō,* www.tobunken.go.jp/~kokusen/english/DATA/Htmlfg/japan/japan01.html.

2. Frank E. Smitha, *Japan from Tokugawa to Meiji,* www.fsmitha.com/h3/h48japan.htm.

3. Among the incentives are subsidies of 50 percent of repair expenses, up to 50 percent reduction in fixed assets tax, 50 percent reduction in land tax (for a building or land property), and low-interest loans from the Development Bank of Japan. Web site of the Agency for Cultural Affairs, www.bunka.go.jp/english/English2002/4/IV-2.html.

4. In addition to matters of registration and annulment, the CAC is consulted on matters of registration and annulment of the designations of cultural properties, on orders for custody, protection, repair and restoration, the execution of excavation of archaeological sites, the selection of Intangible Cultural Properties for documentation and grants of support, and the purchase of Important Cultural Properties by the state. See Law for the Protection of Cultural Properties, Article 84-3.

5. There are sets of books that picture and describe every object registered on the top two levels of National Treasure and Important Cultural Property; Ann Yonemura, personal communication, 2005.

6. Charles T. Keally, Japanese Archaeology, www.t-net.ne.jp/~keally/jpnarch.html.

7. The ownership of artworks acquired during the 1910-45 Japanese occupation of Korea is a sensitive matter for both nations. Recent recoveries of hoarded artworks have been returned to Korea, but there are an estimated three hundred thousand works of Korean art in Japan, mostly in private collections. Deborah Cameron, "Looted Treasures Find a Way Home," *Sydney Morning Herald,* December 11, 2004.

8. A 1997 exhibition curated by James Ulak and cataloged by Ann Yonemura at the Sackler Gallery, Washington, D.C., *Imperial Gift: An Artistic Legacy, Introduction to Twelve Centuries of Japanese Art from the Imperial Collections,* was organized by the Imperial Household Agency, the Agency for Cultural Affairs, the Japan Foundation, and the Freer and Sackler galleries.

9. Law Concerning Controls on the Illicit Export and Import of Cultural Property, www.bunka.go.jp/english/law.html.

10. The Japanese Civil Code, Article 192, states, "(Immediate acquisition). If a person has peaceably and openly commenced to possess a movable, acting bona fide and without negligence, he shall immediately acquire the right which he purports to exercise over such movable." And under Article 193, "(Recovery of stolen or lost article). If in the case mentioned in the preceding Article the thing possessed is a stolen or lost article, the injured party or the loser may recover the article from the possessor within two years from the time when the article was stolen or lost."

11. Database on Laws for Protection of Cultural Property, www.tobunken.go.jp/ ~kokusen/english/RESEARCH/law_ db.html.

12. National Gallery press releases, 1989 and 1998, Web site of the National Gallery of Art, www.nga.gov.

13. Web site of the Korea Society, www.koreasociety.org.

14. Web site of the Ministry of Education, Culture, Sports, Science and Technology, www.mext.go.jp/english/org/ struct/040.html, and Web site of the Agency for Cultural Affairs, www.bunka .go.jp/english/English2002/4/IV-1.html.

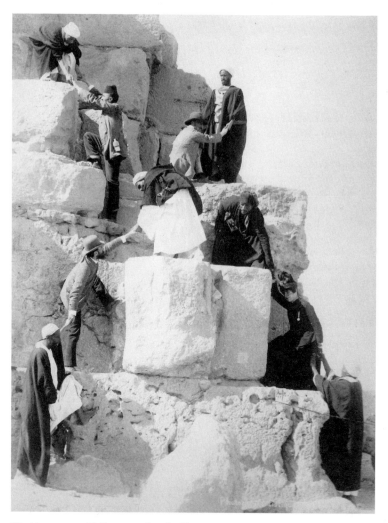

Climbing a pyramid, Egypt, c. 1870-80. Photo courtesy Anahita Gallery, Inc.

THE AMERICAN COUNCIL for Cultural Policy (ACCP) Web site, www.cultural policycouncil.org, has direct links to the full texts of many domestic and international laws, bilateral and emergency agreements, complete law journal articles, and other documentary materials including an extensive bibliography on cultural-property issues.

ACCP Site Links, www.culturalpolicycouncil.org
Laws and Conventions Page

US Property, Cultural Heritage, and Immunity from Seizure Laws

1948 National Stolen Property Act

1965 Immunity from Seizure under Judicial Process of Cultural Objects Imported for Temporary Exhibition or Display

1968 New York Arts and Cultural Affairs Law § 12.03

1972 Regulation of Importation of Pre-Columbian Monumental or Architectural Sculpture or Murals

1979 Archaeological Resources Protection Act

1983 Convention on Cultural Property Implementation Act and US Senate Report, 97–564

1990 Native American Graves Protection and Repatriation Act

The copies of the US federal statutes and regulations on these Web pages are not official. For official copies of US statutes, see the United States Code, www.gpoaccess.gov/uscode/index.html. For official copies of regulations, see the *Federal Register* and the *Code of Federal Regulations*. Official copies are located at www.gpoaccess.gov/index.html.

Foreign Laws and International Conventions

1954 Hague Final Act of the Intergovernmental Conference on the Protection of Cultural Property in the Event of Armed Conflict

1970 UNESCO Convention on the Means of Prohibiting and Preventing the Illicit Import, Export and Transfer of Ownership of Cultural Property

1995 UNIDROIT Convention on Stolen or Illegally Exported Cultural Objects

1999 Second Protocol to the Hague Convention of 1954 for the Protection of Cultural Property in the Event of Armed Conflict

2001 UNESCO Convention on the Protection of the Underwater Cultural Heritage

2003 British Dealing in Cultural Objects (Offences) Act

2003 Swiss Cultural Property Transfer Act

US and International Laws and Conventions to Limit the Damage of War

1863 Lieber Code—Instructions for the Government of Armies of the United States in the Field

1874 Brussels International Declaration concerning the Laws and Customs of War

1880 Oxford publication regarding the Laws of War on Land

1899 Convention for the Pacific Settlement of International Disputes

1907 Hague Convention (IV) respecting the Laws and Customs of War on Land and Regulations concerning the Laws and Customs of War on Land

1935 Roerich Pact—Theory on the Protection of Artistic and Scientific Institutions and Historic Monuments

1945 Nuremberg Agreement for the Prosecution and Punishment of the Major War Criminals of the European Axis

A more extensive linked list of international charters and conventions related to cultural heritage and preservation is available at www.getty.edu/conservation/research_resources/charters.html.

Bilateral Agreements, Emergency Restrictions, and Customs Regulations

Bilateral agreements, emergency restrictions, and customs regulations resulting from a request by a source country for relief under the Convention on Cultural Property Implementation Act of 1983 are listed on the ACCP Web site at: www.culturalpolicycouncil.org/bilateral_agreements.htm.

Readers will also find all these agreements as well as substantial background information at the official State Department International Cultural Property Protection Web site, http://exchanges.state.gov/culprop/.

Other Sites Linked to ACCP Links Page

Links listed below are subject to change. In order to better serve the public interest, the ACCP will continue to place updated links to these and other offsite Web pages on the ACCP Web site as they become available.

International Organizations

International Centre for the Study of the Preservation and Restoration of Cultural Property (ICCROM), www.iccrom.org

International Council on Monuments and Sites, (ICOMOS), www.icomos.org/

International Council of Museums (ICOM), http://icom.museum/

Organization of World Heritage Cities (OWHC), www.ovpm.org

United Nations Educational, Scientific and Cultural Organization (UNESCO), www.unesco.org

World Heritage Committee (WHC), http://whc.unesco.org/pg.cfm

World Monuments Fund (WMF), www.wmf.org/

Codes of Ethics, Mission Statements, and Position Papers

American Anthropological Association (AAA), Code of Ethics (1998), www.aaanet.org/committees/ethics/ethcode.htm

American Association of Museums (AAM), Code of Ethics for Museums (2000), www.aam-us.org/museumresources/ethics/

Antique Tribal Art Dealers Association (ATADA), Article X, Trade Practices and Guarantee, www.atada.org/

Archaeological Institute of America (AIA), Code of Professional Standards, www.archaeological.org/pdfs/AIA_Code_of_Professional_StandardsA5S.pdf

Art Dealers Association of America (ADAA), the ADAA follows CINOA guidelines, www.artdealers.org/ and www.cinoa.org

Association of Art Museum Directors (AAMD), Art Museums, Private Collectors, and the Public Benefit (2002), www.aamd.org/pdfs/Private%20Collectors.pdf

Association of Art Museum Directors (AAMD), Art Museums and the Identification and Restitution of Works Stolen by the Nazis (2002), www.aamd.org/pdfs/Nazi%20Looted%20Art.pdf

Association of Art Museum Directors (AAMD), Art Museums and the International Exchange of Cultural Artifacts (2002), www.aamd.org/pdfs/Cultural%20Property.pdf

Association of Art Museum Directors (AAMD), Report of the AAMD Task Force on the Acquisition of Archaeological Materials and Ancient Art (June 2004), www.aamd.org/papers/documents/June10FinalTaskForceReport_001.pdf

College Art Association (CAA), A Code of Ethics for Art Historians and Guidelines for the Professional Practice of Art History (1995), www.collegeart.org/caa/ethics/art_hist_ethics.html

La Confédération Internationale des Négociants en Oeuvres d'Art (CINOA), www.cinoa.org

International Council of Museums (ICOM), Code of Professional Ethics (2001), http://icom.museum/ethics_rev_engl.html#begin

National Association of Dealers in Ancient, Oriental & Primitive Art (NADAOPA), Administrative office contact: P.O. Box 6794, Yorkville Finance Station, New York, NY 10128; Tel: 212 249 2762; Fax: 212 249 7619

Society for American Archaeology (SAA), Principles of Archaeological Ethics (1996), www.saa.org/publications/saabulletin/14-3/saa9.html

Society of Professional Archaeologists, Code of Ethics, Standards of Research Performance and Institutional Standards (1976), www.rpanet.org

United Nations Educational, Scientific and Cultural Organization (UNESCO), International Code of Ethics for Dealers in Cultural Property (1999), http://portal.unesco.org/culture/admin/ev.php?URL_ID=13095&URL_DO=DO_TOPIC&URL_SECTION=201&reload=1073901505

Digital Information Networks and Projects

Arts Network for the Exchange of Cultural Knowledge (VANEYCK Project), www.hart.bbk.ac.uk/van_eyck.html

Canadian Heritage Information Network (CHIN), www.chin.gc.ca/

Council for the Prevention of Art Theft (COPAT), The Estate Office, Stourhead Park, Warminster, BA12 6QD, United Kingdom, Tel/Fax: +44.1747.841540

European Heritage Network (HEREIN), www.european-heritage.net/

Getty Research Institute, www.getty.edu/research/institute/

International Committee for Documentation of the International Council of Museums (ICOM-CIDOC), www.willpowerinfo.myby.co.uk/cidoc/index.htm

Koninklijk Instituut voor de Tropen (KIT) (Royal Tropical Museum), www.kit.nl/objectid/html/programme_asp

Museum Computer Network, www.mcn.edu/

National Initiative for a Networked Cultural Heritage (NINCH), www.ninch.org/

ObjectID, www.object-id.com/

Art Registries and Art Crime Alerts

Antique Tribal Art Dealers Association (ATADA), www.atada.org

Art Loss Register, www.artloss.com/

Federal Bureau of Investigation, National Stolen Art File, www.fbi.gov/hq/cid/arttheft/arttheft.htm

ICOM Red List, www.icom.org/redlist/english/intro.html

Interpol, www.interpol.int

Museum Security Network, www.museum-security.org/artcrime.html

Stolen Works of Art, CD-ROM database by Jouve using Interpol data, www.stolenart.net/

TRACE, www.trace.co.uk

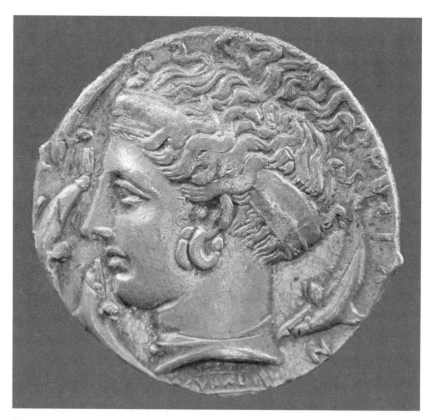

Silver tetradrachm of Syracuse, c. 405-400 BCE, Greece. Head of the water
nymph Arethusa, four dolphins around; signature of Eukleidas below.
Photo copyright © Peter K. Tompa.

ANN M. BROSE is an associate in the Intellectual Property Department at McDermott, Will, and Emery, Washington, D.C. Ms. Brose worked in the Rights and Reproductions departments for both the Los Angeles County Museum of Art and the Smithsonian American Art Museum. She practices e-business and copyright law.

ANTHONY BROWNE is a former director of Christie's, London, and chairman of the British Art Market Federation, established in 1996 to represent the interests of the art trade in discussion with the government and other bodies. He was a member of the British Government's Illicit Trade Advisory Panel.

EMMA C. BUNKER is an archaeologist, art historian, and scholar specializing in the art of Central Asia, western China, and Southeast Asia. She is presently a consultant to the Denver Art Museum and actively coordinates efforts to revitalize cultural institutions in Cambodia. Dr. Bunker is the author of many books and articles on art and archaeology; her most recent book is *Glory and Adoration: The Golden Age of Khmer Art.*

JUDITH CHURCH is counsel at Debevoise & Plimpton LLP in New York and a member of the Corporate Department and Intellectual Property Practice Group. Ms. Church speaks regularly on intellectual property issues in mergers and acquisitions and has written a number of articles on related topics as well as articles on the protection of cultural property under US law. Prior to becoming an attorney she was a painter and printmaker, and her work is included in a number of public and private collections.

STEPHEN W. CLARK is deputy general counsel for the Museum of Modern Art (MOMA) in New York. He worked in various capacities at the museum from 1982 to 1986, and served as assistant director of the American Craft Museum in 1986–87 before returning to MOMA. He is a member of the Art Law Committee of the Association of the Bar of the City of New York, and has served as chairman of the Museum Attorneys Group and as a member of the Steering Committee and faculty for the annual American Law Institute/American Bar Association Legal Problems of Museum Administration conference. He is president of the Museum Association of New York, an advocacy organization for New York's fourteen hundred museums and historical societies.

CLEMENCY CHASE COGGINS is professor of archaeology and art history at Boston University. She is a specialist in ancient Mesoamerica and Andean art and archaeology and has written extensively on archaeology, cultural-property issues, and ethical practices in archaeology. Her published work includes the 1992 *Artifacts from the Cenote of Sacrifice, Chichen Itza, Yucatan.* Dr. Coggins received the Gold Medal Award for Distinguished Archaeological Achievement from the Archaeological Institute of America in 1997.

JAMES CUNO is director of the Art Institute of Chicago. Dr. Cuno served as the Elizabeth and John Moors Cabot Director of the Harvard University Art Museums and professor of the history of art and architecture at Harvard from 1991 to 2002. He was director of the Courtauld Institute, London, in 2003–2004 and has written extensively on the role of art museums in contemporary American cultural policy. Dr. Cuno's most recent book is *Whose Muse? Art Museums and the Public Trust.*

LUDOVIC DE WALDEN is a partner in Lane and Partners, London, United Kingdom. He specializes in complex commercial litigation and arbitration as well as the international art market.

ANDRÉ EMMERICH is a retired dealer and specialist in Pre-Columbian art, classical art, and contemporary painting. He is the author of numerous books and articles on art, including *Sweat of the Sun and Tears of the Moon* and *Art Before Columbus.*

JEREMY G. EPSTEIN is a partner in Shearman & Sterling with a specialty in fine arts litigation. Mr. Epstein has been director of Volunteer Lawyers for the Arts since 1998, and has served for many years on the Art Law Committee of the Association of the Bar of the City of New York. His published articles have appeared in the *New York Times, National Law Journal,* and *New York Law Journal.*

KATE FITZ GIBBON is a consultant on collections management and cultural-property issues and specialist on Central Asian art. She is the co-author with Andrew Hale of several books, including *Ikat: Silks of Central Asia,* which received the George Wittenborn Award for best art book of 1997. Ms. Fitz Gibbon served on the Cultural Property Advisory Committee to the president from 2000 to 2003.

LEO V. GAGION is a partner specializing in complex commercial litigation and arbitration in the New York offices of Dewey, Ballantine LLP. Mr. Gagion participated in the defense in *The Republic of Lebanon v. The Trustee of the Marquess of Northampton 1987 Settlement* (N.Y. Supreme Ct., N.Y. Co.), in which the governments of Lebanon, Croatia, and Hungary each claimed ownership of a collection of Roman silver known as the Sevso Treasure, owned by a trust controlled by the Marquess of Northampton.

ASHTON HAWKINS is counsel at Gersten, Savage and Kaplowitz, where he focuses on art law, estates and trusts, international legal questions, and other issues of concern to collectors, philanthropists, museums, and nonprofit institutions. Mr. Hawkins was secretary and counsel to the Metropolitan Museum of Art, and then executive vice president and counsel to the trustees. He also served as chairman of the DIA Center for the Arts, the New York–based contemporary-arts organization. He was involved in the drafting of the UNESCO Treaty on International Movement of Works of Art and worked with former New York senator Daniel Patrick Moynihan to draft the Convention on Cultural Property Implementation Act.

ARIELLE KOZLOFF was curator of ancient art at the Cleveland Museum of Art for twenty years. She organized the exhibition and catalogues for *Animals in Ancient Art from the Leo Mildenberg Collection; The First 4000 Years: Judaean Antiquities from the Ratner Collection; The Gods Delight: The Human Figure in Classical Bronze* (with David Gordon Mitten); and *Egypt's Dazzling Sun: Amenhotep III and His World* (with Betsy Bryan). From 1997 to 2001 she was vice president of the Merrin Gallery, and she is now a private consultant to museums and collectors.

HARVEY KURZWEIL is co-chairman of the Litigation Department of Dewey, Ballantine LLP, a New York law firm, and a member of the firm's Executive and Management Committees. Mr. Kurzweil was lead counsel in *The Republic of Lebanon v. The Trustee of the Marquess of Northampton 1987 Settlement.* He is a fellow of the International Academy of Trial Lawyers.

PETER MARKS is a painter. For forty-two years he owned a New York gallery specializing in the art of South and Southeast Asia. He has written numerous articles on art and cultural property.

DAVID MATSUDA is a lecturer in anthropology and human development at California State University, Hayward. He has worked for fifteen years on studies of underground economies and their relation to the international antiquities market in Pre-Columbian antiquities as well as cross-cultural, comparative research on religion, human development, education, and gender. Dr. Matsuda received the Minoru Yasui human rights award for his work with indigenous peoples.

MARGARET ELLEN MAYO was curator of ancient art at the Virginia Museum of Fine Arts, Richmond, for more than twenty-six years. Among her accomplishments are the groundbreaking 1982 exhibition *The Art of South Italy: Vases from Magna Graecia* and its accompanying catalogue. Dr. Mayo is the author of *Ancient Art,* a handbook of the collection of the Virginia Museum of Fine Arts. She served as a research scholar for Greek vases at Hearst Castle, San Simeon, California, and was a Parker Scholar at the Center for Old World Archaeology at Brown University in 1984.

JOHN HENRY MERRYMAN is Nelson Bowman Sweitzer and Marie B. Sweitzer Professor of Law, Emeritus and Affiliated Professor in the Department of Art, Emeritus at Stanford University. He was a member of the UNIDROIT Working Group, was an organizer and first president of the International Cultural Property Society, and co-founded the *International Journal of Cultural Property.* He has received numerous national and international honors and awards, and is the author of more than a dozen books and many articles on comparative and art law.

RAMONA MORRIS is a specialist in Native American art and a former president of the Antique Tribal Art Dealers Association, a trade association dedicated to public education and the establishment of ethical standards for dealers in ethnographic artifacts. She has worked as an advisor to several US museums.

REBECCA NOONAN is an associate counsel at the Metropolitan Museum of Art in New York, specializing in immunity issues and art law.

WILLIAM G. PEARLSTEIN is of counsel at Golenbock Eiseman Assor Bell and Peskoe LLP. He specializes in art law and is the author of several law journal articles on related issues including "Claims for the Repatriation of Cultural Property: Prospects for a Managed Antiquities Market" and "Jeanneret v. Vichey: Sales of Illegally Exported Art Under the Uniform Commercial Code."

CYNTHIA ROSENFELD serves as a development advisor to the Kathmandu Valley Preservation Trust and has worked extensively in Asia as a writer and travel-industry executive.

ANDREW SOLOMON is author of *The Noonday Demon: An Atlas of Depression,* which has won eleven national awards, including the 2001 National Book Award. Mr. Solomon is a regular contributor to *The New Yorker, Artforum,* and the *New York Times Magazine.* He is the author of *The Irony Tower: Soviet Artists in a Time of Glasnost* and the novel *A Stone Boat,* which was a finalist for the *Los Angeles Times* First Fiction Award. He serves on the board of the World Monuments Fund and on the Conservators' Council of the New York Public Library.

RONALD D. SPENCER is counsel at Carter, Ledyard & Milburn in New York City. Mr. Spencer serves on numerous art-authentication boards, including the Pollock-Krasner Authentication Board, the Jacob Lawrence Catalogue Raisonné Project, and the Andy Warhol Art Authentication Board. A leading authority on art-authentication law, Mr. Spencer is the author of many articles and is the editor and principal author of the 2004 book *The Expert Versus the Object: Judging Fake and False Attributions in the Visual Arts.*

ERICH THEOPHILE has practiced architecture and historic preservation between Nepal and New York City since 1987. He is co-founder of the Kathmandu Valley Preservation Trust, a nonprofit foundation dedicated to safeguarding the architectural heritage of Nepal, and is actively engaged in the restoration of monuments, temples, and architectural landmarks throughout the country. Mr. Theophile is co-editor of *The Sulima Pagoda: East Meets West in the Preservation of a Nepalese Temple.*

PETER K. TOMPA is a partner in Dillingham & Murphy LLP in Washington, D.C., focusing on cultural property as well as environmental insurance matters. Mr. Tompa has written a number of law review and magazine articles on cultural-property issues. He is a fellow and trustee of the American Numismatic Society, a board member of the Ancient Coin Collectors Guild, a life member of the American Numismatic Association, and a member of the Ancient Numismatic Society of Washington, D.C.

PIERRE VALENTIN is a solicitor with the law firm Withers in London, where he is head of the Art and Cultural Assets Group. Formerly, he was European Counsel at Sotheby's.

STEVEN VINCENT is a freelance author writing on arts issues, specializing in cultural policy. He is a frequent contributor to numerous US and international art magazines and author of the 2004 book *In the Red Zone: A Journey into the Soul of Iraq.*

SHELBY WHITE is an author, collector, and philanthropist. She serves on the board of the Metropolitan Museum of Art. Ms. White is chair of the White-Levy Program for Archaeological Publications. With her husband, Leon Levy, Ms. White established the New Initiative Program at the Institute for Advanced Studies, Princeton, New Jersey, and the Leon Levy Biogenetics Center at Rockefeller University. Ms. White is a director of Alliance Capital Money Market Funds.

353

Seals, stone, and faience objects, 2300–2200 BCE, Harappa, Indus Valley,
South Asia. Photo c. 1930, courtesy Anahita Gallery, Inc. All rights reserved.

357

artifacts, 36-39; of private collections, 313-14; *vs.* national representation in museum, 117

replevin, 61, 125, 127

Republic of Croatia (formerly Socialist Federal Republic of Yugoslavia), 83, 85-89, 91-93

Republic of Hungary, 83, 85, 86-87, 89-93

Republic of Lebanon, 84, 85, 85n5

resale rights, 104

resource management systems, 292-300, 315, 331-37. *See also* databases; export controls

restoration, 112, 113, 162-63. *See also* preservation of art

Richter, Gisela, 167

Rizk, Ramiz, 84

Robert S. Peabody Museum, 36

Rockefeller, Nelson, 73

Roerich Pact, 4

Romans, 3, 134-35, 139, 183, 206-7

Rome, Italy, 136, 183

Rosen, Jonathan, 195

Royal Numismatic Society, 209

Royal Tropical Institute (KIT), 296-97

Rubens, Peter Paul, 137

Rudenstine, David, 115

Russell, Steve, 34

S.605 Senate bill, 19-21, 21n19, 150

sacred objects, 33, 40-41

safe harbor doctrine, 17, 18

Said, Edward, 145

sales statistics, 97, 187-88

San Antonio Museum of Art, 168n9

satisfactory evidence, 17, 17n14, 18

Schiele, Egon (paintings), 71, 75-76, 275

Schiele case, 71-81

Schimmel, Norbert, 170-71

Schneider, Alan L., 34, 39

Schoenburg, Peter, 42

Schultz, US v., 10-11, 19, 21-22, 126n5, 154

science *vs.* humanistic views, 36-39, 43, 232-35

scienter, 14, 24-26, 79

Seizure and Detention of Pre-Columbian Artifacts (Customs), 150

seizure legislation, 45-52, 71-75

Sekler, Eduard F., 305, 307

Senate bills, 19-21, 21n19, 150

Sevso Treasure, 83-93

The Shaping of Diamyo Culture 1185-1868 (exhibition), 337

Shchukin, Sergei, 51-52

Shelby White Inventory Project for the National Museum of Cambodia, 315

Shoshone-Bannock tribes, 38

Shroder, Ivan Karlovich, 50

Shumei collection, 175

site destruction: building construction, 12, 114, 188, 188n10, 195, 249; looting, 118, 210, 222-24, 248; natural disaster, 249; pollution, 118; solutions to, 263, 264, 316; war, 3-5, 188n10, 240-44, 247-48

Sloane, Sir Hans, 138, 143

Smithsonian Institution, 6, 35, 47, 173, 173n14

smuggling: Egyptian art *(Schultz),* 19, 21-22, 99, 154; Iranian art, 186; penalties for, 99, 100-101, 186; Pre-Columbian art *(McClain),* 283. *See also* looting; stolen property

Snow, C. P., 232

Snyder, O'Keeffe v., 62

Socialist Federal Republic of Yugoslavia, 83, 85-89, 91-93

software, inventory management, 294-300. *See also* databases

Solomon R. Guggenheim Museum, 59-62

source countries: cooperation benefits, 294, 295-96, 316; and education, 263, 316; marketing of discovered objects, 186-87; and patrimony interpretations, 275-76; resource management of, 292-96; theft characterization, 7. *See also* patrimony, national

Soviets, 5, 49, 241

St. Clair, William, 110

statutes of limitation (theft reclamation): for Elgin Marbles, 116; for Holocaust-related crimes, 126; in Japan, 336; lawsuits involving, 58-59, 125-26; and legislative registry proposal, 63-66; prescriptive possession, 79, 79n6; rules of, 61-62, 62n15, 125. *See also* due diligence

Steinhardt, Michael (*Steinhardt* case), 24-26

stelae, 222-23

stolen property: ATADA theft alert, 203; British criminal legislation, 98-101; definition of, Implementation Act, 15; definition of, National Stolen Property Act, 16, 77-78, 79; Implementation Act *vs.* National Stolen Property Act, 15-16; UNESCO (1970) limitation of definition, 150, 282-83; UNIDROIT (1995), 6, 283; *vs.* illegal export, 282-84

Stolen Property Act. *See* National Stolen Property Act (NSPA)

Strada, Jacopo, 137

Strasszer, Istvan, 89-90

subpoena duces tecum, 71n1

subsistence digging: history of, 258, 261; organization of, 256-58; seasonal patterns of, 261-63; socioeconomics promoting, 255-56, 263-64; solutions, 263, 264

subsistence farming, 258-61

Suger, Abbot of Saint-Denis, 183

Sumegh, Jozef, 86, 92

Switzerland, 102

Sylloque Numorum Graecorum, 209

tainted objects, defined, 100

Taiwan, national inventory of, 294

Taliban, 240-43, 248

tax deductions, 174-75, 185-86

Tax Reform Act of 1986, 174-75

terrorism, 48, 319

testing, authentication, 160

Thani, Sheikh Saud al-, 175, 252

Thaw, Eugene, 165, 172-73, 175

DATE DUE